THE Artist's Complete Book of
Drawing

A STEP-BY-STEP PROFESSIONAL GUIDE

THE Artist's Complete Book of
Drawing
A STEP-BY-STEP PROFESSIONAL GUIDE

Barrington Barber

ARCTURUS

ARCTURUS

This edition published in 2016 by Arcturus Publishing Limited
26/27 Bickels Yard, 151–153 Bermondsey Street,
London SE1 3HA

ISBN: 978-1-78599-482-1
AD004920UK

Printed in China

CONTENTS

INTRODUCTION

The aim of this book is to show you that learning to draw the visual world is not about some mysterious talent or innate facility but rather about looking at objects in a different way from that in which you normally do. It is also about application, motivation and practice. If your desire to draw is strong enough, you will be able to.

When I first started to 'look' in the way in which I am asking you to do, I thought it was cheating because it seemed too much like copying. I had been told that drawing was about using my imagination rather than seeing in a different way. It was only when I started to look at the work of great painters I realized that seeing was what really mattered, and unless you saw what was there in reality you had nothing on which to feed your imagination. In the end, imagination is more about how you remember what you have seen than conjuring up something out of nothing.

Beginning to see in a manner that can be translated to paper can give you a new way of looking at the world, seeing its shapes and forms perhaps for the first time. This can not only stimulate your imagination but also give you a view of the world that is unique to you.

Although not all the exercises in this book are easy, they are within everyone's grasp if they are prepared to put in the time. Like most things, drawing becomes easier the more you do it. I have not attempted to show you all the ways of drawing that exist – such as imaginative, illustrative, technical, and so on – as I believe that what is important in the beginning is to have confidence and belief in yourself. One of the best ways of gaining this confidence is by being able to represent the visual world in two dimensions by drawing it.

Drawing is a wonderful experience; seeing objects gradually appear on the paper can be magical. Once this magic has started to work you will want to take things further. Then it not only becomes a process of improving your drawing skills but also a road towards getting to know more about yourself.

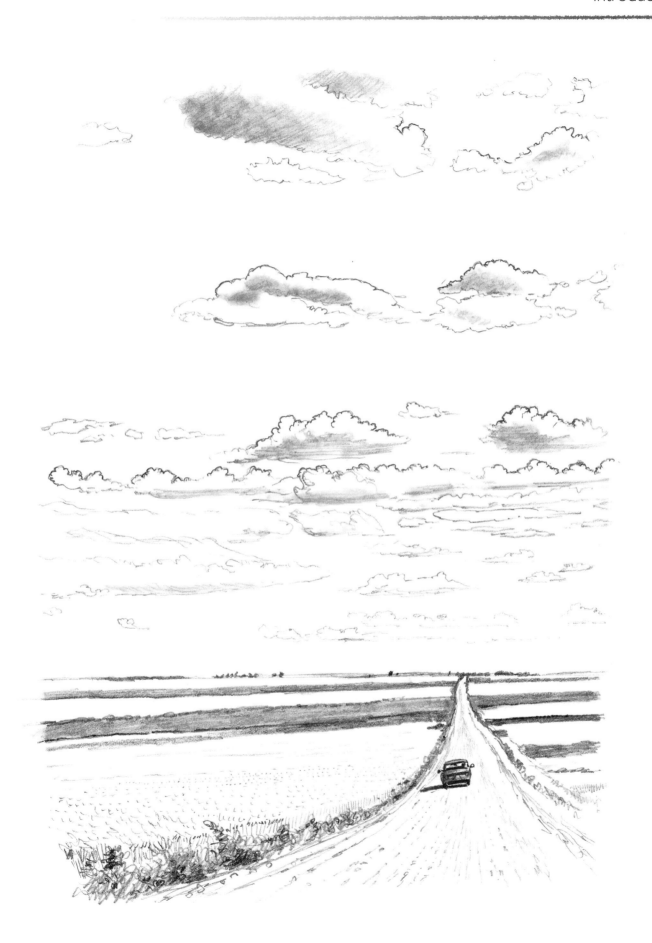

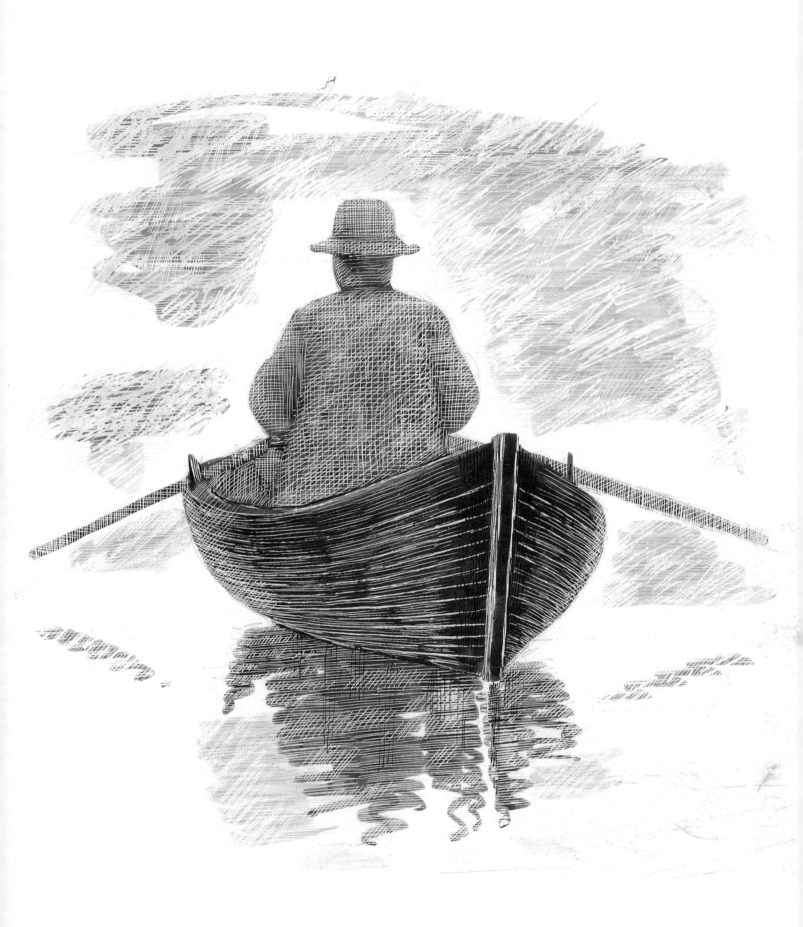

CHAPTER 1

METHODS AND MATERIALS

When we draw, we are not creating the objects we draw; we are merely making marks on paper that represent some kind of visual experience that we recognize as something familiar in our view of the world. The drawings are illusions of forms and shapes that we see. So mark-making is important, and you need to practise in order to improve your ability to do it easily and effectively.

Probably the first thing to consider when you begin to draw is exactly how you are going to organize yourself. So, in this section, we shall first examine whether you sit or stand to draw; the way you hold your drawing implements; how you choose your viewpoint; and the mechanical devices you might use to help you. It is well worth spending time over these matters, although much is a matter of common sense.

We shall also explore the wide range of tools with which you can make your drawings, and look at how various great artists have used them over the centuries.

DRAWING YOUR WORLD

Before we begin to explore the practical aspects of drawing, I would like you to bear in mind a few points that I hope will stay with you beyond the period it takes you to absorb the contents of this book. They concern methods of practice and good habits.

One invaluable practice is to draw regularly from life – that is, drawing the objects, people, landscapes and details around you. These have an energy and atmosphere that only personal engagement with them can capture. Photographs or other representations are inadequate substitutes and should only be used as reference as a last resort.

Always keep a sketch book or two and use them as often as possible. Constant sketching will sharpen your drawing skills and keep them honed. Collect plenty of materials and tools – pencils, pens, erasers, sharpeners, ink, paper of all sorts – and invest in a portfolio in which to keep all your drawings.

Don't throw away your drawings for at least a year after you've finished them. At that distance you will be more objective about their merits or failings and will have a clear idea of which ones work and which ones don't. In the white-hot creative moment you don't actually know whether what you've done is any good or not, as you are too attached to your end result. Later on you'll be more dispassionate and clearer in your judgement.

Build a portfolio of work and sometimes mount your drawings. Then, if anyone wants to see your work, you will have something to show them. Don't be afraid of letting people see what you have done. In my experience, people always find drawings interesting. Have fun with what you are doing, and enjoy your investigations of the visual world.

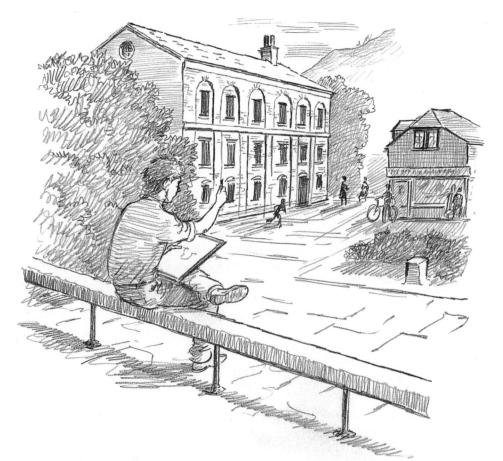

Keep a sketch book with you at all times – you never know when you'll stumble across a scene that you want to put down on paper.

These quick sketches of different parts of buildings are the result of drawing often and at any time. There is always the possibility of making a sketch of something seen out of a window. It's very good practice, too.

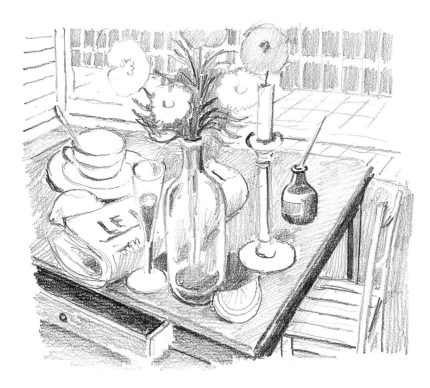

One of the most important lessons I hope you will take from this book is the value of simplicity. Successful drawing does not demand a sophisticated or complex approach. The quality of this sketch derives from a simple approach to shapes and the assimilation of their graphic effects into one picture. I had to make an effort to keep those shapes basic and simple. Always try to do the same in your drawings.

POSITIONS AND GRIPS

To start with, let's consider methods of standing or sitting to draw
and ways of holding the drawing implement to get the best results.

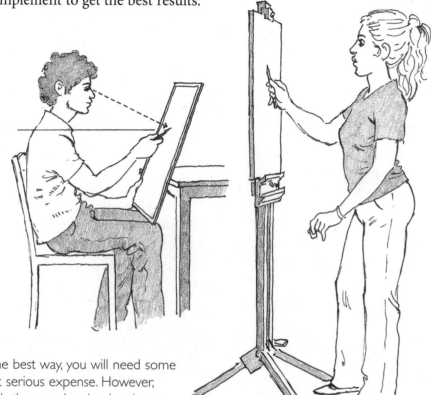

When drawing objects laid out
upon a table, you can sit down and
work on a large enough drawing
board to take the size of paper you
are using. You will need to attach
the paper with clips, drawing pins
or masking tape. Of these, I prefer
the last as it is easier to change the
paper and it doesn't matter if you
lose the bits of masking tape.

To draw standing up, which is much the best way, you will need some
kind of easel, and this will be your first serious expense. However,
they last for ever if you are careful with them, and make drawing so
much easier. There are several types, such as portable easels, radial
easels (my own favourite), and large studio easels, which you should
buy only if you have sufficient space and are intent upon a career
in art.

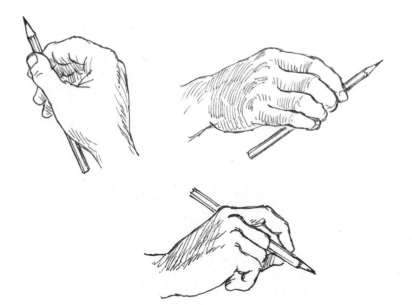

The way that you hold your pencil
has a great influence on your
drawing ability. Try to relax your
hand and wrist and hold it loosely
so that there is no unnecessary
tension; the quality of your line
should improve immediately.

Also, try out different ways of
holding your pencil, for instance
more like a stick or sword than a
pen. While the pen-holding method
(bottom left) is not wrong, it is
often too constrained for really
effective drawing.

SKETCHING

Going to a place that you know, and simply drawing what you see to the best of your ability, is one of the best exercises that you can perform. Rather than loose sheets of paper, consider keeping a bound sketch book to record your immediate impressions of a scene. You will need a small one (A5), and another one a bit larger (A4 or A3). There are many versions with various types of binding and you can just choose those that suit your particular needs.

When you make sketches of things, people and places, you will need to draw them from several viewpoints to become really familiar with them. Include as many details as you can, because this information is often useful later on.

MEASURING AND FRAMING

There are various ways of measuring the subjects of your drawings and this one is called 'sight size' drawing, where you reproduce everything the size that it appears to you from your point of view. This system is very useful where you have a large area to draw, but it is often difficult to correct when you go wrong because the difference between the correct and the incorrect marks on the paper can be very small.

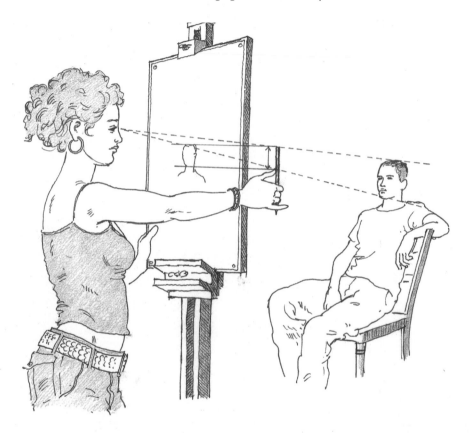

Here the subject is a figure. When you are portraying smaller subjects, take measurements to get the proportions right, but draw the item up larger in order to make correction easier. It is most important to correct your drawings rigorously in order to learn to draw well. It doesn't matter if the final work looks a bit of a mess; the habit of continual correcting will lead you to draw much better as you go along.

It's a good idea to take photographs to supplement your sketches, since the information you require to work further on your drawings cannot be too detailed. Take the subject from more than one angle, just as you will have done while sketching it. If you cannot sketch on the spot, using your own photographs is always better than drawing from photographs in books or on the internet, as yours will remind you of your experience of the subject.

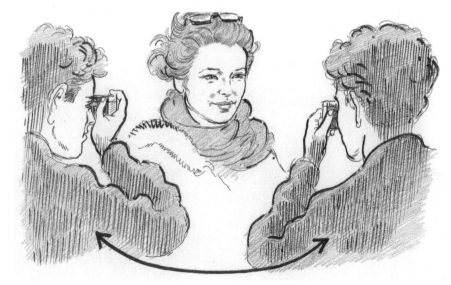

Before you can begin to draw your finished piece, you need to decide whether your composition is to be a vertical ('portrait') or horizontal ('landscape') picture. Try out both possibilities before you become too committed to either one of them.

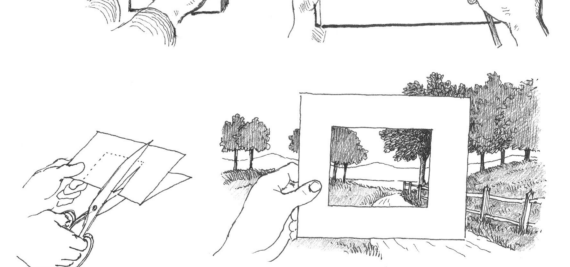

A framing device is very useful and often helps towards the better composition of the drawing that you are about to work on. Take a small sheet of paper or card and cut out a rectangle that seems roughly the same proportion as your working surface. Hold it up in front of you and view the subject matter through it. This will give you some idea of how your drawing should look on the paper and it also eliminates all the unnecessary surroundings that might distract your eye.

A rather more adaptable version of the cut-out rectangle is a pair of right-angled strips that you can arrange to any proportion that suits you.

MECHANICAL DEVICES

Mechanical methods of producing drawings have been used by artists down through the centuries, and here I shall show you a couple of the most useful. Of course, tracing and copying are probably the methods that spring to mind most readily, but there are others. Let us look first at one time-honoured way of getting the correct perspective and shape of relatively small objects – though this method may even be used for landscapes, as long as you are able to maintain a fixed viewpoint.

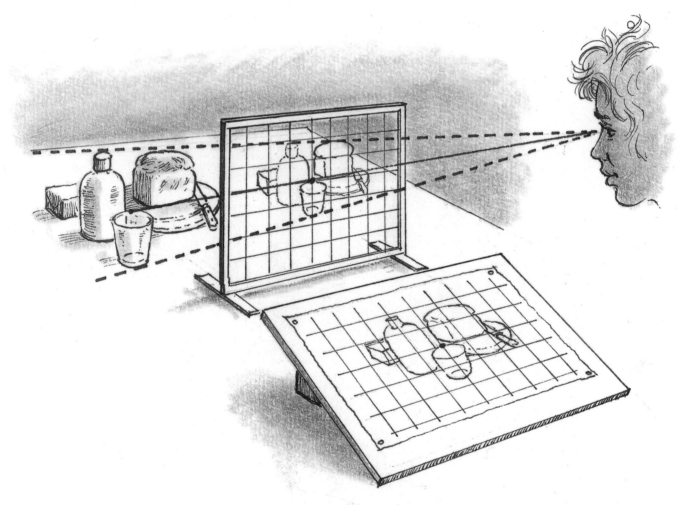

The frame for your image shown here can be made either from wood with equidistant threads attached to form a grid or from a sheet of glass or acetate onto which you have drawn squares in black ink. You must make sure that the squares are regular or the method won't work. Choose a particular point where two lines cross as your starting place and mark this point correspondingly on the still-life group itself, then you can begin to reproduce your still-life arrangement on a sheet of paper drawn up with a similar grid. This way you should get a very accurate outline drawing of the objects.

Another method is to project an image of the chosen object onto a plain wall, enlarging or reducing it as required. The only difficulty with tracing this way is that sometimes you will be unable to avoid blocking out the image with your shadow. Before photography, artists often used a device called a 'camera obscura', which was a darkened box with an aperture through which an image was projected onto an interior wall.

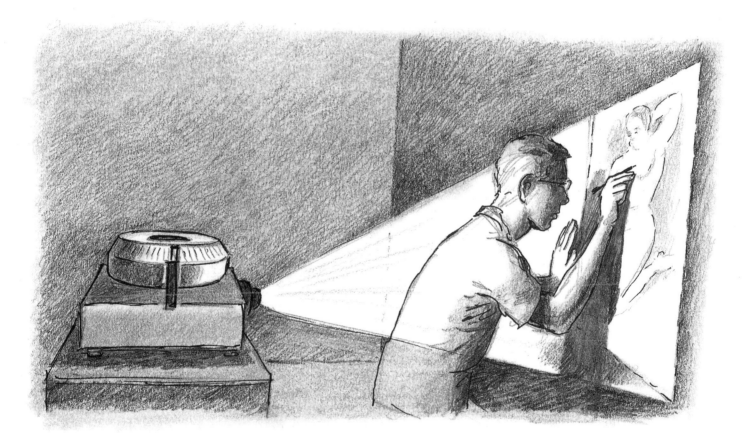

TOOLS AND MATERIALS

The tools we draw with are important, as is the material we draw on. Artists will draw with anything and make it work to their advantage, since most have a need to draw, no matter the situation they are in. If nothing else is available, they will use sticks in sand, coal on whitewashed walls, coloured mud on flat rocks – anything to be able to draw. If you don't have a wide range of equipment at your disposal, don't let that stop you; just use whatever is to hand. Ideally, though, you should buy the best materials you can afford. If you try as many new tools and materials as you can, you will discover what suits you best. Here are some basic tools that will provide you with an excellent drawing kit.

Pencil

The simplest and most universal tool of the artist is the humble pencil, which is very versatile. It ranges from very hard to very soft and black (H grades being the hardest and B grades the softest, with HB in the middle) and there are differing thicknesses. Depending on the type you choose, a pencil can be used very precisely and also very loosely.

You should have at least three degrees of blackness, such as an HB (average hardness and blackness), 2B (soft and black) and 4B (very soft and black).

For working on a toned surface, you might like to try white carbon pencil.

Graphite

Graphite pencils are thicker than ordinary pencils and come in a wooden casing or as solid graphite sticks with a thin plastic coating. The wood-encased type probably feels better to use, but the solid stick is thicker and lasts longer. It is also very versatile because of the breadth of the drawing edge, which enables you to draw a line 6 mm (¼ in) thick, or even thicker, and also very fine lines. Graphite also comes in various grades, from hard to very soft and black.

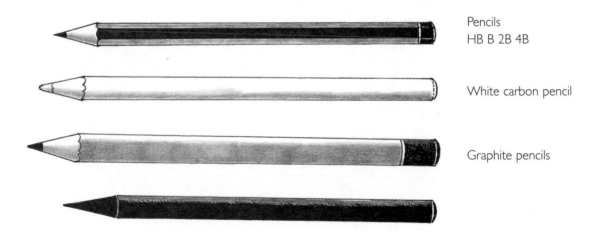

Pencils
HB B 2B 4B

White carbon pencil

Graphite pencils

Charcoal

Conté charcoal pencils, made of compressed charcoal mixed with clay or wax, are excellent in black, grey and white when you need to produce three-dimensional images on toned paper and are less messy to use than conté sticks. However, the sticks are more versatile because you can use the long edge as well as the point. Willow charcoal, made by burning willow twigs, is very soft and easily broken but is great for expressive drawings. Charcoal drawings need to be sprayed with fixative to stop them smudging.

Chalk

You can buy chalk in a range of tones for drawing on white or toned paper. White chalk is a cheaper and longer-lasting alternative to white conté.

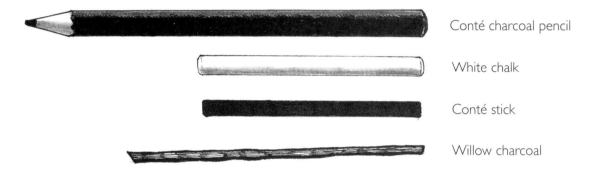

Conté charcoal pencil

White chalk

Conté stick

Willow charcoal

Pen

Traditional push-pens, or dip-pens, come with a fine pointed nib, either stiff or flexible, depending on what you wish to achieve. The ink to use for dip-pens is black 'Indian ink' or drawing ink; this can be permanent or water-soluble. Modern fine-liner graphic pens are easier to use and less messy but not so versatile, as they produce a line of unvarying thickness. There are also felt tips, which are thicker than the graphic pens, and permanent markers that produce very thick lines in indelible colours.

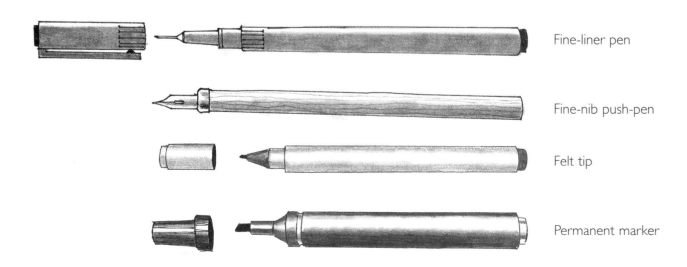

Fine-liner pen

Fine-nib push-pen

Felt tip

Permanent marker

Brush

A number 0 or number 2 nylon brush is satisfactory for drawing. For applying washes of tone with ink or watercolour paint, a number 6 or number 10 brush in sable or any other material capable of producing a good point is recommended.

Paper and board

Any decent smooth cartridge paper is suitable for drawing. A rougher surface gives a more broken line and greater texture. Try out as many different papers as you can. For brushwork, use a modestly priced watercolour paper to start with. Most line illustrators use a smooth board, but you may find this too smooth, with your pen sliding across it so easily that your line is difficult to control.

Scraperboard is coated with a china-clay layer which is thick enough to allow dry ink to be scraped off but thin enough not to crack off. It comes in black and white. White scraperboard is the more versatile of the two, and allows ink marks to be scraped with a sharp point or edge when it is dry to produce interesting textures or lines. The black version has a thin layer of black ink printed evenly over the whole surface which can be scraped away to produce a reverse drawing resembling a woodcut or engraving. Try both out, cutting your first piece of board into smaller pieces so that you can experiment with a range of different approaches. The tools you need to work effectively with scraperboard can be obtained at any good art or craft shop.

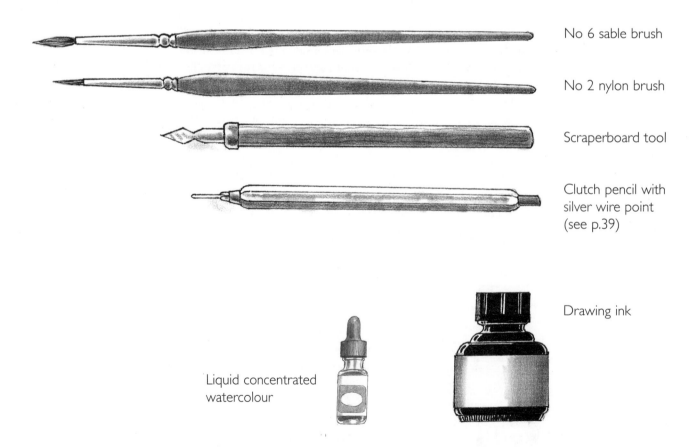

No 6 sable brush

No 2 nylon brush

Scraperboard tool

Clutch pencil with silver wire point (see p.39)

Drawing ink

Liquid concentrated watercolour

Accessories

When drawing in pencil you will almost certainly want to get rid of some of the lines you have drawn. There are many types of eraser, but a good solid one (of rubber or plastic) and a kneadable eraser (known as a 'putty rubber') are both worth having. The putty rubber is a very efficient tool, useful for very black drawings; applied with a dabbing motion, it lifts and removes marks, leaving no residue on the paper.

Putty or kneadable eraser

Soft rubber eraser

Scalpel

Craft knife

You will need some way of sharpening your pencils frequently, so investing in a good pencil-sharpener, either manual or electric, is worthwhile. However, many artists prefer to keep their pencils sharp with a craft knife or a scalpel. Of the two, a craft knife is safer, while a scalpel is sharper. Scalpels can be used as scraperboard tools as well.

Stump

For blending charcoal, chalk and soft pencil marks, use a stump, or tortillon, which is just paper rolled up into a solid tube and sharpened at both ends. This will produce very gradual changes of tone quite easily.

PENCIL DRAWING

When the pencil was invented some time in the 17th century, it revolutionized artists' techniques because of the enormous variety of skilful effects that could be produced with it. Consequently, it soon came to replace well-established drawing implements such as silverpoint.

The production of pencils in different grades of hardness and blackness greatly enhanced the medium's versatility. Now it became easy to draw in a variety of ways: delicately or vigorously, precisely or vaguely, with linear effect or with strong or soft tonal effects.

Here we have several types of pencil drawing, from the carefully precise to the impulsively messy, and from powerful, vigorous mark-making to sensitive shades of tone.

Michelangelo is a good starting point for ways of using pencil. His work was extremely skilful and as you can see from this drawing his anatomical knowledge was second to none. The careful shading of each of the muscle groups in the body gives an almost sculptural effect, which is not surprising when you consider that sculpture was his first love. To draw like this takes time, patience and careful analysis of the figure you are drawing.

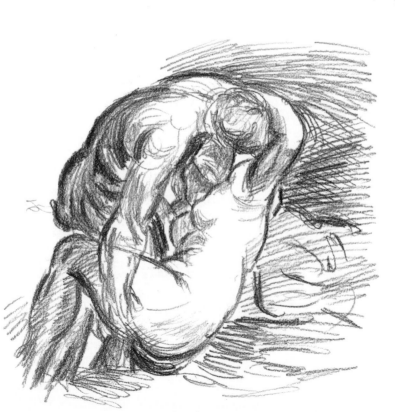

Titian's drawing, however, is quite different. He is obviously feeling for texture and depth and movement in the space and is not worried about defining anything too tightly. The lines merge and cluster together to make a very powerful tactile group.

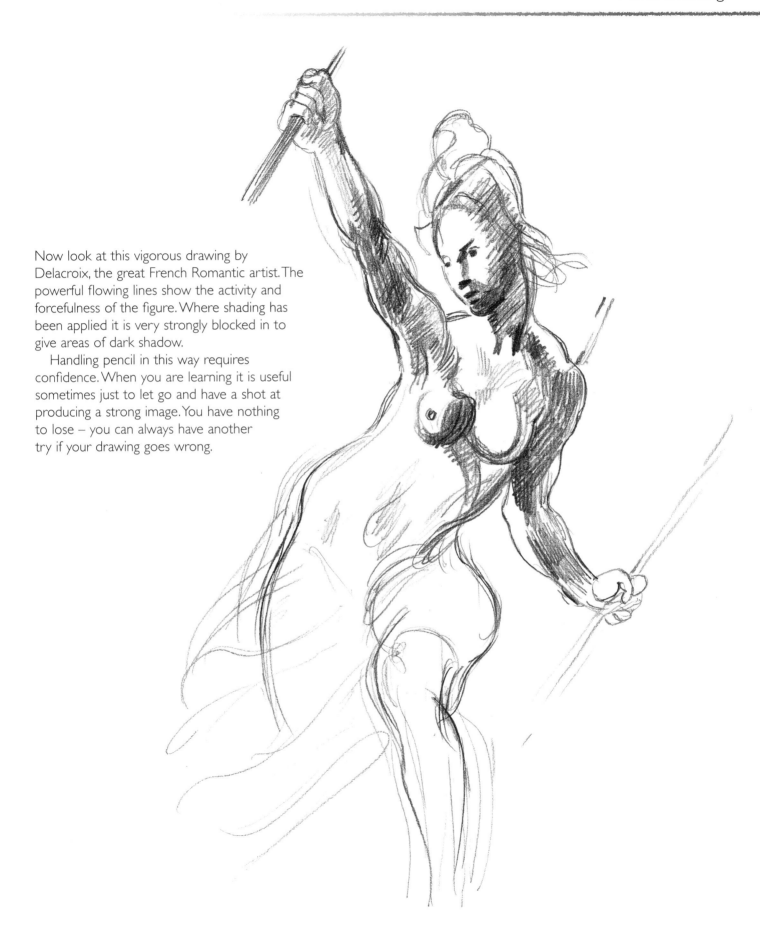

Now look at this vigorous drawing by Delacroix, the great French Romantic artist. The powerful flowing lines show the activity and forcefulness of the figure. Where shading has been applied it is very strongly blocked in to give areas of dark shadow.

Handling pencil in this way requires confidence. When you are learning it is useful sometimes just to let go and have a shot at producing a strong image. You have nothing to lose – you can always have another try if your drawing goes wrong.

PRECISION

In this example the pencil is used almost scientifically, with the line taking pre-eminence. Sometimes it is used to produce an exact effect of form, sometimes to show the flow and simplicity of a movement.

This meticulous pencil drawing, after the German Julius Schnorr von Carolsfeld, is one of the most perfect drawings in this style I've ever seen. The result is quite stupendous, even though this is just a copy and probably doesn't have the precision of the original. Every line is visible. The tonal shading which follows the contours of the limbs is exquisitely observed. This is not at all easy to do and getting the repeated marks to line up correctly requires great discipline. It is worth practising this kind of drawing because it will increase your skill at manipulating the pencil and test your ability to concentrate.

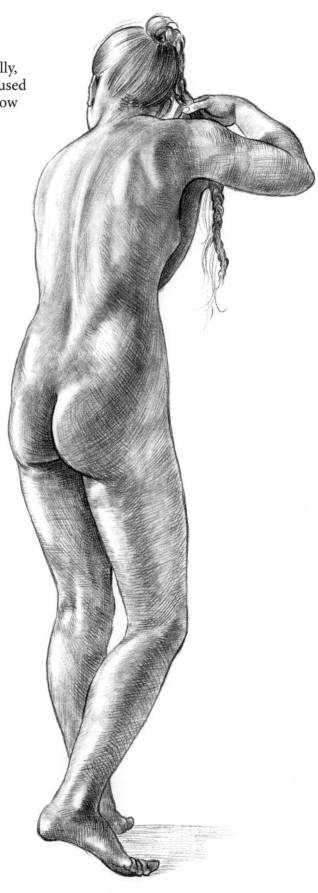

THE SIMPLE OUTLINE

In different ways both of the drawings on this page use a simple outline. Such simplicity serves to 'fix' the main shape of the drawing, ensuring the effect of the additional shading. A very economical method of drawing has been used for Rembrandt's portrait of an elderly woman, but note that this has not been at the expense of the information offered about the subject.

In some of Rembrandt's drawings the loose, trailing line, with apparently vague markings to build up the form, are in fact the result of very clear and accurate observation.

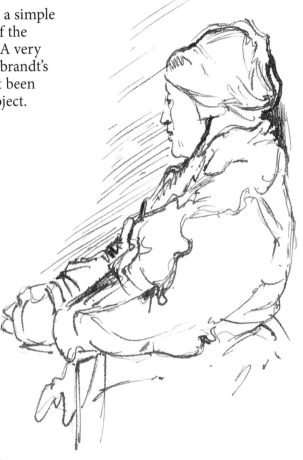

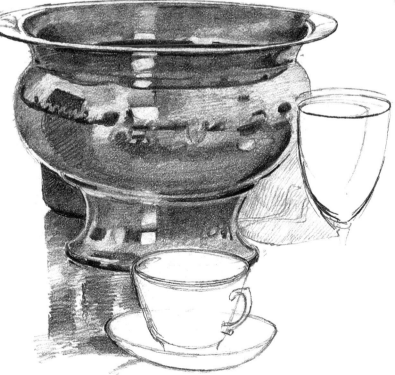

Only one of the objects in this still-life group has been drawn in great detail. The rest of them are in a bare outline drawing. This is an unfinished drawing but does show how to achieve a convincing solidity by first drawing clearly defined outline shapes before leaping in at the deep end with detailed drawing.

PEN AND INK

Pen and ink is special in that once you've put the line down it can't be erased. This really puts the artist on their mettle because unless they can use a mass of fine lines to build a form, they have to get the lines 'right' first time. Either way can work.

Once you get a taste for using ink, it can be very addictive. The tension of knowing that you can't change what you have done in a drawing is challenging. When it goes well, it can be exhilarating.

Leonardo probably did the original of this as a study for a painting. Drawn fairly sketchily in simple line, it shows a young woman with a unicorn, a popular courtly device of the time. The lines are sensitive and loose but the whole hangs together very beautifully with the minimum of drawing. The curving lines suggest the shape and materiality of the parts of the picture, the dress softly creased and folded, the face and hand rounded but firm, the tree slightly feathery looking. The use of minimal shading in a few oblique lines to suggest areas of tone is just enough to convey the artist's intentions.

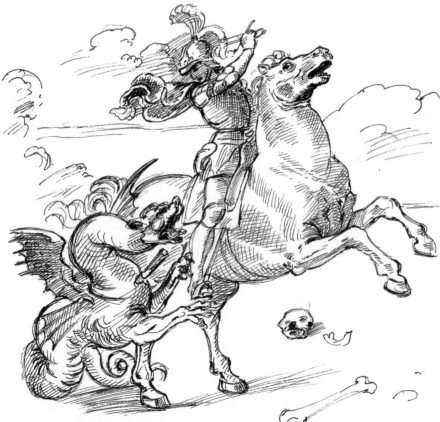

This copy of a Raphael is more heavily shaded in a variety of cross-hatching, giving much more solidity to the figures despite the slightly fairy-tale imagery. The movement is conveyed nicely, and the body of the rider looks very substantial as he cuts down the dragon. The bits of background, lightly put in, give even more strength to the figures of the knight, horse and dragon.

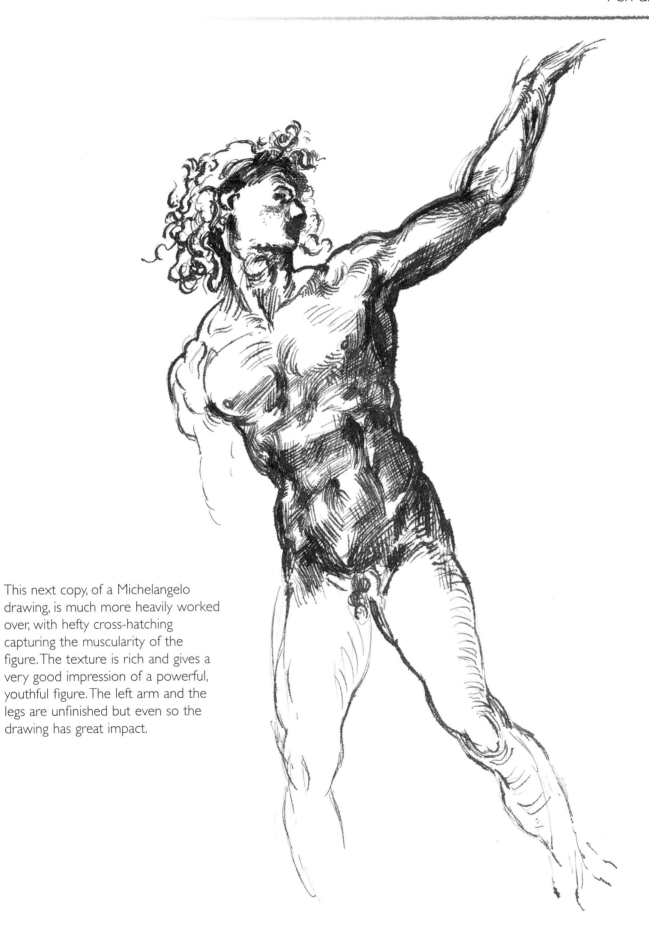

This next copy, of a Michelangelo drawing, is much more heavily worked over, with hefty cross-hatching capturing the muscularity of the figure. The texture is rich and gives a very good impression of a powerful, youthful figure. The left arm and the legs are unfinished but even so the drawing has great impact.

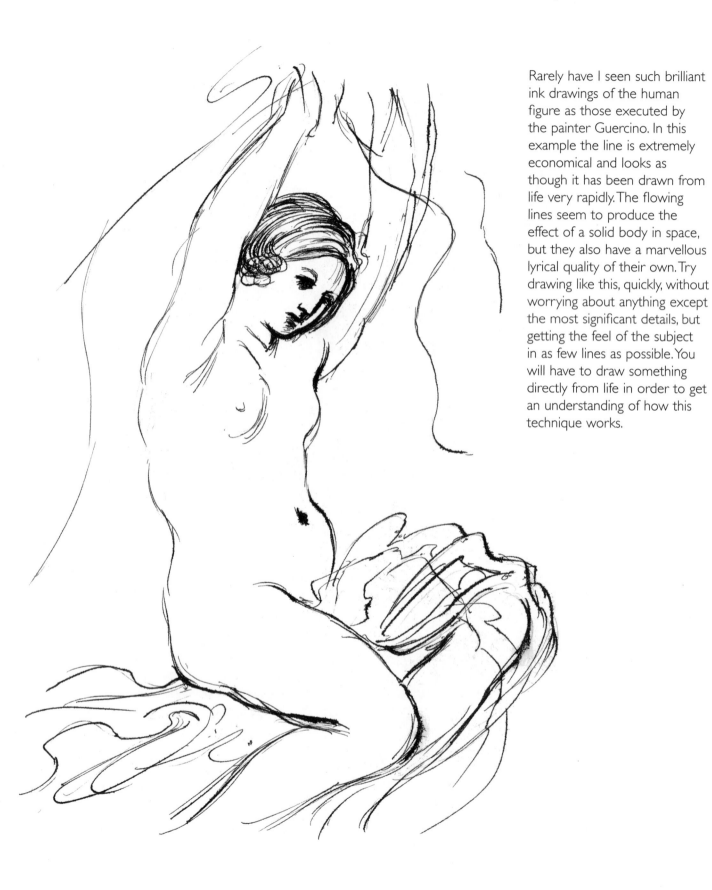

Rarely have I seen such brilliant ink drawings of the human figure as those executed by the painter Guercino. In this example the line is extremely economical and looks as though it has been drawn from life very rapidly. The flowing lines seem to produce the effect of a solid body in space, but they also have a marvellous lyrical quality of their own. Try drawing like this, quickly, without worrying about anything except the most significant details, but getting the feel of the subject in as few lines as possible. You will have to draw something directly from life in order to get an understanding of how this technique works.

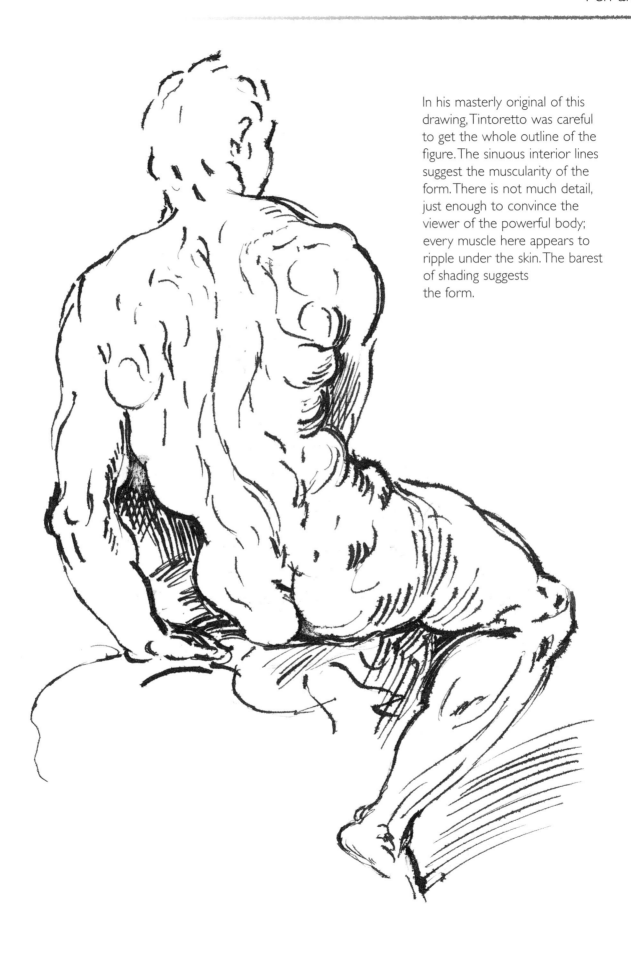

In his masterly original of this drawing, Tintoretto was careful to get the whole outline of the figure. The sinuous interior lines suggest the muscularity of the form. There is not much detail, just enough to convince the viewer of the powerful body; every muscle here appears to ripple under the skin. The barest of shading suggests the form.

LINE AND WASH

Now we move on to look at the effects that can be obtained by using a mixture of pen and brush with ink. The lines are usually drawn first to get the main shape of the subject in, then a brush loaded with ink and water is used to float across certain areas to suggest shadow and fill in most of the background to give depth.

A good-quality solid paper is necessary for this type of drawing; try either a watercolour paper or a very heavy cartridge paper. The wateriness of the tones needs to be calculated to the area to be covered. In other words, don't make it so wet that the paper takes ages to dry.

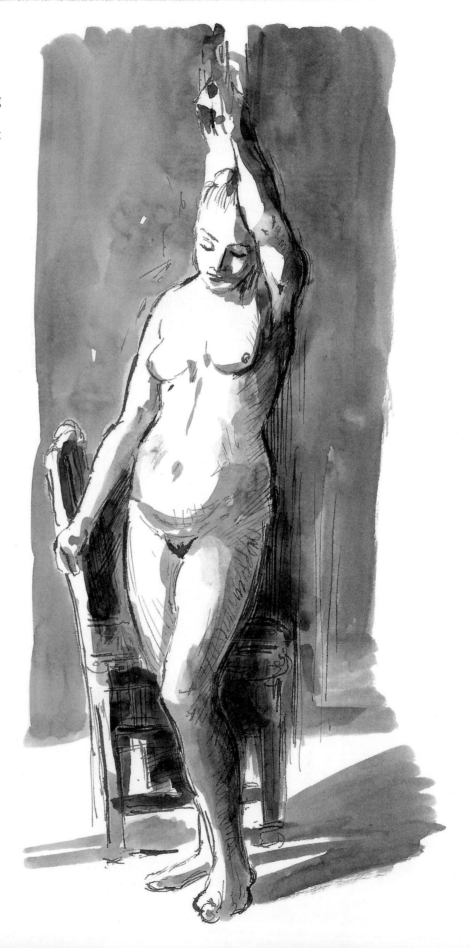

This copy of a Rembrandt is very dramatic in its use of light and shade.

When using line and wash in landscape drawing, the handling of the wash is particularly important, because its different tonal values suggest space receding into the picture plane. Here we look at three drawings by Claude Lorrain.

This sensitive pen line drawing of part of an old Roman ruin has a light wash of watery ink to suggest the sun shining from behind the stones. The wash has been kept uniform.

These two deer are fairly loosely drawn in black chalk. Different tones of ink wash have been freely splashed across the animals to suggest form and substance.

This mainly wash drawing of the Tiber in Rome has a few small speckles of pen work near the horizon. The tones vary from very pale in the distance to gradually darkening as we approach the foreground, which is darkest of all. The dark tone is relieved by the white patch of the river, reflecting the light sky with a suggestion of reflection in a softer tone – a brilliant sketch.

A master landscape painter, Claude Lorrain gives a real lesson in how to draw nature in this study of a tree. Executed with much feeling but great economy, the whole drawing is done in brushwork.

To emulate this you need three different sizes of brush (try Nos. 0 or 1, and 6 and 10), all of them with good points. Put in the lightest areas first (very dilute ink), then the medium tones (more ink less water), and then the very darkest (not quite solid ink).

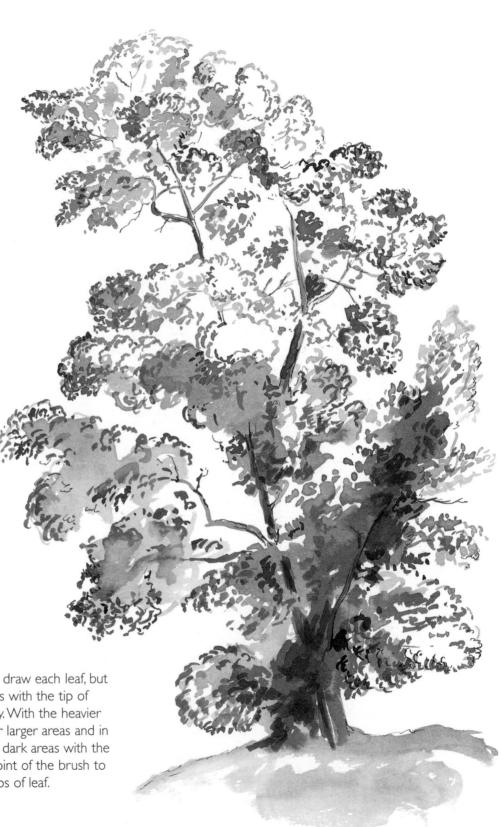

Notice how Lorrain doesn't try to draw each leaf, but makes interesting blobs and scrawls with the tip of the brush to suggest a leafy canopy. With the heavier tones he allows the brush to cover larger areas and in less detail. He blocks in some very dark areas with the darkest tone and returns to the point of the brush to describe branches and some clumps of leaf.

CHALK ON TONED PAPER

The use of toned paper can bring an extra dimension to a drawing and is very effective at producing a three-dimensional effect of light and shade. Whether you are drawing with chalk, pastel or charcoal it is very important to remember that the paper itself is in effect an implement, providing all the tones between the extremes of light and dark. You must resist the temptation to completely obliterate the toned paper in your enthusiasm to cover the whole area with chalk marks. Study the following examples.

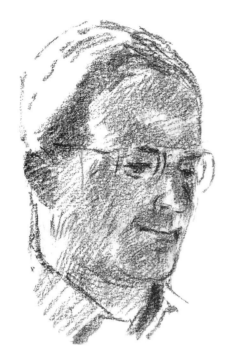

This head is drawn simply in a medium toned chalk on a light paper. Here the challenge is not to overdo the details. The tones of the chalk marks are used to suggest areas of the head, and definite marks have been kept to a minimum.

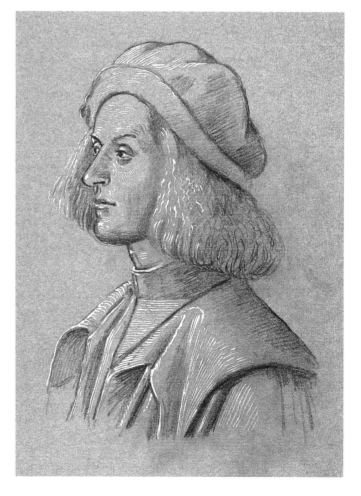

The mid-tone of the paper has been used to great effect in this copy of Carpaccio's drawing of a Venetian merchant. Small marks of white chalk pick out the parts of garments, face and hair that catch the light. No attempt has been made to join up these marks. The dark chalk has been used similarly: as little as the artist felt he could get away with. The medium tone of the paper becomes the solid body that registers the bright lights falling on the figure. The darkest tones give the weight and the outline of the head, ensuring that it doesn't just disappear in a host of small marks.

As we have seen in the examples on the previous spread, the use of toned paper reduces the area that has to be covered in chalk and heightens the effect of the chalk marks, especially if these have been made in white. The three illustrations shown here exemplify the range of effects that can be achieved with toned paper.

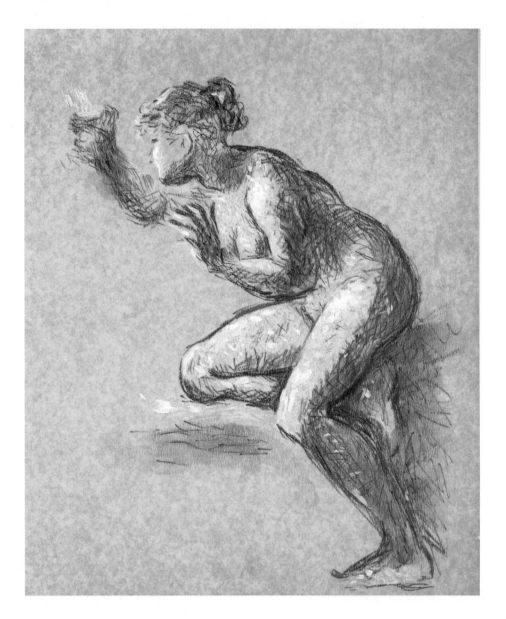

The French neo-classicist master Pierre-Paul Prud'hon was a brilliant worker in the medium of chalk on toned paper. In this drawing of Psyche, marks have been made with dark and light chalk, creating a texture of light which is rather impressionistic in flavour. The lines, which are mostly quite short, go in all directions. The impression created is of a figure in the dark. This is helped by the medium tone of the paper, which almost disappears under the pattern of the mark-making.

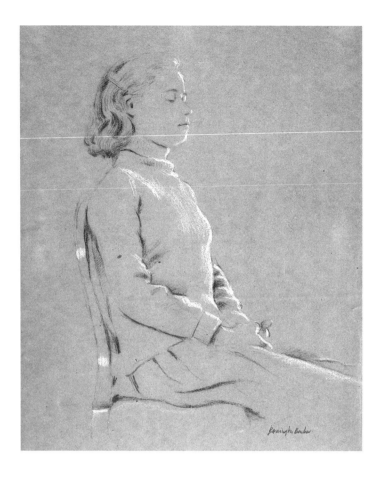

The approach taken in this drawing is about as economical as you can get. The form of the surface of the girl's face and figure is barely hinted at down one side, with just the slightest amount of chalk. A similar effect is achieved on the other side, this time in dark chalk. The bare paper does much of the rest of the work.

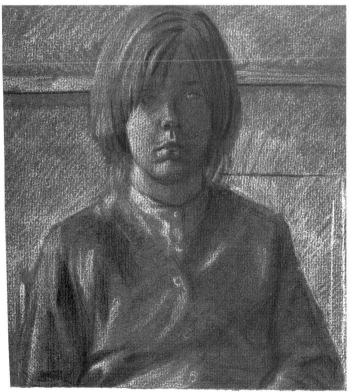

The second drawing takes the use of dark and light much further, creating a substantial picture. In places the white chalk is piled on and elsewhere is barely visible. The dark chalk is handled in the same way. More of the toned paper is covered, but its contribution to the overall effect of the drawing is not diminished for that.

SCRAPERBOARD

Scraperboard is similar in some respects to engraving on wood or metal, although because of the ease of drawing it is more flexible and less time-consuming. You can see in the example below how scraperboard technique lends itself to a certain formalized way of drawing. The scratch marks can be made to look very decorative.

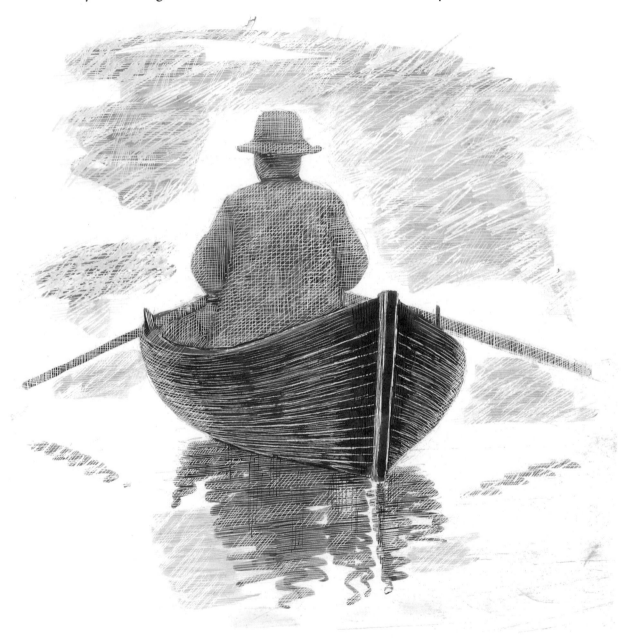

In this drawing the boatman rowing across a misty lake or river was first sketched in pencil, then blocked out in large areas of ink. The figure of the man, the oars and the atmospherics were done in diluted ink to make a paler tone. The boat was drawn in black ink. Using a scraperboard tool, lines were carefully scratched across the tonal areas, reducing their tonal qualities further. Some areas have few or no scratched lines, giving a darker tone and a three-dimensional effect.

SILVERPOINT

Probably for most people the least likely drawing technique to be attempted is silverpoint, the classic method used in the times before pencils were invented. Many drawings by Renaissance artists were made in this way. If you are interested in producing very precise drawings you should try this refined and effective technique.

First you have to buy a piece of silver wire (try a jeweller or someone who deals in precious metals) about 1 mm thick and about 7.5 cm (3 in) long. This is either held in a wooden handle taped to it or – the better option – within a clutch-action propelling pencil that takes wire of this thickness. Then you cover a piece of cartridge paper (use fairly thick paper because it is less likely to buckle) with a wash of permanent white gouache designer paint; the coat must cover the whole surface and mustn't be either too thick or too watery. When the white paint has dried, you draw onto it with the silver wire; ensure that the end of the wire is smooth and rounded to prevent it tearing the paper. Don't press too hard. The silver deposits a very fine silky line, like a pencil, but lasts much longer. Silverpoint is a very nice way to draw and I thoroughly recommend that you make the effort to try it as it's very rewarding as well as instructive.

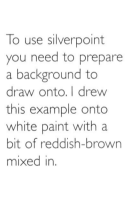

To use silverpoint you need to prepare a background to draw onto. I drew this example onto white paint with a bit of reddish-brown mixed in.

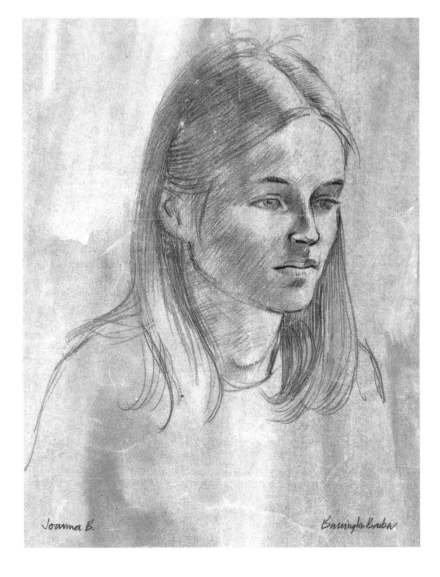

Joanna B. Barrington Barber

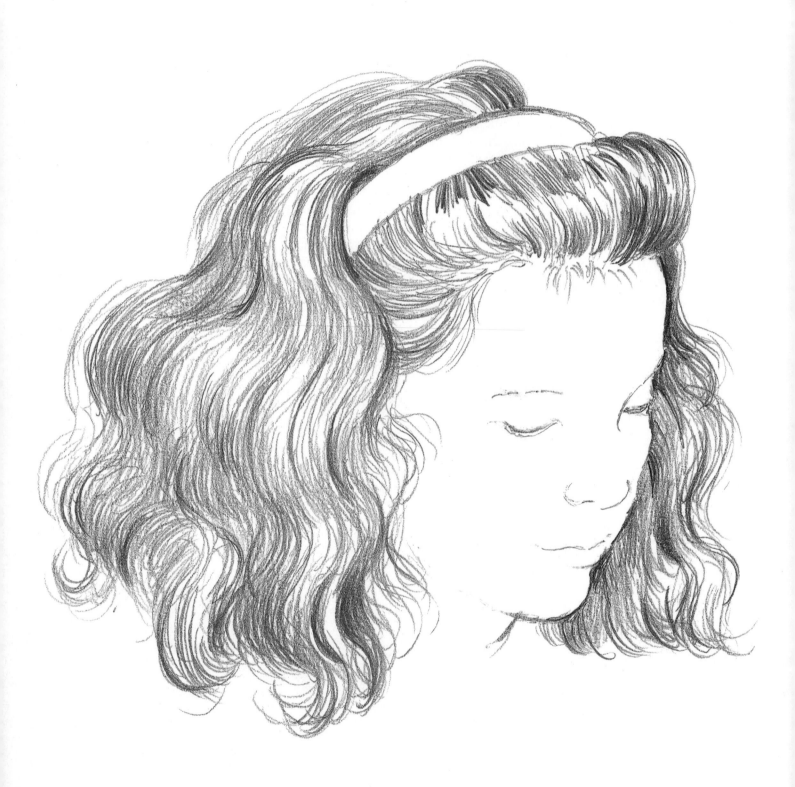

CHAPTER **2**

BASIC EXERCISES IN LINE, SHAPE AND TEXTURE

This chapter is primarily designed for people who haven't done very much drawing, but even if you are already quite practised you may find that carrying out the exercises shown here is a good way to loosen yourself up for what follows. The main point of them is to work on the basic skills necessary to draw anything with some degree of verisimilitude. The practice of making marks, which after all is what drawing consists of, never loses its usefulness however accomplished you become.

So included in this section are exercises in drawing lines, tones and simple shapes. All need a certain amount of control of the pencil, and practising this is never time wasted. Finally, you will find exercises that give you some practice in describing textures so that you can draw the various surfaces of your subjects to make them look more realistic.

LINES INTO SHAPES

Before you begin any kind of drawing, it is necessary to practise the basics. This is essential for the complete beginner, and even for the experienced artist it is very useful. If you are to draw well you must be in control of the connection between eye and hand. There are many exercises to help you achieve this. The following are the simplest and most helpful I know.

Complete them all as carefully as you can, drawing freehand, at the sizes shown. The more you repeat them the more competent and confident you will become, and this will show in your drawing.

Lines

As you draw, try to keep your attention exactly on the point where the pencil touches the paper. This will help to keep mind and hand synchronized and in time will make drawing easier.

I. Begin with vertical lines, keeping them straight and the same length.

2. Produce a square with a series of evenly spaced horizontal lines.

3. Now try diagonal lines, from top right to bottom left, varying the lengths while keeping the spacing consistent.

4. Next, draw diagonals from top left to bottom right. You may find the change of angle strange at first.

5. To complete the sequence, try a square made up of horizontals and verticals crossing each other.

Circles

At first it is difficult to draw a circle accurately. For this exercise I want you to draw a series of them next to each other, all the same size. Persist until the circles on the paper in front of you look like the perfect ones you can see in your mind's eye. When you achieve this, you will know that your eye and mind are coordinating.

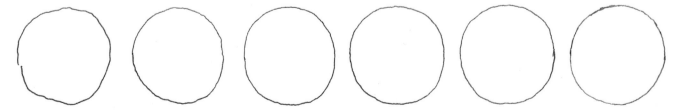

Variations

Paul Klee described drawing as 'taking a line for a walk'. Try drawing a few different geometric figures.

1. Triangle – three sides of the same length.

2. Square – four sides of the same length.

3. Star – one continuous line.

4. Spiral – a series of decreasing circles ending in the centre.

5. Asterisk – 16 arms of the same length radiating from a small black point.

Finish by practising a few S-shaped figures, which are formed by making two joined but opposing arcs. You will constantly come across shapes like these when drawing still life.

THREE DIMENSIONS

Every object you draw will have to appear to be three-dimensional if it is to convince the viewer. The next series of practice exercises has been designed to show you how this is done. We begin with cubes and spheres.

1. Draw a square.

2. Draw lines that are parallel from each of the top corners and the bottom right corner.

3. Join these lines to complete the cube.

This alternative method produces a cube shape that looks as though it is being viewed from one corner.

1. Draw a diamond shape or parallelogram elongated across the horizontal diagonal.

2. Now draw three vertical lines from the three angles shown; make sure they are parallel.

3. Join these vertical lines.

Shading

Once you have formed the cube you are halfway towards producing a realistic three-dimensional image. The addition of tone, or shading, will complete the trick.

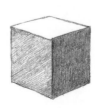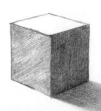

There is only one way of drawing a sphere. What makes each one individual is how you apply tone. In this example we are trying to capture the effect of light shining on the sphere from top left.

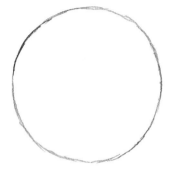

1. Draw a circle as accurately as possible.

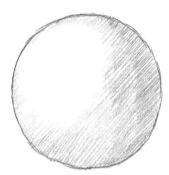

2. Shade in a layer of tone around the lower and right-hand side in an almost crescent shape, leaving the rest of the surface untouched.

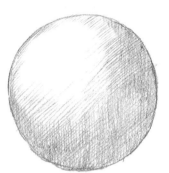

3. Subtly increase the depth of the tone in much of the area already covered without making it uniform all over.

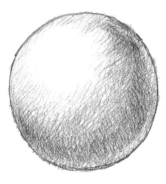

4. Add a new crescent of darkish tone, slightly away from the lower and right-hand edges; ensure this is not too broad.

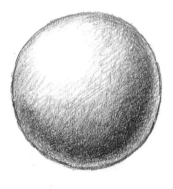

5. Increase the depth of tone in the darkest area.

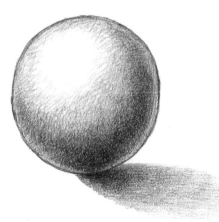

6. Draw in a shadow to extend from the lower edge on the right side.

ELLIPSES

One shape you need to learn to draw if you are to show a circular object seen from an oblique view is an ellipse. This is a curved figure with a uniform circumference and a horizontal axis longer than the perpendicular axis.

An ellipse changes as our view of it shifts. Look at the next series of drawings and you will see how the perspective of the glass changes as its position alters in relation to your eye-level.

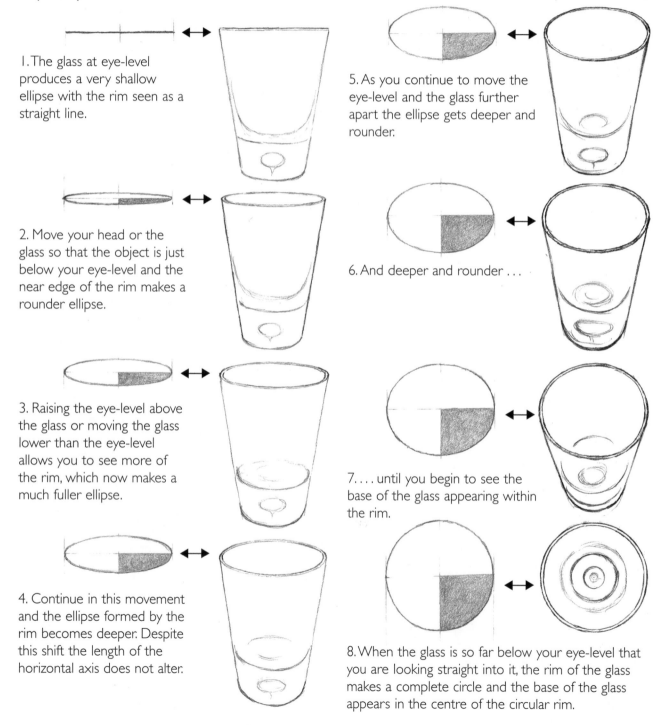

1. The glass at eye-level produces a very shallow ellipse with the rim seen as a straight line.

2. Move your head or the glass so that the object is just below your eye-level and the near edge of the rim makes a rounder ellipse.

3. Raising the eye-level above the glass or moving the glass lower than the eye-level allows you to see more of the rim, which now makes a much fuller ellipse.

4. Continue in this movement and the ellipse formed by the rim becomes deeper. Despite this shift the length of the horizontal axis does not alter.

5. As you continue to move the eye-level and the glass further apart the ellipse gets deeper and rounder.

6. And deeper and rounder . . .

7. . . . until you begin to see the base of the glass appearing within the rim.

8. When the glass is so far below your eye-level that you are looking straight into it, the rim of the glass makes a complete circle and the base of the glass appears in the centre of the circular rim.

ELLIPSES PRACTICE: CYLINDERS

Ellipses come into their own when we have to draw cylindrical objects. As with our previous examples of making shapes appear three-dimensional, the addition of tone completes the transformation.

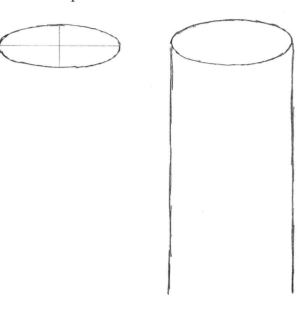

1.

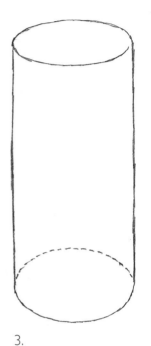

2.

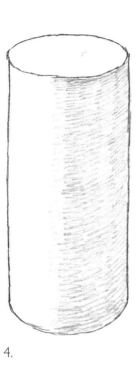

3.

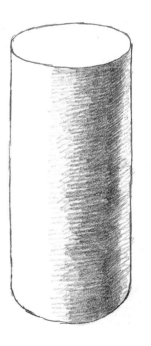

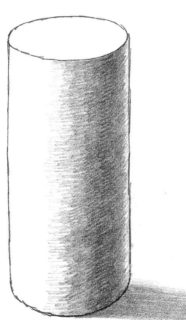

1. Draw an ellipse.

2. Draw two vertical straight lines from the two outer edges of the horizontal axis.

3. Put in half an ellipse to represent the bottom edge of the cylinder. Or, draw a complete ellipse lightly then erase the half that would only be seen if the cylinder were transparent.

4. To give the effect of light shining from the left, shade very lightly down the right half of the cylinder.

5. Add more shading, this time to a smaller vertical strip that fades off towards the centre.

6. Add a shadow to the right, at ground level. Strengthen the line of the lower ellipse.

5.

6.

USING TONE

There are many ways of using tone, depending on the effect you are trying to achieve and the materials you are using. The techniques shown here are the ones you will find most useful and effective over a broad range of still-life drawing. As with the previous exercises you have tried, the more you practise the better your expertise with handling tone will become. Start by becoming familiar with the range of exercises provided below.

Pencil Exercises

| I. | 2. | 3. | 4. | 5. | 6. | 7. | 8. |

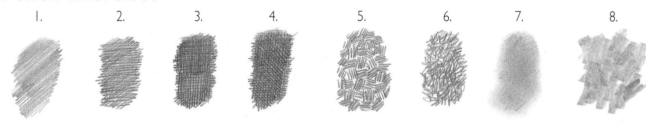

1. Draw diagonal lines close together to form an area of tone.

2. Draw horizontal lines over the diagonal lines.

3. Draw vertical lines over the diagonal and horizontal lines.

4. Draw diagonal lines in the opposite direction to those shown in Step 1.

5. Experiment with small groups of lines in varying directions.

6. Try making random short strokes in any direction but achieving an even effect.

7. Lightly draw with a soft pencil and then smudge with your finger.

8. Use the edge of the pencil lead to get thicker, softer lines in any direction.

Ink Exercises

This set of technical exercises is to help you get your hand in when you are applying tone with a pen.

| I. | 2. | 3. | 4. | 5. | 6. | 7. | 8. |

1. Draw groups of short, fine vertical lines close together but sufficiently apart that the paper shows between each stroke.

2. Draw a series of longer strokes.

3. Try drawing diagonal strokes close together.

4. Draw a set of vertical strokes over the diagonals to create a darker tone.

5. Apply a set of horizontal lines over the last two. You can make strokes in as many directions as you like, in layers; eventually you will get a very black tone.

6. Now try making lots of small dots with the point of the pen as close together as you can.

7. Draw a set of randomly made swirling lines to create a cloudy texture. You need not even take the pen off the paper to achieve this effect.

8. Splash on diluted ink with a brush to achieve a medium grey tone.

Applying Tone

Now I want you to practise controlling tone over an area. This requires patient, careful manipulation of the pencil. Regular and diligent practice will pay dividends. Begin by drawing a row of eleven squares.

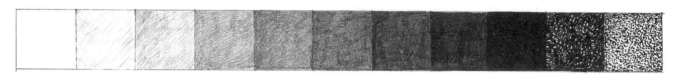

1. Leave the first square blank.

2. Fill the square with a very light covering of tonal lines.

3. Apply a slightly heavier tone all over.

4–7. In the next four squares the tone should become progressively heavier and darker.

8. Now total black – as black as it gets with pencil.

9. Fill in this square with black ink. Now compare the result with No. 8.

10. Fill the area with many small, overlapping marks in ink.

11. In the final square, make many small separate ink marks that do not quite touch.

Shading Exercises

This series of technical exercises is designed to enable you to control changes of tone over an area.

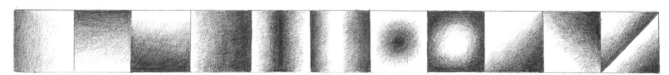

1. Shade from the left side fading to white on the right.

2. Start at the top and fade towards the bottom.

3. Start at the bottom and fade out at the top.

4. Start at the right side and fade towards the left; the reverse of the shading in the first square.

5. Shade across the centre vertically, fading out at either side.

6. Shade from both sides, fading to white in the centre.

7. Shade in the central area, fading out to the edges.

8. Shade around the edges, fading at the centre.

9. Shade from the bottom right corner, fading diagonally towards the top left.

10. Shade from top right, fading to bottom left.

11. Draw a diagonal across the square. In one half shade from the centre fading to one corner, in the other half shade from the corner fading to the centre.

TEXTURES AND MATERIALITY

Here we look at developing a feel for different types of materials and transferring their textural qualities on to paper. Take care over the appearance of your drawings as a group.

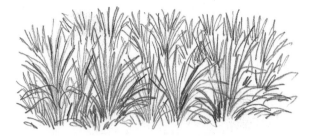

Grass

The first of these drawings of texture shows an impression of an area of grass-like tufts – that is to say, very conventional patterns that resemble grass, not drawings taken directly from life. When you have tried the stylized version, you could go and look at a real lawn and try to draw that from life.

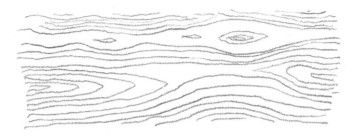

Wood

Now try doing this wooden plank, with its knots and wavy lines of growth. The floorboards in your house might be a good example of this kind of wood pattern.

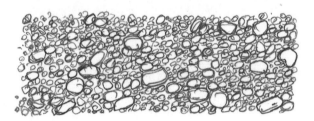

Beach

Next, a drawing that resembles a pebbled beach, with countless stones of various sizes. Again, after drawing a conventional version like this, you could try working with a real area of pebbles or stones.

Mesh

This carefully drawn mesh looks a bit like a piece of hessian or other loosely woven cloth. Make sure that the lines don't get too heavy or the cloth-like effect will be destroyed.

Fur

This resembles fur, such as on a rug or the back of a cat. The short, wavy lines go in several directions, but follow a sort of pattern.

Rock

This drawing shows the surface of what might be a piece of grained and fissured rock. Again, after trying out this example, have a look at the real thing which will show you how comparatively stylized this pattern is.

Clouds

This smoky texture is produced by using a soft pencil, then a paper stump to smudge the dark areas. After that, a little rubbing of some of the darker parts gives a cloudy look.

Brick

This brickwork effect is not difficult but is a bit painstaking. The trick is to keep the horizontals as level as possible but draw the edges rather wobbly, which gives the rather worn look of older bricks. Smudge some tone on some of the bricks, varying it rather than making it even.

Leaves

All that is needed to give the effect of thick, hedge-like leaves is a large number of small leaves drawn adjacent to and overlapping each other. Try to maintain a certain amount of variety in the angles of the leaves to make them more convincing.

Snakeskin

Drawing snakeskin or fish scales is just a matter of drawing many overlapping scale shapes without being too precise or you will lose the movable look of natural scales. Again, it requires a rather painstaking effort, but apart from that it is easy.

Water

This watery texture is achieved by keeping all the marks you make horizontal and joined together to create the effect of ripples. Smudge a little of the drawing to create greyer tones, but leave some untouched areas to look like reflected light.

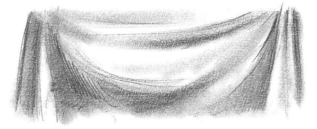

Drapery

This drapery is done by drawing descending curves to emulate cloth, and then using a paper stump to smudge and soften the edges of the tone. The only sharp lines should be at the sides where the cloth appears to be gathered up.

PRACTISING TEXTURE

In these two exercises we go a stage further with textures, exploring a girl's long curly hair and some fabric.

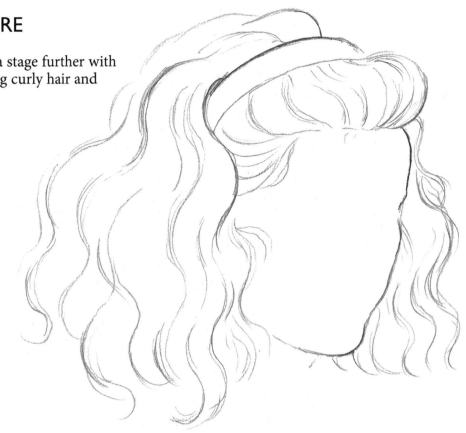

To start with, draw a very careful but simple outline of the shapes of the cascading hair, getting a feeling of the way it winds and curves as it grows away from the head. Apply the same principle when working on the second exercise (on the facing page) – it doesn't matter if you don't get some of the curves of fabric quite right as long as the main shapes are followed.

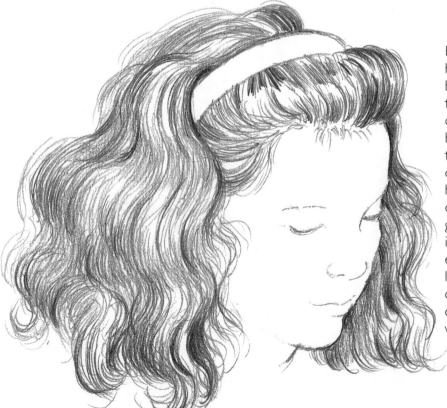

Having got the main shapes of the hair and the fabric you can now build up a texture of lines and tone to produce a convincing impression of the way they look. The hair can be worked in with strokes following the main shapes of the curves of the hair, in some cases drawn heavier and darker and elsewhere drawn much lighter and fainter. This gradually produces the look of hair in waves. Notice how often at the edges of the mass of hair the tone looks darker, and how there is a contrast between the dark under curve and the lighter upper curve where the larger waves curl round.

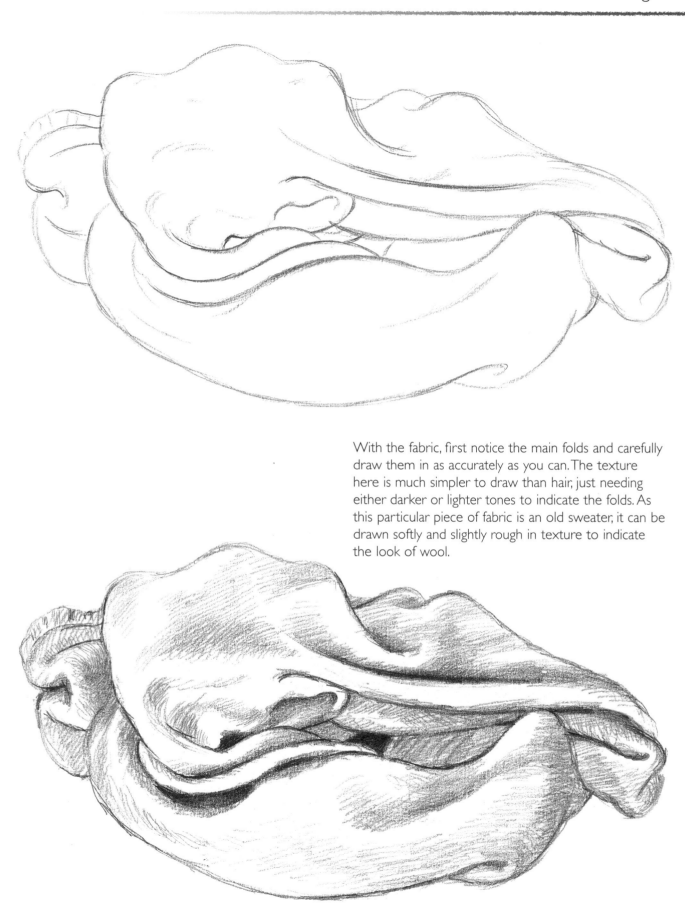

With the fabric, first notice the main folds and carefully draw them in as accurately as you can. The texture here is much simpler to draw than hair, just needing either darker or lighter tones to indicate the folds. As this particular piece of fabric is an old sweater, it can be drawn softly and slightly rough in texture to indicate the look of wool.

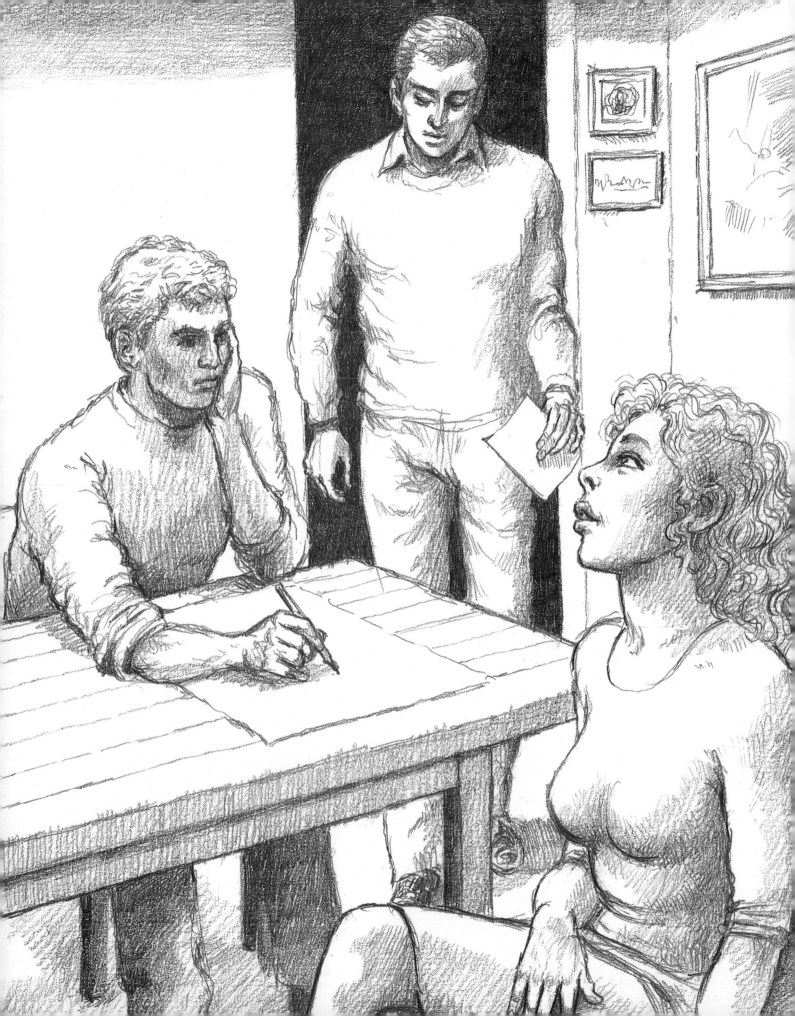

CHAPTER 3

COMPOSITION

The most creative possibilities for an artist come from the process of composition. No matter how well you have learned to draw objects, animals, figures or landscapes, until you have considered the question of composition you have arrived at satisfying pictures only by accident. The intellectual process of determining how the individual elements of a picture hang together is what differentiates the accomplished artist from the beginner.

There are many routes by which to arrive at a strong composition and this chapter will not by any means be exhausting all the possibilities, but you will discover several time-honoured methods of going about it. Of course an artist soon develops an eye for arranging his or her elements in such a way that the result is interesting, but there are techniques to provide guidance in this.

It is often a question of balance, or sometimes imbalance, that gives a composition its power. This chapter discusses how to divide the surface of your picture in such a way that it will give an interesting balance of shapes and ends with a specific exercise in practising a composition that should help you to get to grips with the basics. You will find this understanding of composition to be a good grounding when working on the other subject areas covered in this book.

COMPOSITIONS BY MASTER ARTISTS

A good way to start understanding the composition of pictures is to look at the work of the masters. Here we'll consider the way various works have been composed, using geometric shapes to show the format. Once you've grasped the basic principles, your best plan for developing your compositional skills is to copy good works of art from books and prints, or in local public galleries. Most galleries will allow you to make copies of the work on the walls as long as you don't inconvenience other people.

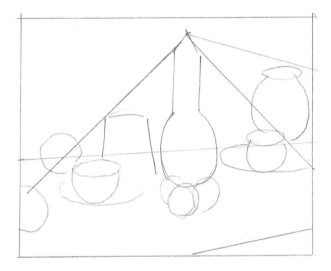

Our first example is a still life by Vincent van Gogh of cups, fruit, jugs and a coffee-pot. Notice how the whole composition is arranged like a pyramid or triangle, which is quite a common device.

Look through your art books and magazines for a picture based on a similar composition and make an outline drawing of it – my choice is just to give an example, and you will learn more by identifying your own. You shouldn't have a problem in finding a suitable picture.

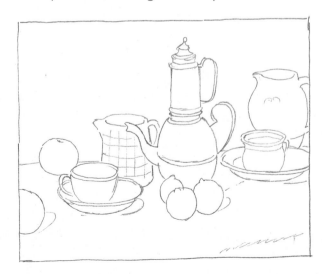

Having drawn it up in line, go ahead and put in all the tones that you can – but the important part of this exercise is to realize the composition and draw it in outline.

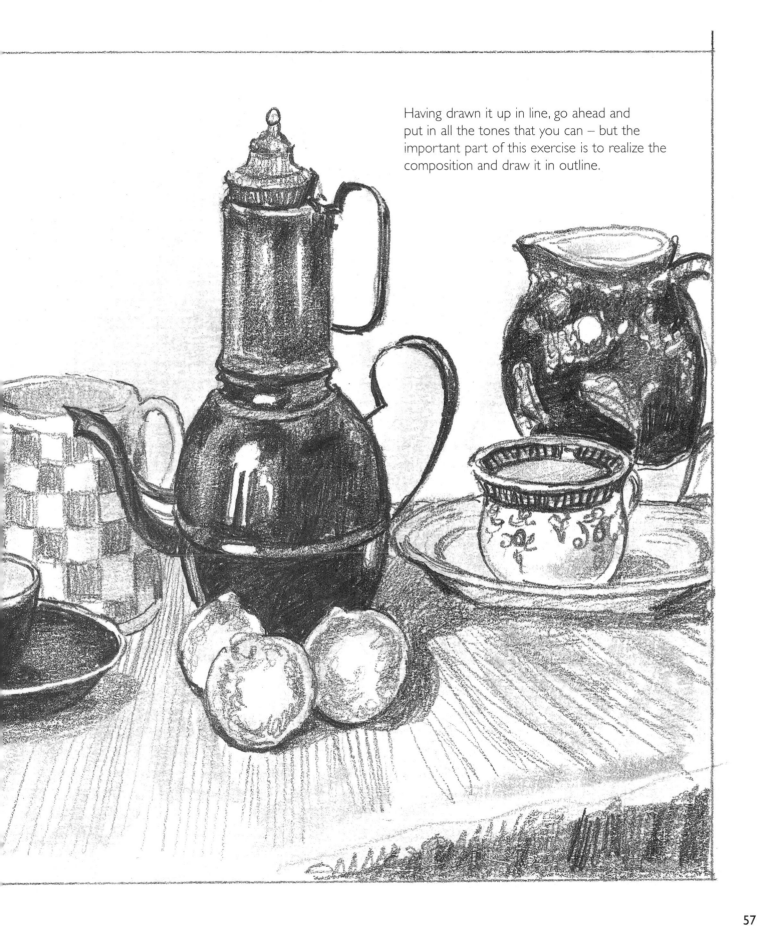

The next example is a picture of Pegwell Bay by William Dyce, a Victorian artist. Here the composition is a very simple halfway horizon with a range of chalk cliffs jutting into it. All the action in the picture is in the lower half, with various areas of rock and sand on which people are gathering shells and so forth. Most of the significant action is in the immediate foreground. The ladies in their crinolines make pleasing large simple shapes.

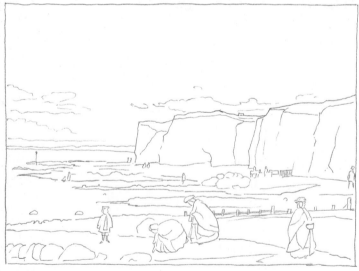

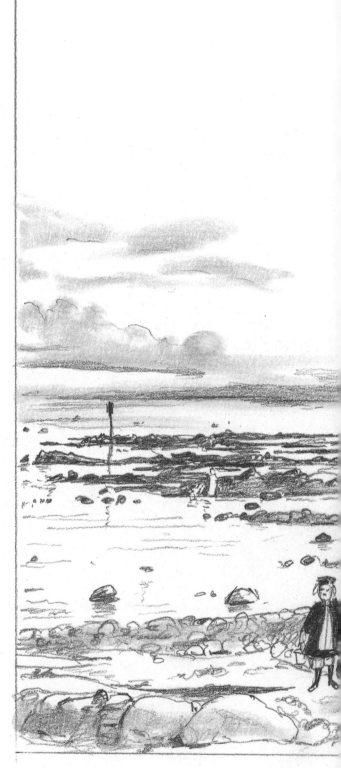

Draw out the scene in outline and then put in the tone. In this picture it is fairly even and light, so you can probably do most of it with linear marks.

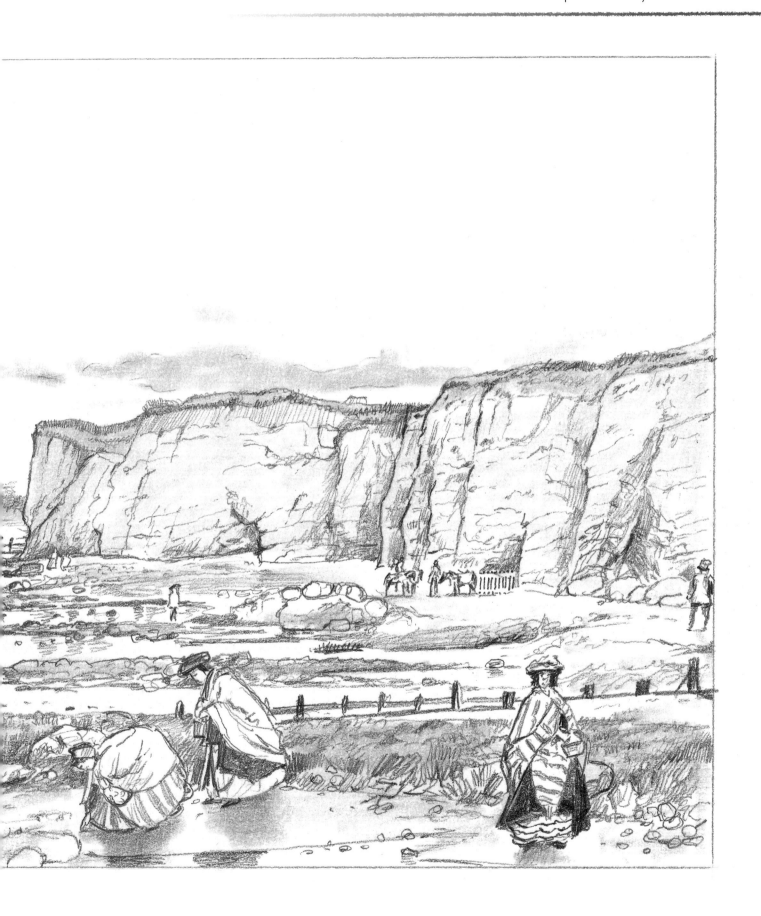

Next, a work by Richard Wilson of the top of Cader Idris in Wales. This design is mainly a large triangle, broken by the curve of a lake and the sweep of more mountain to one side. The curve is repeated twice in a mound below the lake and another body of water lower down to the left.

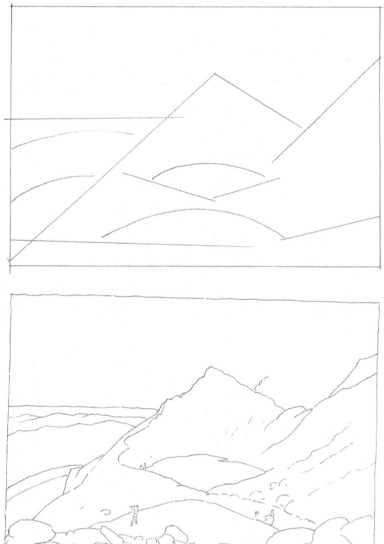

Because of the dramatic view, the tones are important as they show the sharp triangle of the peak above the lake, silhouetted against the sky. Have a go at copying this scene.

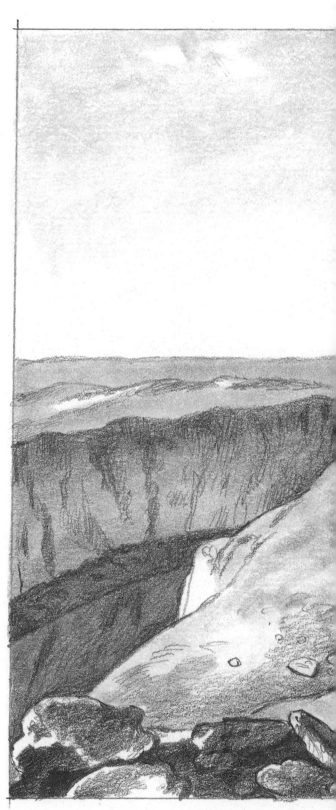

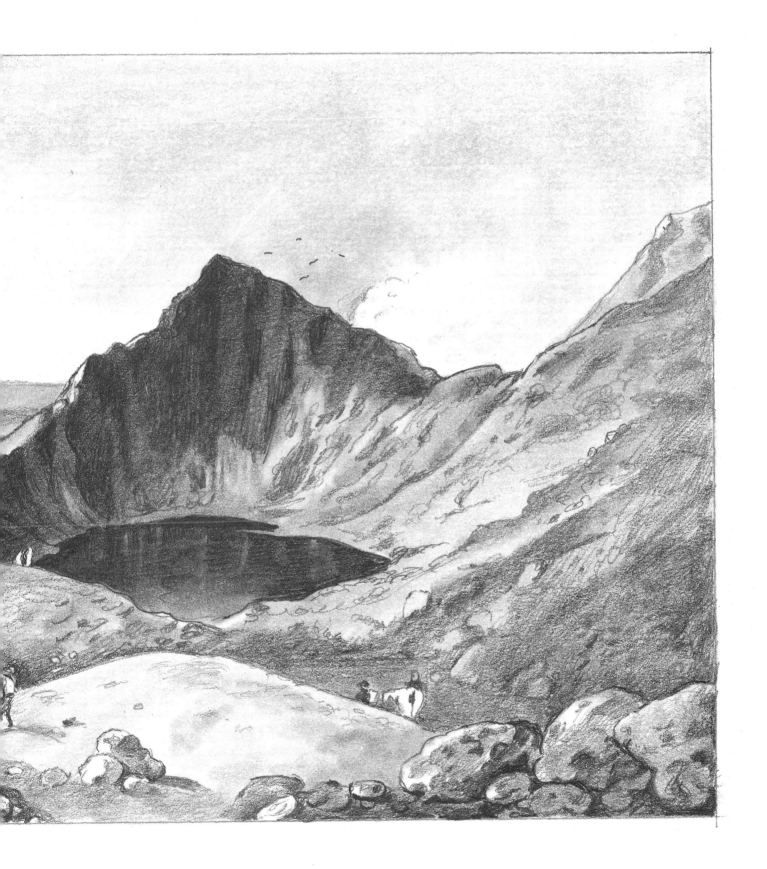

The next example is of a townscape by Walter Sickert, which is defined by the perspective of the street winding away on the left and the foreground shopfront at the right edge – thus, two perspective depths which work to the left and right of the picture.

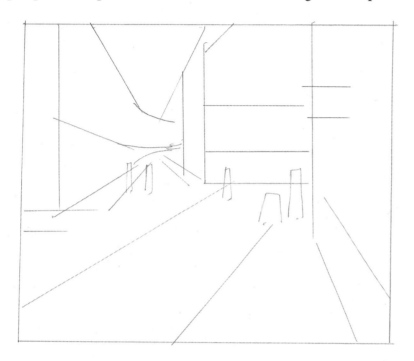

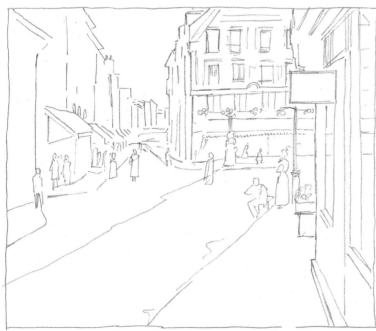

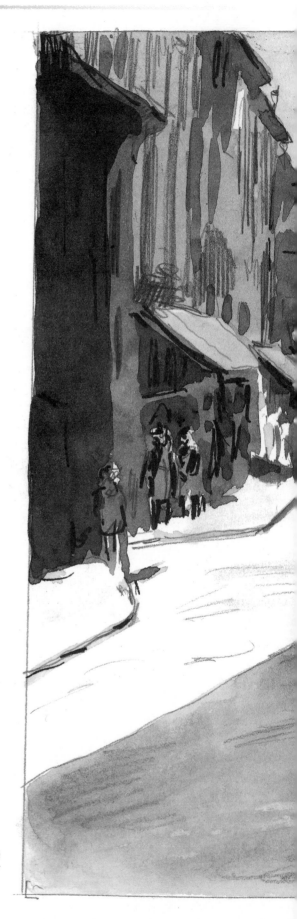

When you come to look at the tonal values you can see how the dark cast shadow of the buildings to the right divides the big open space of the foreground street diagonally. It all helps to draw the eye into the centre of the picture and then on down into the far street.

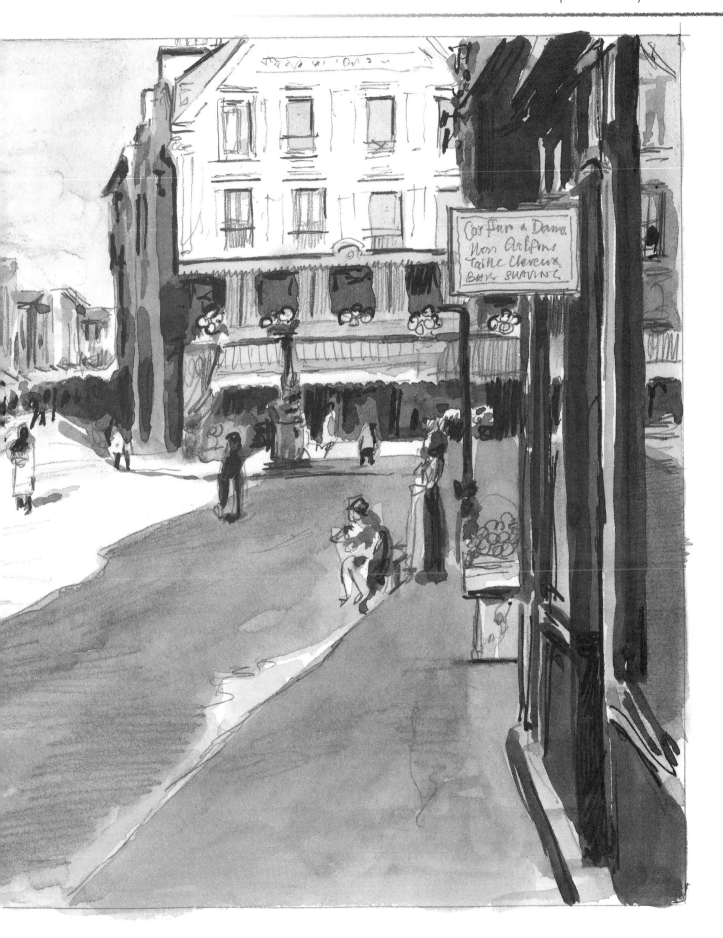

Our final example is by the famous Spanish master Diego Velázquez, who painted this picture of a woman in the process of cooking eggs. The whole scene is played out against a dark background, so that the figure of the woman is thrown forward, while the figure of the young boy almost disappears and he is seen only as a disembodied head and two hands. This allows the curve of the various utensils, including the ones he is holding, to form a curve across the picture ending at his face. This clever device attracts the attention to the contrast and connection between the two people.

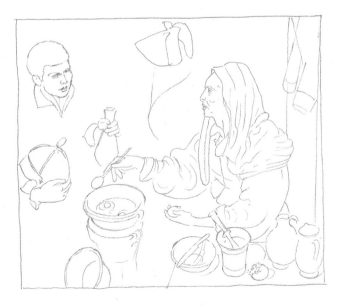

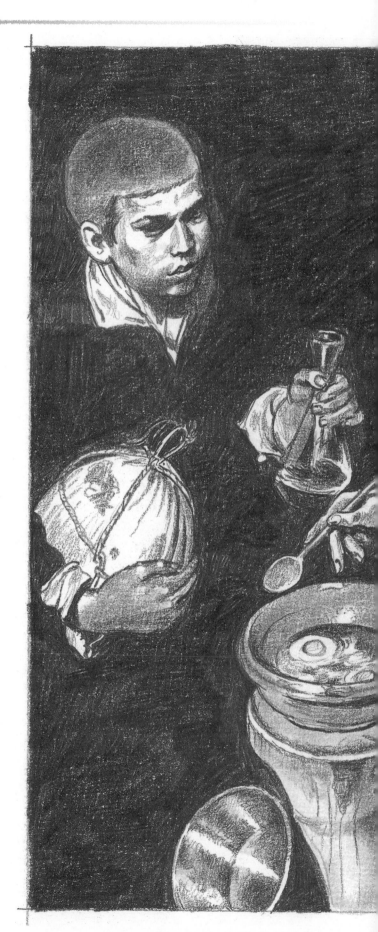

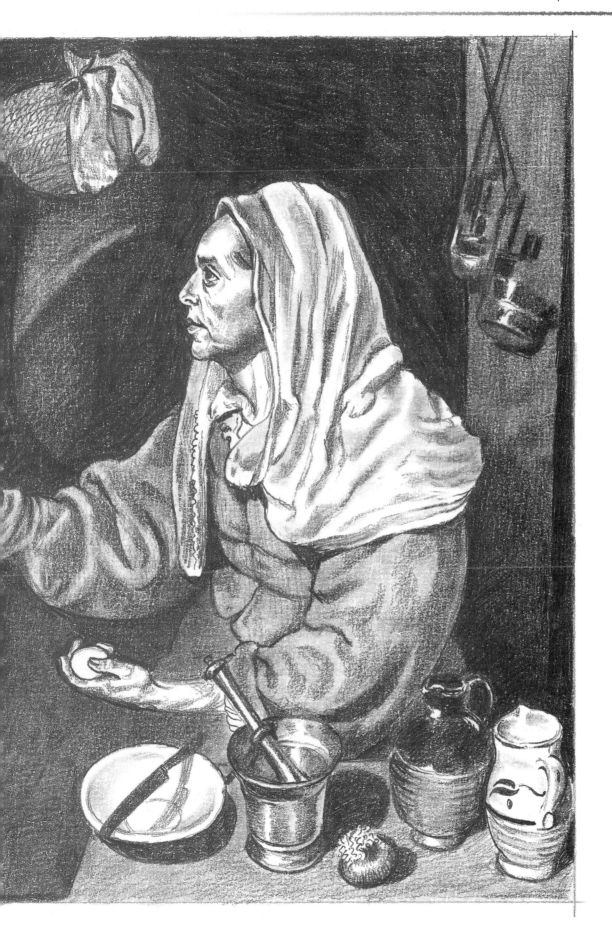

CREATING A BALANCED COMPOSITION

Dividing the page

This exercise is concerned with dividing up your page so that you may construct a balanced composition on it. It's not by any means the only way to do it, but it's probably the simplest at this stage of your development.

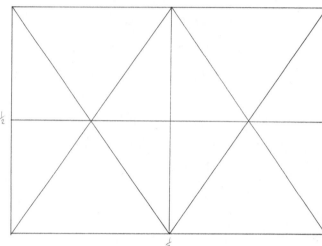

The first step is to take your A3 or A4 paper and fold it in half. Be exact about this, because your other measurements rely on it. Unfold the paper and draw a line along the fold, then divide both rectangles with diagonals from corner to corner. Where they cross, draw a line horizontally across the whole paper from centre to centre, extending to the edges. You now have your paper divided in half vertically and horizontally, without measuring anything – a simple device but effective.

You can now draw two diagonals across the whole paper from the corners. They should cross each other at the centre point if your lines are precise enough.

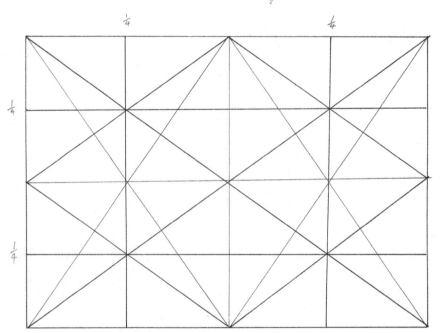

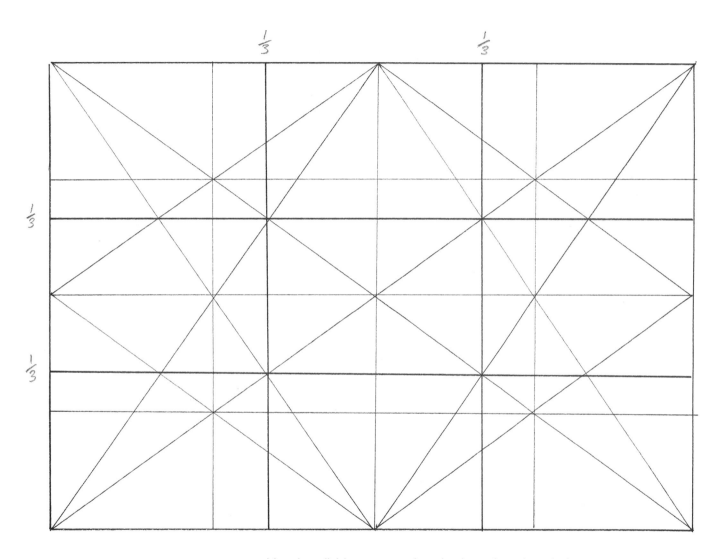

Your last divisions are to draw horizontals and verticals from where the main big diagonals cut across the two sets of diagonals of the half pages. These will be the third divisions of the page which already has the halves and quarter divisions. You now have a template to divide any piece of paper of the same size into halves, quarters and thirds, and the next examples will show you simple ways in which to use it to create compositions.

DIVIDING THE PAGE: PRACTICE

As you can see from these examples, a simple reduction of your page to thirds, quarters and halves can give you a number of compositional schemes to play with.

The first composition is one where a tree stands one-third from the right and two-thirds from the left of the scene. Its roots are at the lowest quarter mark. Across the picture at the lower third mark is a fence that appears to stretch about halfway. The horizon in the background is one-third from the top of the picture. There is a lone tree in the distance which is about one-third away from the left-hand side of the composition. As you can see, it all looks a satisfactory balance.

The next picture is a still life which uses a similar format. This time the largest vase is on the left third vertical, one-quarter from the top and one-quarter from the bottom. The rest of the objects are mainly on the right-hand vertical, with those at the third and halfway marks projecting out to the side. Once again this creates a well-balanced composition.

The two remaining pictures are both in a landscape format. First, a figure composition with two people, one sitting and one standing. The standing figure is one-third from the right edge of the picture and almost touches the top and bottom edge. The seated figure is near a wall that projects from the left-hand side of the picture to a third of the way across. This very simple design already gives an interesting tension between the two figures.

The last example is of a townscape in which one foreground building projects from the right to about one-third across, and from the top of the picture to about one-third from the lower edge. The other main block is projecting from the left to about one-third of the way across, with the top one-quarter from the top edge of the picture and the bottom edge at the halfway point. I've then put a lone block in the distant piazza at the halfway mark vertically and just below the quarter mark horizontally. A little vegetation in the lower left at the quarter horizontally could soften the hard edges of the buildings.

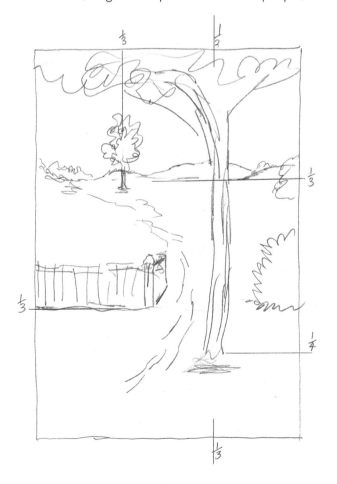

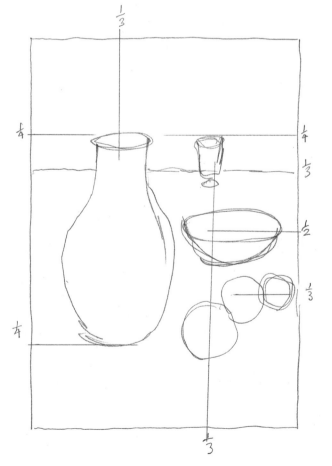

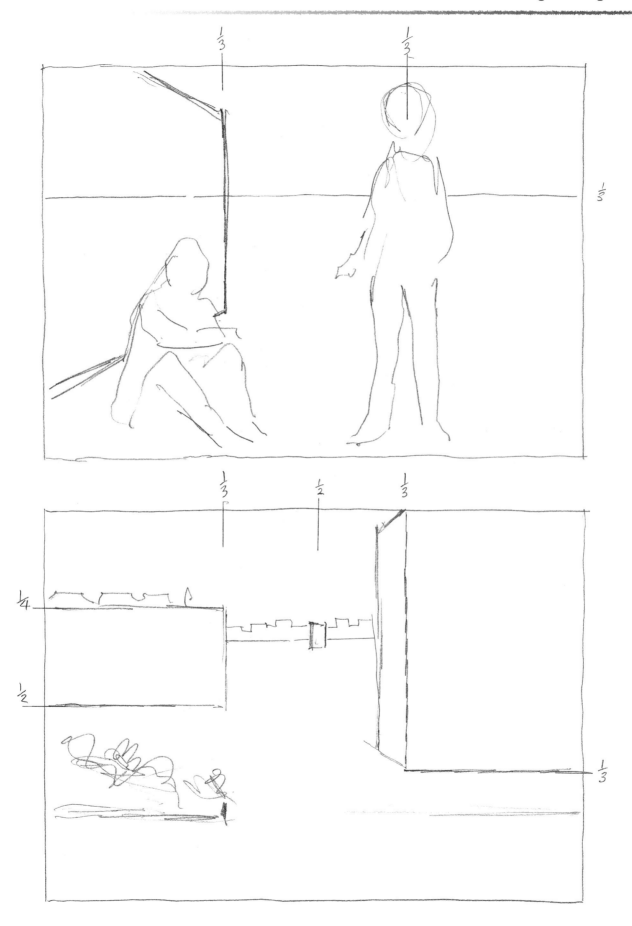

DESIGNING A FIGURE COMPOSITION

Now we are going to have a go at producing a complete figure composition. This will be done in a very practical way, with me drawing up a composition that you may want to copy. I will show you step by step how I might go about it, and you can then apply the same system when you make your own drawings.

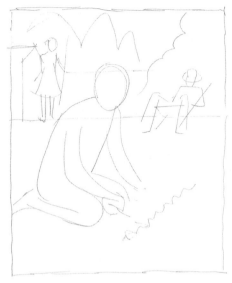

Step 1

I've started by using two slightly different formats, imagining a simple scene that I know well. If you want to make your own picture think of something familiar in your life, as it will lend verisimilitude to the composition.

In one picture I've put three figures in a garden setting. The nearest figure is a woman kneeling by a flowerbed with a garden tool in her hand. She is almost centre but just off to the left to create some space on the right. In that space is a male figure sitting in a deckchair, rather far back in the scene. To the left of the main figure is another woman walking towards her. The trees in the next garden go across the picture at about a third of the way from the top.

Again taking a familiar scene, I decided to draw an artist with a model, adding another figure to complicate the matter a little.
I placed the artist at a table which juts across the centre of the space, with him behind it and his model in front to the right. I made his model a girl and the other figure a male walking forward into the room from another room.

The model is the largest figure, and her feet are not visible. She sits in the right-hand corner of the picture, taking up about one-third of the scene diagonally across the picture. The artist is the next nearest but he is hidden by the table from his waist up. The third figure is almost in the centre of the picture, but further back as though coming through a doorway. This is design number two.

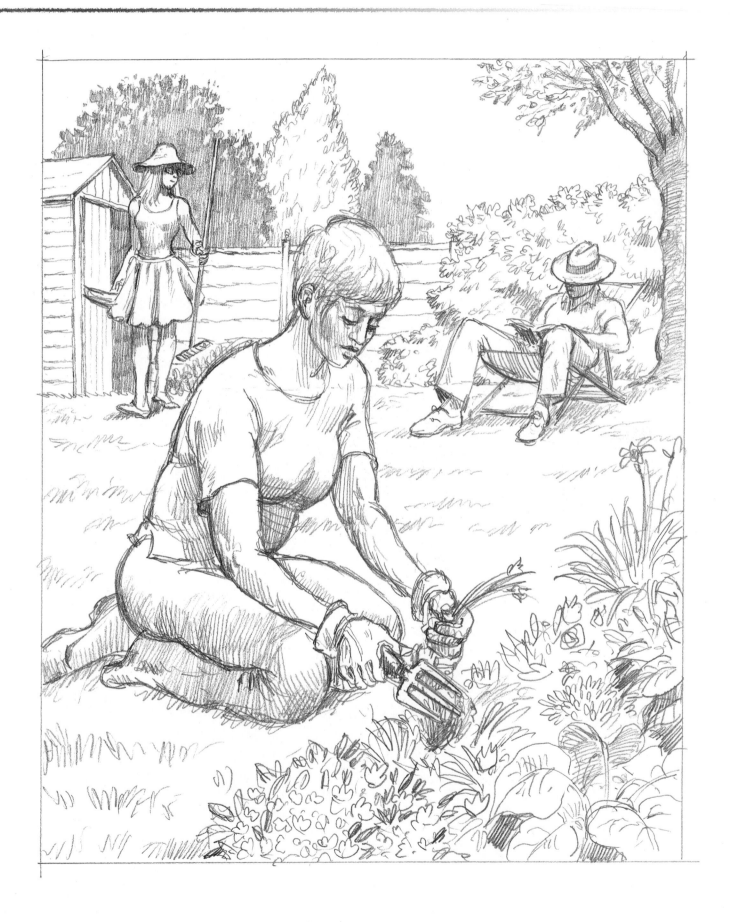

Step 2

Having produced a rough draft of the pictures, I still couldn't make up my mind which one to follow, so I drew them both up more seriously in greater detail. This may take some time, but it's the stage where you decide exactly what everything is going to look like. You may decide halfway through drawing one picture that you prefer the other one, and if so you can stop and just concentrate on the one of your choice. Stopping short with one of them doesn't matter – this is an exercise in coming to a final decision.

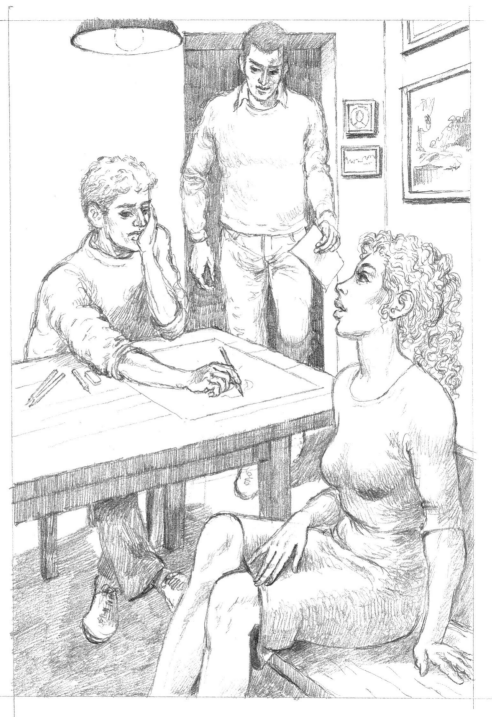

Step 3

My decision was to go with the artist drawing the model, and now I needed to consider it in more detail.

First I decided what the main figure would really look like. Ideally I would find a person to model for me, and after getting her to sit in the correct pose for my composition I would carefully draw her from life. If that were not possible I would work from my own previous drawings or use photographic reference.

As you can see I drew her head twice in different positions and I also tried different ways of placing her arms and hands. All this acted as useful information for the final picture.

Then I moved on to the other two figures, getting some idea of how the artist would look and how the other man would actually approach the scene. As you can see, I tried different positions for the head of the walking man.

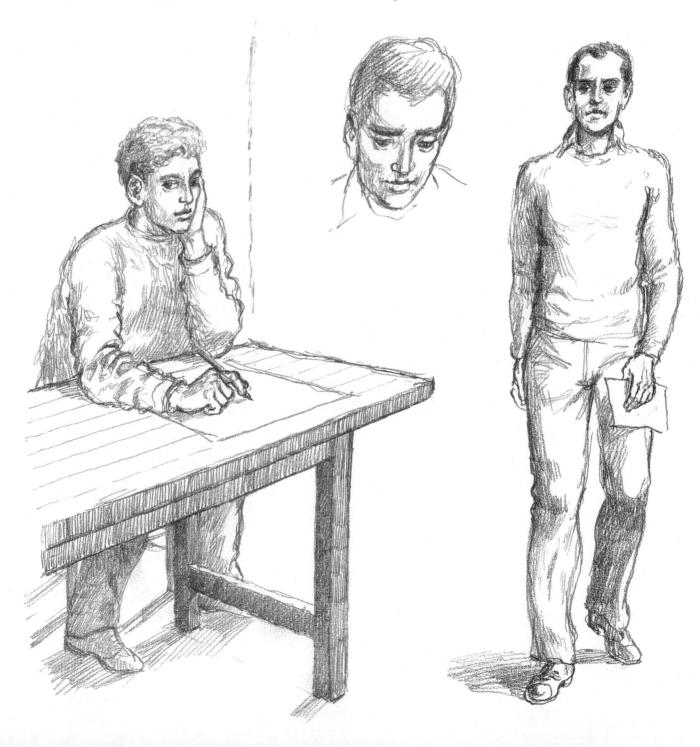

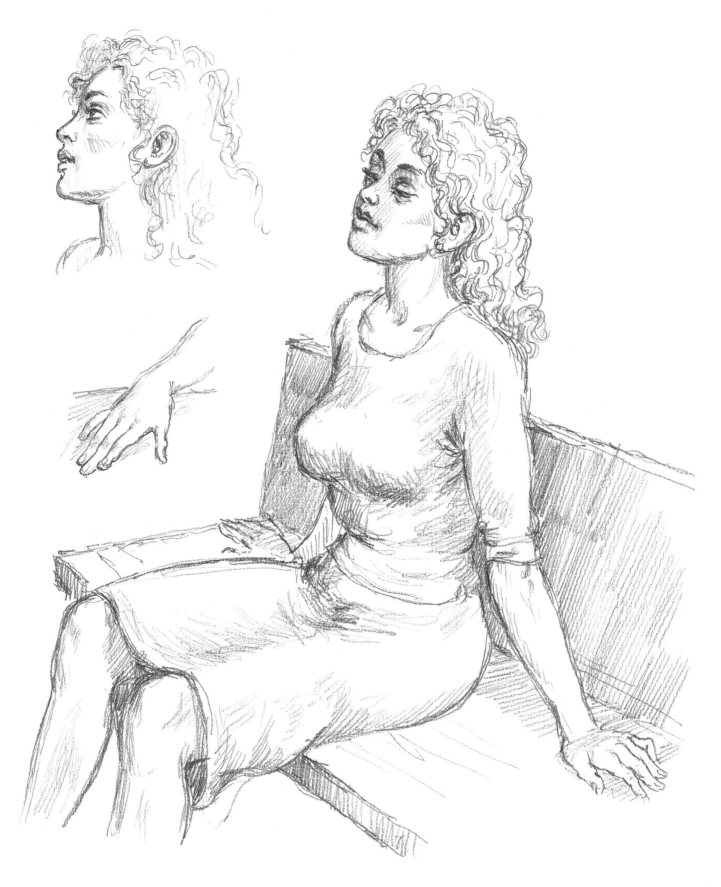

Step 4

Having researched the figures I now put them all into context by drawing up what is known as a cartoon, which is an outline of the complete picture. This was the last stage where I could alter the scene if required. In your own drawings, keep a version of the cartoon to enable you to correct any details when you have put in the tone.

Having got the full picture drawn up in line, I could now put in the main areas of tone or shadow in one light tone (opposite). At this stage don't overdo the weight of tone, because you will find it harder to get rid of it than to add more if you need to. It shows you where the light is coming from and gives you an idea as to how solid your figures may look.

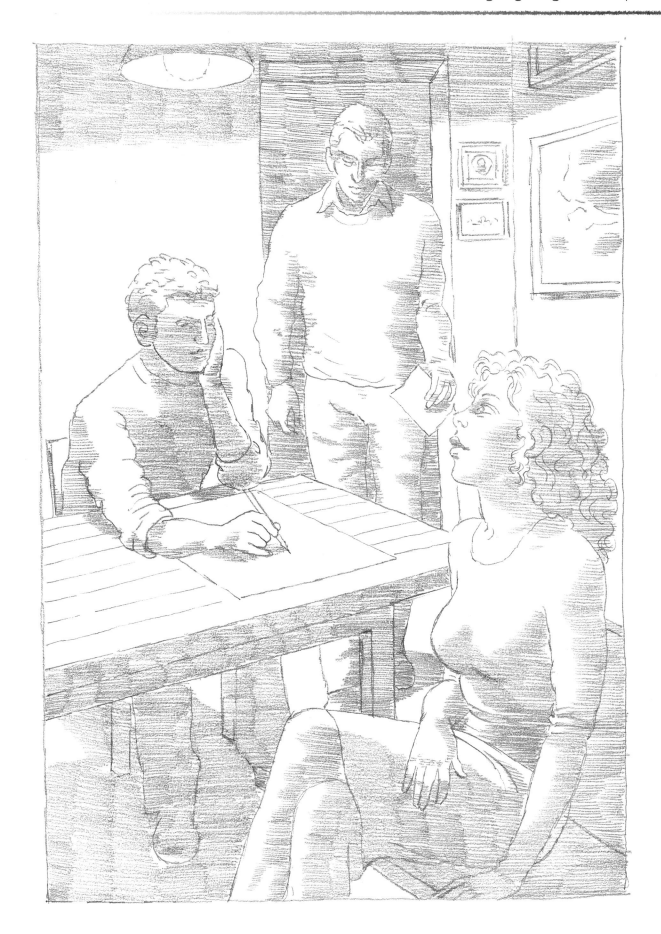

Step 5

Now comes the final stage, where everything is put in with great detail. Using your copy of the cartoon to ensure that all the shapes remain correct, begin to build up the heaviest tones so that you can see how the depth of space works in your composition. Take your time, because the quality of your work depends on the care and attention that you give to this finishing stage.

So now you have your completed composition with all the preliminary drawings that you made. Keep these for a while, because they might be useful in later drawings. In the ateliers of old, the drawings made for pictures were always kept for quite a time to be used over and over again in other compositions.

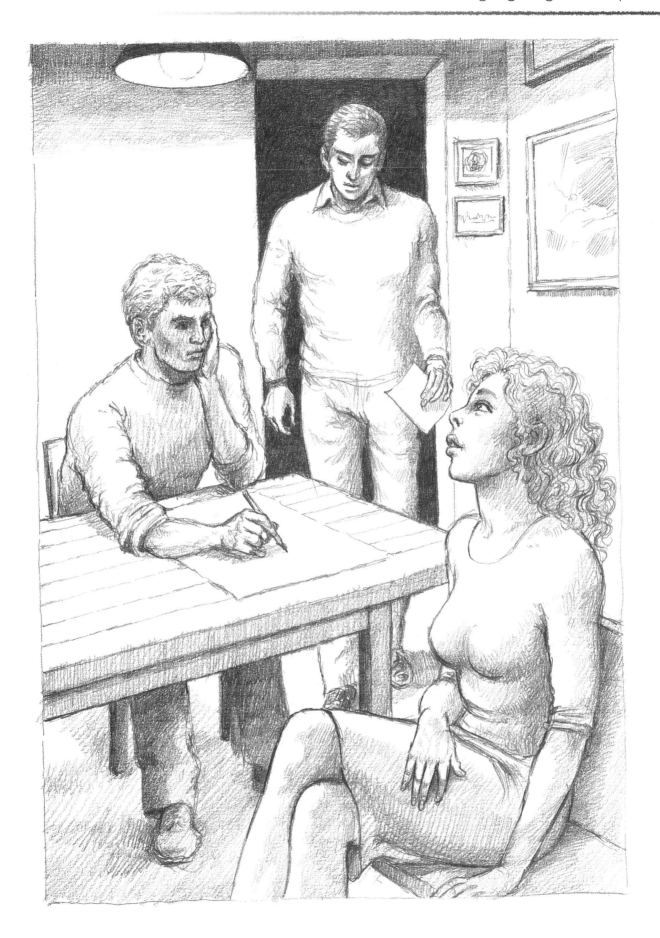

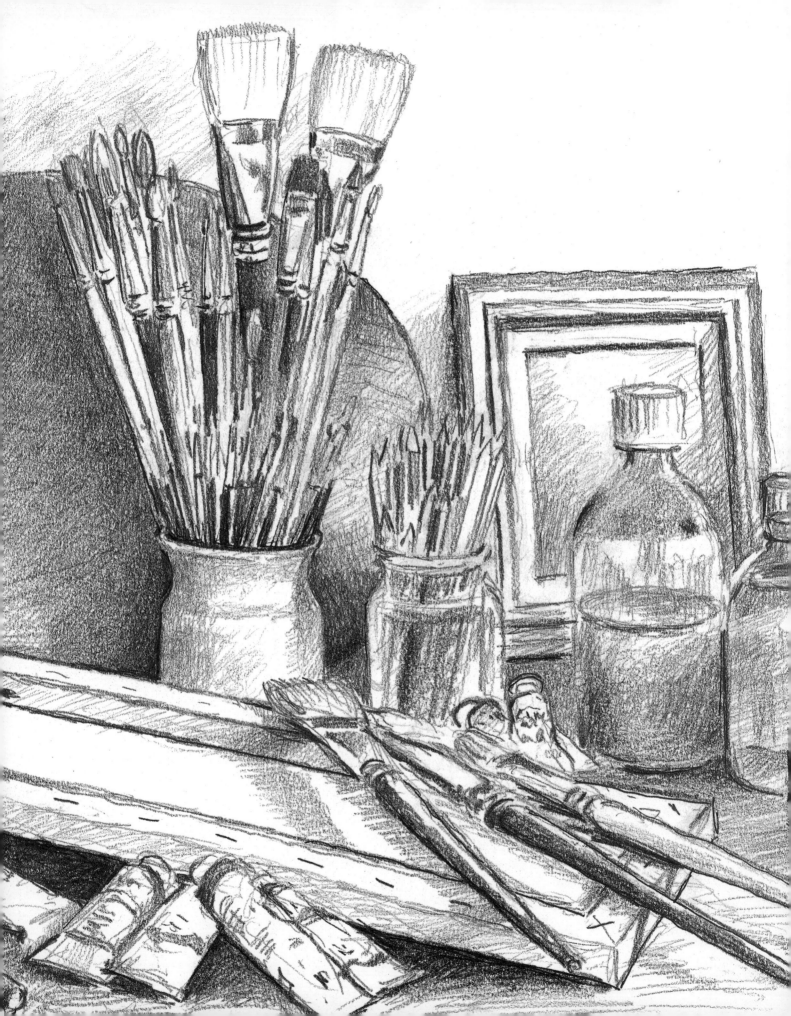

CHAPTER **4**

STILL LIFE

Still life is a very well-practised area of drawing and painting
and has been the route by which many artists have learnt about
technique and style. This is because it is the most easily available
of art's themes and doesn't require a model or a fine day; the artist
has only to look around their home to find all they need for an
enjoyable drawing session to keep their hand and eye in. For a
novice artist in particular, still life is ideal because you can choose
any objects you feel you can draw successfully and take all the time
you need in order to achieve that.

Drawing still life opens your eyes to the possibilities of quite
ordinary items becoming part of a piece of art. Around the house
there are simple everyday groups of objects that can be used to
produce very interesting compositions. If you follow my suggestions
you will quickly learn how to select objects and put them together
in ways that exploit their contrasting shapes, sizes and tones, and
also the materials that they are made of.

So in this chapter we shall build up from simple shapes to
complex, before moving on to tackle the drawing of still life
arrangements and themed compositions.

SIMPLE OBJECTS

To begin our exploration of how to draw still life subjects, I have chosen a couple of simple examples: a tumbler and a bottle. Glass objects are particularly appropriate at this stage because their transparency allows you to get a clear idea of their shape.

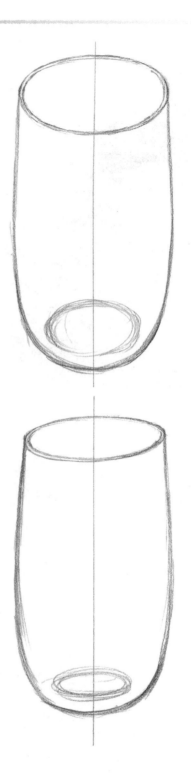

In pencil, carefully outline the shape (right). Draw the ellipses at the top and bottom as accurately as you can. Check them by drawing a ruled line down the centre vertically. Does the left side look like a mirror image of the right? If it doesn't, you need to try again or correct your first attempt. The example has curved sides and so it is very apparent when the curves don't match.

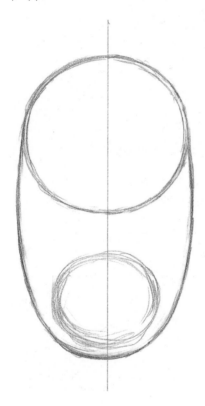

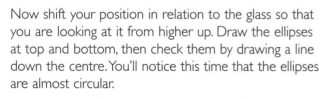

Now shift your position in relation to the glass so that you are looking at it from higher up. Draw the ellipses at top and bottom, then check them by drawing a line down the centre. You'll notice this time that the ellipses are almost circular.

Shift your position once more, this time so that your eye-level is lower. Seen from this angle the ellipses will be shallower. Draw them and then check your accuracy by drawing a line down the centre. If the left and right sides of your ellipses are mirror images, your drawing is correct.

You have to use the same discipline when drawing other circular objects, such as bottles and bowls. Here we have two different types of bottle: a wine bottle and a beer bottle. With these I want you to start considering the proportions in the height and width of the objects. An awareness of relative proportions within the shape of an object is very important if your drawings are to be accurate.

After outlining their shapes, measure them carefully, as follows. First, draw a line down the centre of each bottle. Next mark the height of the body of the bottle and the neck, then the width of the body and the width of the neck. Note also the proportional difference between the width and the length. As you can see, in our examples the proportions differ a lot.

The more practice at measuring you allow yourself, the more adept you will become at drawing the proportions of objects accurately. In time you will be able to assess proportions by eye, without the need for measuring. To provide you with a bit more practice, try to draw the objects below, all of which are based on a circular shape although with slight variations and differing in depth.

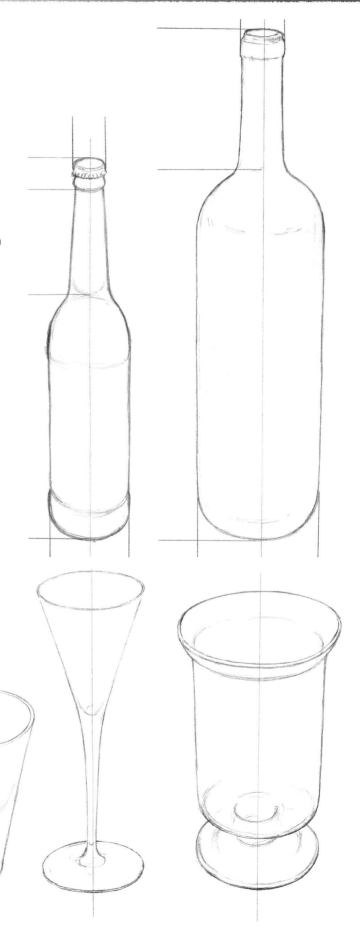

SURFACE TEXTURE

Solid objects present a different challenge and can seem impossibly daunting after you have got used to drawing objects you can see through. When I encourage novice pupils to put pencil to paper, they often initially complain, 'But I can't see anything!' Not true. Solid objects have one important characteristic that could have been especially designed to help the artist out: surface texture. In the beginning you might find these practices a bit tricky, but if you persevere you will find them immensely rewarding.

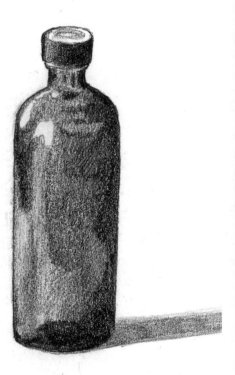

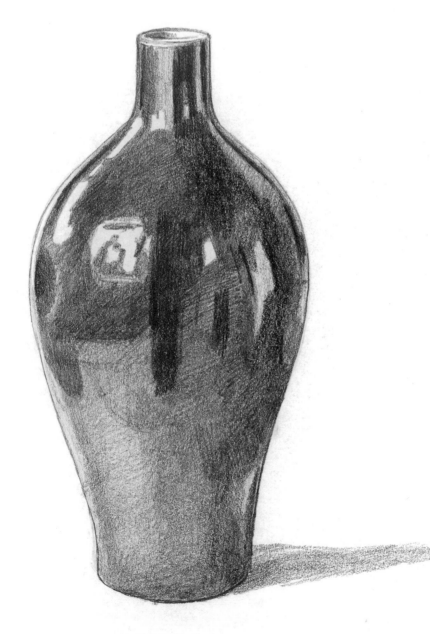

The two darkly glazed objects presented here appear almost black with bright highlights and reflections. Begin by putting in the outlines correctly, then try to put in the tones and reflections on the surface as carefully as you can. You will have to simplify at first to get the right look, but as you gain in confidence you will have a lot of fun putting in detailed depictions of the reflections.

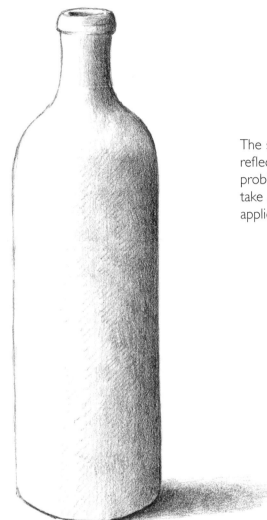

The surface of this matt bottle is non-reflective and so presents a different problem. To get this right you have to take a very subtle approach with the application of tone.

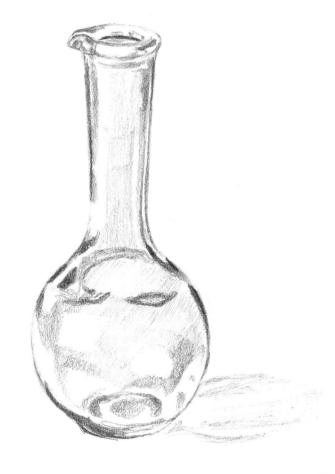

The problem with clear glass is how to make it look like glass. In this example the bright highlights help us in this respect, so put them in. Other indicators of the object's materiality are the dark tones, which give an effect of the thickness of the glass.

RECTANGULAR OBJECTS

Unlike some other types of drawing, you don't need to know a great deal about perspective to be able to produce competent still lifes. You will, however, find it useful to have a basic grasp of the fundamentals when you come to tackle rectangular objects.

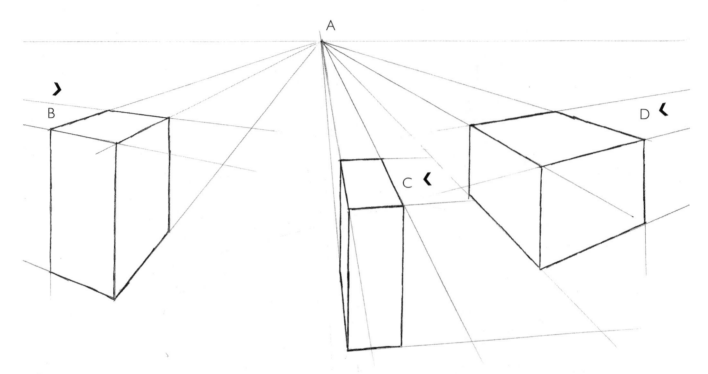

Perspective can be constructed very simply by using a couple of reference points: eye-level (the horizontal line across the background) and (A) one-point perspective lines (where all the lines converge at the same point).

The perspective lines relating to the other sides of the object (B, C and D) would converge at a different point on the eye-level. For the sake of simplicity at this stage, they are shown as relatively horizontal.

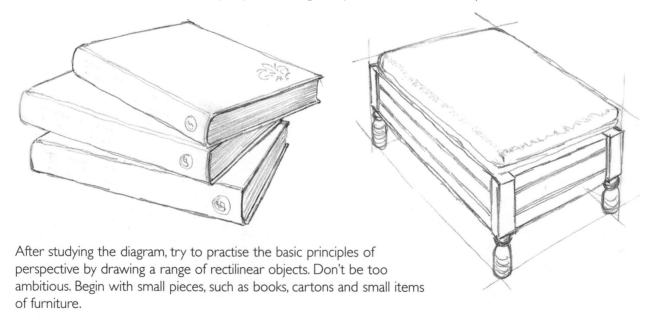

After studying the diagram, try to practise the basic principles of perspective by drawing a range of rectilinear objects. Don't be too ambitious. Begin with small pieces, such as books, cartons and small items of furniture.

You will find that different objects share perspectival similarities – in my selection, compare the footstool with the pile of books, and the chair with the carton.

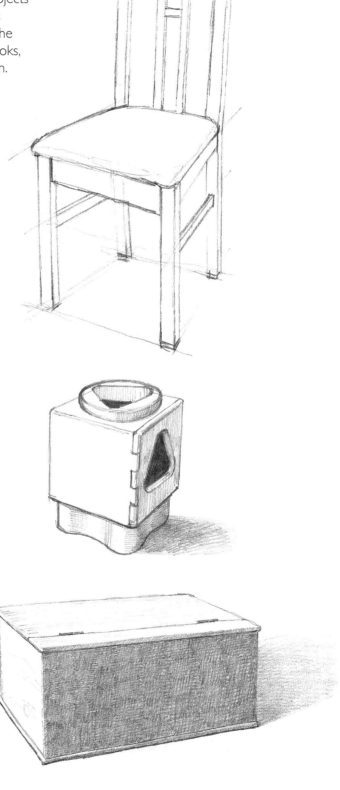

The wicker basket and plastic toy box offer slightly more complicated rectangles than the blanket box. With these examples, when you have got the perspective right, don't forget to complete your drawing by capturing the effect of the different materials. Part of the fun with drawing box-like shapes comes in working out the relative evenness of the tones needed to help convince the viewer of the solidity of the forms. In these three examples, use tone to differentiate the lightest side from the darkest, and don't forget to draw in the cast shadow.

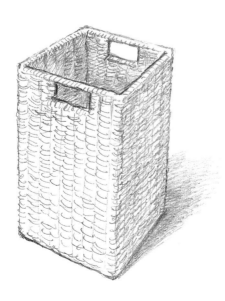

SPHERICAL OBJECTS

You shouldn't find it difficult to practise drawing spherical objects. Start by looking in your fruit bowl, and then scanning your home generally for likely candidates. I did this and came up with an interesting assortment. You will notice that the term spherical covers a range of rounded shapes. Although broadly similar, none of the examples is identical. You will also find variations on the theme of surface texture. Spend time on these practices, concentrating on getting the shapes and the various textural characteristics right.

I chose an apple, an orange and a plum. Begin by carefully drawing in the basic shape of each fruit, then mark out the main areas of tone.

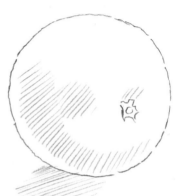

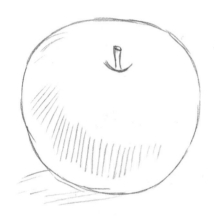

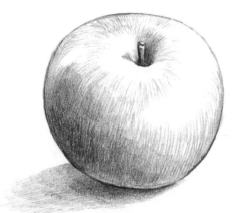

The orange requires a stippled or dotted effect to imitate the crinkly nature of the peel.

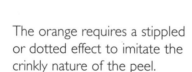

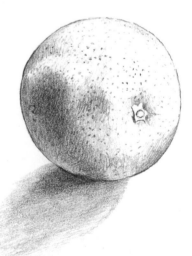

Take the lines of tone vertically round the shape of the apple, curving from top to bottom and radiating around the circumference. Gradually build up the tone in these areas. In all these examples don't forget to draw the cast shadows.

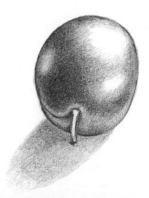

To capture the silky-smooth skin of a plum you need an even application of tone, and obvious highlights to denote the reflective quality of the surface.

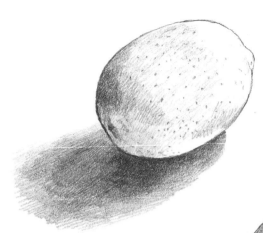

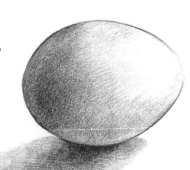

The surface of an egg, smooth but not shiny, presents a real test of expertise in even tonal shading.

The texture of a lemon is similar to that of the orange. Its shape though is longer.

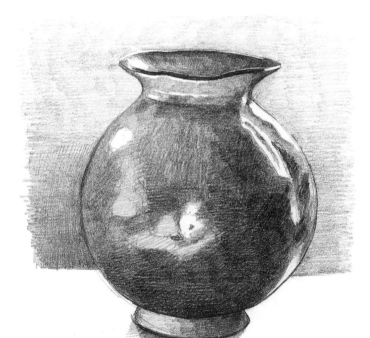

The shading required for this round stone was similar to that used for the egg but with more pronounced pitting.

The perfect rounded form of this child's ball is sufficiently shiny to reflect the light from the window. Because the light is coming from behind, most of the surface of the object is in shadow; the highlights are evident across the top edge and to one side, where light is reflected in a couple of smaller areas. The spherical shape of the ball is accentuated by the pattern curving round the form.

The texture of this hand-thrown pot is not uniform and so the strongly contrasting dark and bright tones are not immediately recognizable as reflections of the surrounding area. The reflections on the surface have a slightly wobbly look.

INTRODUCING DIFFERENT MEDIA

Taking an object and drawing it in different types of media is another very useful practice when you are developing your skills in still life. The materials we use have a direct bearing on the impression we convey through our drawing. They also demand that we vary our technique to accommodate their special characteristics. For the first exercise I have chosen a cup with a normal china glaze but in a dark colour.

Drawn in pencil, each tonal variation and the exact edges of the shape can be shown quite easily – once you are proficient, that is.

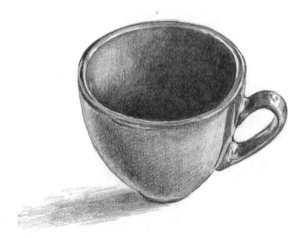

Attempt the same object with chalk (below) and you will find that you cannot capture the precise tonal variations quite so easily as you can with pencil. The coarser tone leaves us with the impression of a cup while showing more obviously the roundness of the shape. A quicker medium than pencil, chalk allows you to show the solidity of an object but not its finer details.

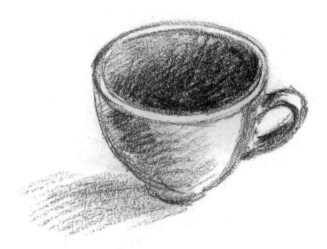

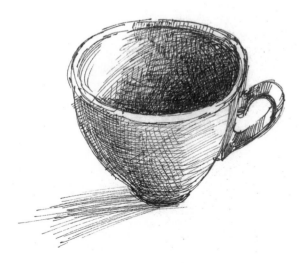

Although ink (left) allows you to be very precise, this is a handicap when you are trying to depict the texture of an object. The best approach is to opt for rather wobbly or imprecise sets of lines to describe both the shape and texture. Ink is more time-consuming than either pencil or chalk but has the potential for giving a more dramatic result.

If you want to make what you are drawing unmistakable to the casual viewer, you will have to ensure that you select the right medium. Unfortunately for the beginner, in this respect the best result is sometimes achieved by using the most difficult method. This is certainly the case with our next trio, where wash and brush succeed best in producing the sharp, contrasting tones we associate with glass.

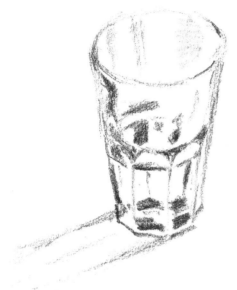

Although this example in chalk is effective in arresting our attention, it gives us just an impression of a glass tumbler.

The quality of the material is most strikingly caught with wash and brush, which produces hard, bright surfaces and the illusion of light coming from behind the object.

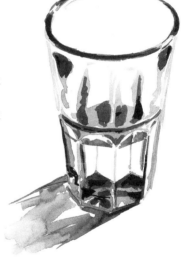

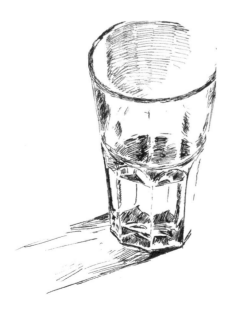

Pen and ink is a very definite medium to work in. Here it allows the crispness of the glass edges to show clearly, especially in the lower half of the drawing.

UNUSUAL SHAPES

When you have learnt to draw simple shapes effectively, the next step is to try your hand at more complicated versions of these shapes. In this next selection, the first set of examples have an extra part or parts jutting out from a main body, in the form of spouts, handles and knobs. Finally, we look at more subtle changes in shape across a range of objects.

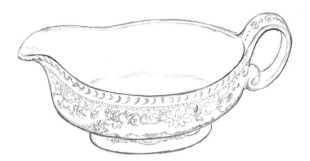

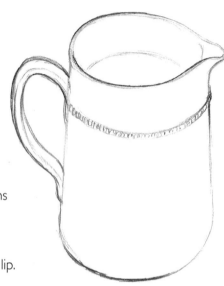

These two items provide some interesting contrasts in terms of shape. Note the delicate pattern around the lip of the sauce-boat which helpfully defines the shape of the outside against the plain white surface of the inside. The main point about the jug is the simple spout breaking the curve of the lip.

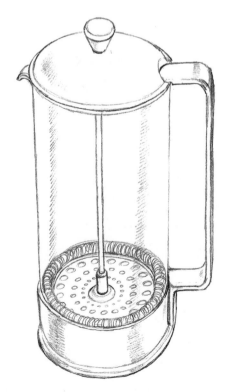

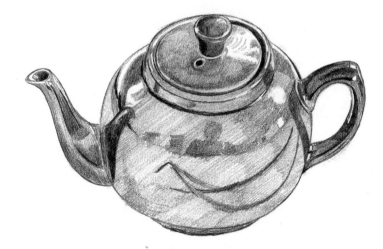

With our next pairing, of teapot and cafetière, the most obvious point of contrast – apart from the relative sizes and shapes of the spouts and handles – is the texture. The cafetière is very straightforward, requiring only that you capture its cylindrical shape and show its transparency. The teapot is more interesting: a solid spherical shape with a dark shiny surface and myriad reflections. When you practise drawing this type of object, ensure that the tones you put in reveal both its surface reflections and underlying structure.

In the following examples there is a hint of continuous form rather than bits being added on.

The shape of this metal mixer tap is not complicated and should present few problems.

A set of cutlery presents quite elegant shapes. The principal difficulty here is rendering accurately the proportion between the business end and the handle of each item. I grouped them close together to help contrast the shapes and make them easier to get right.

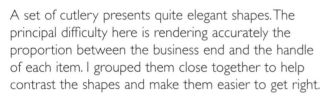

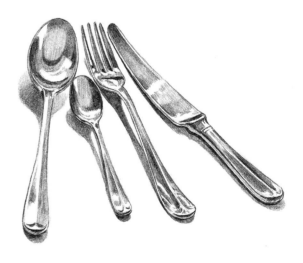

Once you are happy with the accuracy of your outline drawings, you can enjoy the process of carefully putting in the tonal reflections. With any shiny metallic object the contrast between darks and lights will be very marked, so ensure that you capture this effect with your use of tone.

UNUSUAL SHAPES: BRUSH AND WASH EXERCISE

Next, to vary the technique of your drawing, switch to a brush and tonal wash, using either ink or watercolour. For this exercise I have chosen a shiny saucepan. As you will have already discovered when carrying out some of the practices on the previous pages, obtaining a realistic impression of a light-reflecting material can only be achieved if you pay particular and careful attention to the tonal contrasts.

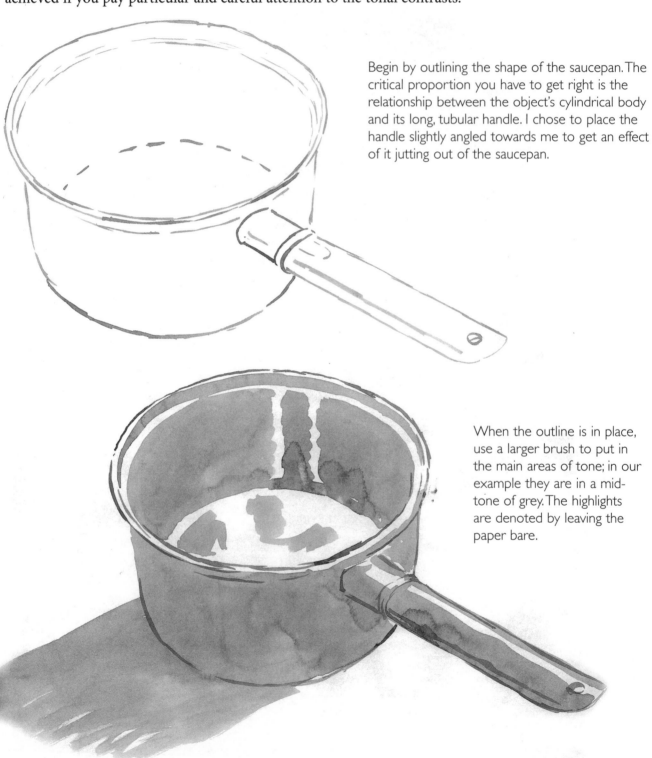

Begin by outlining the shape of the saucepan. The critical proportion you have to get right is the relationship between the object's cylindrical body and its long, tubular handle. I chose to place the handle slightly angled towards me to get an effect of it jutting out of the saucepan.

When the outline is in place, use a larger brush to put in the main areas of tone; in our example they are in a mid-tone of grey. The highlights are denoted by leaving the paper bare.

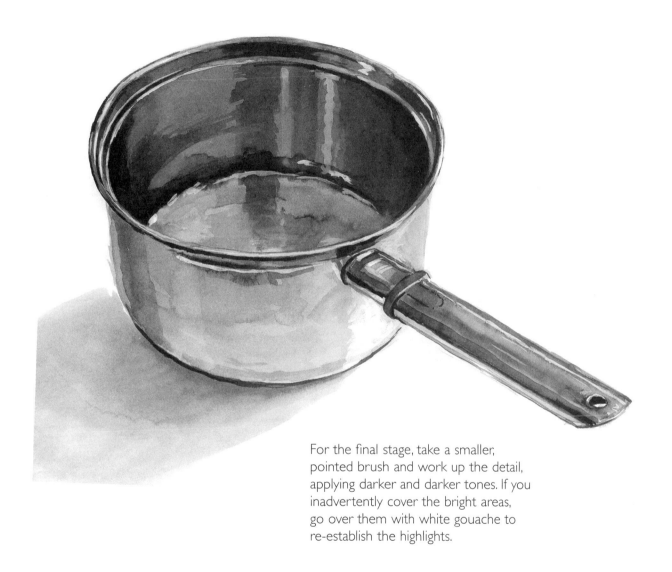

For the final stage, take a smaller, pointed brush and work up the detail, applying darker and darker tones. If you inadvertently cover the bright areas, go over them with white gouache to re-establish the highlights.

UNUSUAL SHAPES: GROUP PRACTICE

In perspective terms, one object by itself doesn't tell you as much as several grouped together. I have selected a few tools for this next exercise, arranging them so they fan out with either the working ends or the handles towards you. Sharply defined shapes such as these are relatively easy to draw, so long as you take care over getting the proportions right. Note carefully the angles at which they appear to be lying on the surface. Their proportions are not quite the same as they would be if they were held straight in front of the eye.

To begin this type of drawing you have to take some form of measurement to ensure that you don't make the length of the head or handle of each tool longer or shorter than it should be. When you are sure of the proportions and perspective, draw each tool in outline as accurately as you can, defining the edges clearly.

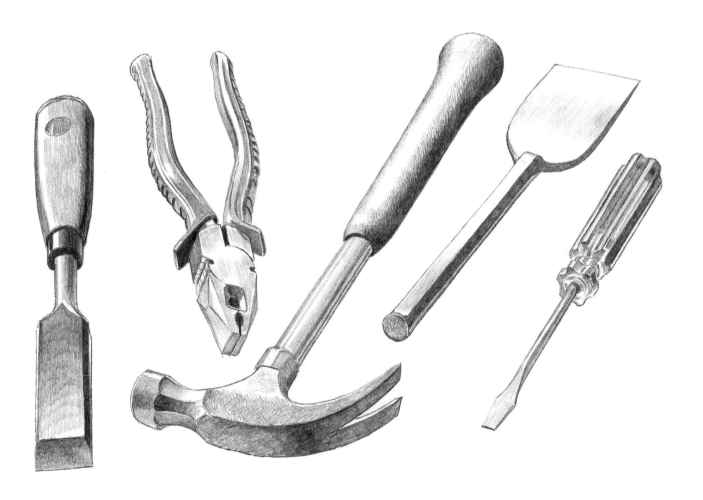

Clarity of definition is very important when drawing objects that have been designed to do a job. If your outline drawings are not accurate the addition of tone will not make them any better. Assuming that your outlines are spot-on, proceed to put in the tones, denoting differences between the various materials of which the tools are made: for example, the sharp contrasts between dark and light in metallic parts and the more subdued tones for parts made of rubber, plastic or wood.

UNUSUAL SHAPES: PRACTICE

Here is a range of common household items for you to practise. The subject matter for still-life compositions is massive, so the more varied your experience of drawing different kinds of objects, in terms of shape, size and texture, the wider will be the possibilities open to you. As with any kind of drawing, you have to work up a body of experience before you can get the best out of it.

This basketwork chair could easily be the centre of a largish still-life arrangement. You need to get the outline shape right first. Because a chair is a large object, you will find it easier to draw one from life if you stand back and view it from a distance where you can take in the whole shape in one glance. Of particular interest here is the difference in texture between the softness of the cushions and the tightly woven basketwork of the chair itself. Notice too the legs jutting out backwards, and the softening effect of the heavily woven edge of the back and arms. Capturing the texture of the material is easier than you might think; look at it closely and you will see it is just sets of horizontal curves lying in columns across the surface of the chair. The bare wooden floor with its clearly defined boards assists in the depiction of the chair's three-dimensional shape.

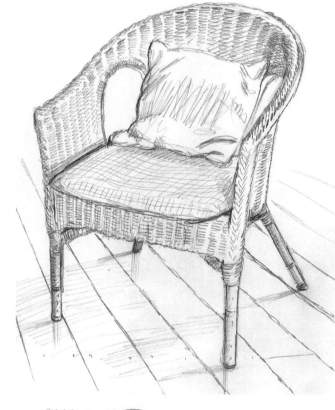

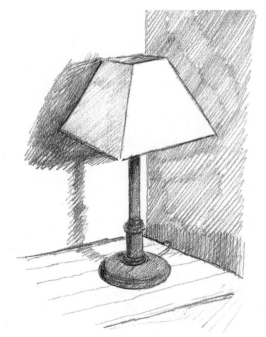

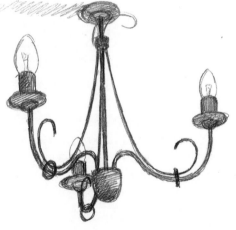

At first glance you may consider this chandelier and lamp a bit too simple. Both are relatively easy to draw. The interesting – and important – aspect of these two objects is the cast shadow, which in both cases is part of the artist's means of placing an object in situ.

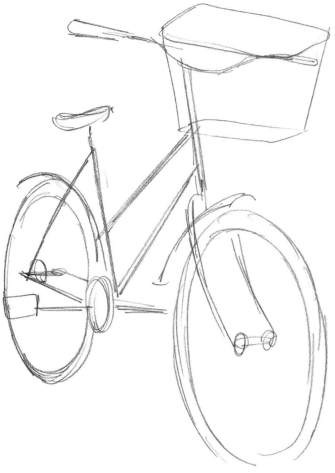

Our final object is a bit bigger than the chair and much more complicated: a bicycle. Although it presents difficulties, there is not much in the way of solid forms to draw, thanks to its linear construction.

The lack of depth in the parts making up the shape means that your initial drawing will probably look very rudimentary. Don't worry about this; concentrate on trying to work out the proportion of, say, the ellipses of the wheels in relation to the structure of the frame.

You may require several attempts before you can produce a convincing bicycle shape. Do keep at it, because this whole exercise provides excellent training for the eye and hand. This object is a bit like drawing a skeleton for a human figure. The structural shape is everything, because this is what makes it work. There are no unnecessary bits and pieces on a machine like this.

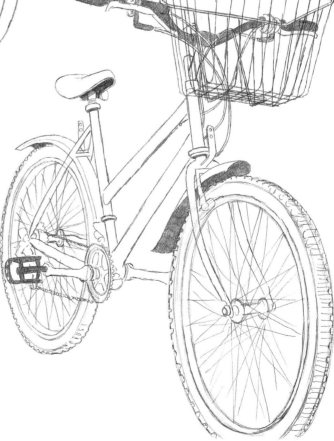

TEXTILES

The best way to understand the qualities of different textures is to look at a range of them. We'll begin by examining different kinds of textiles: viscose, silk, wool and cotton. The way the folds of cloth drape and wrinkle is key to each example. You will need to look carefully too at the way the light and shade fall and reflect across the folds of the material, because these will tell you about the more subtle qualities of the surface texture.

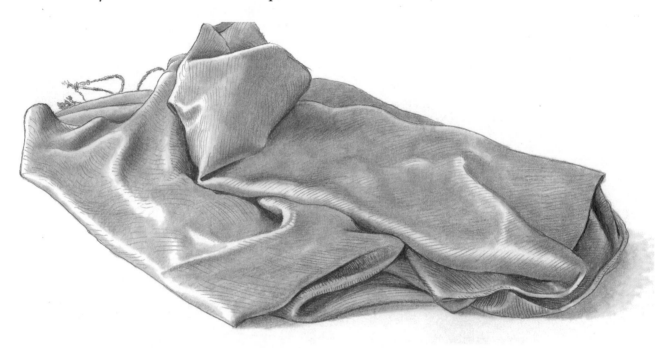

This scarf or pashmina made of the synthetic material viscose is folded over upon itself in a casual but fairly neat package. The material is soft and smooth to the touch, but not silky or shiny; the folds drape gently without any harsh edges, such as you might find in starched cotton or linen. The tonal quality is fairly muted, with not much contrast between the very dark and very light areas; the greatest area of tone is a medium tone, in which there exists only slight variation.

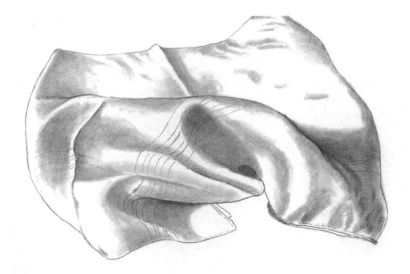

Here is a silk handkerchief which, apart from a couple of ironed creases in it, shows several smooth folds and small undulations. The tonal qualities are more contrasting than in the first example – the bright areas ripple with small patches of tone to indicate the smaller undulations. We get a sense of the material's flimsiness from the hem and the pattern of stitched lines.

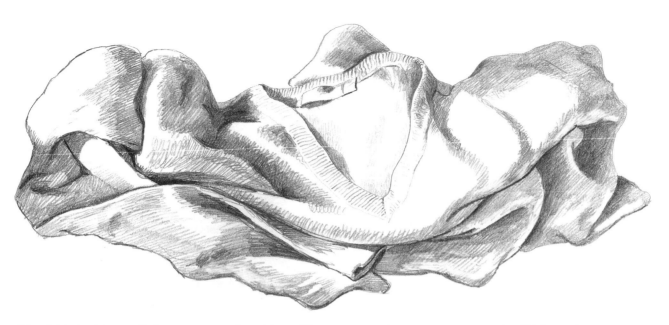

The folds in this woolly jumper are soft and large. There are no sharp creases to speak of. Where the two previous examples were smooth and light, the texture here is coarser and heavier. The showing of the neckline with its ribbed pattern helps to convince the eye of the kind of texture we are looking at.

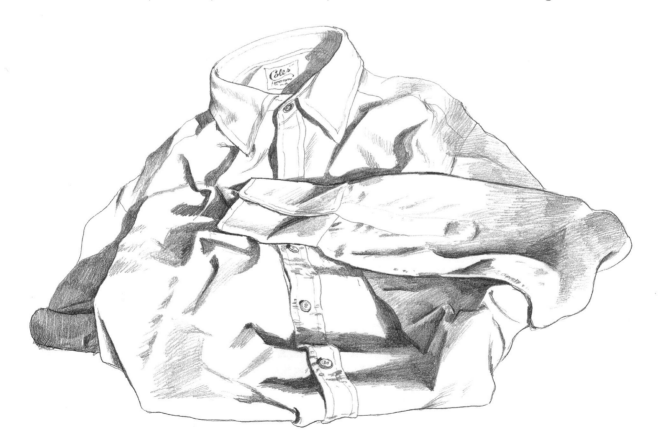

This well-tailored cotton shirt is cut to create a certain shape. The construction of the fabric produces a series of overlapping folds. The collar and the buttoned fly-front give some structure to the otherwise softly folded material.

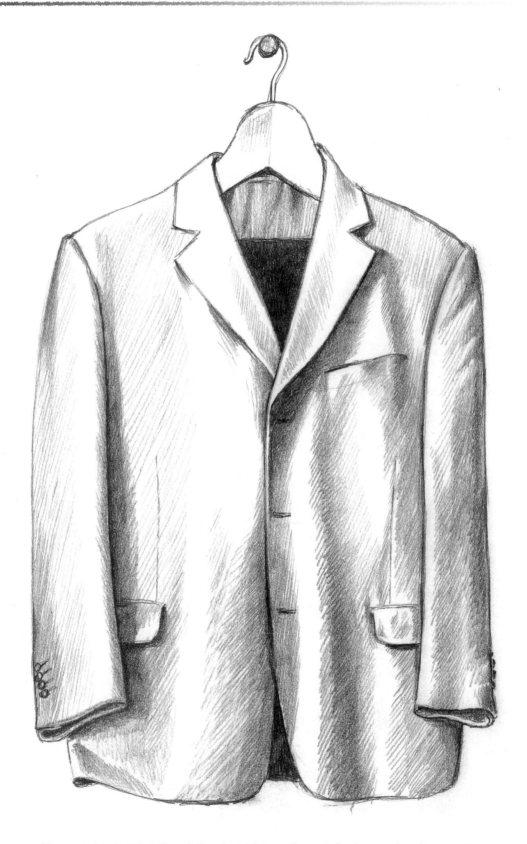

This wool jacket is tailored, like the shirt on the previous page. Its placement on a hanger gives us a clear view of the object's shape and the behaviour of the material. The few gentle folds are brought to our attention by the use of tone.

A deck shoe in soft leather, with soft edges and creases across the toe area, has none of the high shine of formal shoes. The contrast between the dark inside of the shoe and the lighter tones of the outside help to define the overall texture.

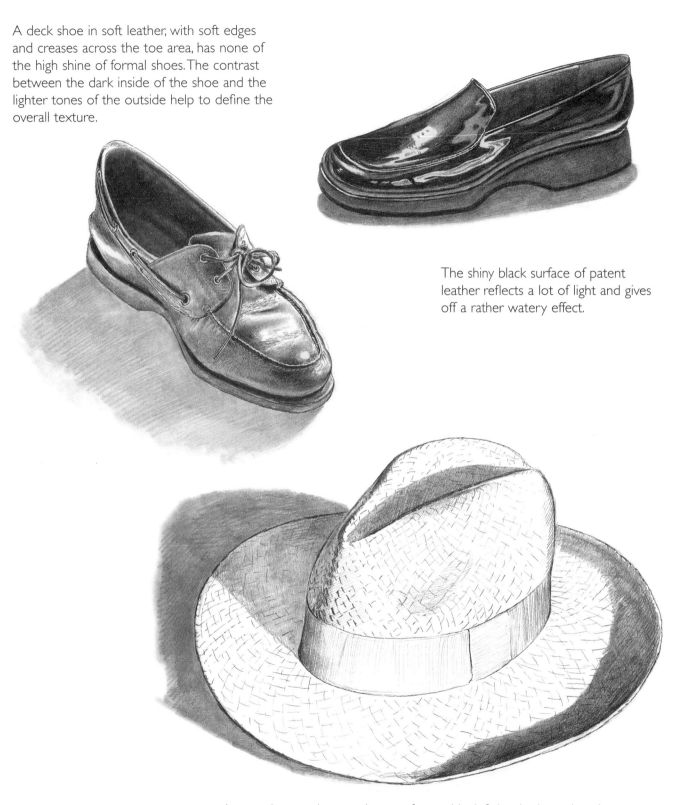

The shiny black surface of patent leather reflects a lot of light and gives off a rather watery effect.

A straw hat produces a clear-cut form with definite shadows that show the shape of the object clearly. The texture of the straw, woven across the structure, is very distinctive. Well-worn hats of this kind tend to disintegrate in a very characteristic way, with broken bits of straw disrupting the smooth line.

EXERCISES WITH PAPER

Now we have a look at something completely different. In the days when still-life painting was taught in art schools the tutor would screw up a sheet of paper, throw it onto a table lit by a single source of light, and say, 'Draw that.' Confused by the challenge, many students were inclined to reject it. In fact, it is not as difficult as it looks. Part of the solution to the problem posed by this exercise is to think about what you are looking at. Soon you will realize that although you have to try to follow all the creases and facets, it really doesn't matter if you do not draw the shape precisely or miss out one or two creases. The point is to make your drawing look like crumpled paper, not necessarily achieve an exact copy.

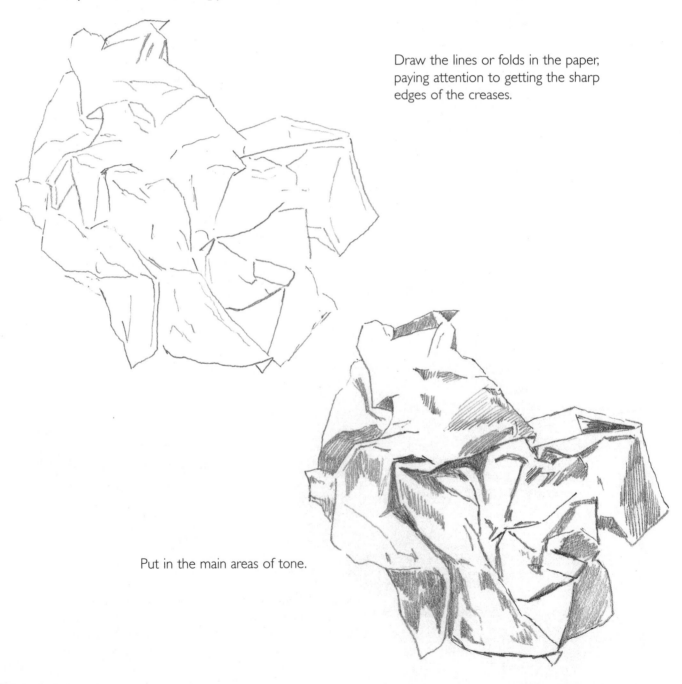

Draw the lines or folds in the paper, paying attention to getting the sharp edges of the creases.

Put in the main areas of tone.

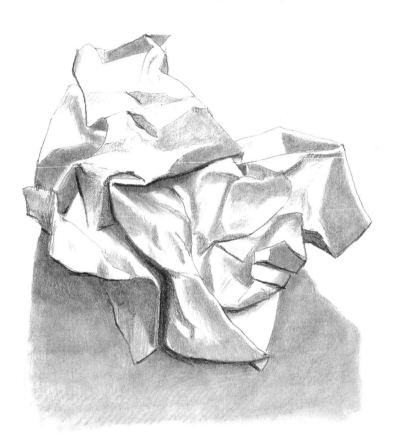

Once you have covered each tonal area, put in any deeper shadows, capturing the contrasts between these areas.

When you have completed the last exercise, try a variation on it. Crumple a piece of paper and then open it out again. Look at it and you will see that the effect is rather like a desert landscape. Before you try to draw it, position the paper so that you have light coming from one side; this will define the facets and creases quite clearly and help you.

Follow the three steps of the previous exercise, putting in the darkest shadows last.

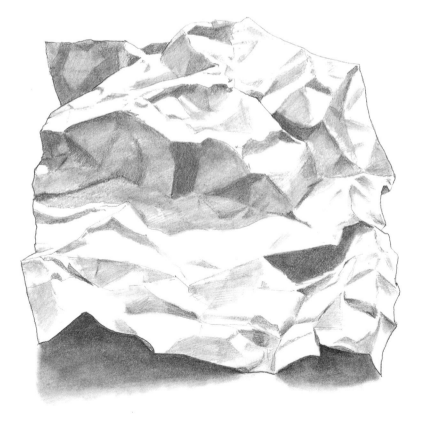

GLASS

Glass is a great favourite with still-life artists because at first glance it looks almost impossible to draw. All the beginner needs to remember is to draw what it is that can be seen behind or through the object. The object is to differentiate between the parts that you can see through the object and the reflections that stop you seeing straight through it. You will find, as with this example, that some areas are very dark and others very bright and often close up against each other. The highlights reflect the brightest light, and whatever is behind the glass is a sort of basis for all the brighter reflections.

Make sure that you get the outside shape correct. When you come to put in the reflections, you can always simplify them a bit. This approach is often more effective than over-elaborating.

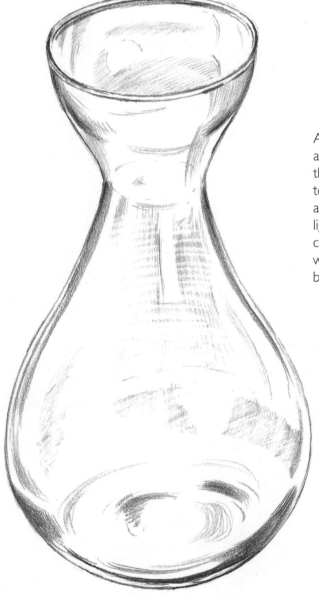

A glass vase, set in front of a white area of background, allows you to see the shape of the glass very clearly. The tonal areas here will be minimal. If you are not sure whether to put in a very light tone, leave it out until you have completed the drawing, then assess whether putting in the tone would be beneficial.

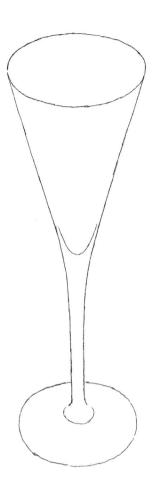

Draw the outline of this glass as carefully as you can. The delicacy of this kind of object demands increased precision in this respect.

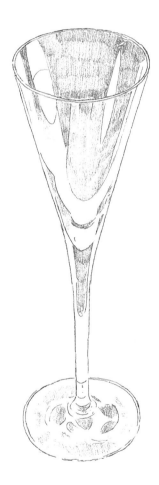

When you are satisfied you have the right shape, put in the main shapes of the tonal areas, in one tone only, leaving the lighter areas clear.

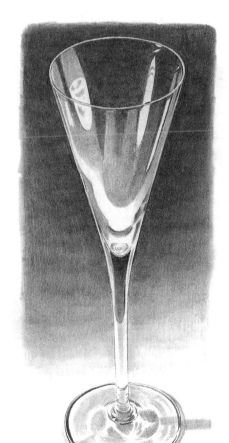

Finally, put in the darkest tones quite strongly. Each of these three drawings should inform anyone seeing them very precisely about the object and its materiality.

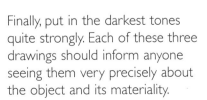

METAL

Now we look at metal objects. Here we have a brass lamp and a silver candlestick, which gives some idea of the problems of drawing metallic surfaces. There is a lot of reflection in these particular objects because they are highly polished, so the contrast between dark and light tends to be at the maximum. With less polished metalware the contrast won't be so strong.

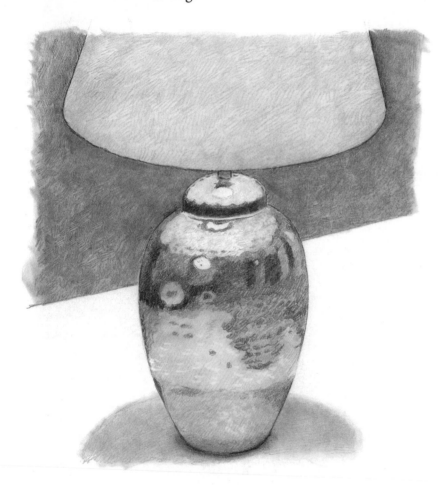

The beaten surface of this brass lamp gives the object many soft-edged facets. Because the light is coming from above, the darkest tones are immediately next to the strong, bright area at the top. The area beyond the darker tones is not as dark because it is reflecting light from the surface the lamp is resting on.

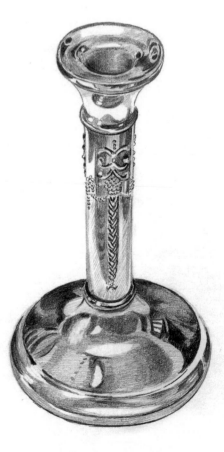

A silver candlestick does not have a large area of surface to reflect from. Nevertheless the rich contrast of dark and light tones gives a very clear idea of how metal appears. Silver produces a softer gleam than harder metals. Note how within the darker tones there are many in-between tones and how these help to create the bright, gleaming surface of our example.

Take your time with this sort of object. It requires quite a bit of dedication to draw all the tonal shapes correctly, but the result is worth it. Your aim must be for viewers to have no doubt about the object's materiality when you have completed the drawing.

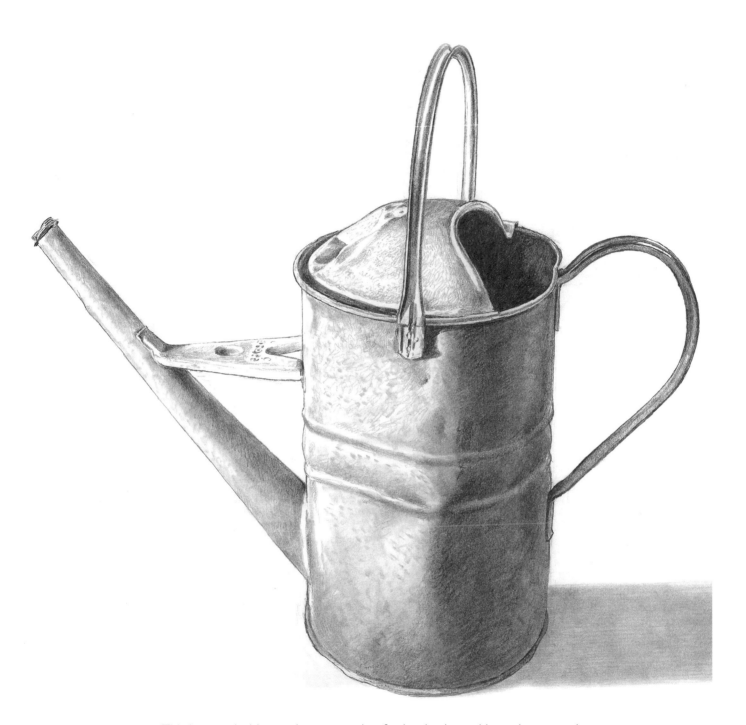

This battered old watering can made of galvanized metal has a hammered texture and many large dents. The large areas of dark and light tone are especially important in giving a sense of the rugged texture of this workaday object. No area should shine too brightly, otherwise the surface will appear too smooth.

BONES AND SHELLS

Skeletons are always interesting to draw because they provide strong clues as to the shape of the animal or human they once supported. They are often used in still-life arrangements to suggest death and the inevitable breaking down of the physical body that is its consequence. Some people may find them rather uncomfortable viewing because of this, but for the artist they offer fabulous opportunities to practise structural drawing, requiring all our skills to portray them effectively.

This old sheep's skull found on a hillside in Wales still retains a semblance of the living animal, despite the extensive erosion. The challenge for the artist is to get the dry, hard, slightly polished effect of the old weathered bone.

This is done by keeping the tones mainly light, with only a few very dark tones in the eye-socket or under the teeth. This contrast and the sharp edges of the tonal areas help to show the hard, smooth surface which catches the light.

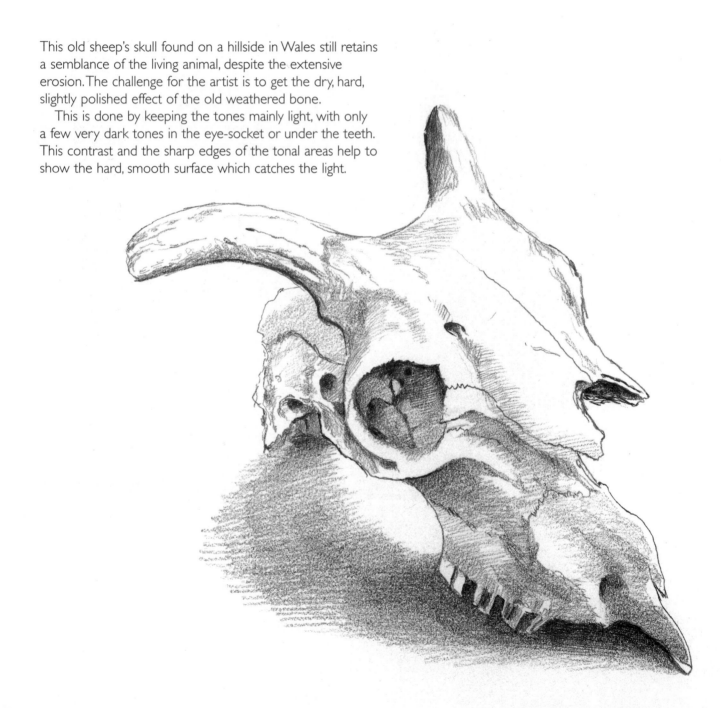

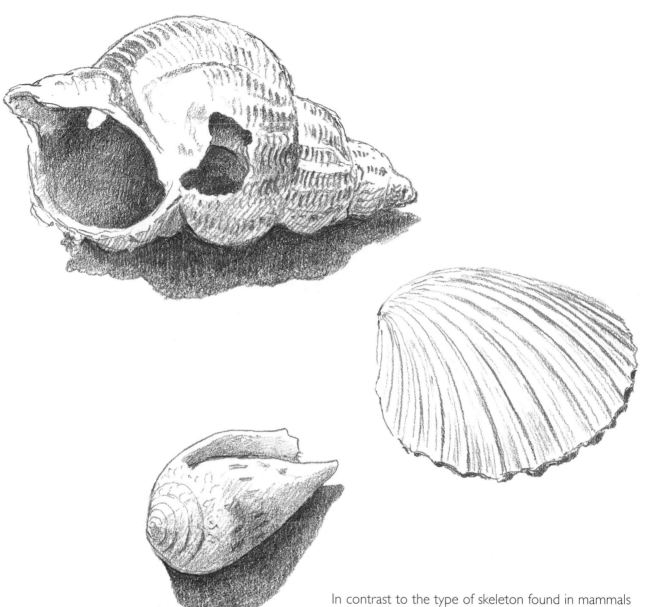

In contrast to the type of skeleton found in mammals and humans, the exo-skeleton lies outside the body. These shells are all that remain of the molluscs they once shielded. As with the sheep's head, each one reveals the characteristic shape of its living entity.

Shells offer the artist practice in the drawing of unusual and often fascinating shapes, as well as different textures ranging from smoothly polished to craggy striations.

STONE

Natural materials such as rock offer a host of opportunities in terms of their materiality. All of the following are hard, solid objects, but that is about as far as the visual similarities go.

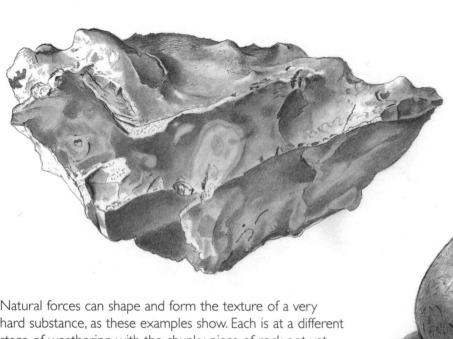

Natural forces can shape and form the texture of a very hard substance, as these examples show. Each is at a different stage of weathering, with the chunky piece of rock not yet eroded to the stature of its rounded neighbour, which has been virtually worn smooth by the action of water and other pebbles, save for a small hollow that has escaped this process.

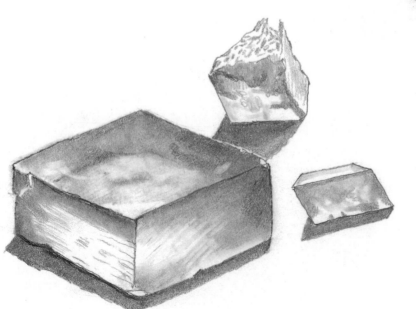

These pieces of feldspar present a different sort of smoothness, an almost glass-like surface in contrast to the opaque solidity of the previous examples.

WOOD

In its many forms, wood can make an attractive material to draw. Here the natural deterioration of a log is contrasted with the man-made construction of a wooden box.

The action of water and termites over a long period has produced a very varied surface on the sawn-off log; in some places it is crumbling and in others hard and smooth and virtually intact apart from a few cracks. The weathering has produced an almost baroque effect.

By contrast, this wooden box presents beautiful lines of growth which endow an otherwise uneventful surface with a very lively look. The knots in the thinly sliced pieces of board give a very clear indication of the material the box is made of.

CONTRASTING TEXTURES

If we succeed in capturing an object's surface, it is very likely we will also manage to convey its presence. Our two man-made objects, a glazed vase and a teddy bear, offer different types of solidity, while the range of plants shown on the facing page test our ability to describe visually the fragility of living matter. The artist should always aim to alter their approach to suit the materiality of the object they are drawing.

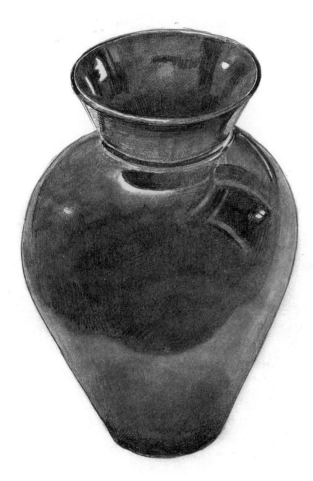

The effects produced by the brilliant glaze on this rather beautiful vase are not so difficult to draw. The reflections are strong and full of contrast, giving us glimpses of the light coming through surrounding windows. They do not, however – as is the case with metallic objects – break the surface into many strips of dark and light; check this difference for yourself by looking at the objects shown on pages 108–9.

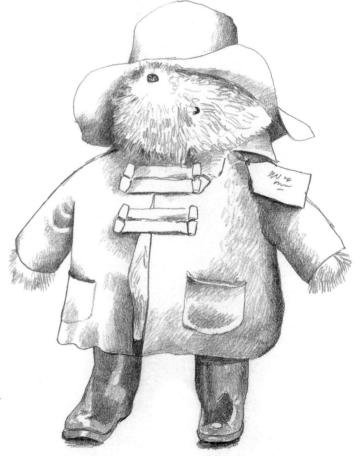

Teddy bears are very attractive to young children and Paddington Bear is particularly so because of the many stories told about him. This particular soft toy incorporates various textures and qualities: the cuddly softness of the character himself, the shiny surface of the plastic boots, the hardness of the wooden toggles and the rather starchy material of the floppy hat and duffle coat.

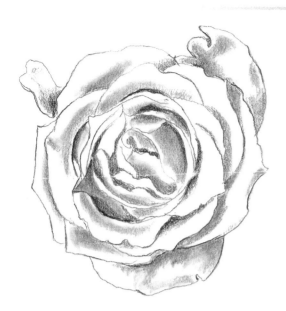

When you come to draw plants, especially flowers, your main task is to avoid making them look either hard or heavy. A very light touch is needed for the outline shapes and it is advisable not to overdo the tonal areas.

Clear, structural lines will help convince the eye of the materiality of leaves. However, although they are sturdier than blooms, you must try not to overdraw or you will end up with leaves that look like pieces of leather.

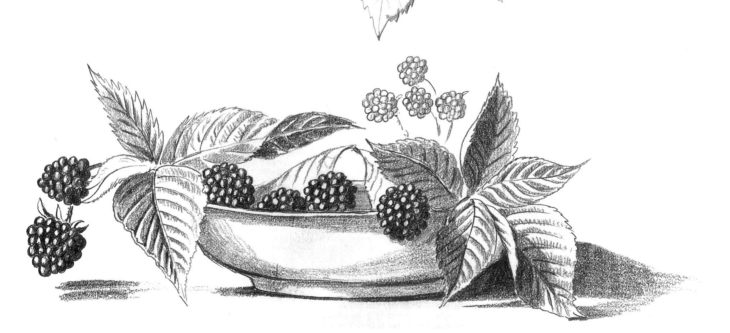

The shiny, dark globes of the blackberries and the strong structural veins of the pointed leaves make a nice contrast. The berries are just dark and bright whereas the leaves have some mid-tones that accentuate the ribbed texture and jagged edges.

ARRANGING GROUPS

Once you reach this stage in your learning process, the actual drawing of individual objects becomes secondary to the business of arranging their multifarious shapes into interesting groups. Many approaches can be used, but if you are doing this for the first time it is advisable to start with the most simple and obvious.

Put together three or four objects of the same type and roughly similar size. Place them close together. The effect, especially if you place them against a neutral background, is a harmonic arrangement of closely related shapes.

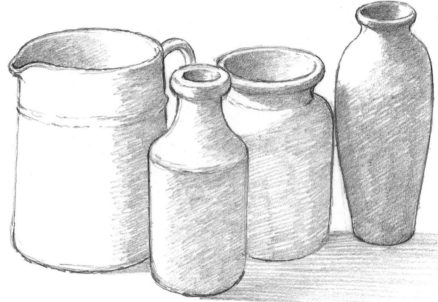

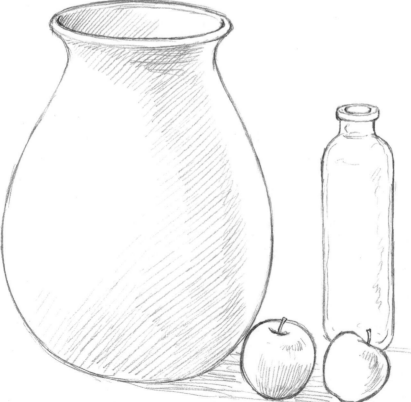

Now try the opposite. Find several objects that contrast radically in size and shape: something large and bulky, something small and neat, and something tall and slim.

Contrast is the point of this combination, so when considering the background go for a contrast in tone.

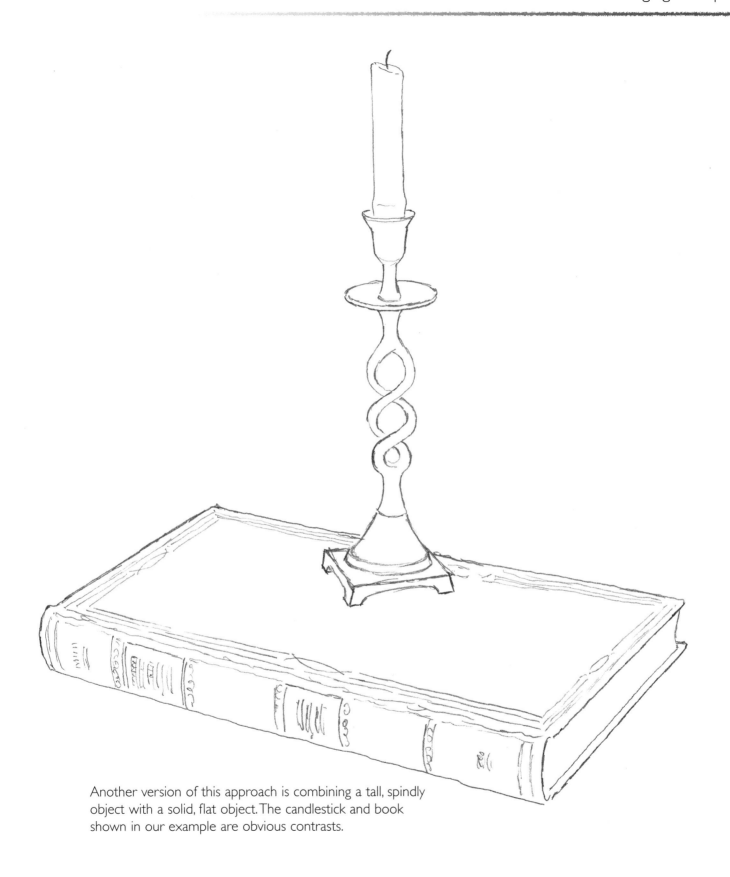

Another version of this approach is combining a tall, spindly object with a solid, flat object. The candlestick and book shown in our example are obvious contrasts.

In this spread we are going to play the numbers game and show how the number of objects included in an arrangement changes the feel or dynamic of the group. The aim of this exercise is to show you how you can slowly build up your still-life compositions if you try drawing them bit by bit. By adding more as you go along, you will begin to see the possibilities of the composition.

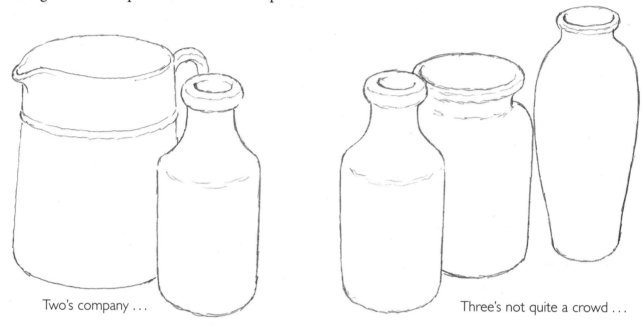

Two's company . . .

Three's not quite a crowd . . .

Now try four, choosing variety over conformity and varying sizes and shapes: mix curves and straight lines, large and bulky, small and slim.

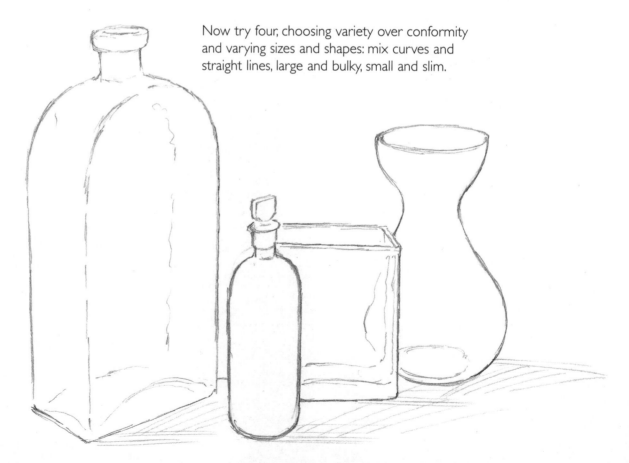

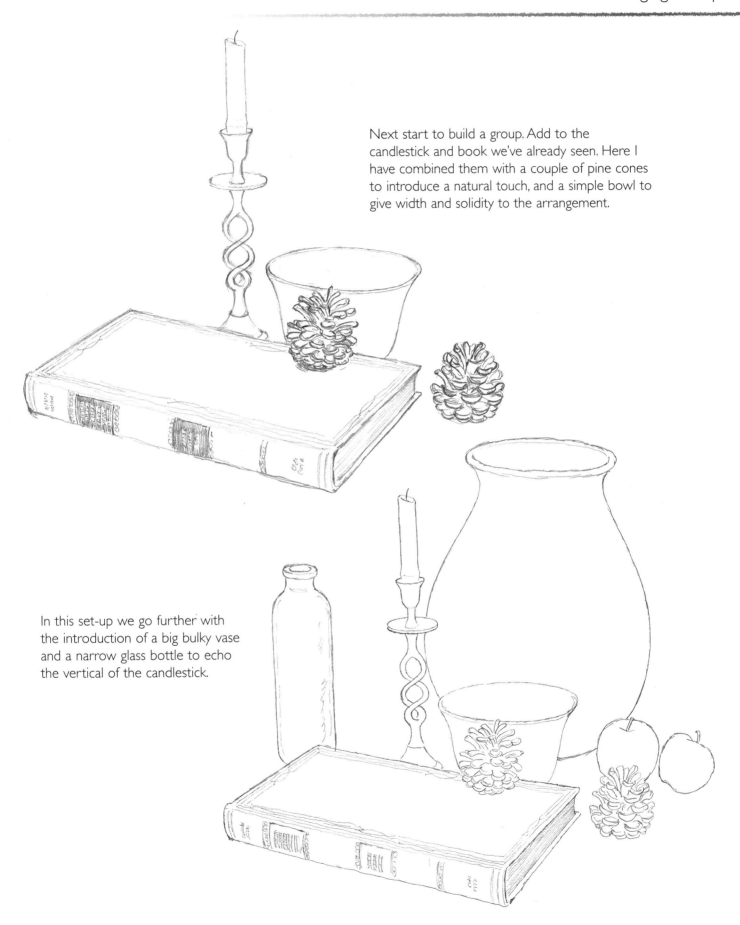

Next start to build a group. Add to the candlestick and book we've already seen. Here I have combined them with a couple of pine cones to introduce a natural touch, and a simple bowl to give width and solidity to the arrangement.

In this set-up we go further with the introduction of a big bulky vase and a narrow glass bottle to echo the vertical of the candlestick.

ENCOMPASSED GROUPS

Sometimes the area of the objects you are drawing may be partially or wholly enclosed by the outside edge of a larger object that contains them. Two classic examples are shown here: a large bowl of fruit and a vase of flowers.

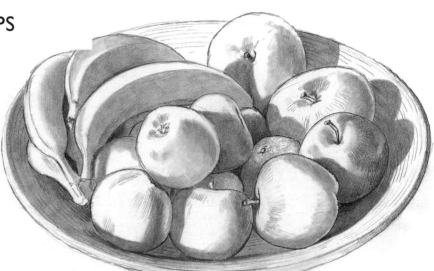

With this type of still life you get a variety of shapes held within the main frame provided by the bowl.

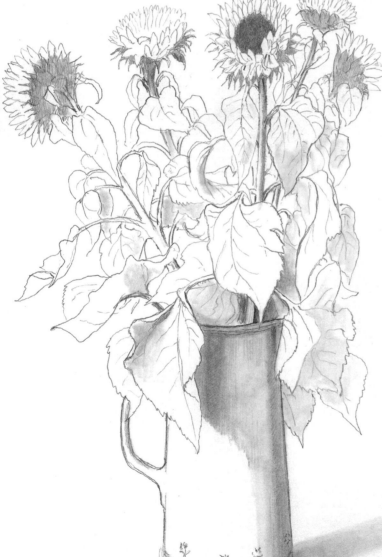

A large vase filled with flowers can be a very satisfying subject to draw. These sunflowers in a large jug make quite a lively picture: the rich, heavy heads of the blooms contrast with the raggedy-edged leaves dangling down the stalks, and the simplicity of the jug provides a solid base.

If you were to take the same jug of flowers seen in the previous arrangement and place it among other objects of not too complicated shape, you would get an altogether different composition and yet one that is just as lively. Particularly noteworthy is the relationship between the smooth rounded shapes in the lower half of the picture and the exuberant shapes of the flowers and leaves in the upper part of the composition.

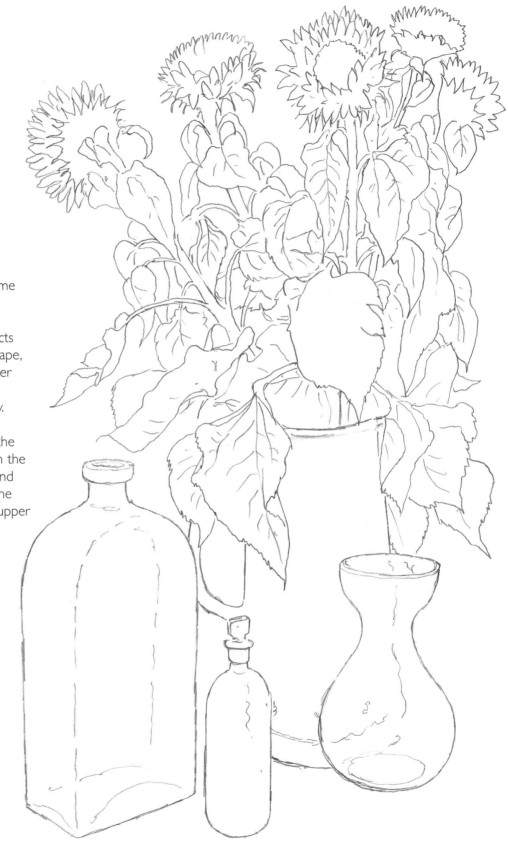

NEGATIVE SHAPES

An element of composition that is often overlooked is the relationship of the shapes or spaces between objects and the objects themselves. Every artist has to learn that when it comes to drawing a group of objects there are no unimportant parts; in any composition, the spaces between objects, known as negative shapes, are as important as the objects themselves, irrespective of whether you are creating an 'ordinary' sort of picture or something you consider really interesting. Study the following examples.

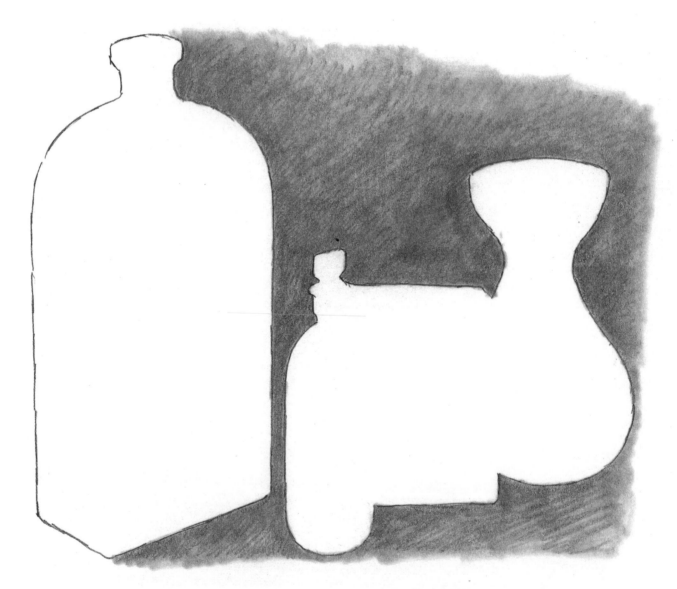

This drawing and that at the top of the facing page were made from groupings seen earlier in the section. Look at the originals (on pages 118 and 116 respectively) and see if you can make out the negative shapes without referring to the pictures shown here. Apply the lesson to your own compositions and try to appreciate how the shapes that make up an empty background have as much effect on your final drawing as does your choice of objects.

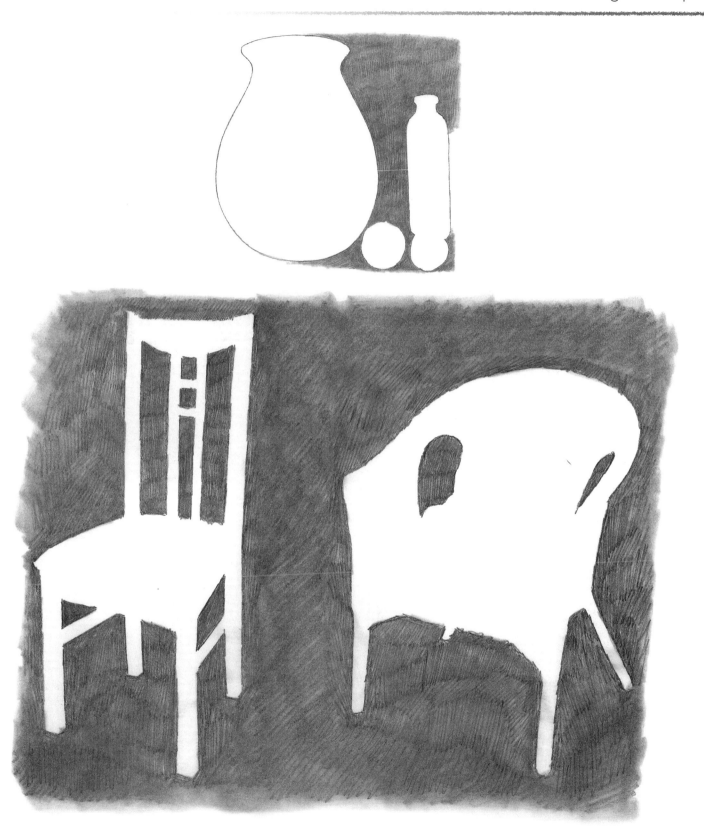

Objects such as furniture clarify the lesson of negative space. Look at these two chairs and you will realize that the definition of the spaces between the legs and arms and the back of the chair describe the objects precisely. The negative spaces are telling us as much about the shapes of the objects as we could discover if they were actually solid.

MEASURING UP

One of your first concerns when you are combining objects for composition will be to note the width, height and depth of your arrangement, since these will define the format and therefore the character of the picture that you draw. The outlines shown below – all of which are after works by masters of still-life composition – provide typical examples of arrangements where different decisions have been made.

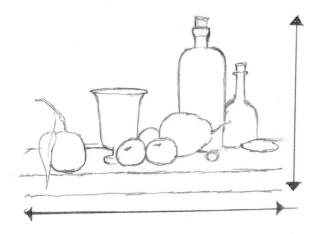

In our first example (after Chardin) the width is greater than the height and there is not much depth.

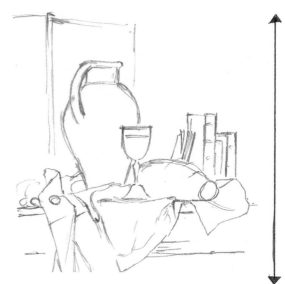

The height is the dominant factor in our second example (also after Chardin). The lack of depth gives the design a pronounced vertical thrust.

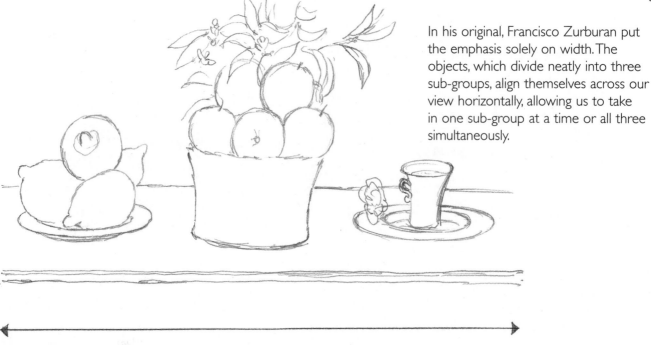

In his original, Francisco Zurburan put the emphasis solely on width. The objects, which divide neatly into three sub-groups, align themselves across our view horizontally, allowing us to take in one sub-group at a time or all three simultaneously.

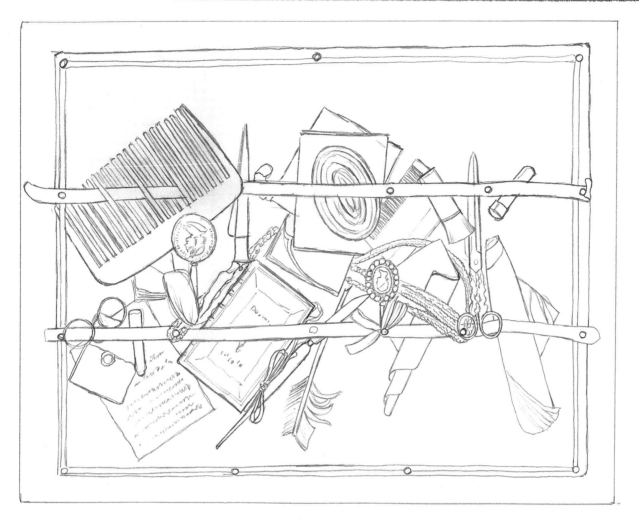

Now for something entirely different, this time after Samuel van Hoogstraten. This sort of still-life was a great favourite in the 17th and 18th centuries, when it provided both a showcase for an artist's brilliance and a topic of conversation for the possessor's guests.

Almost all the depth in the picture has been sacrificed to achieve what is known as a 'trompe l'oeil' effect, meaning 'deception of the eye'. The idea was to fix quite flat objects to a pin-board, draw them as precisely as possible and hope to fool people into believing them to be real.

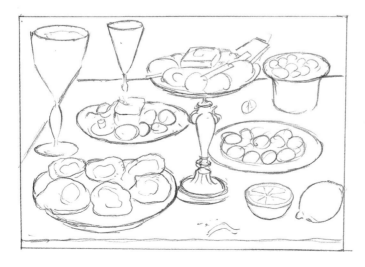

Depth is required to make this kind of arrangement work (after Osias Beert). Our eye is taken into the picture by the effect of the receding table-top and the setting of one plate behind another.

FRAMING

Every arrangement includes an area that surrounds the group of objects you are drawing. How much is included of what lies beyond the principal elements is up to the individual artist and the effect that they are trying to achieve. Here, we consider three different 'framings', where varying amounts of space are allowed around the various objects.

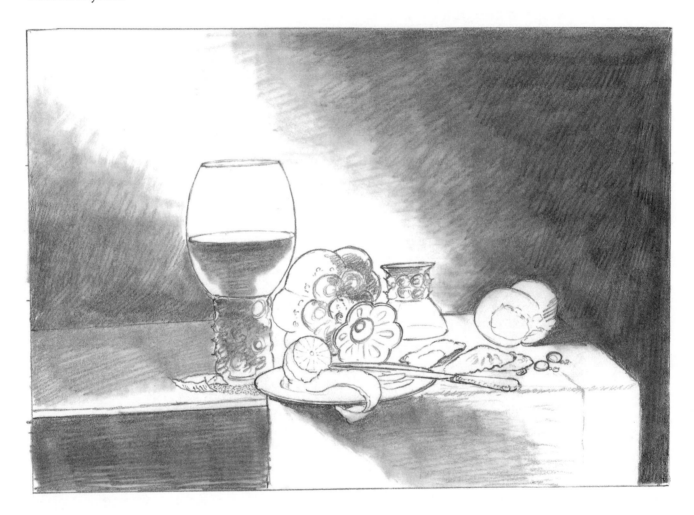

1. A large area of space above the main area, with some to the side and also below the level of the table. This treatment seems to put distance between the viewer and the subject matter.

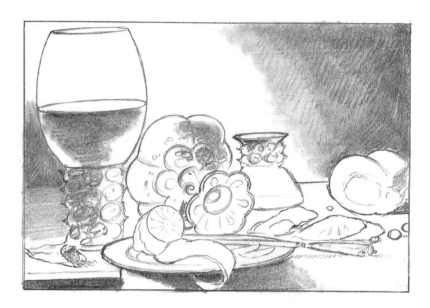

2. The composition is made to look crowded by cropping into the edges of the arrangement.

3. This is the framing actually chosen by the artist, Willem Claesz. The space allowed above and to the sides of the arrangement is just enough to give an uncluttered view and yet not so much that it gives a sense of the objects being left alienated in the middle of an empty space.

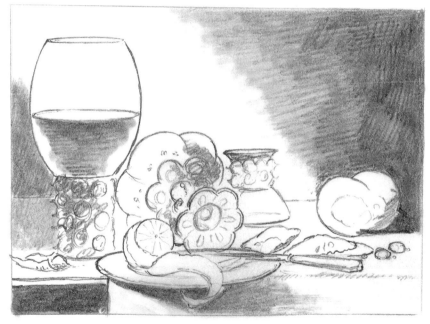

THE EFFECTS OF LIGHT

Many an art student has been put out by the discovery that the natural light falling on their still-life arrangement has changed while they have been drawing and they have ended up with a mish-mash of effects. You need to be able to control the direction and intensity of the light source you are using until your drawing is finished. If this can't be done with a natural light source, use an artificial lighting set-up.

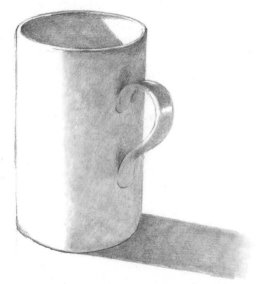

Lit directly from the side; this produces a particular combination of tonal areas, including a clear-cut cast shadow.

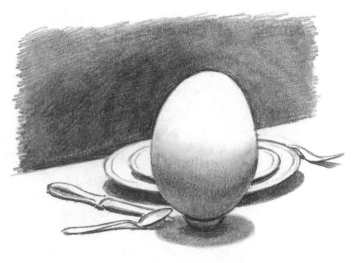

Lit from above; the result is cooler and more dramatic than the first example.

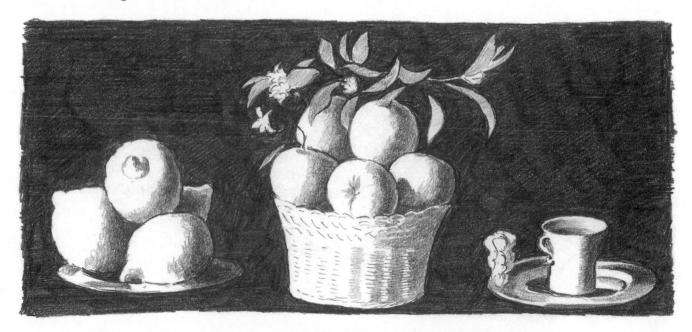

Lit strongly from the side; the strength of the light and the fact that the arrangement is set against such a dark background produces the effect of spotlighting, attracting our attention to the picture and giving a rather theatrical effect.

Here a small table lamp is lighting a lidded glass jar from directly above. The upper surfaces are very bright. The cast shadows are simple and encircle the bases of both object and lamp. The glass jar catches the light from all around, as we can see from the small reflections in it. The darkest areas are behind the light, around the lamp and especially the lampshade.

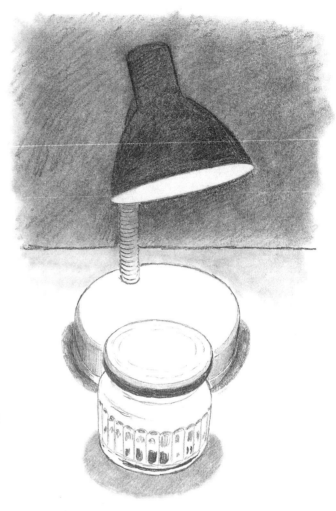

Directing light from below and to one side is traditionally the way to make objects look a bit odd, unearthly or sinister. Mainly this interpretation is down to our perception; because we are not used to viewing objects lit from below, we find it disturbing when we do. Seen in an ordinary light this cherub's expression looks animated, but lit from below, as here, it appears to have a malign tinge.

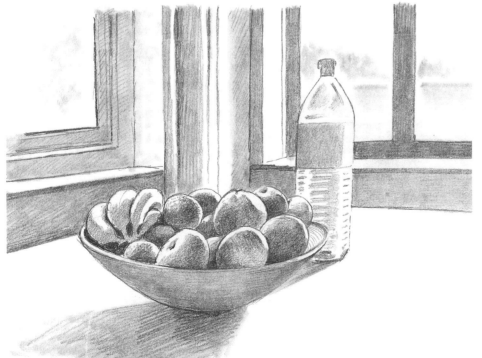

Now a more traditional form of lighting, although still unusual. The bowl of fruit and the bottle of water are backlit from the large windows with the sun relatively low in the sky; I made this sketch in the evening, but you can get a very similar light in early morning. The effect is to make the objects look solid and close to us, but also rather beautiful, because of the bright edges.

EXPLORING THEMES

There are many themes which you can use in still life, and in this chapter I have suggested just a few of them to give you a starting point. Choosing a theme helps to focus the mind of the artist, because it limits the type of object that can be used. Also the viewer can find satisfaction in being able to recognize the connection between the objects. In a way a themed still life is like a narrative; it tells a story about a particular subject, which adds a point of interest that otherwise would not be there.

The first drawing shows the different forms of material that you can incorporate in a composition to show off your abilities in rendering texture. Here we have a basket with a wooden spatula leaning against it, a ceramic jug, a wine glass, a cloth tea towel and a metal saucepan. So in one still life you can show six or more materials, and if you are dextrous enough they will make an interesting picture.

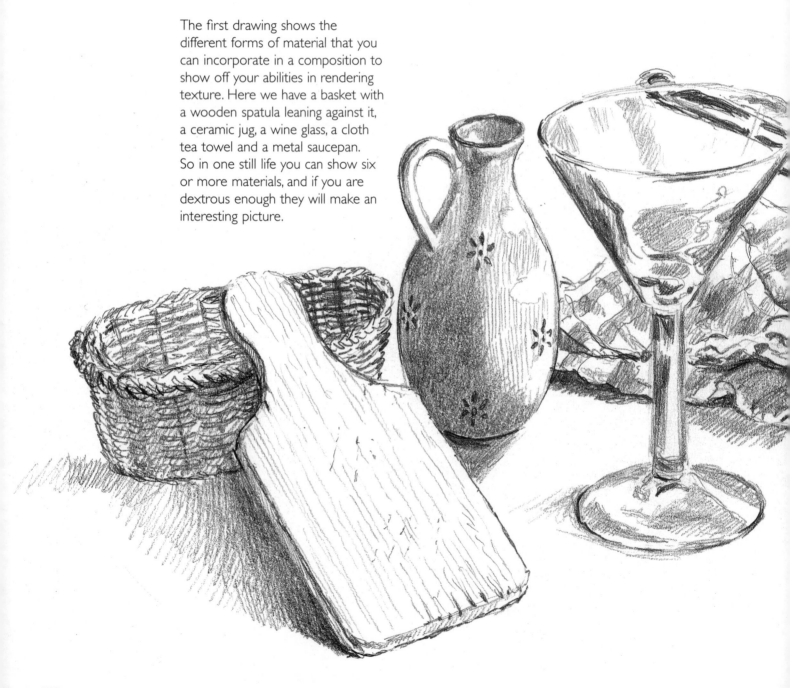

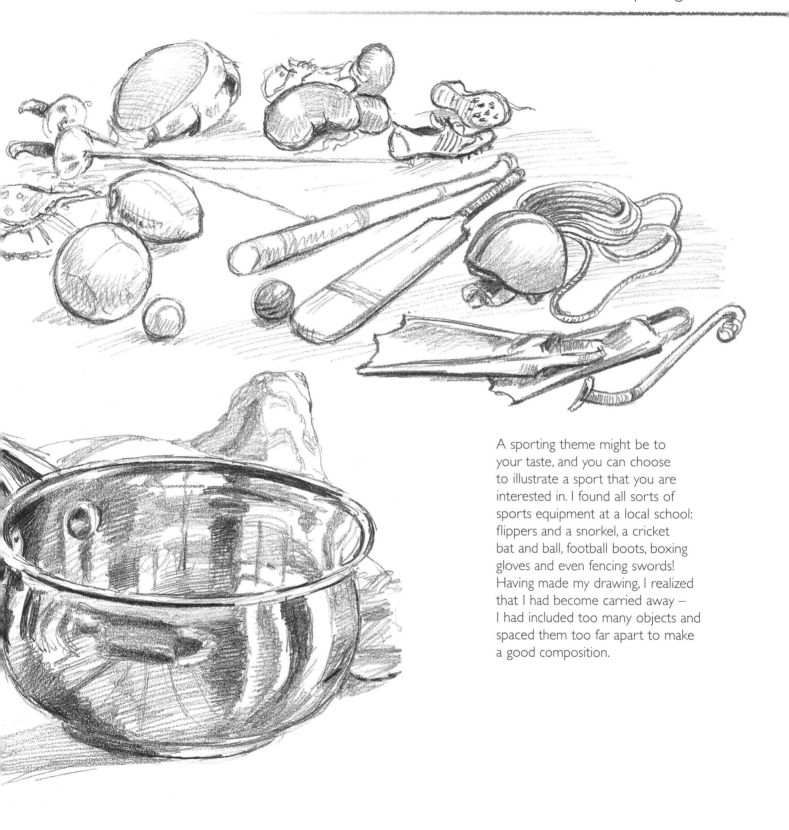

A sporting theme might be to your taste, and you can choose to illustrate a sport that you are interested in. I found all sorts of sports equipment at a local school: flippers and a snorkel, a cricket bat and ball, football boots, boxing gloves and even fencing swords! Having made my drawing, I realized that I had become carried away – I had included too many objects and spaced them too far apart to make a good composition.

Next is a still life of children's toys, including a
tricycle, a toy cat, a plastic duck, a toy car, a set
of interlocking jars and a painted egg. There
are many other toys that you could show in a
composition like this. For example, stuffed toys
and dolls have a strong hold on the imagination,
and the contrast between a large hard object like
the tricycle and a woolly teddy bear would give a
maximum textural range.

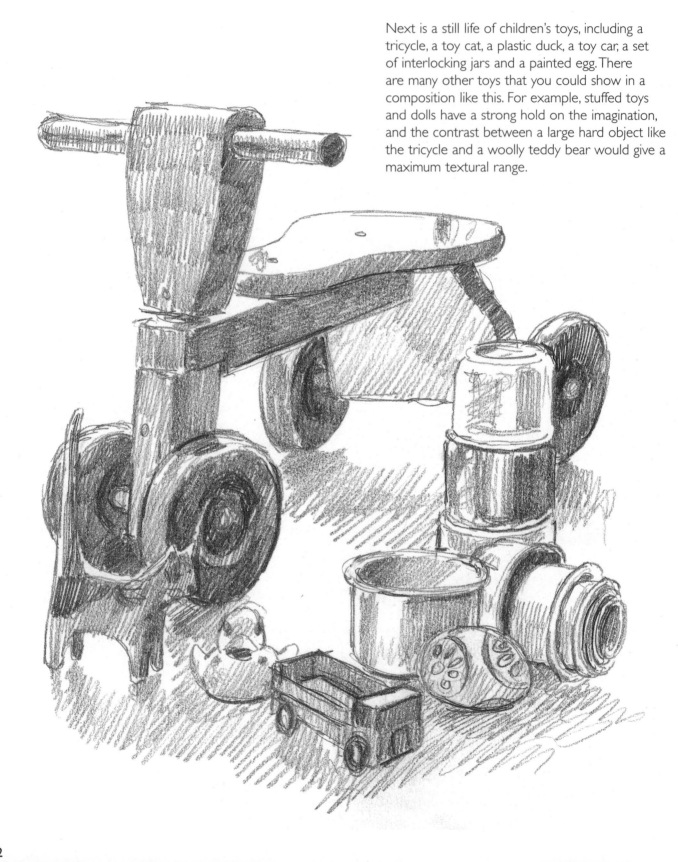

Here the theme is travel, with a suitcase, a rucksack, a soft bag, some boots and an overcoat. The objects look as though they are just about to be picked up and stowed in a car to set off somewhere.

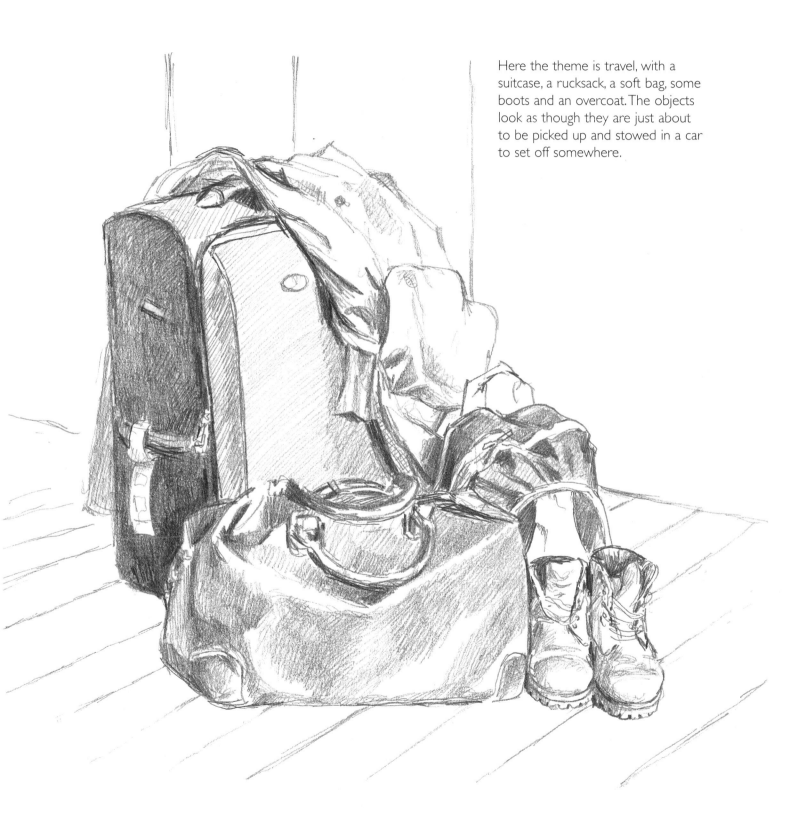

A very popular theme for more traditional still-life artists is that of cooking. Here we see various items that may be used in the creation of a cake or pudding, or just as part of a larger meal. Again the variety of shapes and textures gives you a chance to show how well you can draw.

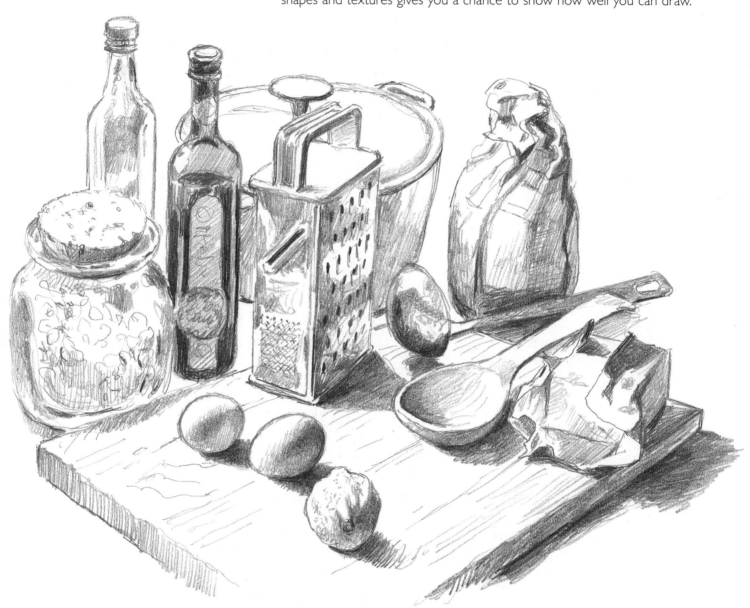

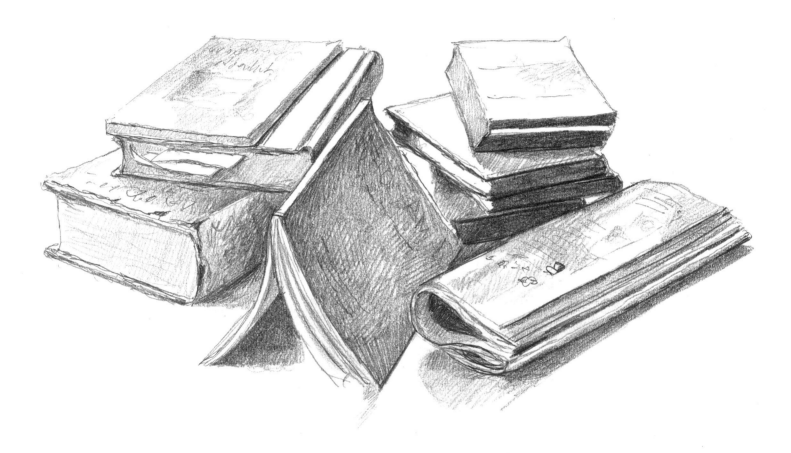

This still life consists of just books and paper and needed to be arranged quite carefully to make an interesting composition. It looks easy but in fact is quite difficult to draw convincingly.

An easy way to create a themed still life is to just take all the things that you keep in your pockets or handbag and strew them on a table. All the items will be on a small scale, so you will have to either draw them larger or work in the style of a miniature to get the best results.

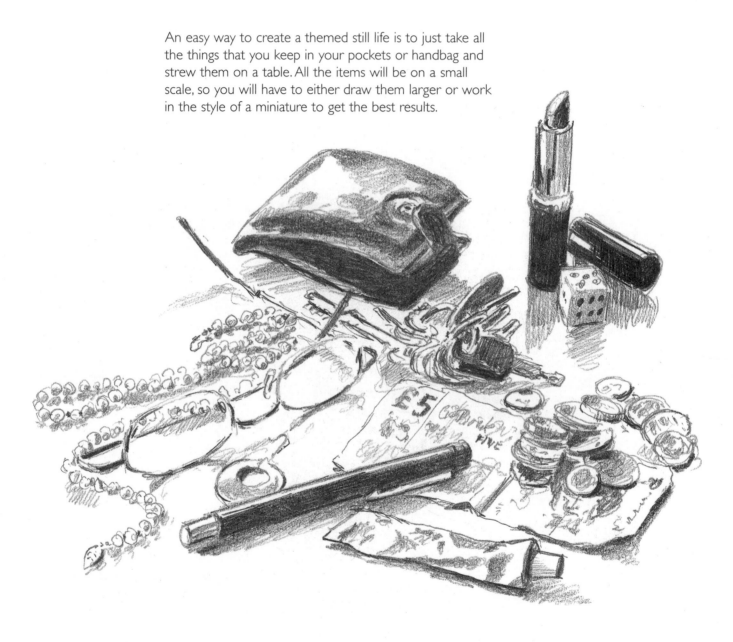

Food is another frequent subject with classic still-life
artists, and a good pile of fruit, vegetables, cheese, meat,
bread and wine will make a cheerful-looking composition.
Add a few jars as well and other groceries such as eggs –
the main thing is to bring out the richness of the variety.

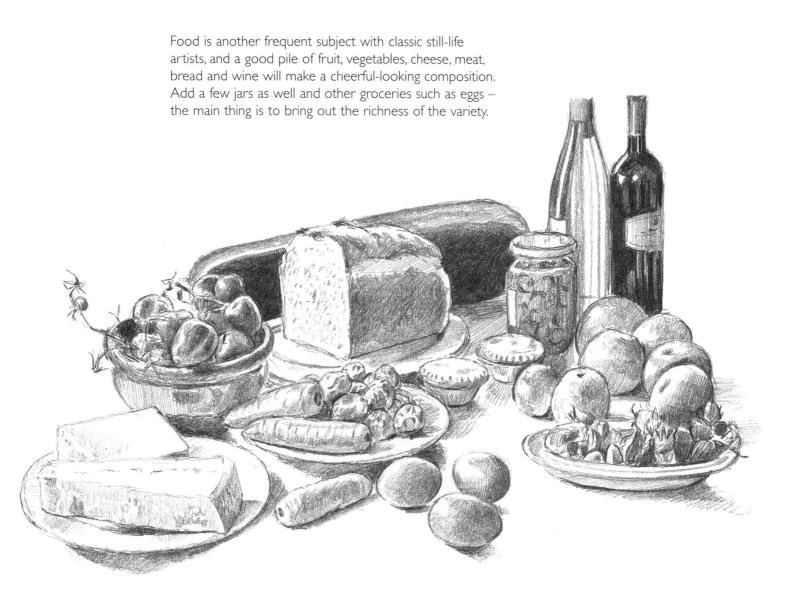

A THEMED STILL LIFE

As you might expect, I chose for this themed still life a set of artists' materials, so here I have put together a palette, some brushes and palette knives, some paints, a couple of canvases and bottles of painting mediums. At the last moment, I added a pomegranate just to give a different shape to the scene.

My first drawing is a very rough outline of the composition to see if it would work as a picture. I stood a canvas and a small picture frame against the back wall, then placed a palette bang in the middle of the background to help set the scene. In front of this I placed a jar full of paintbrushes to make a more vertical statement. Next to it is a jar of pencils and a couple of bottles of varnish and turpentine. Scattered across the foreground is a small canvas with a smaller frame under it, plus a few large brushes, a couple of palette knives and some tubes of oil paint. Just to the left of the whole arrangement is the pomegranate, but it could have been anything with a rounded shape, which I felt might be useful. So now I have got some idea of how the final composition will look.

My next task was to draw up the whole arrangement in line, making sure that everything was in proportion and the right shape. It's at this stage that you can erase any parts that don't look right and correct them, and I can't emphasize too much how important it is to continue correcting until you are satisfied with the results. This is the way that you improve your drawing systematically.

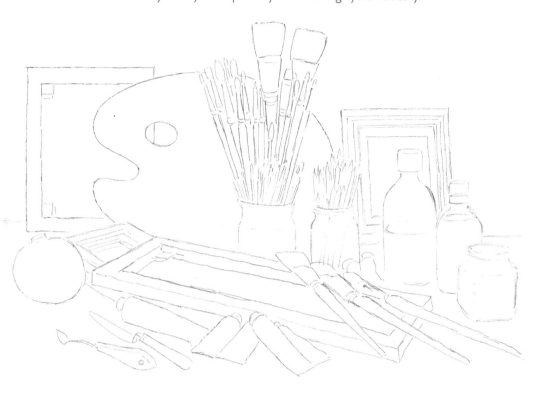

The next stage was to put in tone over all the areas that seemed to be in shadow of some sort without worrying at this stage how dark or light it was. This was simply to mark out the areas that read as tone.

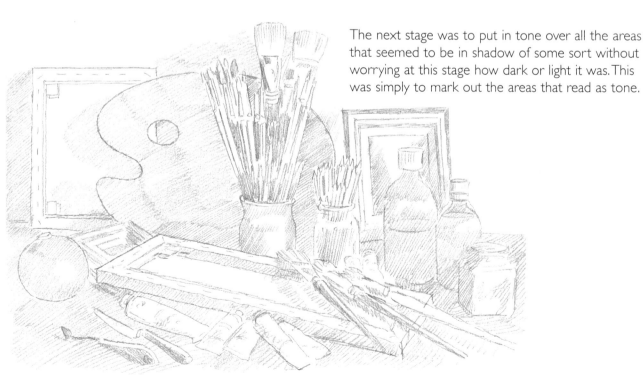

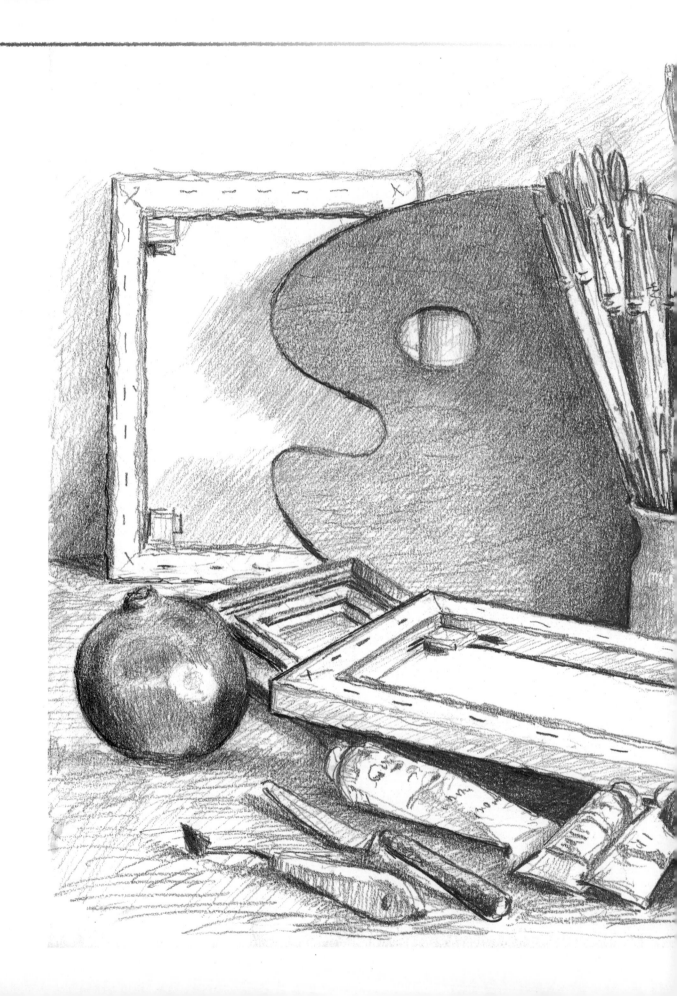

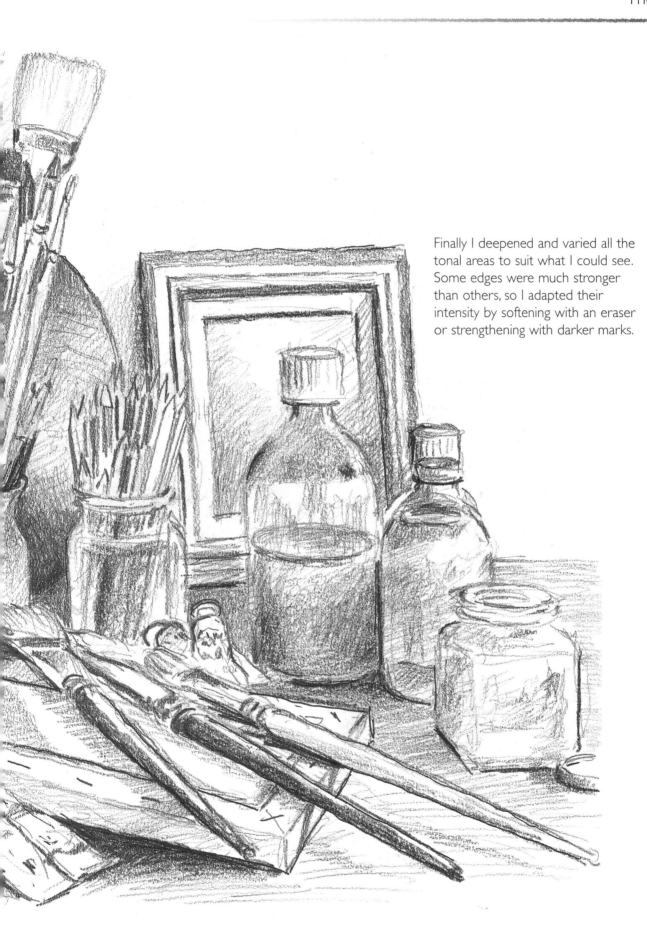

Finally I deepened and varied all the tonal areas to suit what I could see. Some edges were much stronger than others, so I adapted their intensity by softening with an eraser or strengthening with darker marks.

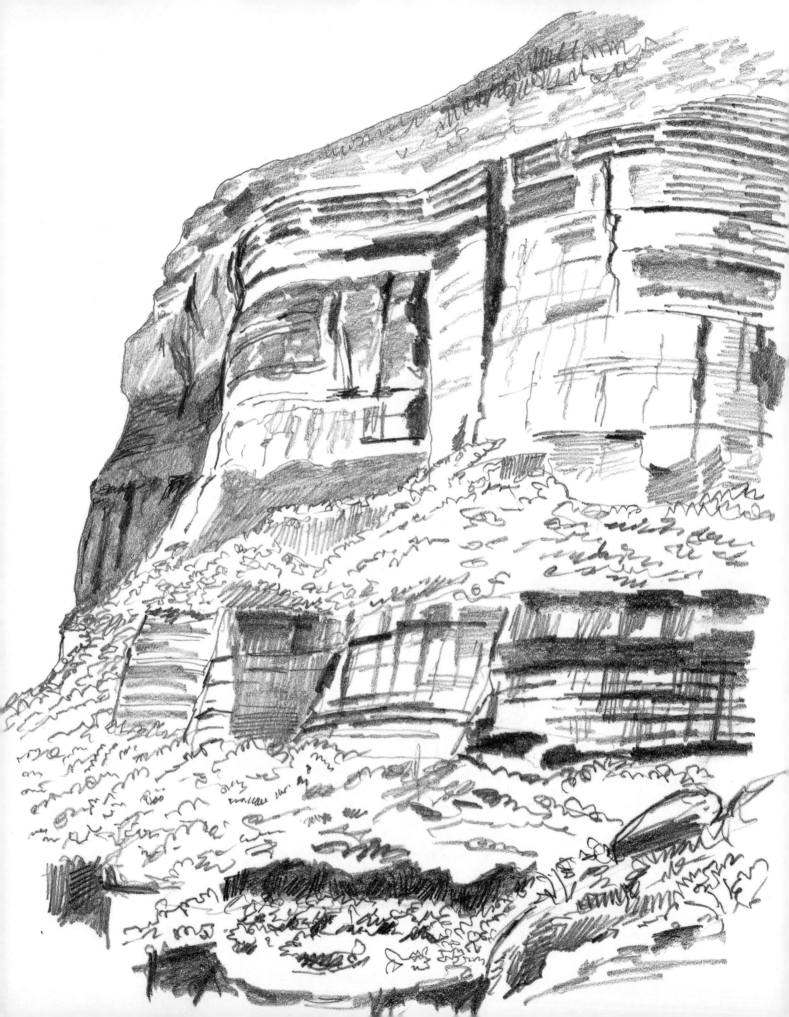

CHAPTER 5

LANDSCAPE

The landscape genre encompasses what we see all around us, wherever we are. As soon as you sample the view outside a building there is some element of landscape available. What you see will be made up of a variety of things but essentially it will be sky; vegetation; man-made edifices; open space; and, possibly, water. People, animals or vehicles may be there as incidentals, but not as focal points.

When tackling a landscape, the artist's first task is to select a view, to decide on how much of that view to show, and from which angle. Complementary with this selection process is analysis of the proportion and organization of the shapes within the landscape and how these may be clarified or emphasized. In this chapter you will find examples of selection and analysis that show you how to construct the building blocks of your own landscapes before you move on to the finer details.

Apart from helping you to appreciate the beauties of the world around you, drawing landscapes calms the mind and emotions. It is also fascinating to discover ways of translating impressions of an outside scene into a two-dimensional set of marks on the paper. Whether or not you share some of the experience of your observation with others, it is a truly beneficial activity.

THE WORLD AROUND US

To begin to draw landscapes, you need a view. Look out of your windows. Whether you live in the countryside or in the town, you will find plenty to interest you. Next go into your garden and look around you. Finally, step beyond your personal territory, perhaps into your street. Once you appreciate that almost any view can make an attractive landscape, you will look at what lies before you with fresh eyes.

The three views shown here are of the area around my home.

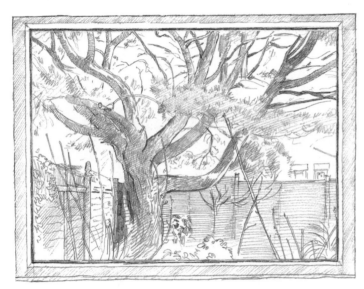

When I look out of the window into my garden, I see a large pine tree of the Mediterranean type. It is a graceful tree and obscures most of the rooftops of the houses backing onto the garden. The window frame usefully restricts my angle of vision so that I have an oblique view of the left-hand fencing with its climbing ivy. Across the back of the garden is a fence with some small bushes under the tree. Plants grow right under the window and their stalks cut across my view. Apart from a few details of the house behind ours, this landscape is mostly of a large tree and a fence, and a few smaller plants.

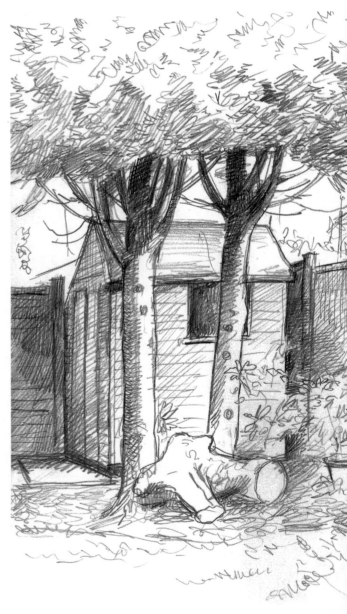

In this outside view of the garden we are looking away from the pine. Behind the fence can be seen the roof of a neighbour's house and some trees growing up in the next-door garden. In the corner of my own garden there is a small shed with two small fir trees growing in front of it, with a large log at their foot. The flowerbed to the right is full of plants, including a large potted shrub, with ivy growing over the fence. Closer in is the edge of the decking with flowerpots and a bundle of cane supports leaning against the fence. A small corner of the lawn is also visible. The main features in this view are a fence, two trees and a garden hut.

The third drawing is of the view from my front gate. Because all the houses in my road have front gardens and there is a substantial area of trees, shrubs and grass before you reach the road proper, the scene looks more like country than suburb. We see overhanging trees on one side and walls, fences and small trees and shrubs on the other, creating the effect of a tunnel of vegetation. The general effect of the dwindling perspective of the path and bushes either side of the road gives depth to the drawing. The sun has come out, throwing sharp shadows across the path interspersed with bright sunlit splashes. The overall effect is of a deep-perspective landscape in a limited terrain.

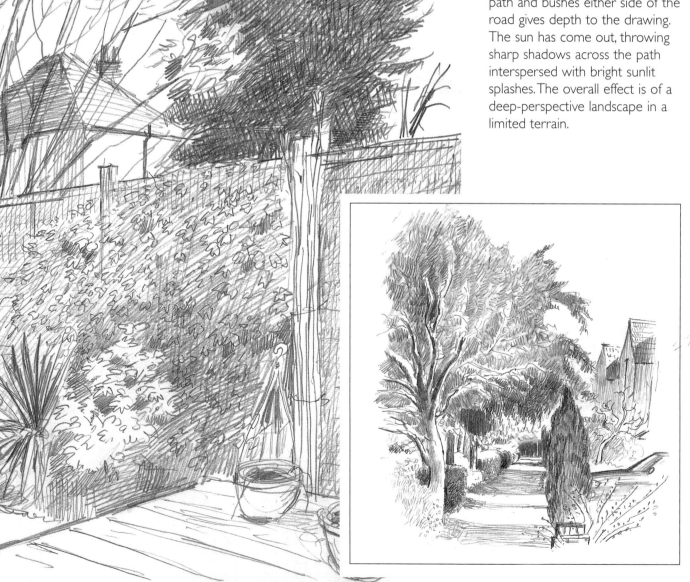

FRAMING A VIEW

One way to get a better idea of what you are going to draw when you attempt a landscape is to use a frame. The first drawing on p.144 was isolated in this way by the ready-made frame of the window. Most artists use a frame at some time as a means of limiting the borders of their vision and helping them to decide upon a view, especially with large landscapes.

In the first example below a very attractive Lake District view has been reduced to a simple scene by isolating one part of it. With landscape drawing it is important to start with a view you feel you can manage. As you become more confident you can include more. Notice how the main shapes are made more obvious by the framing method.

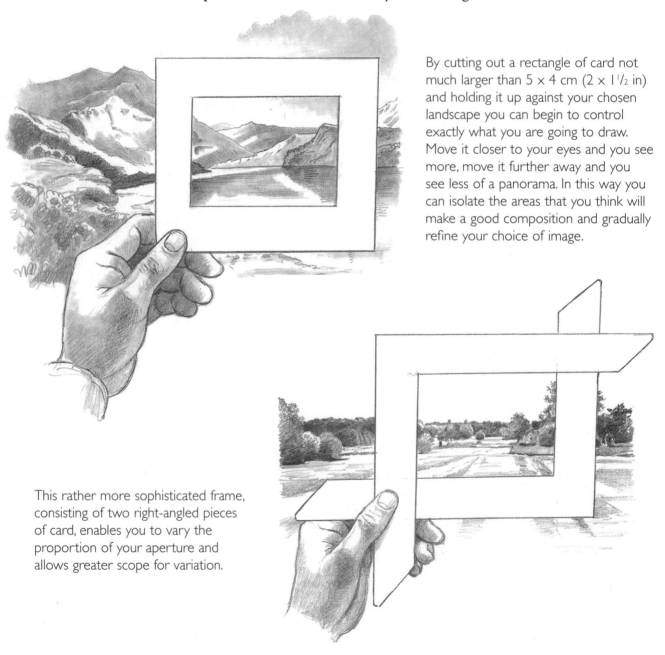

By cutting out a rectangle of card not much larger than 5 x 4 cm (2 x 1¹/₂ in) and holding it up against your chosen landscape you can begin to control exactly what you are going to draw. Move it closer to your eyes and you see more, move it further away and you see less of a panorama. In this way you can isolate the areas that you think will make a good composition and gradually refine your choice of image.

This rather more sophisticated frame, consisting of two right-angled pieces of card, enables you to vary the proportion of your aperture and allows greater scope for variation.

CHOOSING A SIZE

At some point you will have to decide how large your landscape picture is going to be. In the beginning you may only have a small pad at your disposal, and this will dictate your decision. Starting small and gradually increasing the size of your picture is advisable for the inexperienced, but you will quickly get beyond this stage and want to be more adventurous.

Ideally you should have a range of sketchbooks to choose from: small (A5), medium (A4) and large (A3). If this seems excessive, choose one between A5 and A4 and also invest in a larger A3. A5 is a very convenient size for carrying around but isn't adequate if you want to produce detailed drawings, so a size between that and A4 is a good compromise. The cover of your sketchbook should be sufficiently stiff to allow it to be held in one hand without bending while you draw.

The grade of paper you use is also important. Try a 160 gsm (98 lb) cartridge paper, which is pleasant to draw on and not too smooth.

When it comes to tools, soft pencils give the best and quickest result. Don't use a grade harder than B; 2B, 4B and 6B offer a good combination of qualities and should meet most of your requirements.

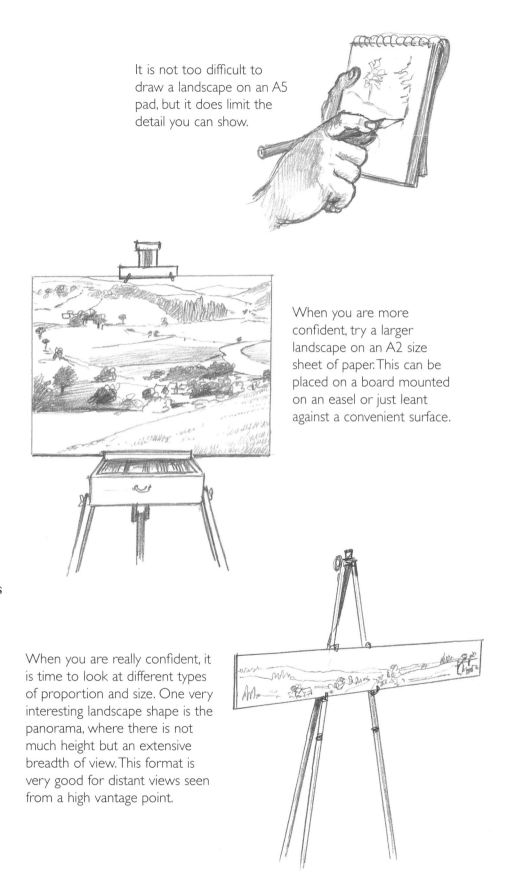

It is not too difficult to draw a landscape on an A5 pad, but it does limit the detail you can show.

When you are more confident, try a larger landscape on an A2 size sheet of paper. This can be placed on a board mounted on an easel or just leant against a convenient surface.

When you are really confident, it is time to look at different types of proportion and size. One very interesting landscape shape is the panorama, where there is not much height but an extensive breadth of view. This format is very good for distant views seen from a high vantage point.

VIEWPOINTS

Finding a landscape to draw can be very time-consuming. Some days I have spent more time searching than drawing. Never regard search time as wasted. If you always just draw the first scene you come to, and can't be bothered to look around that next corner to satisfy yourself there is nothing better, you will miss some stunning opportunities. Reconnaissance is always worthwhile.

Let's look at some different kinds of viewpoint and the opportunities they offer the artist.

A view along a diminishing perspective, such as a road, river, hedge or avenue, or even along a ditch, almost always allows an effective result. The change of size gives depth and makes such landscapes very attractive. Well-drawn examples of this type suggest that we, the onlookers, can somehow walk into them.

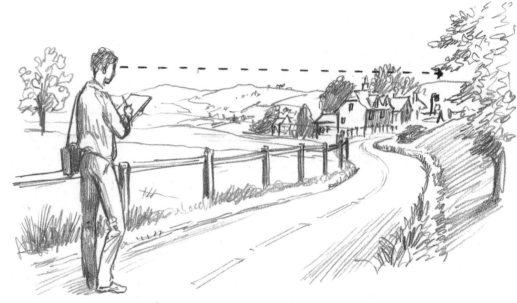

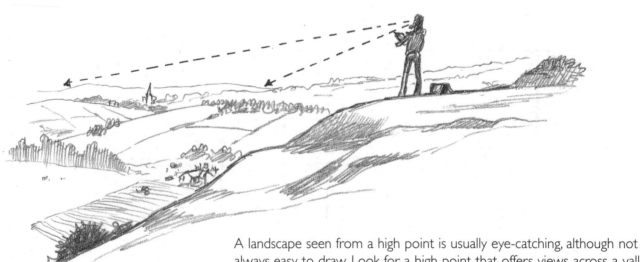

A landscape seen from a high point is usually eye-catching, although not always easy to draw. Look for a high point that offers views across a valley to other high points in the distance. From such a perspective the landscape is somehow revealed to the viewer. If you try this approach, you will have to carefully judge the sizes of buildings, trees and hillsides to ensure the effect of distance is recognized in your picture.

EDITING YOUR VIEWPOINT

A good artist has to know what to leave out of their picture. You don't have to rigorously draw everything that is in the scene in front of you; it is up to you to decide what you want to draw. Sometimes you will want to include everything, but often some part of your chosen view will jar with the picture you are trying to create. Typical examples are objects that obscure a spacious view or look too temporary, or ugly, for the sort of timeless landscape you wish to draw. If you cannot shift your viewpoint to eliminate the offending object, just leave it out. The next two drawings show a scene before and after 'editing'.

In this view a telegraph pole and its criss-crossing wires, a large tree and a car parked by the road are complicating what is an attractive landscape.

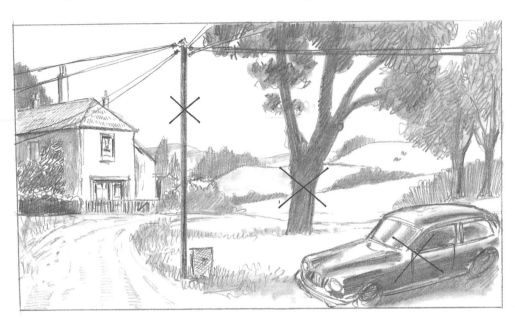

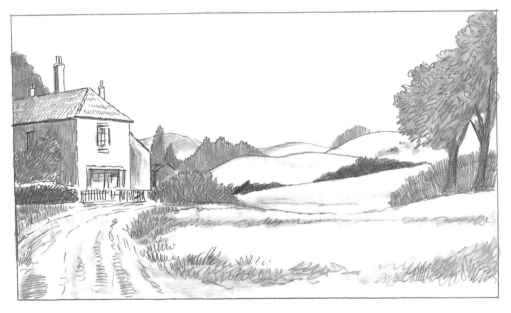

Eliminate those offending objects and you are left with a good sweep of landscape held nicely between the country cottage and unmade road and the coppice of trees over to the right.

THE ARTIST'S EYE

We can learn a great deal from the compositions of professional photographers and painters and how they 'see' landscape. Here are examples of different kinds of landscapes; two of the drawings are taken from photographs and the other two from paintings.

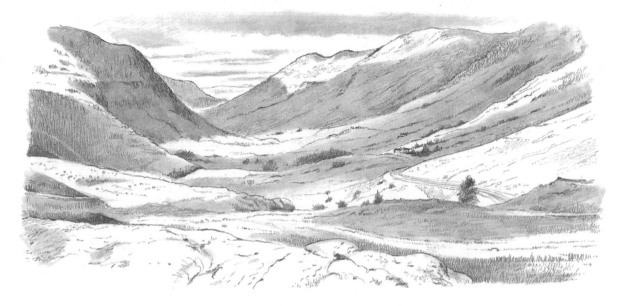

This marvellous open sweep of mountainous landscape shows the valley of Glencoe in the Scottish Highlands. The original photograph catches the effect of sunlight and cloud shadows flitting across the land. The drawing reflects this by showing one side of the valley much more clearly. The side with the sharper perspective has one large bluff or spur in the shadow of the cloud, which helps to create depth and drama. A sense of scale is given by the road seen winding along the valley and the minute cottage in the distance.

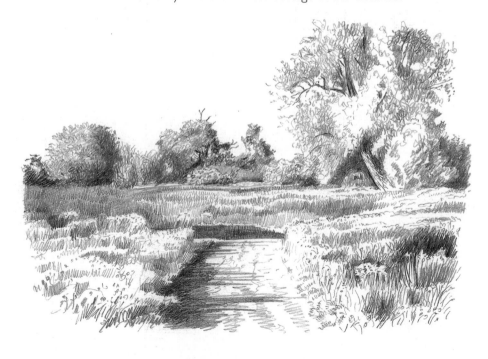

The second photograph-based scene is quite different, with a very localized view. Here we are close to trees and bushes viewed across an expanse of long grass and cow parsley. There is no distance to speak of and the interest lies in the rather cosy effect of a flattened path through the long grass, turning off suddenly with the luxuriant vegetation of summer hemming in the view. The effect is of a very English lowland landscape; pleasant but without drama.

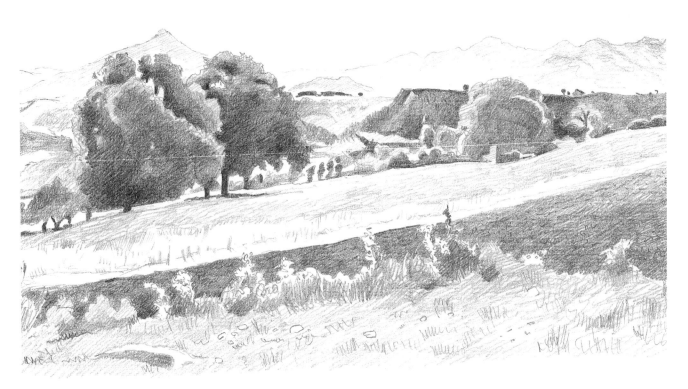

Here is a beautiful sweep of landscape (after Corot) in the Haute Savoie, France. The scope of the viewpoint is broad and shows mountain ranges in the distance. Closer up we see slopes and large trees in full foliage, while the foreground consists of a large empty slope of grass, scrub and ploughed land. The broad movement from the high left side towards the lower right side of the picture is balanced by the large group of trees at left of centre.

Now a view of Venice (after Monet) which combines compactness with a great effect of depth, thanks to the masterly handling of foreground details and distant buildings. Close up we see water and mooring poles rising out of the ripples to the left. Across the centre and right background, seen through mist, are the domes of Venetian churches caught in the light of the setting sun.

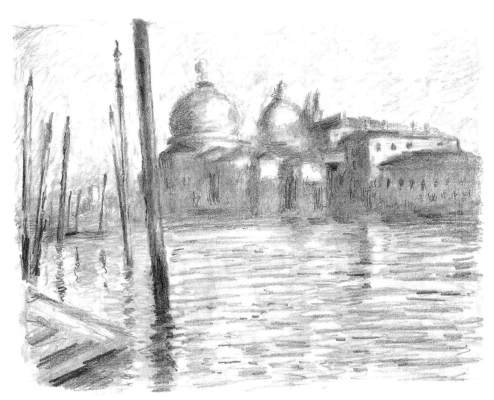

TYPES OF LANDSCAPE

Put very simply, there are four possible types of landscape to be considered in terms of the size and shape of the picture you are going to tackle. Your landscape could be large and open, small and compact, tall and narrow or very wide with not much height.

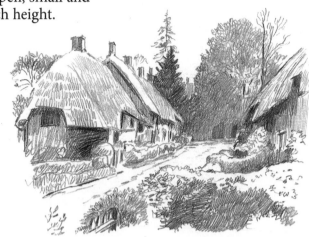

Small and compact

The emphasis here is on the close-up details and textures in the foreground, with a good structural element in the middleground and a well-defined but simplified background. The direction of the light helps the composition, showing up the three-dimensional effects of the row of small cottages with the empty road between them and the solid-looking hedges and walls in the foreground. Look at the way the pencil marks indicate the different textures and materiality of these various features.

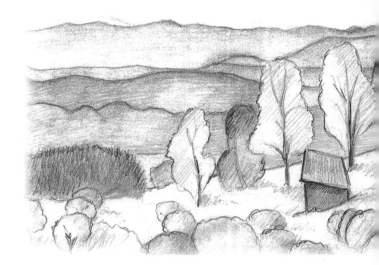

Open and spreading

The most impressive aspect of this example (right) is the sculptural, highly structured view of the landscape. This has been achieved by keeping the drawing very simple. Note that the textures are fairly homogenous and lacking in individual detail. The result is a landscape drawing that satisfies our need for a feeling of size and scope.

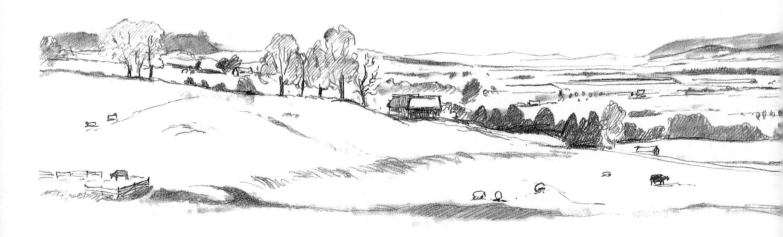

Tall

Because most landscapes are horizontally extended, generally speaking the vertical format is not appropriate. However, where you are presented with more height than horizontal extension the vertical format may come into its own, as here. The features are shown in layers: a road winding up a hill where a few cypresses stand along the edge of the slope, sharply defined; behind it another hill slanting off in the opposite direction; and above that the sky with sun showing through mist.

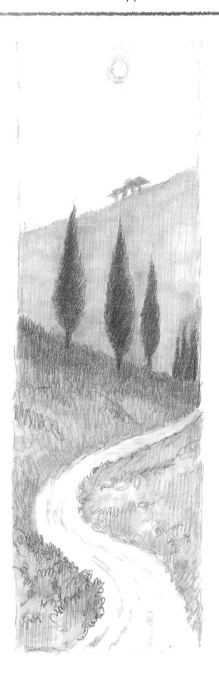

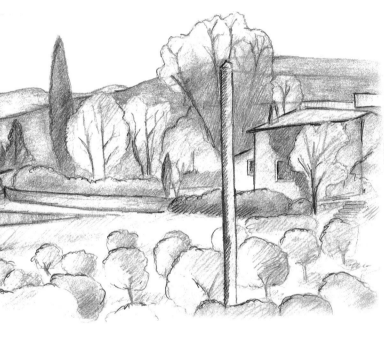

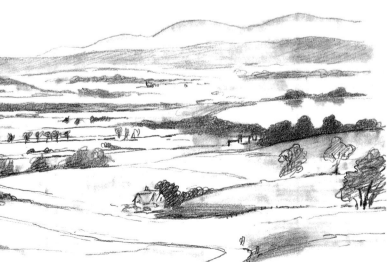

Panoramic

A panoramic landscape is the view you get when you turn your head to the left and right and cover a very wide angle of vision. However, this view is not easy to draw because you have to keep changing your point of view and adjusting your drawing as you go. Remember: the vertical measurement of a panoramic drawing is always much less than the horizontal measurement.

SKIES AND HILLS

Any landscape will be made up of one or more of the features shown on the following pages. These are sky, hills, water, rocks, vegetation, such as grass and trees, beach and buildings. Obviously each grouping offers enormous scope for variation. For the moment I want you to look at each set of comparative examples and note how the features are used.

A very simple landscape/seascape is brought to dramatic life by the contrast of dark and light tones. The moon shines through clouds that show up as dark smudges around the source of light. The lower part of the picture features calm water reflecting the light, and the dark silhouette of a rocky shore.

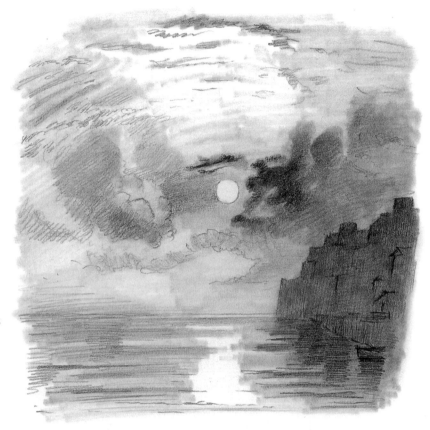

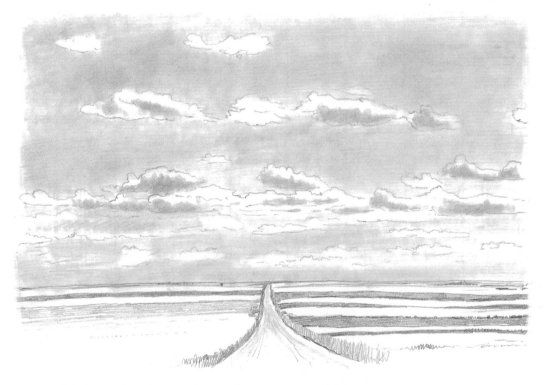

A halcyon sky takes up almost three-quarters of this scene and dominates the composition, from the small cumulus clouds with shadows on their bases to the sunlight flooding the flat, open landscape beneath.

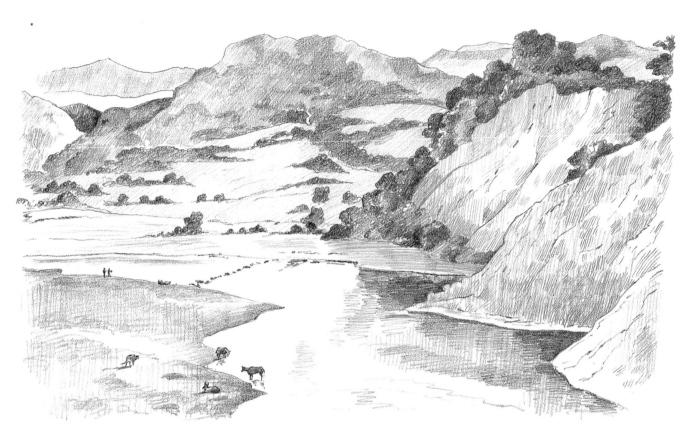

In this example the high viewpoint allows us to look across a wide river valley to rows of hills receding into the depth of the picture. The tiny figures of people and cattle standing along the banks of the river give scale to the wooded hills. Notice how the drawing of the closer hills is more detailed, more textured. Their treatment contrasts with that used for the hills further away, which seem to recede into the distance as a result.

The myriad layers of features make this type of landscape very attractive to artists. This example is after Leonardo. Notice the way details are placed close to the viewer and how the distance is gradually opened up as the valleys recede into the picture. Buildings appear to diminish as they are seen beyond the hills and the distant mountains appear in serried ranks behind.

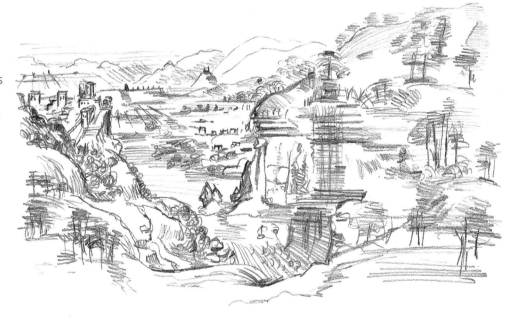

WATER AND ROCKS

The reflective qualities of water make it a very useful addition to a landscape. It can also introduce movement to contrast with stiller elements on view. Below we look at three of the possibilities given by the addition of water, while on the opposite page we consider the raw power that the inclusion of rocks can bring to a picture.

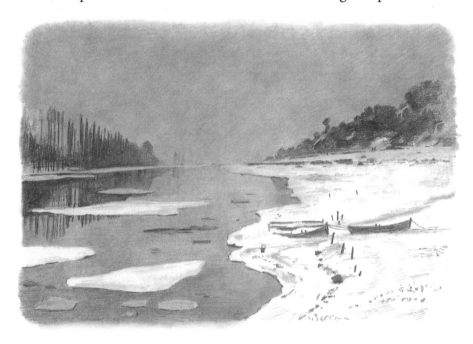

The impact of this wintry scene (after Monet) is made by the contrasts in darks and lights. These are noticeable between the principal features and especially within the river. Contrast the dark of the trees on either bank of the river with the white of the snow-covered banks; the inky blackness where the tall poplars on the far bank reflect in the water; the grey of the wintry sky reflecting in other areas of the river; and the brilliance of the white ice floes. On the bank a few smudgy marks help to define the substance of the snowy landscape.

The River Oise in summer (after Perrier) looks more inviting than Monet's depiction of the Seine. The leafy trees are presented as a solid mass, bulking up above the ripples of the river, where the shadowed areas of the trees are strongly reflected. The many horizontal strokes used to draw these reflections help to define the rippling surface of the calmly flowing river.

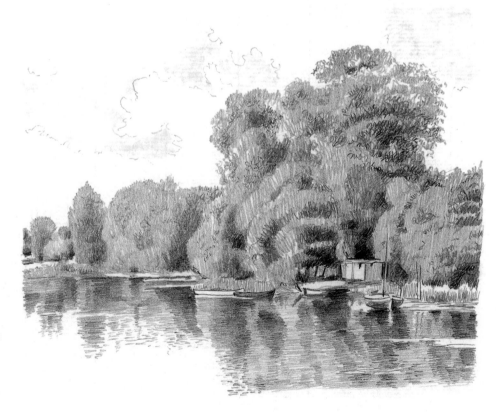

The turbulence of the water and its interaction with the static rocks is the point of this small-scale study. Note how the contrast between the dark and light parts of the water intensifies nearer to the shore. As the water recedes towards the horizon the shapes of the waves are less obvious and the tonal contrast between the dark and light areas lessens.

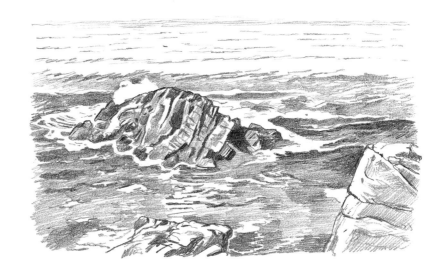

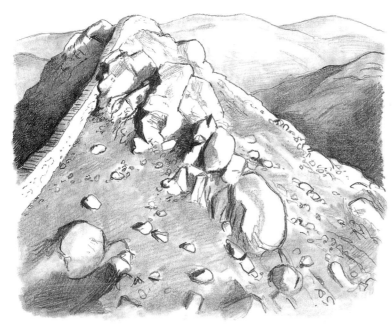

This close-up view of a rocky promontory shows starkly against a background of mountaintops drawn quite simply across the horizon. The rock wall effectively shadows the left-hand side of the hill, creating a strong definite shape. In the middleground large boulders appear embedded in the slope. Smaller rocks are strewn all around. Note how the shapes of the rocks and the outline of the hill are defined by intelligent use of tone.

The main feature in this landscape is the stretch of rocky shoreline, its contrasting shapes pounded smooth by heavy seas. Pools of water reflect the sky, giving lighter tonal areas to contrast with the darker shapes of the rock. This sort of view gives a good example of an important first principle when drawing landscapes: include more detail close to the viewer and less detail further away.

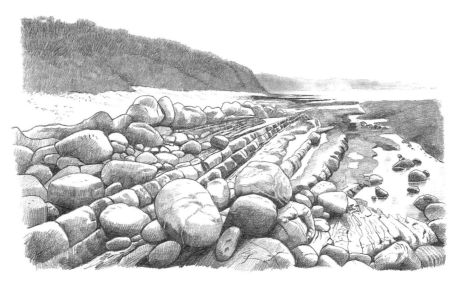

GRASS AND TREES

Grass and trees are two of the most fundamental elements in landscape. As with the other subjects, there are many variations in type and in how they might be used as features.

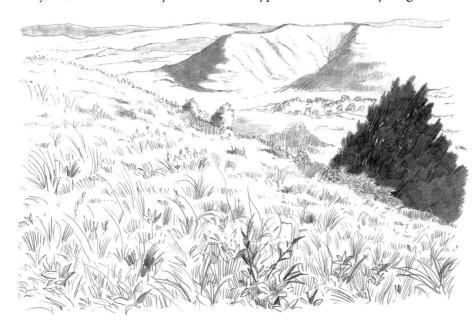

Tufts and hummocks of grass mingle with flowers in this close-up of a hillside. The foreground detail helps to add interest to the otherwise fairly uniform texture. The smoothness of the distant hills suggests that they too are grassy. The dark area of trees just beyond the edge of the nearest hill contrasts nicely with the fairly empty background.

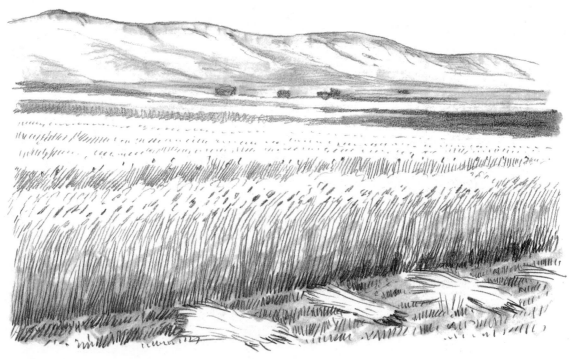

Cultivated crops produce a much smoother top surface as they recede into the distance than do wild grasses. The most important task for an artist drawing this kind of scene is to define the height of the crop – here it is wheat – by showing the point where the ears of grain weigh down the tall stalks. The texture can be simplified and generalized after a couple of rows.

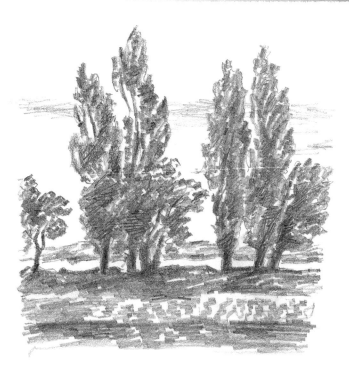

When you tackle trees, don't try to draw every leaf. Use broad pencil strokes to define areas of leaf rather than individual sprigs. Concentrate on getting the main shape of the tree correct and the way the leaves clump together in dark masses. In this copy of a Constable the trees are standing almost in silhouette against a bright sky with dark shadowy ground beneath them.

The trees in this old orchard were heavy with foliage when I drew them, on a brilliant sunny day. Nowhere here is there a suggestion of individual leaves, just broad soft shapes suggesting the bulk of the trees. They presented themselves as textured patches of dark and light with a few branches and their trunks outlined against this slightly fuzzy backdrop. An area of shadow under the nearest trees helps to define their position on the ground. To the left, some old beehives show up against the shadow. In the immediate foreground the texture of leafy plants in the grass helps to give a sense of space in front of the trees.

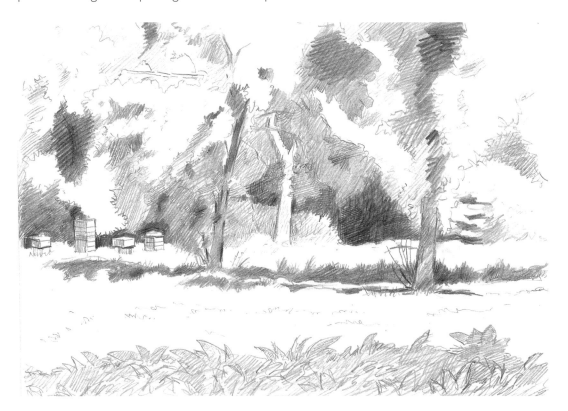

BEACHES

Beaches and coastline are a rather specialized example of landscape because of the sense of space that you find when the sea takes up half of your picture.

Our first view is of Chesil Bank in Dorset, which is seen from a low cliff-top looking across the bay. Our second is of a beach seen from a higher viewpoint, from one end, and receding in perspective to a small headland of cliffs just across the background.

This view looks very simple. A great bank of sand and pebbles sweeps around and across the near foreground, with a lagoon in front and right in the foreground and hilly pastureland behind the beach to the left. Across the horizon are the cliffs of the far side of the bay and beyond them the open sea. Notice the smooth tones sweeping horizontally across the picture to help show the calm sea and the worn-down headland, and the contrast of dark tones bordered with light areas where the edge of sand or shingle shows white.

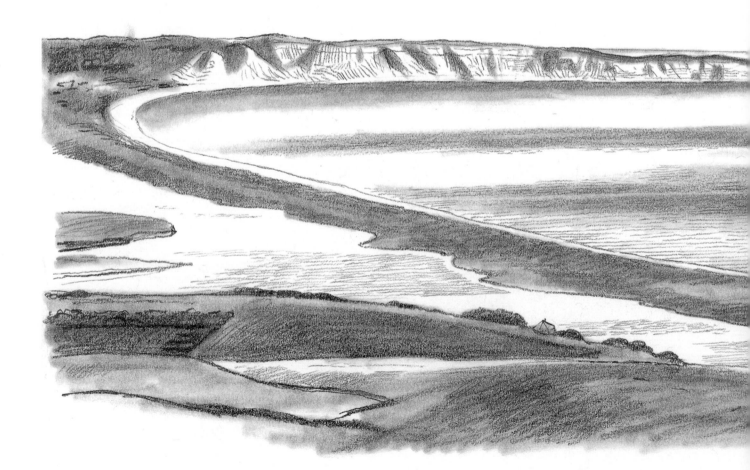

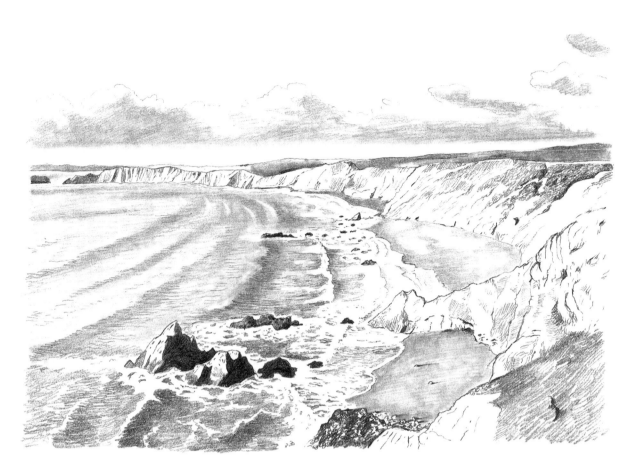

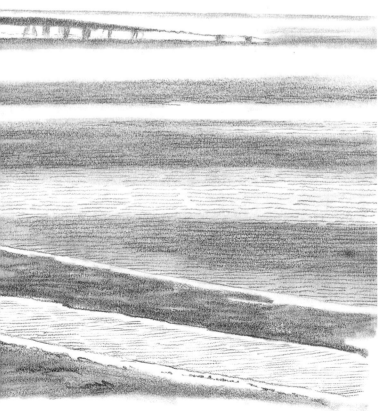

Here the dark, grassy tops of the cliffs contrast with the lighter rocky texture of the sides as they sweep down to the beach. The beach itself is a tone darker than the cliff but without the texture. The hardest part of this type of landscape is where the waves break on the shore. You must leave enough white space to indicate surf, but at the same time intersperse this with enough contrasting areas of dark tone to show the waves. The tone of the rocks in the surf can be drawn very dark to stand out and make the surf look whiter. The nearest cliff-face should have more texture and be more clearly drawn than the distant cliffs.

BUILDINGS

Unless you are drawing in the wilderness, buildings will often feature in your landscapes and may offer interest because of their arbitrary appearance against the sky and/or vegetation. Where they form the main subject of a landscape, they will tend to dominate as a mass of verticals and horizontals against geometric hard shapes.

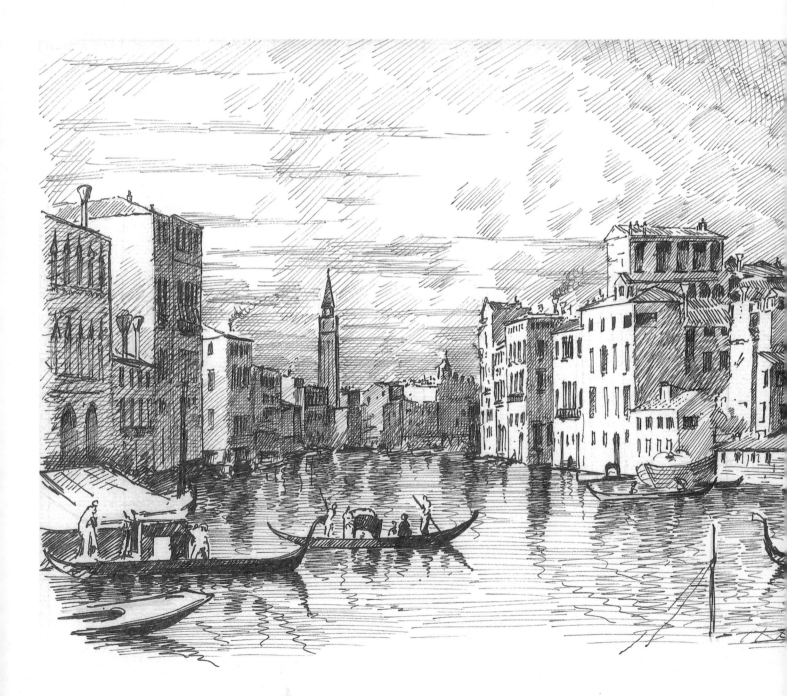

In this copy of a Pissarro study of a street in Rouen the emphasis is on the vertical character of the Gothic church and old houses. Only the narrow space of the street is allowed to project into these verticals, which are also etched sharply against the sky. Notice how the contrasting textures created by the house fronts pull the vertical shapes closer together as they recede down the street.

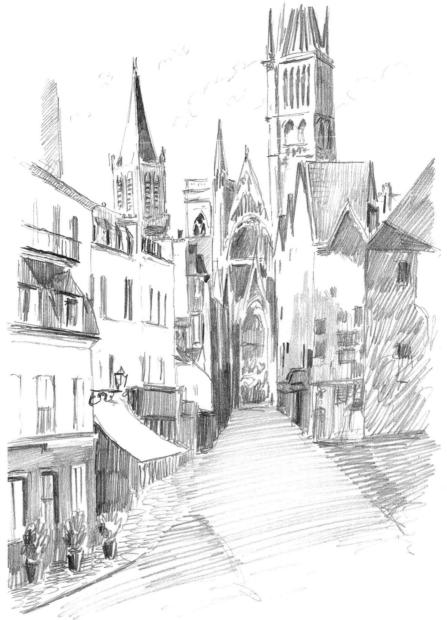

It is easy to become confused with the details of texture in a scene such as this of the Grand Canal in Venice (after Canaletto). It exemplifies one of landscape's golden rules: always put the main shapes of buildings in first. The repetition of architectural details must be kept as uniform as possible, otherwise the buildings will look as though they are collapsing. Never try to draw every detail: pick out only the most definite and most characteristic, such as the arches of the nearer windows and doors, and the shapes of the gondolas in the foreground. The reflections of the buildings in the water are suggested, with the darkest shadows depicted by horizontal lines under the buildings. Multiple cross-hatching has been put in to denote the darker side of the canal. On the lit side, white space has been left and the sky above lightly shaded to enhance the definition and provide greater contrast.

UNDERSTANDING PERSPECTIVE

The science of perspective is something with which you will have to become acquainted in order to produce convincing depth of field. This is especially important if you want to draw urban landscapes. The following diagrams are designed to help you understand how perspective works and so enable you to incorporate its basic principles in your work.

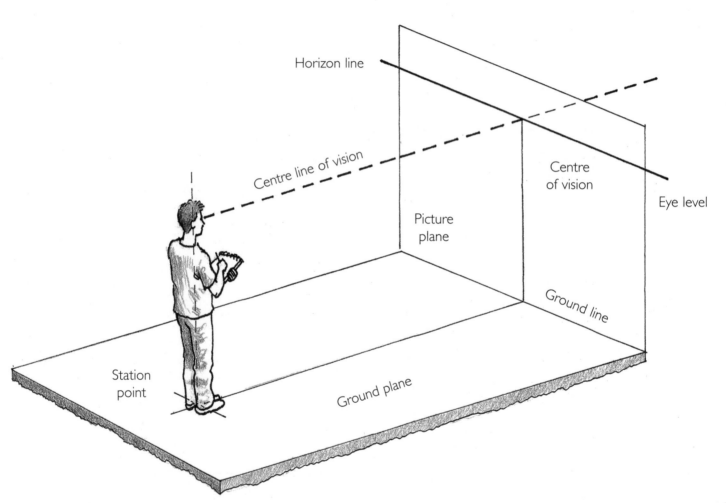

Like any science, perspective comes with its own language and terms. This diagram offers a visual explanation of the basic terms as well as giving you an idea of the depth of space. The centre line of vision is the direction you are looking in. The horizon line (your eye level) produces the effect of the distant horizon of the land or sea. The picture plane is effectively the area of your vision where the landscape is seen. The other terms are self-explanatory.

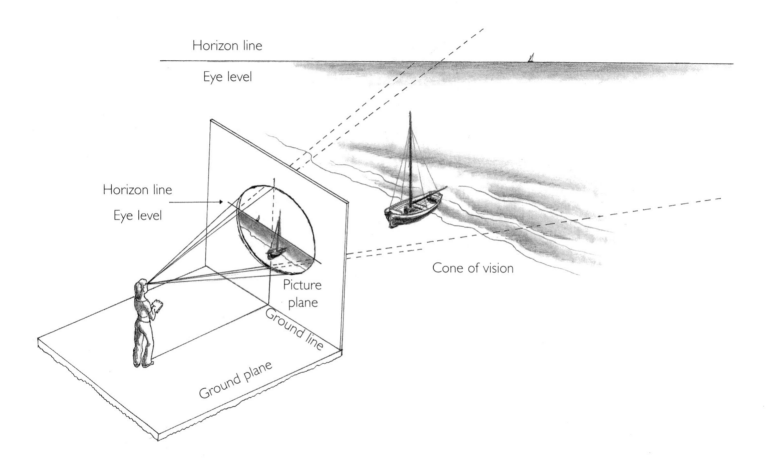

The cone of vision is a sort of mental construct of how much you can draw without the effects of distortion appearing in your picture. In practice it is what you can take in of a scene without turning your head; it extends to about 60 degrees across. The cone of vision in the illustration encompasses the whole view right to the distant horizon. When you look through the lens of a camera, you may have noticed that the shapes of the objects on the periphery of your vision appear to be slightly different than when you look directly at them. Here, the impression of the scene through the cone of vision is that the nearer areas are much larger than the distant areas, whereas in reality the reverse is true. The cone of vision is of necessity a narrow view of a scene.

TYPES OF PERSPECTIVE

The eye being a sphere, it comprehends the lines of the horizon and all verticals as curves. You have to allow for this when you draw by not making your perspective too wide, otherwise a certain amount of distortion occurs.

Below we look at three types of perspective, starting with the simplest.

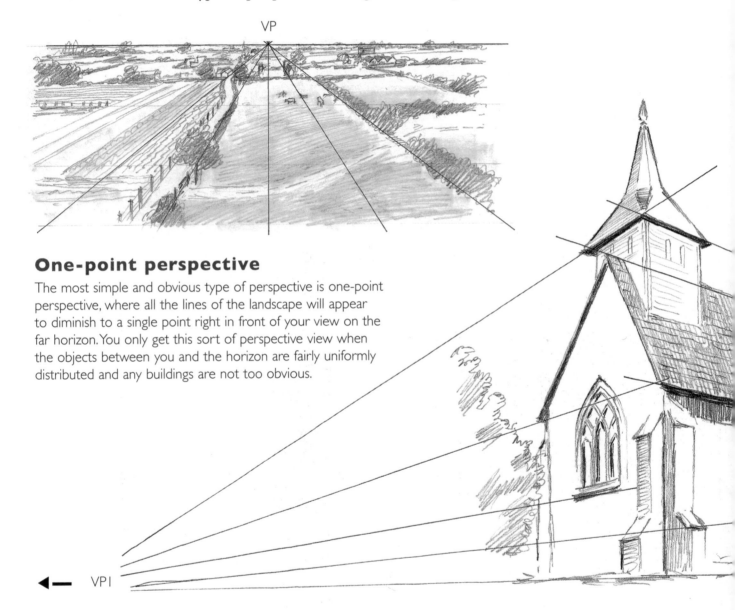

One-point perspective

The most simple and obvious type of perspective is one-point perspective, where all the lines of the landscape will appear to diminish to a single point right in front of your view on the far horizon. You only get this sort of perspective view when the objects between you and the horizon are fairly uniformly distributed and any buildings are not too obvious.

Two-point perspective

Where there is sufficient height and solidity in near objects (such as houses) to need two vanishing points at the far ends of the horizon line, two-point perspective comes into play. Using two-point perspective you can calculate the three-dimensional effect of structures to give your picture convincing solidity and depth. Mostly the vanishing points will be too far out on your horizon line to enable you to plot the converging lines precisely with a ruler. However, if you practise drawing blocks of buildings using two vanishing points you will soon be able to estimate the converging lines correctly.

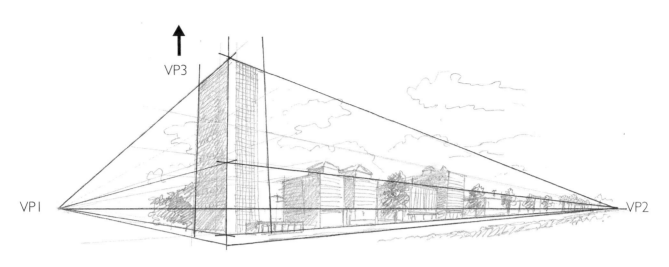

Three-point perspective

When you come to draw buildings that have both extensive width and height, you have to employ three-point perspective. The two vanishing points on the horizon are joined by a third which is fixed above the higher buildings to help create the illusion of very tall architecture. Notice in our example how the lines from the base of the building gently converge to a point high in the sky. Once again, you have to gauge the rate of the convergence. Often, artists exaggerate the rate of convergence in order to make the height of the building appear even more dramatic. When this is overdone you can end up with a drawing that looks like something out of a comic book.

USING PERSPECTIVE

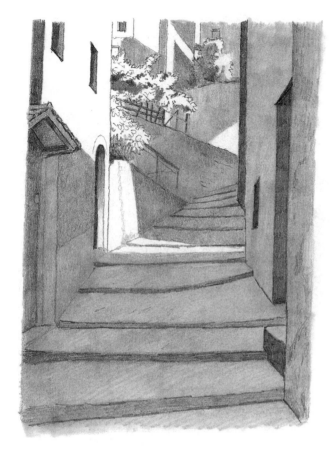

This drawing of the entrance to the mountain town of Boveglio in Tuscany gives many clues to our position and that of the buildings in front of us. The angle of the steps upwards and the change in size of the windows provide information that helps us to detect how the path winds up into the old town.

A classic image of perspective is instantly shown in this drawing of railway lines. The drama of the curve as the rails sweep around to the left where they merge and disappear takes us into the picture and shows us the clarity of perception of the viewer. All that we see beyond the rails are softly silhouetted buildings about half a kilometre away.

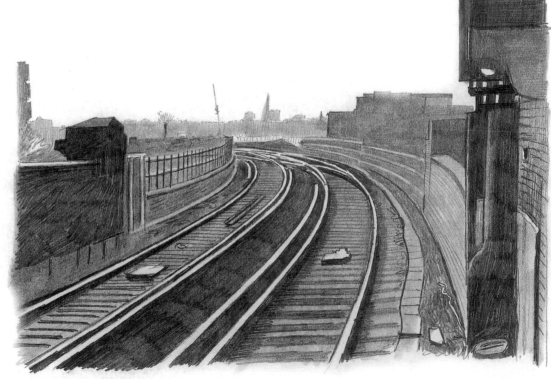

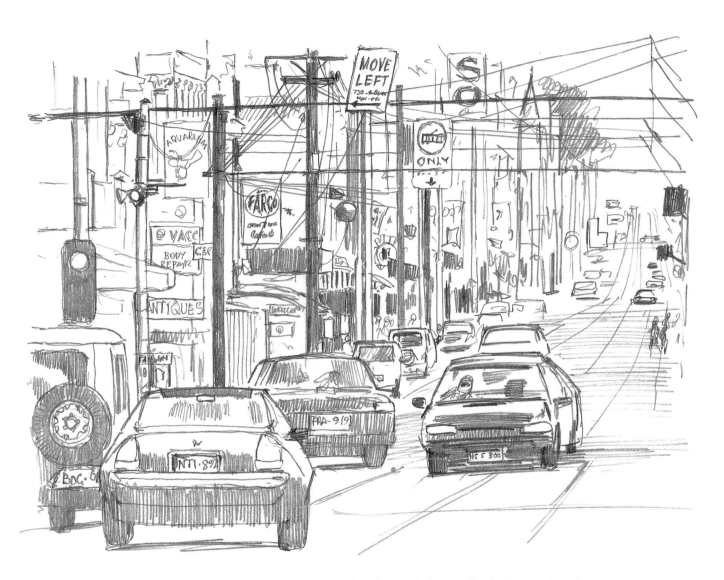

The chaos of signs and telephone wires along a
Melbourne street give us a sense of the texture of
Australian city life. The sweep of the road and the
diminishing sizes of the vehicles certainly convince us of
the distance observed, and yet the signs and posts flatten
out the depth, making it difficult to judge distances.

In the three examples shown here formal perspective is conspicuous by its absence. In all cases the effect the artist is after does not rely so much on perspective.

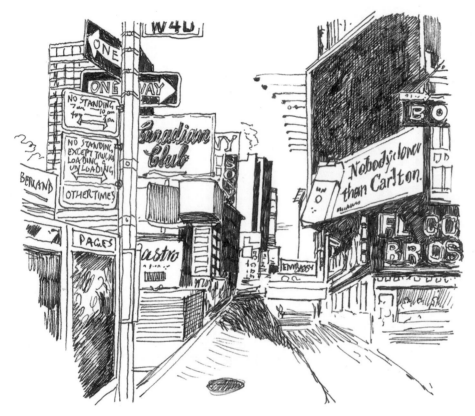

The complex artificial surface of city life is the point of this picture of information clutter, as sign vies with sign to confuse the eye. The only nod to the idea of perspective is the variation in the size of the lettering.

This close-up of plant life (after primitive painter Henri Rousseau) is a huge jump stylistically from the first drawing. All the emphasis is on the pattern of jungle-like plants which have been rendered very painstakingly. There is no real depth in the picture, although each plant has its own solidity of form. What we have is a network of plant shapes that present a texture to the eye without any attempt to describe depth of perspective.

Perspective does not count much in our final picture either. Also from the naïve school of drawing, this depiction of Karlsbad (after Antonin Rehak) gives an impression of perspective knowledge, but the actual detail of each part of the picture is the same whether near, far or in between.

ENCLOSED LANDSCAPES

An enclosed landscape is characterized by a limitation of the spread of land. This limitation occurs either out of choice – ie, the artist choosing a viewpoint that purposely excludes a wider or deeper spread – or in a landscape where the number of features cuts off a view that might otherwise be more expansive. Artists sometimes choose enclosed landscapes when they want us to concentrate on a feature – perhaps a figure or figures – in the foreground, as in our first example, after Giorgione's painting 'The Tempest'.

Without the two figures in Giorgione's original we can concentrate on how the artist succeeds in limiting the extent of our vision while achieving an impressive effect of depth. The composition is carefully framed by dark trees on the right and a tower-like edifice surrounded by trees and bushes on the left. The effect is to funnel our view towards the centre of the picture. The bridge and the buildings also ensure that our attention doesn't wander beyond the left bank of the stream and the broken pillars (where the figures are placed in the original).

In this pen and wash drawing of the Roman countryside (after Claude Lorrain) the limit to our vision is by deliberate choice of the artist. We are viewing the scene from a hollow or small ravine with rocky outcrops to the left and in front. Up on the rocks in front is an old tower, sharply silhouetted against the sky. Our low viewpoint and the high rocky ridges prevent us from seeing much more of the landscape. As a result of the position taken by the artist, our view is restricted to a few metres, forcing us to concentrate on the details in the foreground, since both the middleground and background are almost non-existent.

OPEN LANDSCAPES

As you will see from the following examples, an open landscape is one in which an effect of space combines with a feeling that we are looking at a view that has no limits. All that is visible goes into the horizon and beyond.

In the examples of an enclosed landscape we saw how the artists had chosen to focus the viewer's attention on features in the foreground by restricting their vision. Here you will see how exactly the same effect can be achieved apparently by doing precisely the opposite.

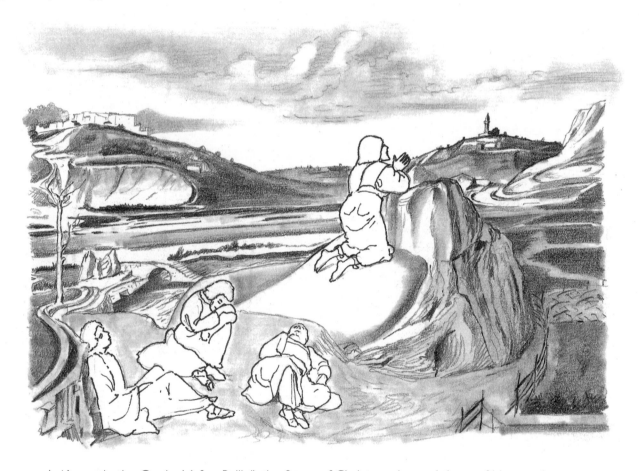

In 'Agony in the Garden' (after Bellini) the figure of Christ praying and three of his apostles sleeping are set in a landscape of immense vistas and spaciousness. The original painting is quite small, but the artist's understanding of the use of perspective suggests a much larger format.

The large rocks and figures are set against a flat, open landscape. A road or path can be seen winding back into the middle distance. To the left is a large hill sloping up to a town or village with cliffs and paths along its side. To the right in the middle distance is a high cliff. Beyond that in the far distance is a hill sweeping up towards another town or village with a tower at the top as a focal point. The figure of Christ, who is placed so that his head is above the skyline, appears to be pointing towards this distant focal point.

The feeling of immense space in the landscape is beautifully suggested by this contrast between the close-up figures and landscape around them and the distant views of hilltop buildings and open spaces between. The careful graduation of highly detailed features in the foreground and diminishing detail as the landscape moves away from our gaze is masterly.

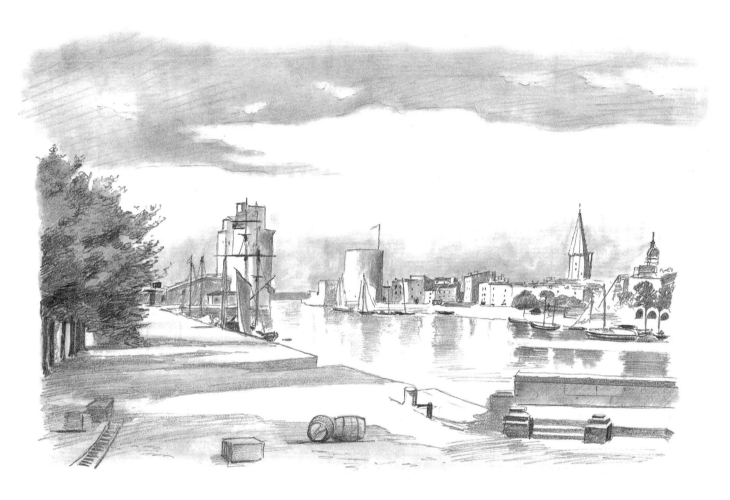

The effect in this landscape of the port of La Rochelle (after Corot) is of a vast space across the centre of the picture, nicely defined by the brightly lit buildings, but suggesting there is much more space beyond them and out to sea. The length of the quay recedes in perspective off to our left. The row of trees helps this effect by drawing our eye in this direction; I have purposely left out a group of figures with horses dotted around this space in order to allow us to concentrate on the spatial effect. At the far end of the quay is a tower jutting out into the harbour, with the masts of boats projecting up to obscure part of the building. An expanse of water fills the middleground. Stretched out along the far right side of the harbour is a row of buildings including a church steeple and a small dome. A large round tower acts as a focus point marking the end of the quayside. Along the length of the far side of the harbour boats are moored, and buildings are brightly lit by the sunlight, which reflects in the limpid water.

DIVIDING A PANORAMA

A large panorama of landscape can be very daunting to the inexperienced artist who is looking at it with a view to making a composition, since there can appear to be so much to handle.

The first point to remember is that you don't have to draw all you see; you can decide to select one part of the landscape and concentrate on that area alone. This is what I have done with the drawing below, dividing it into three separate compositions. See the next spread for assessments of the individual drawings.

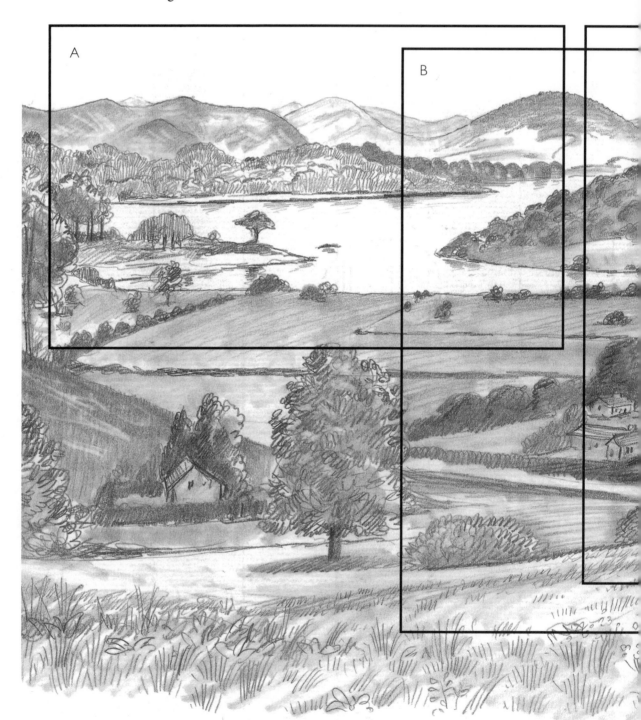

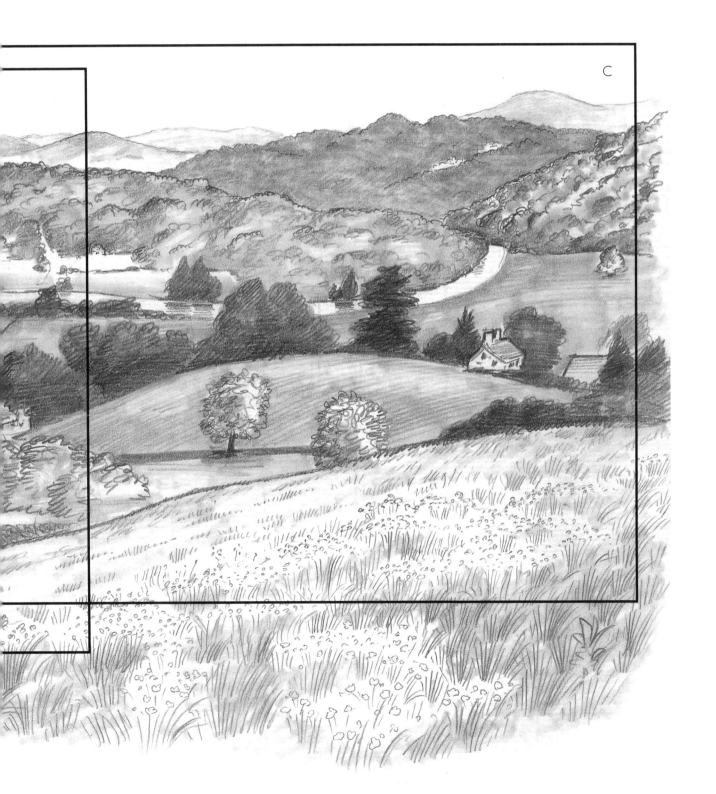

C

Here I have extracted three views from the large landscape on the previous spread, each of them equally valid.

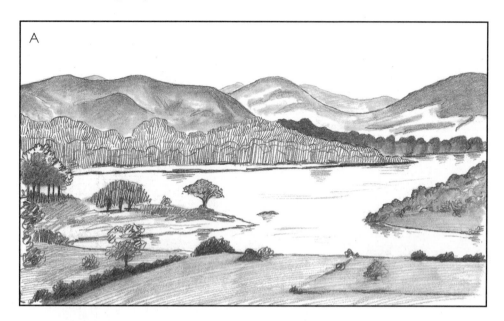

A: The main feature in this part of the landscape is a large area of water sweeping across the whole composition. The large hills in the background provide a backdrop to the more open landscape on the near side of the water. Two small spits of land jut out from either side just above the foreground area of open fields with a few hedges and trees.

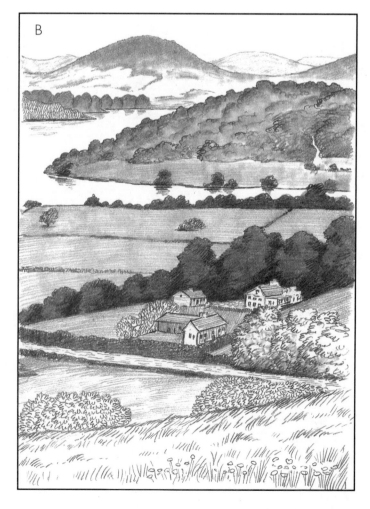

B: With its more vertical format, this composition gives just a hint of the open water beyond the stretch of river in the middleground. The extensive foreground contains hedges, trees, bushes and cottages. The wooded hill across the river provides contrast and the slope of hillside in the near foreground adds depth. The distant hills provide a good backdrop.

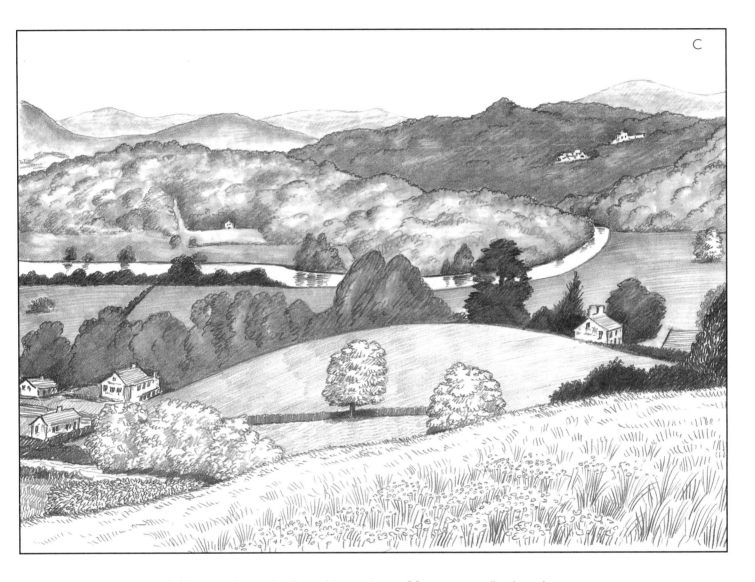

C: Here we have a horizontal layered set of features receding into the picture plane. In the foreground is a close-up of hillside sloping across from right to left. Just beyond is a low rounded hill surrounded by trees and in the left lower corner there are some houses. Beyond the low hill is the river, curving around a large bend and disappearing into wooded banks on the right. The banks slope up either side into wooded hills, and beyond these into another layer showing a larger darkly wooded hill with a couple of villages or properties to the right. At upper left, layer upon layer of hills disappear into the distance.

SAME LANDSCAPE, DIFFERENT WEATHER

One very significant feature in any landscape is, of course, the effect of weather. In every season there are different effects. These can be as simple as the change in the look of the sky. More dramatic changes will demand that you change the way you draw and perhaps the use of different techniques. We shall look at these techniques in detail later. For now, just note the changes that shifts from sunshine to rain, from snowfall to mist bring in their wake.

Shown here are four versions of the same landscape, of Fiesole in Tuscany, drawn almost in the same way, without the application of any special techniques, but merely adapting the same medium to the changing scene.

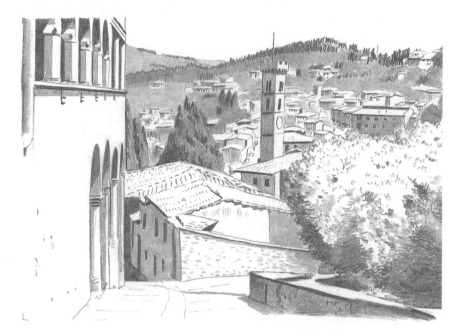

Intense sunlight is very typical of this region in summer. Everything in the picture is clearly defined, with a lot of contrast between black and white. Shadows tend to be sharp-edged and strong. Where there is a medium shadow it is a smooth all-over tone. Even the distant hillsides are sharply defined, with the trees darkly marked and clearly silhouetted against the skyline.

To emphasize and imitate the visual effect of rain, I've used downward strokes of the pencil. You'll notice the tones are rather soft overall and similar; the darkest shadows are not very much darker than the lighter ones, and even the lightest areas have some tone. The distant hillsides just become simple areas of tone in vertical strokes. The pattern of raindrops on the path helps to maintain the effect.

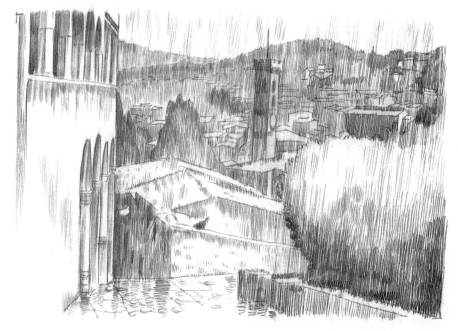

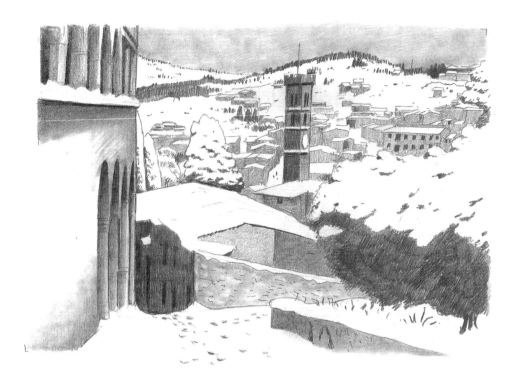

With the landscape covered in snow, there is a great deal of contrast between the snow and other features; here it is between the brightness of the snow lying on the ground, roofs and foliage and the dark tones of the walls of the buildings and the sky. The line of trees on the horizon stands out starkly against the snow-covered hills below it. The overall effect is almost like a negative photograph.

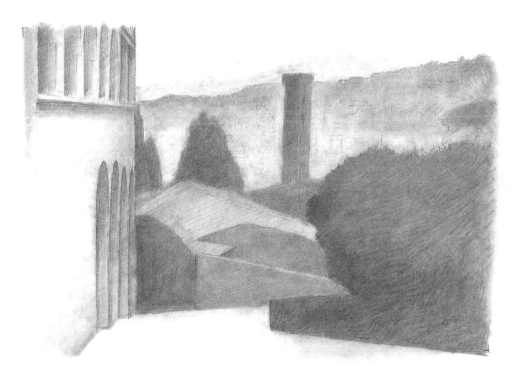

Seen in mist, the same landscape is almost unrecognizable, with its contours softened and the tonal areas simplified. Shapes seem to loom up out of the background rather than show themselves clearly. The pencil tones have been smudged with a stump to soften the contrasts.

SAME SCENE, DIFFERENT VIEWPOINT

The view we get of a landscape is determined by our position. Take the same landscape and view it from three different positions and you will get three different compositions. In the next three drawings we view the landscape across the valley of the River Stour (after Constable), from three different positions. Compare the three and note how the change in position alters the balance of the elements as well as the overall appearance of the scene.

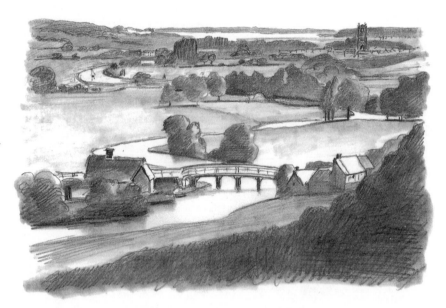

This is quite literally taking the highest viewpoint, which was where Constable chose to position himself to record the scene. From here we get a very broad, expansive view.

If we come down the hill a short way, although we still get quite a broad view, the land in the distance is greatly compressed. Our eye is drawn to the dominant foreground and middleground.

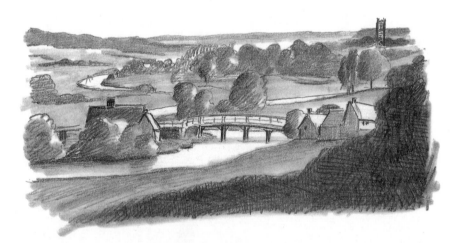

Lower still and the distant horizon is almost completely blocked out by the houses and trees in what is now the middleground. The only distant feature visible is the tower of the church.

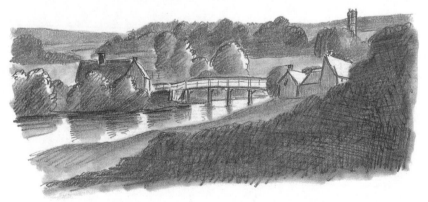

SAME SCENE, DIFFERENT TECHNIQUE

There is more than one way of drawing landscapes. People often think, erroneously, that everything has to be drawn exactly as it would be seen by the eye or the lens of a camera, and if a high degree of verisimilitude is not achieved a drawing is worthless. Below are two different approaches to the same landscape. Beginners who are not confident of their drawing skills might find the technique used in the second of these worth considering.

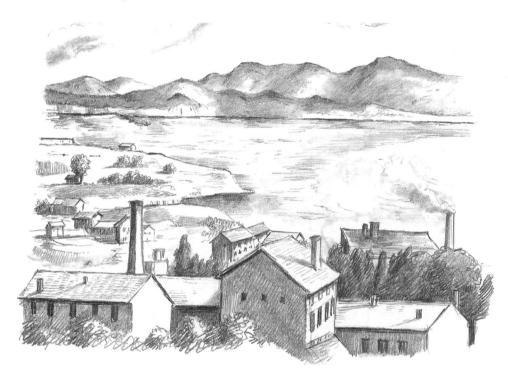

The difference between distant and close-up objects is made obvious by means of texture, definition and intensity. The weight and thickness of line varies to suggest the different qualities of features and their distance in relation to each other and the viewer.

Here an attempt has been made to create an extremely simple scheme of solid forms. The only difference between the treatment of nearer forms and further ones is in intensity. Every detail has been subsumed in the effort to describe the solidity of the forms in a very simple way. The result is a sort of sculptural model universe where the bulk of the form is clearly shown but the differences in texture or detail are greatly reduced. The effect is of a very strong three-dimensional landscape, albeit one that is rather detached from the way our eyes would really see it. Nevertheless many artists have used this increase in total form successfully.

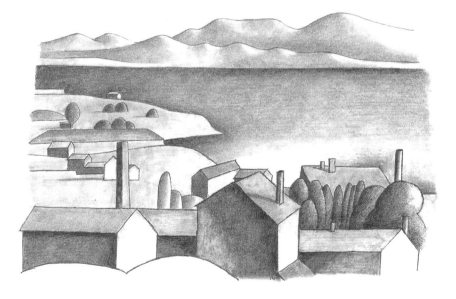

TREES IN THE LANDSCAPE

When tackling a landscape with trees, novice artists often make the mistake of thinking they must draw every leaf. Survey such a scene with your naked eye and you will discover that you can't see the foliage well enough to do this. You need to be bold and simplify. If you understand the general outline and appearance of different trees, you will convey a sense of the unity that exists in the landscape space.

The following series of drawings is intended to help you to capture the shapes of a range of common trees seen in full foliage and from a distance. You can see that differences in leaf type are indicated entirely by marking the general texture and shape. Let's look at these examples.

Oak

The oak makes a compact, chunky cloud-like shape, with leaves closely grouped on the mass of the tree.

Ash

By contrast the ash is much more feathery in appearance.

Lombardy poplar

The poplar is indicated by long, flowing marks in one direction, whereas with the aspen (opposite) marks have to go in all directions.

Horse chestnut

Some trees, such as the horse chestnut, can be blocked in very simply, just needing some shading to indicate the foliage masses.

Elm

The elm and lime are very similar in structure. The way to tell them apart is to note the differences in the way their leaves layer and form clumps.

Lime

Cypress

The cypress holds itself tightly together in a flowing, flame-like shape; very controlled and with a sharp outline.

Walnut

The walnut requires scrawling, tight lines to give an effect of its leaf texture.

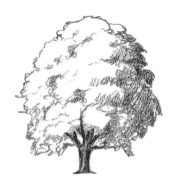

Sycamore

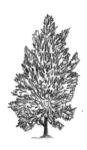

Holly

The holly tree is shaped like an explosion, its dark, spiky leaves all outward movement in an expressive organic thrust.

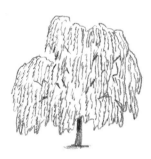

Weeping willow

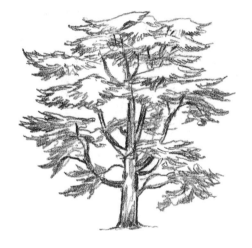

Cedar of Lebanon

You will also have to take note of where a darker or lighter weight of line or tone is required. Compare, for example, the weight of line needed for trees with dense dark leaves, such as the cypress and holly, with the light tone appropriate to the willow and cedar.

Aspen

Yew

Although they are of a similar family, the cedar of Lebanon and yew are easily told apart. Whereas the yew is dense and dark, the stately cedar is open-branched with an almost flat layered effect created by its canopies of soft-edged leaves.

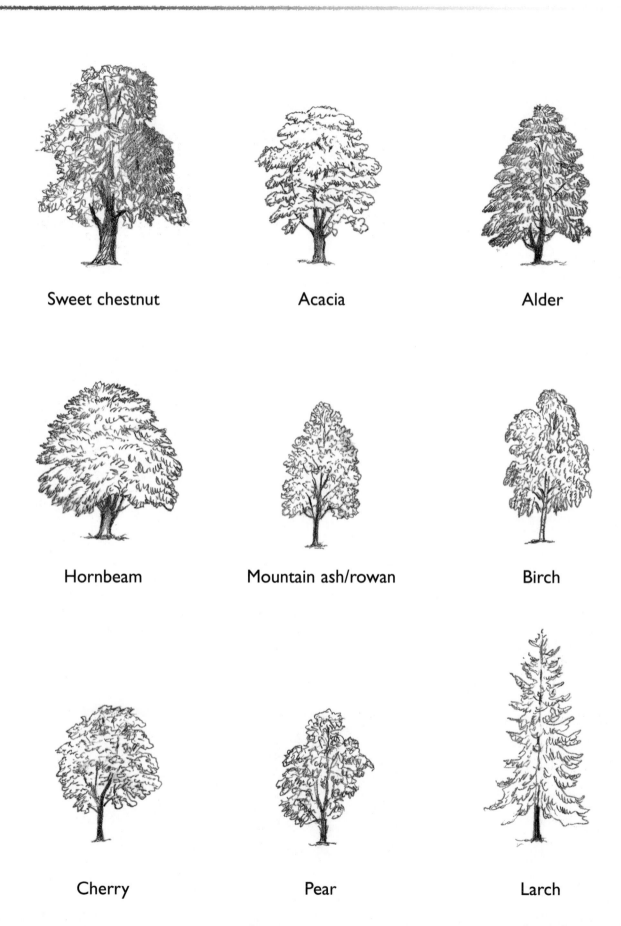

Sweet chestnut

Acacia

Alder

Hornbeam

Mountain ash/rowan

Birch

Cherry

Pear

Larch

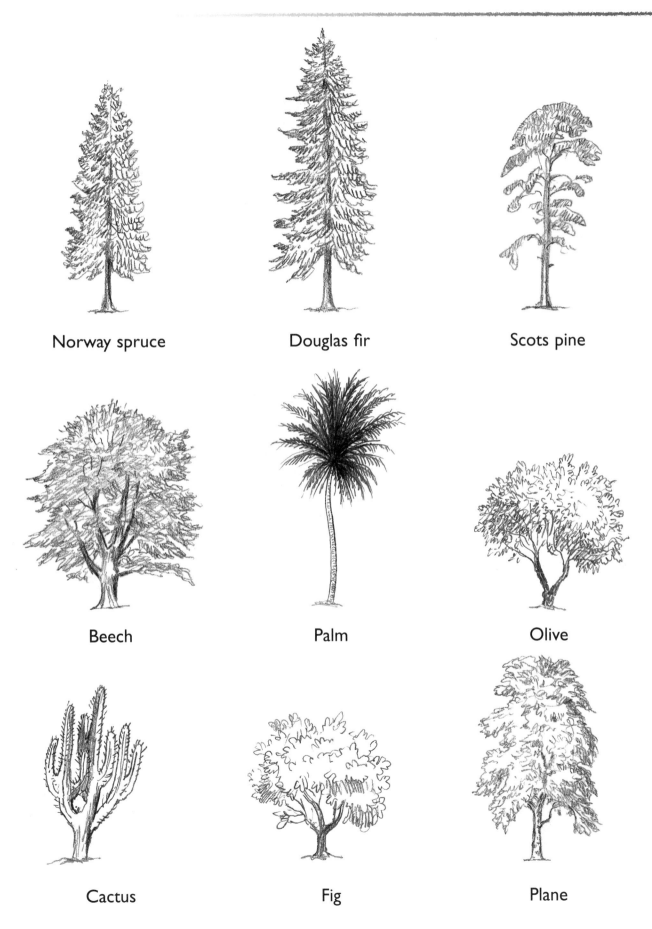

Norway spruce

Douglas fir

Scots pine

Beech

Palm

Olive

Cactus

Fig

Plane

FOLIAGE: THE CLASSICAL APPROACH

Drawing trees can be quite daunting at first. It is a common misconception that every leaf has to be drawn. This is not the case. Over the next few pages you will find examples by Italian, French and Dutch masters which demonstrate how to solve the problem of showing masses of small shapes that build up to make larger, more generalized outlines.

In these examples a lively effect of plant growth is achieved, by the use of vigorous smudges, brushed lines and washes, and finely detailed pen lines, often in combination.

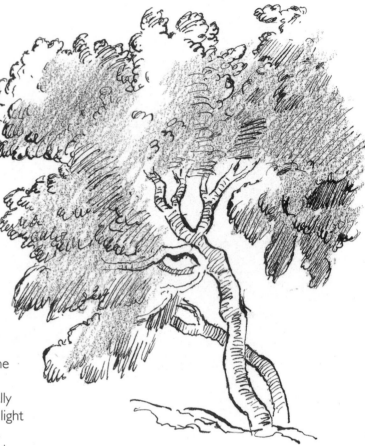

Notice the soft, almost cloud-like outline given to the groups of foliage in this example after Titian (drawn in pen, ink and chalk). No individual leaves are actually shown. Smudges and lines of tone make patches of light which give an impression of thick bunches of leaves. The branches disappear into the bulging form, stopping where the foliage looks most dense.

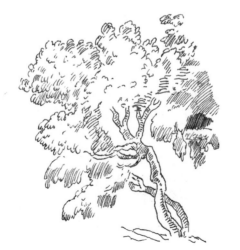
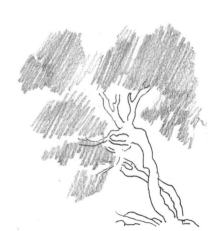

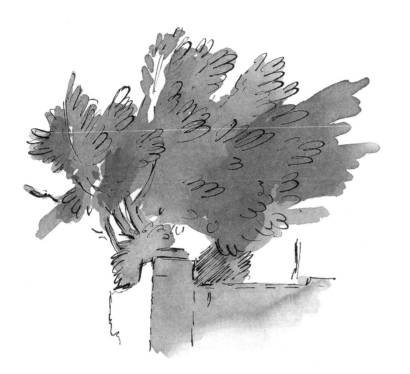

Despite the minimal drawing, this example after Tiepolo (in pen and ink) is very effective. The solidity of the wall has been achieved with a few lines of the pen. A similar technique has been used to capture the general effect of the longish groups of leaves. The splash of tone has been applied very freely. If you try this yourself, take time painting on the wash. Until you are sure of what you are doing, it is wise to proceed with care.

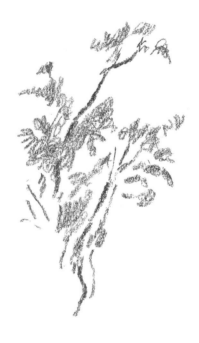

The approach in this chalk drawing after Boucher is to put in the sprays of branches and leaves with minimal fuss but great bravura. The technique of using squiggles to describe bunches of leaves evokes the right image, as does drawing in the branches more heavily but with no effort to join them up. The approach works because our eyes expect to see a flow of growth, and seen in context the leaves and branches would be easily recognizable.

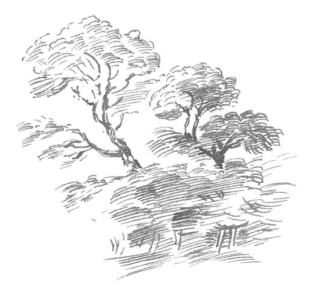

The emphasis here, in an example after Guercino, is on giving unity to the whole picture while producing an adequate representation of trees in leaf.

The lines around the outside edges of the clumps of leaves give a good impression of tree-like shapes. Simple uni-directional hatching, smoothing out as the lines get further from the edge, give the leafy areas solidity without making them look like a solid wall. Darker, harder lines make up the branches and trunk. The suggestion of softer and harder tone, and the corresponding tonal contrasts, works very well.

With your first attempts, try to get a general feel of the way that branches and foliage spring out from the trunk of the tree, and also how the bunches of leaves fan and thrust out from the centre of the plant. Note from the examples shown below what gives a convincing effect: weaving, crinkly lines; lines following the general layering of leaves; uneven thicks and thins with brush or pen; the occasional detail of leaves in the foreground to help the eye make the assumption that this is also seen deeper in the picture. Whatever type of foliage you draw, try to give a lively, organic shape to the whole.

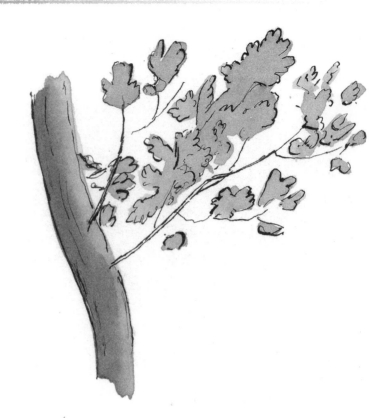

Very efficient methods have been used in this drawing of a branch (after Lorrain) to convince us of its reality. The combination of line and wash is very effective for branches seen against the light. If any depth is needed, just a few extra marks with the brush will supply it.

The two basic stages before the finished drawing are given below.

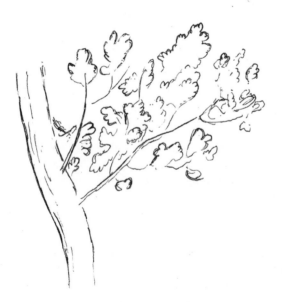

First, the outline shapes of the branch and leaves are drawn in pen; the approach is very similar to that adopted for the sketch after Titian on p.188.

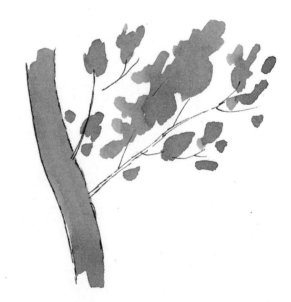

Next a wash of tone is applied over the whole area of the branch and each bunch of leaves.

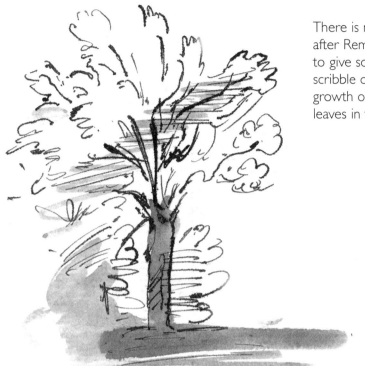

There is no hesitation in this pen, ink and wash drawing after Rembrandt. Minimal patches of tone are just enough to give solidity to the trunk and ground. Look at the quick scribble of lines, horizontally inscribed across the general growth of the branches, suggesting there are plenty of leaves in the middle of the tree.

In this graphite drawing (also after Rembrandt) very firm, dark slashes of tone are accompanied by softer, more rounded scribbles to describe leaves at different distances from the eye. The growth pattern of the tree is rendered by a strong scrawl for the trunk and slighter lines for the branches.

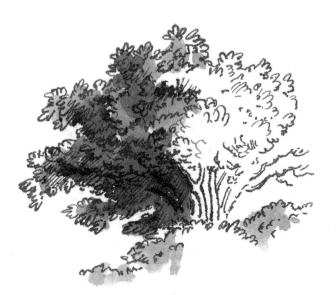

This neat little copse of trees (after Koninck), lit from one side with heavy shadows beneath, looks very substantial, even though the drawing is not very detailed. The carefully drawn clumps of leaves around the edges, and where some parts of the tree project towards us, help to give the impression of thick foliage. The closely grouped trunks growing out of the undergrowth are clearly drawn.

MOUNTAINS AND ROCKS

When drawing the solid rocks that make up the surface of the world, it can be instructive to think small and build up. Pick up a handful or soil or gravel and take it home with you for close scrutiny, then try to draw it in some detail. You will find that those tiny pieces of irregular material are essentially rocks in miniature. You can get a very clear idea of how to draw the earth in all its guises by recognizing the essential similarities between earth materials and being prepared to take a jump from almost zero to infinity.

If we attempt to draw a rocky outcrop or the rocks by the sea or along the shore of a river, it is really no different from drawing small pieces of gravel, only with an enormous change of scale. It is as though those pieces of gravel have been super-enlarged. You will find a similar random mixture of shapes, though made more attractive to our eyes because of the increase in size.

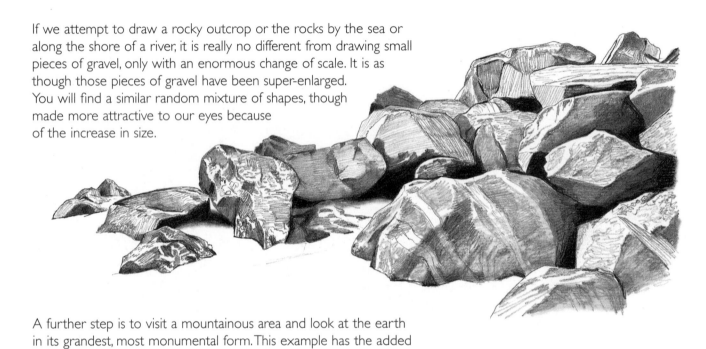

A further step is to visit a mountainous area and look at the earth in its grandest, most monumental form. This example has the added quality of being above the snow-line and showing marvellously simplified icy structures against contrasting dark rocks.

Now look at a large cliff face, with its cleavages and striations of geological layering, some of it no doubt partially hidden by plants, but nevertheless showing the structure very clearly.

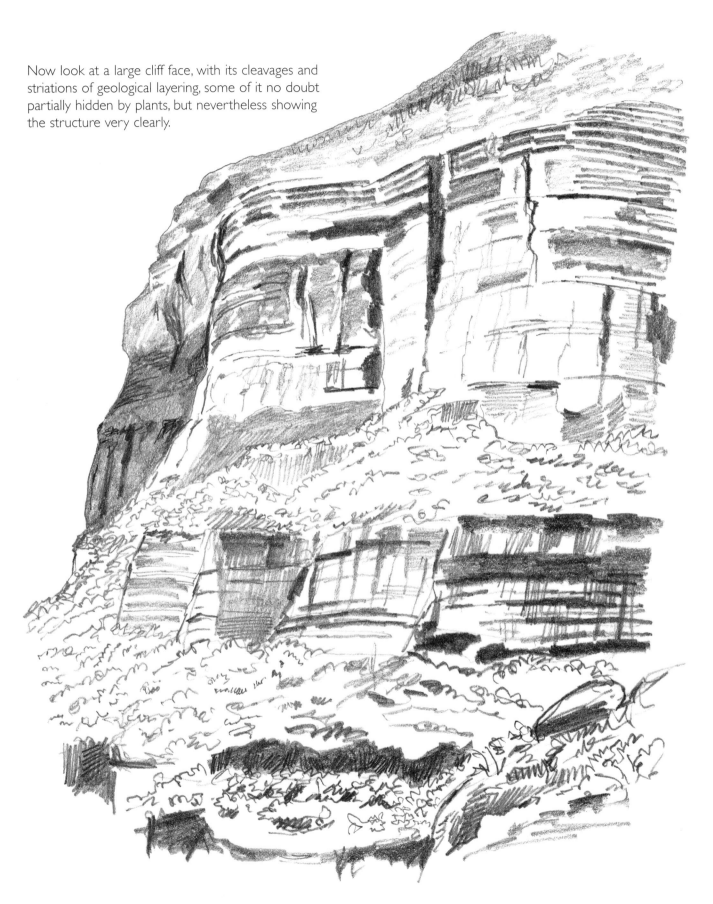

WATER

The character and mood of water changes depending on how it is affected by movement and light. Over the next few pages we look at water in various forms, which present very different problems for artists and very different effects on viewers. To understand how you can capture the effect of each of the forms shown here requires close first-hand study, supported by photographic evidence of the movement of the water.

A waterfall is an immensely powerful form of water. Most of us don't see such grand works of nature as this magnificent example. Of course, you would need to study one as large as this from a distance to make some sense of it. This drawing is successful largely because the watery area is not overworked, but has been left almost blank within the enclosing rocks, trees and other vegetation. The dark tones of the vegetation throw forward the negative shapes of the water, making them look foaming and fast-moving.

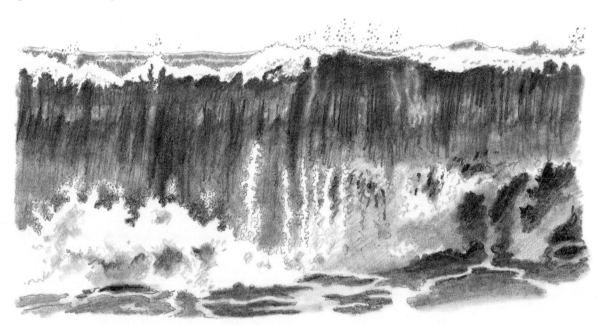

Unless you were looking at a photograph, it would be almost impossible to draw with any detail the effect of an enormous wave breaking towards you as you stood on a shore. Leonardo made some very good attempts at describing the movement of waves in drawings, but they were more diagrammatic in form.

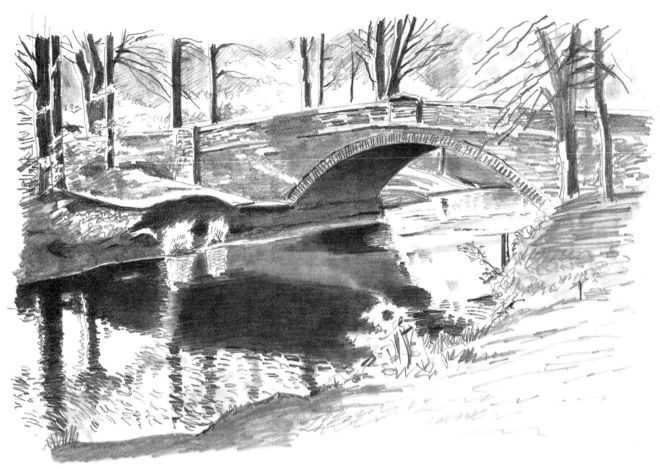

This is water as most of us who live in an urban environment see it – relatively still and reflective. Although the surface of a stretch of water may look smooth, usually there is a breeze or currents causing small shallow ripples. Seen from an oblique angle, these minute ripples give a slightly broken effect along the edges of any objects reflected in the water. When you draw such a scene you need to gently blur or break the edges of each large reflected tone to simulate the rippling effect of the water.

In this very detailed drawing of a stretch of gently rippling water, there appear to be three different tones for the smooth elliptical shapes breaking the surface. This is not an easy exercise but it will teach you something about what you actually see when looking at the surface of water.

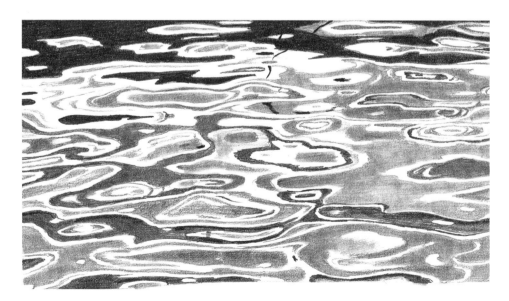

WATER: CONTRASTING MOODS

The contrast in moods between the choppy sea depicted in the first drawing and the glassy-looking water in the second couldn't be more extreme. Pay particular attention to the absence of any reflecting light in the first example, and the fact that the water in the second drawing is described mainly by reflections.

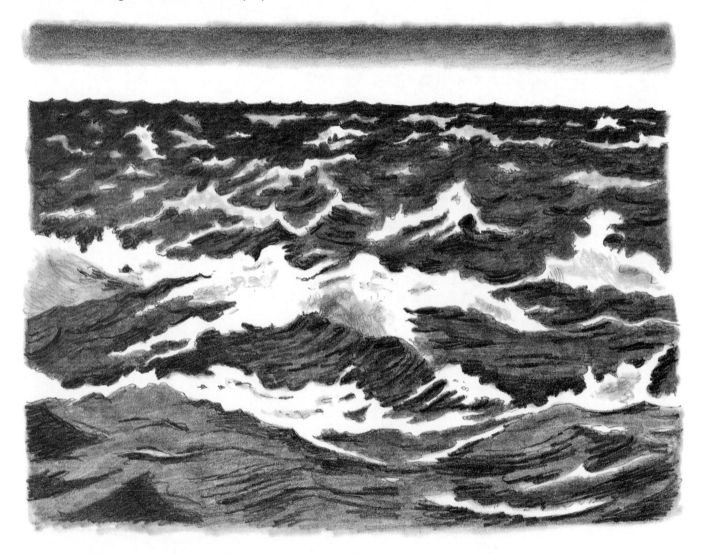

In this view of a choppy inky sea, with breaking crests of foam, the skyline is dark and there is no bright reflection from the sky. The shapes of the foaming crests of the wind-blown waves are very important. They must also be placed carefully so that you get an effect of distance, with large shapes in the foreground graduated to smaller and smaller layers as you work up the page towards the horizon.

Observe how foam breaks; take photographs and then invent your own shapes, once you've seen the typical shapes made in reality. No two crests of foam are alike, so you can't really go wrong. If you are depicting a stormy sea, it is important to make the water between the crests dark, otherwise the effect might be of a bright, albeit breezy, day.

This whole drawing is made up of the sky and its reflection in the river below. The lone boat in the lower foreground helps to give a sense of scale. Although the trees are obviously quite tall in this view, everything is subordinated to the space of the sky, defined by the clouds, and the reflected space in the water. The boat and a few ripples are there to tell the viewer that it is water and not just air. The effect of this vast space and mirror is to generate awe in the viewer.

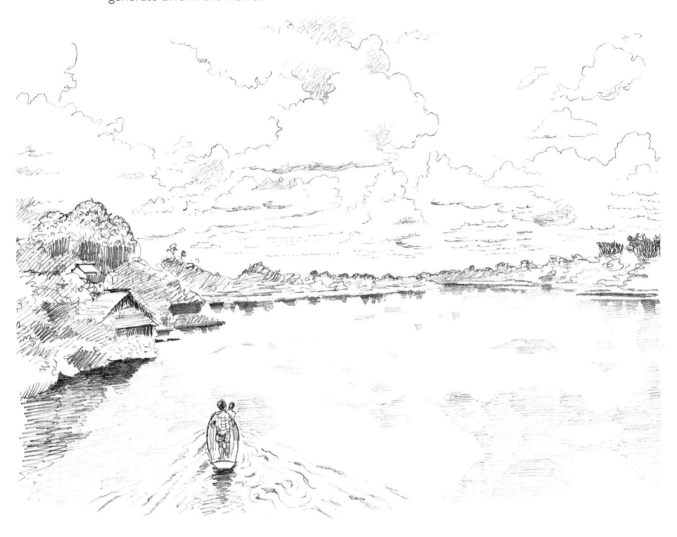

Water is one of the most interesting of subjects for an artist to study and certainly adds a lot to any composition. As you will have noticed, the different shapes it can make and the myriad effects of its reflective and translucent qualities are quite amazing. The subject is limitless, and you will always manage to find some aspect of it that is a little bit different. Go out and find as many examples as you can to draw.

FALLING WATER

One of the problems with drawing waterfalls is the immense amount of foam and spray that the activity of the water kicks up. This can only be shown by its absence, which means you need to have large areas of empty paper right at the centre of your drawing. Novice artists never quite like this idea and usually put in too many lines and marks. As you become more proficient, however, it can be quite a relief to leave things out, especially when by doing so you get the right effect. The spaces provide that effect.

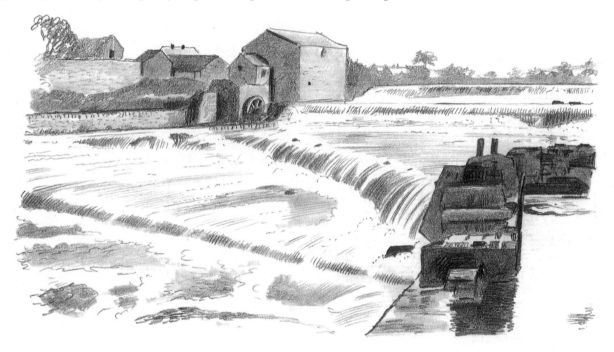

The rapids at Ballysadare produce the most amazing expanse of white water. Most of the drawing has gone into what lies along the banks of the river, throwing into sharp relief the white area of frothing water. These features were put in fairly clearly and in darkish tones, especially the bank closest to the viewer. The four sets of small waterfalls are marked in with small pencil strokes, following the direction of the river's flow. The far bank is kept simple and the farthest away part very soft and pale in tone.

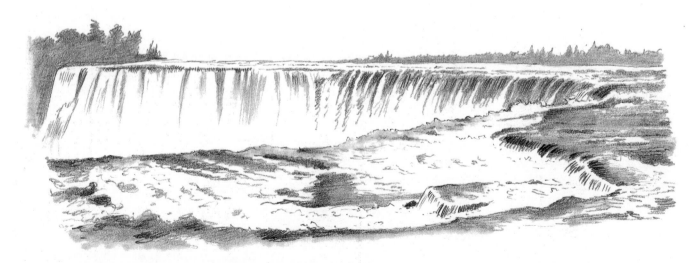

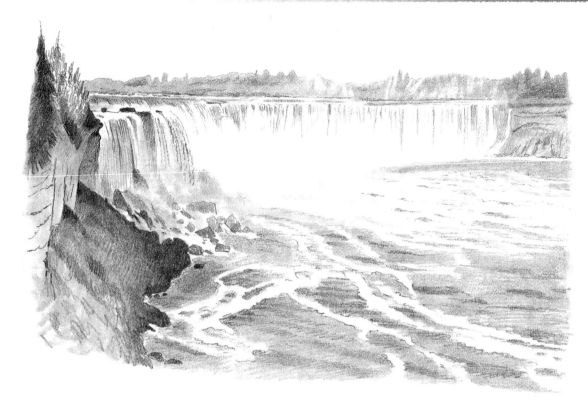

The daddy of all falls – Niagara. The view on the facing page (bottom) is after F. E. Church and shows the Horseshoe from above. The drawing shown above is after Albert Bierstadt and looks at the falls from below. In both examples the falling water is mostly left as white paper with just a few streaks marked to indicate it. The contrast between the almost blank water, the edges of the bank and the tone of the plunge pool gives a good impression of the foam-filled area as the water leaps down into the gorge it has cut in the rock. Drawing such a scene is not difficult as long as the tonal detail is limited.

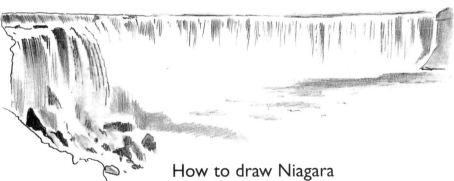

How to draw Niagara

For this exercise I have chosen to ignore the details on the lower river to concentrate on the area of the falls themselves. Mark in the top line of the falls clearly and carefully, but leave a strip of white paper between the distant grey line of the banks and the series of vertical marks of line and tone that denote the tumbling water. These verticals must not be carried too far down or they will destroy the effect of the cloud of spray rising from the bottom of the fall and obscuring our view of the fall itself. You will notice that at either end of the falls the lines continue from top to bottom. At these points the spray is not so dense. In the central area, where the water is boiling with agitation, there is almost nothing to draw. The gaping hole gets across the idea of water being dissolved, almost into mist.

FALLING WATER: PRACTICE

The scale of High Force waterfall in the Pennines is of a different order to that of Niagara, and presents other challenges. Where Niagara is broad, High Force is narrow and, of course, the volume of water that rushes down its steep sides and over its series of steps is much less. As with drawing Niagara, it is mostly the strong tones of the banks that provide contrast with the almost white strip of the waterfall.

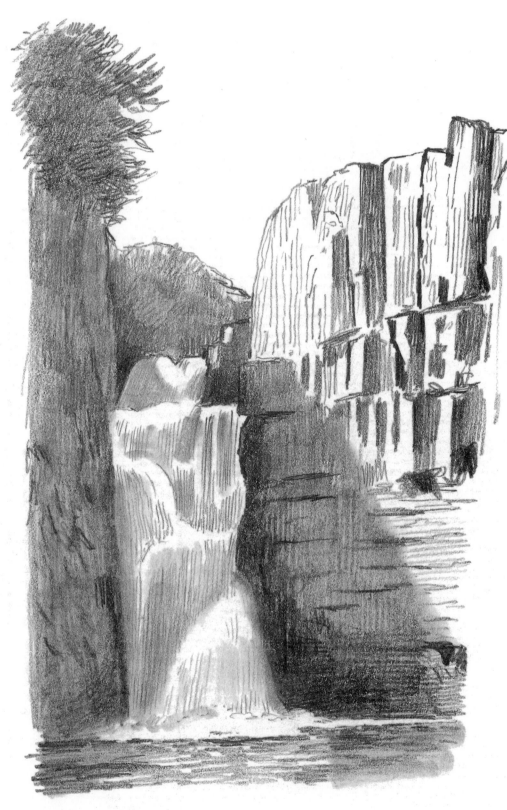

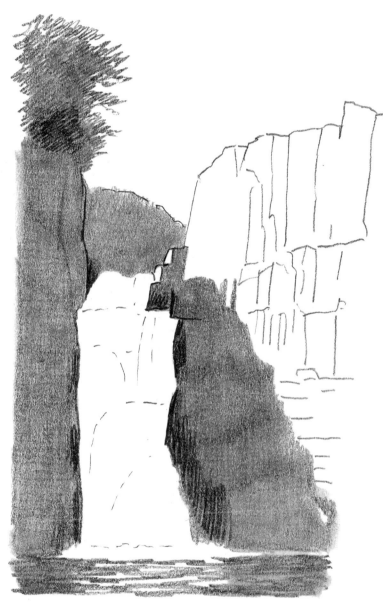

1. Start with the cliffs on either side. Where they are in shadow, use dark tone to block them in. Where they are not, draw them in clearly. In our view the area all around the falls is in shadow and it is this deep tonal mass that will help to give the drawing of the water its correct values. Leaving the area of the falls totally blank, put in the top edges of each ledge in the cliff face. Draw in the plunge pool and the reflection in the dark water at the base of the falls.

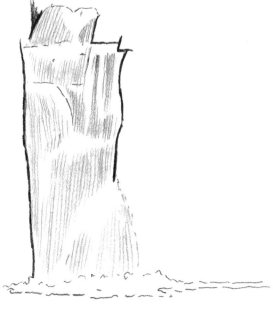

2. Leaving a clear area of white paper at the top of the ledges, indicate the downward fall of the water with very lightly drawn closely spaced vertical lines. Don't overdo this. The white areas of paper are very important in convincing us that we are looking at a drawing of water.

SEA: LITTLE AND LARGE

When you want to produce a landscape with the sea as part of it, you have to decide how much or little of the sea you want to show. The viewpoint you choose may mean you have to draw very little sea, a lot of sea, or all sea. In the next series of drawings we examine these propositions and look at ways of using the sea in proportion to the land.

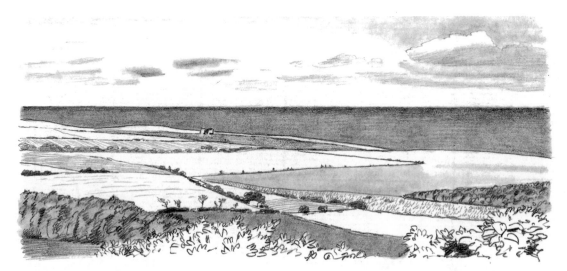

In our view of the Norfolk coast the sea takes up about one-eighth of the whole picture. Because the landscape is fairly flat and the sky is not particularly dramatic, the wide strip of sea serves as the far-distant horizon line. The result is an effective use of sea as an adjunct to depth in a picture. The calm sea provides a harmonious feel to the whole landscape.

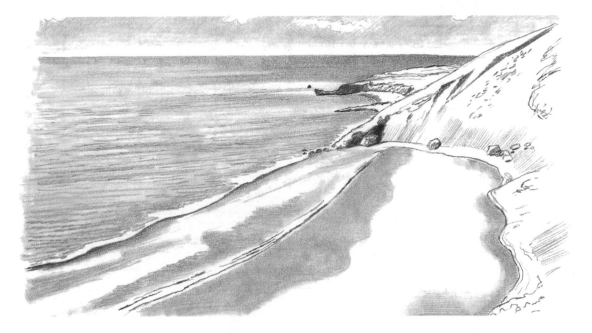

In the next scene the sea takes up two-thirds of the drawing, with sky and land relegated in importance. The effect is one of stillness and calm, with none of the high drama often associated with the sea. The high viewpoint also helps to create a sense of detachment from everyday concerns.

Such a large expanse of sea could be boring unless it was turbulent. What makes the scene interesting is the strip of solid earth jutting into the picture and dividing the sea from the sky. This transforms the sea into a foil for the rugged cliffs.

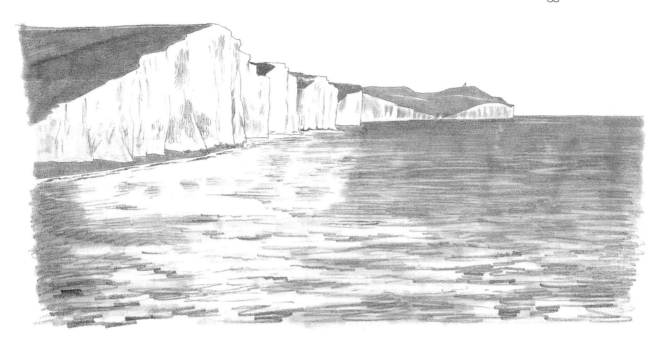

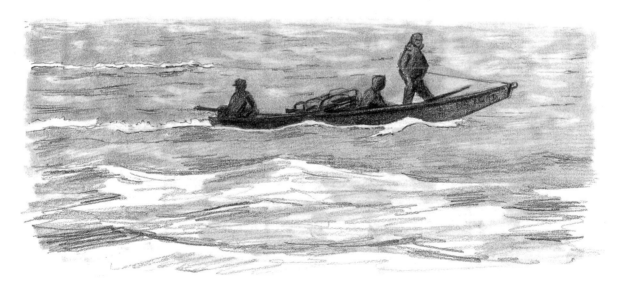

When the sea is the whole landscape the result is called a seascape. The boat with the three fishermen is just a device to give us some idea of the breadth and depth of the sea. If the sea is to be the whole scope of your picture, a feature like this is necessary to give it scale.

SEA IN THE LANDSCAPE: PRACTICE

The sea takes up two-thirds of this picture, which shows a wide bay with rocky cliffs enclosing a flat beach on Lanzarote. The sweep of the sea from the horizon to the surf on the beach creates a very pleasant and restful depth to the drawing. The close-up of rocky boulders adds a touch of connection to the onlooker, as does the viewpoint, which suggests we are viewing the scene from high up on the cliff. As with the drawing on p.202, it is the area of calm sea that sets the mood.

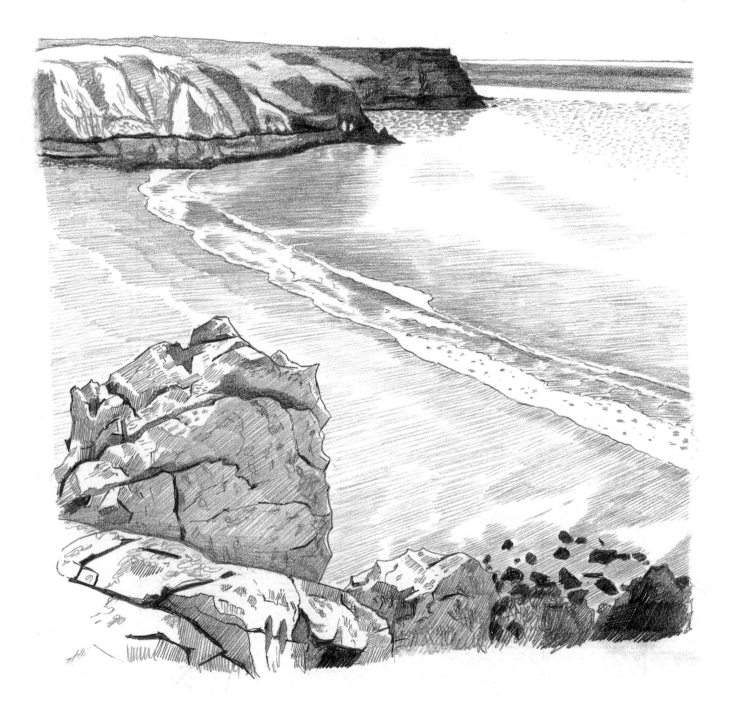

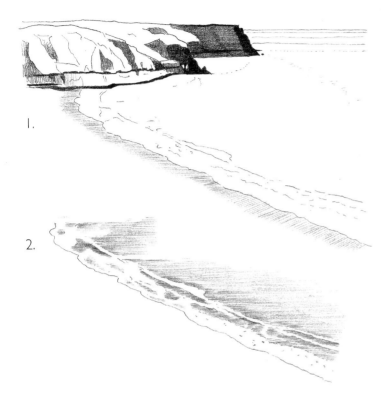

1. Outline the main areas, starting with the horizon and the cliffs in the background, then the edge of the water across the bay, and finally the close-up of the nearest rocks on the cliff-top.

When the outline is in place, put in the very darkest areas of the background. This will establish the values for all the other tones you will be using. Keep it simple to start with, just blocking in the main areas. Then add the lighter tones to the background, including the furthest layers of tone to designate the sea near the horizon.

2. Add tones to the beach in two stages. First, mark in very gently and carefully the tone along the line of the surf. Keep this fairly light and very even and follow the slope of the beach with your pencil marks. Next, draw the slightly darker areas of the sea where it is closest to the surf line. The contrast between this tone and the white paper left as surf is important to get a convincing effect. Lastly, put in the larger areas of tone in the sea. Use dotted or continuous lines, but don't overdo them; leave plenty of white space to denote reflections of light. Tonal lines similar to those already put in can be carefully stroked in all over the beach area. Don't vary your mark-making too much or you may end up with the effect of deep furrows, which would not look natural on a flat beach.

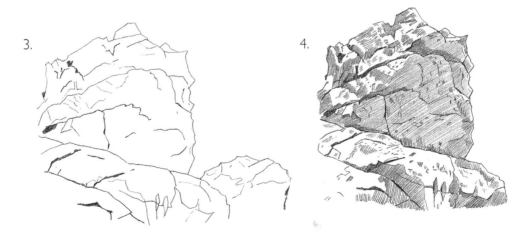

3/4. For the rocks, use clear outlines, deep shadows where there are cracks, and carefully layered tones composed of closely drawn lines all in the same direction. Some of these should be in small patches, others in larger areas. Leave all well-lit surfaces as white paper, with only marks to show texture.

SEA IN THE LANDSCAPE: PRACTICE WITH BRUSH AND WASH

One of the most effective, and fun, ways of capturing tonal values is to do them in brush and wash. In this view of the Venetian lagoon in early morning, looking across from the Giudecca to the island of San Giorgio, its Palladian church etched out against the rising sun, the use of wash makes the task of producing a successful result much simpler. Getting the areas of tone in the right places is the key to success. It doesn't matter if your final picture is a bit at variance with reality – just make sure the tones work within the picture. More confidence is needed for this kind of drawing, and it is advisable to practise your brush techniques before you begin to make sure the wash goes on smoothly. Don't worry if you make a mistake. You certainly won't get it right first time, but over time you will come to appreciate the greater realism and vividness this technique allows.

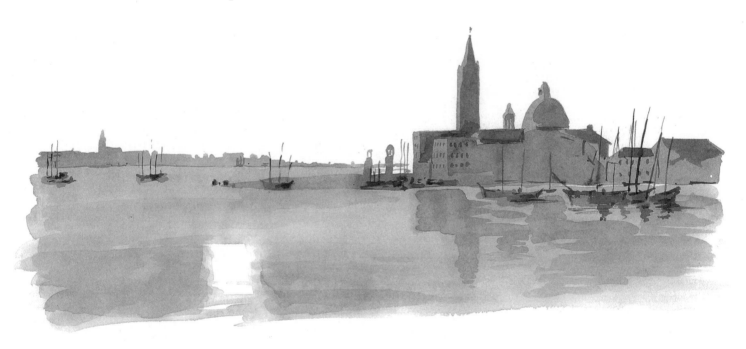

First the main shape of the island and its church was brushed in with a medium tone of wash. Then, while it dried, the far-distant silhouette of the main part of Venice was brushed in with the same tone. Then the darker patches of tone on the main area were put in, keeping it all very simple. Now it was possible to wash in a fairly light all-over tone for the water, leaving one patch of white paper where the reflected sun caught the eye. Even darker marks could now be put in with a small brush to define the roofs, the windows and the boats surrounding the island. The reflections in the water were put in next. After that, when all was dry, the very darkest marks such as the details of the boats were added to make them look closer to the viewer than the island and background.

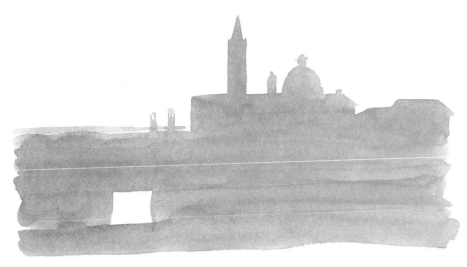

1. The first tone to put in is the lightest and most widespread which shows us the horizon line and the basic area of the buildings with differentiation except where they jut up above the horizon and are outlined against the sky. Leave a patch of white paper to indicate the lightest reflection in the water. Don't worry if your patch doesn't quite match the area that you can see.

2. Your second layer of tone should be slightly heavier and darker than the first. This requires more drawing ability, because you have to place everything as close as possible to effectively show up the dimension of the buildings. Also with this tone you can begin to show how the reflections in the water repeat in a less precise way the shapes of the buildings. Once again, try to see where the reflections of light in the water fall.

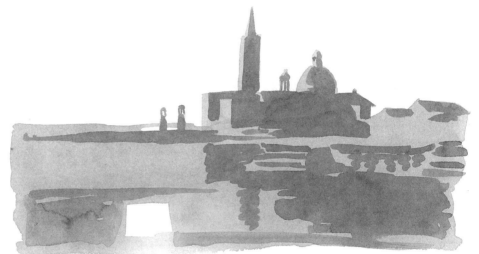

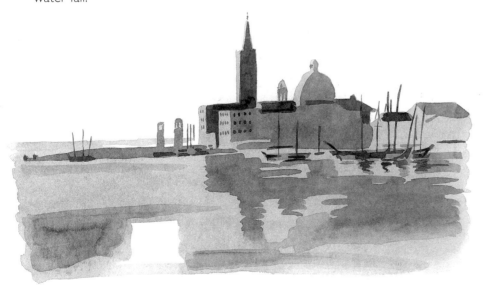

3. The third layer of tone is darker still. With this you can begin to sharply define the foreground areas. The parts of the buildings strongly silhouetted against the sky are particularly important. Now put in the patches showing the boats moored near the quay and the dark, thin lines of their masts jutting up across the sky and buildings.

You can go on adding detail but these first three stages are the most important. If they're correct the rest will work. If they're badly wrong the additions won't redeem your picture, and it is better to have another shot.

SKY – ITS IMPORTANCE

The next series of pictures brings into the equation the basic background of most landscapes, which is, of course, the sky. As with the sea in the landscape, the sky can take up all or much of a scene or very little. Here we consider some typical examples and the effect they create. Remember, you control the viewpoint. The choice is always yours as to whether you want more or less sky, a more enclosed or a more open view.

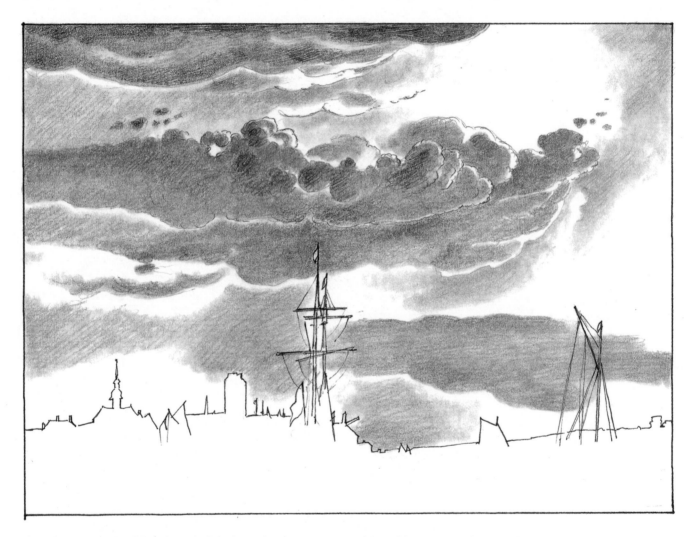

Our first example (after Albert Cuyp) is of a dramatic sky with a chiaroscuro of tones. Very low down on the horizon we can see the tops of houses, ships and some land. The land accounts for about one-fifth of the total area, and the sky about four-fifths. The sky is the really important effect for the artist. The land tucked away at the bottom of the picture just gives us an excuse for admiring the spaciousness of the heavens.

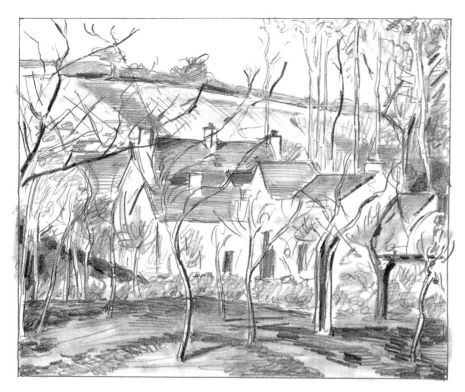

This country scene (after Pissarro) is a very different proposition. The hills behind the village, which is screened by small orchard trees, allow us a glimpse of only a small area of sky beyond the scene. The fifth of sky helps to suggest space in a fairly cluttered foreground, and the latticework quality of the trees helps us to see through the space into the distance. It is important when drawing wiry trees of this type to capture their supple quality, with vigorous mark-making for the trunks and branches.

John Constable's view of East Bergholt church through trees shows what happens when almost no sky is available in the landscape. The overall feeling is one of enclosure, even in this copy. Constable obviously wanted this effect. By moving his position slightly and taking up a different viewpoint he could have included much more sky and banished the impression of a secret place tucked away.

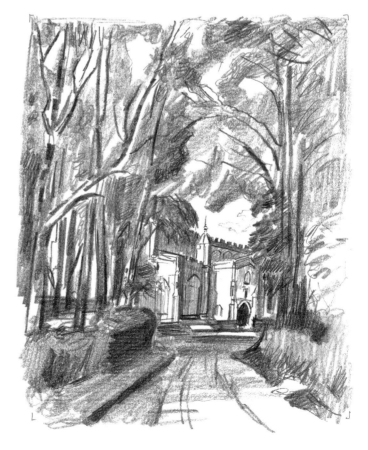

CLOUDS

The importance of clouds to suggest atmosphere and time in a landscape has been well understood by the great masters of art since at least the Renaissance period. When landscapes became popular, artists began to experiment with their handling of many associated features, including different types of skies. The great landscape artists filled their sketchbooks with studies of skies in different moods. Clouded skies became a significant part of landscape composition with great care going into their creation, as the following range of examples shows.

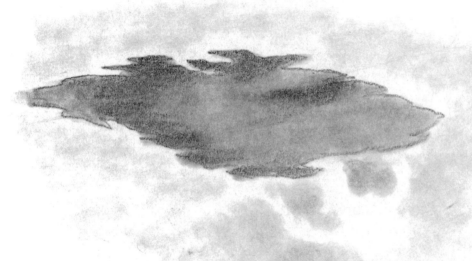

After a follower of Claude Lorrain

This study is one of many such examples which show the care that artists lavished on this potentially most evocative of landscape features.

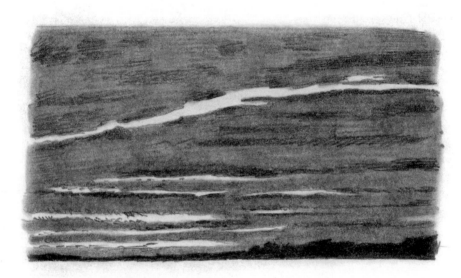

After Caspar David Friedrich

One of the leading German Romantic artists, Friedrich gave great importance to the handling of weather, clouds and light in his works. The original of this example was specifically drawn to show how the light at evening appears in a cloudy sky.

After Willem van de Velde II

Some studies were of interest to scientists as well as artists and formed part of the drive to classify and accurately describe natural phenomena.

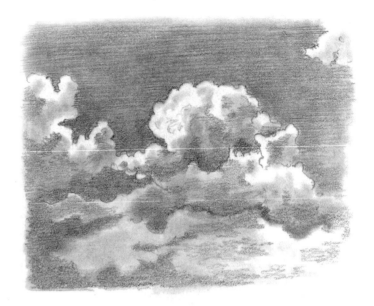

After Alexander Cozens

The cloud effects are the principal interest here. The three evident layers of cloud produce an effect of depth, and the main cumulus on the horizon creates an effect of almost solid mass.

After J. M. W. Turner

Together with many other English and American painters, Turner was a master of using cloud studies to build up brilliantly elemental landscape scenes. Note the marvellous swirling movement of vapour, which Turner used time and again in his great landscapes and seascapes.

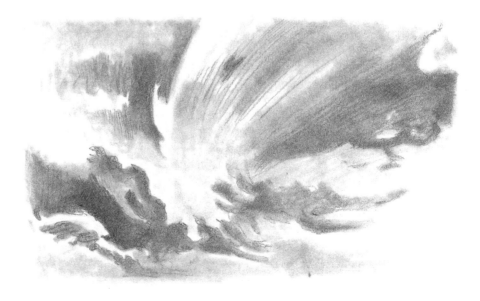

A DRAMATIC SKY: PRACTICE

Here is a large dramatic sky, after Constable, depicting a rainstorm over a coastal area, with ships in the distance. The sweeping linear marks denoting the rainfall give the scene its energy. The effect of stormy clouds and torrential rain sweeping across the sea is fairly easily achieved, as long as you don't mind experimenting a bit. Your first attempt might not be successful, but with a little persistence you will soon start to produce interesting effects, even if they are not exactly accurate. This type of drawing is great fun. Keep going until you get the effect you want.

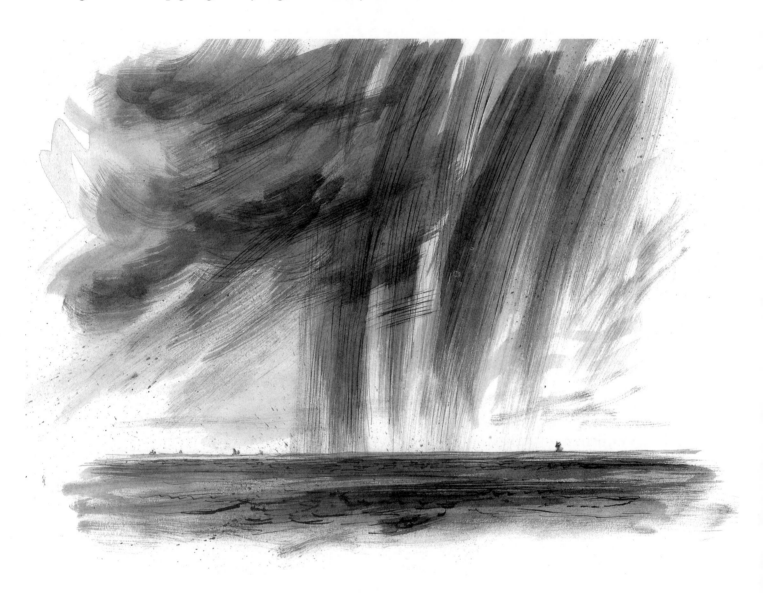

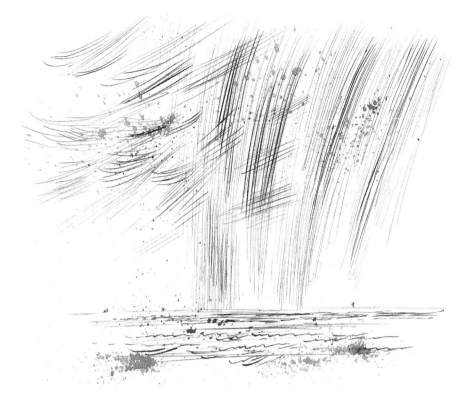

1. For the first stage, use a fine pen with a bit of flexibility in the nib and black ink. Scribble in vertical and wind-blown lines to suggest heavy rainfall. The sea can be marked in using both fine horizontal strokes and more jagged, fairly strong wave-like marks. To complete the effect, dip a hogs-hair brush into dark watercolour paint and splatter this across areas of the picture. This produces a more uneven texture to suggest agitated sea and rain.

2. Then, using a large and small (size 12 and smaller) hogs-hair brush, put in pale washes of watercolour across the sweep of the rain and horizontally across the sea. Repeat this with a darker tone until you get the effect you require in the sky and sea. Allow the brush to dry out periodically and then apply almost dry brush marks to accentuate the effect of unevenness or patchiness.

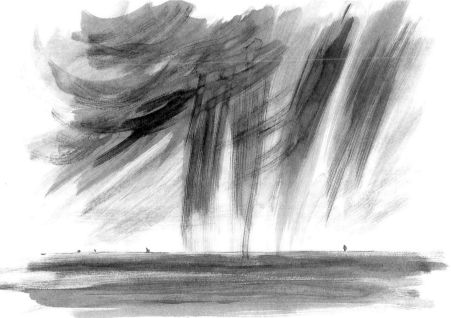

SKY: EXPRESSIVE CLOUDS

The sky plays a very dramatic role in these two examples of landscapes: copies of
Van Gogh's picture of a cornfield with cypress trees, and of Van Ruisdael's 'Extensive
Landscape'. Although different in technique, both types of landscape are easier to do
than they look.

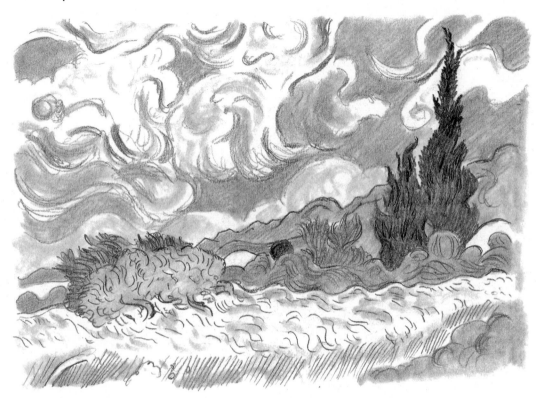

The Van Gogh copy is characterized by strange, swirling mark-making for the sky, trees and
fields. The feeling of movement in the air is potently expressed by the cloud shapes which,
like the plants, are reminiscent of tongues of fire. Somehow the shared swirling characteristic
seems to harmonize the elements. The original painting was produced not very long before
the artist killed himself.

Draw in the main parts of the
curling trees and clouds and the
main line of the grass and bushes.
Once you have established the
basic areas of vegetation and cloud,
it is just a case of filling in the gaps
with either swirling lines of dark
or medium tones or brushing in
lighter tones with a stump. Build up
slowly until you get the variety of
tones required.

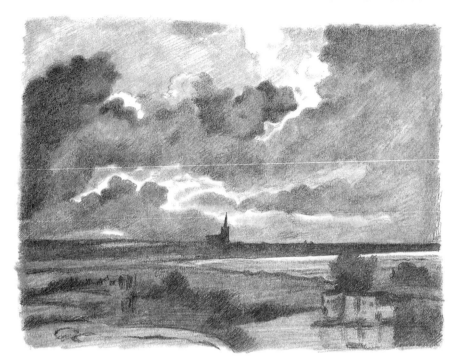

Ironically the land referred to in the title 'Extensive Landscape' only takes up a third of the space. The clouds, drawn in contrasting dark areas with a few light patches, create an enormous energetic sky area in which most of our interest is engaged. The land by comparison is rather muted and uneventful.

First, mark in with light outlines the main areas of cloud, showing where the dark cloud ends and the lighter sky begins. Draw in the main areas of the landscape, again marking the lines of greatest contrast only.

Next, take a thick soft pencil (2B–4B) and shade in all the darker and medium tones until the sky is more or less covered and the landscape appears in some definition. Finish off with a stump to smooth out some of the darker marks and soften the edges of clouds. The more you smear the pencil work the more subtle will be the tonal gradations between dark and light. Afterwards you may have to put in the very darkest bits again to increase their intensity.

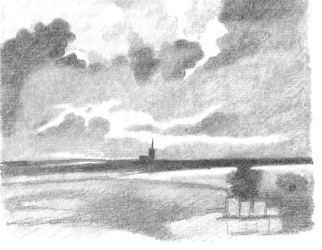

SKY: USING SPACE

The spaces between clouds as well as the shapes of clouds themselves can alter the overall sense we get of the subject matter in a drawing. The element of air gives us so many possibilities, we can find many different ways of suggesting space and open views. Compare these examples.

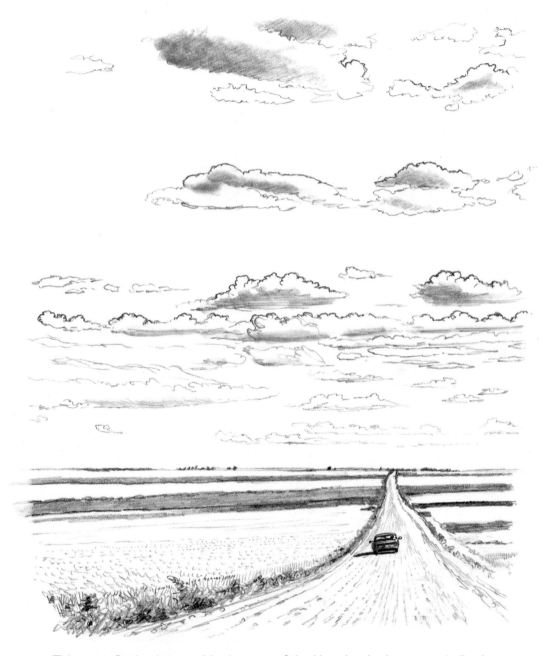

This open, flat landscape with pleasant soft-looking clouds gives some indication of how space in a landscape can be inferred. The fluffy cumulus clouds floating gently across the sky gather together before receding into the vast horizon of the open prairie. The sharp perspective of the long, straight road and the car in the middle distance tell us how to read the space. This is the great outdoors.

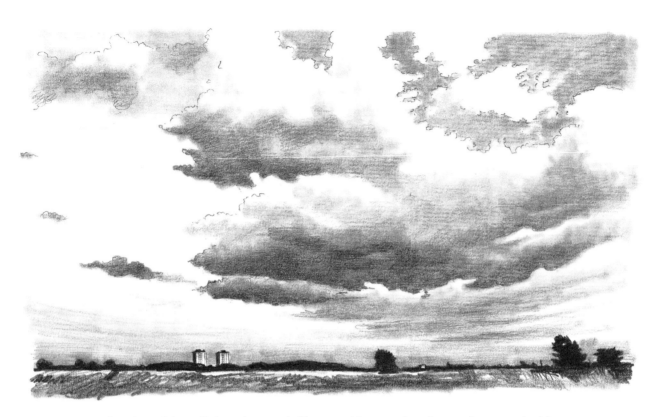

Another vision of air and space is illustrated here: a sky of ragged grey and white clouds, and the sun catching distant buildings on the horizon of the flat, suburban heathland below. Note particularly the low horizon, clouds with dark, heavy bottoms and lighter areas higher in the sky.

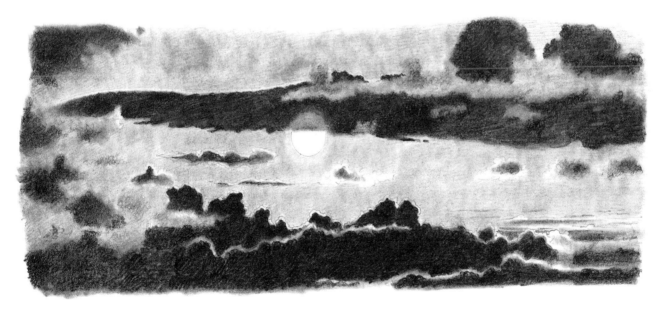

Despite the presence of dark, dramatic clouds in this scene at sunset the atmosphere is not overtly gloomy or brooding. The bright sun, half-hidden by the long flat cloud, radiates its light across the edges of the clouds, which tell us that they are lying between us and the sun. The deep space between the dark layers of cloud gives a slightly melancholic edge to the peacefulness.

LEAVES, GRASS AND FLOWERS

Plants carefully drawn instantly tell us that they are very close to the viewer and help to impart a sense of depth and space to a scene, especially when you contrast the detail of the leaves with the more general structure of whole trees further away.

A very good practice, when you are unable to find a satisfying landscape view, is to draw in detail the leaves of plants in your garden or even in pots in your house. This exercise is always useful and never a waste of time because it helps to keep your eye in and your hand exercised. The information you get from it about growth patterns will also help when you start on a full-blown landscape.

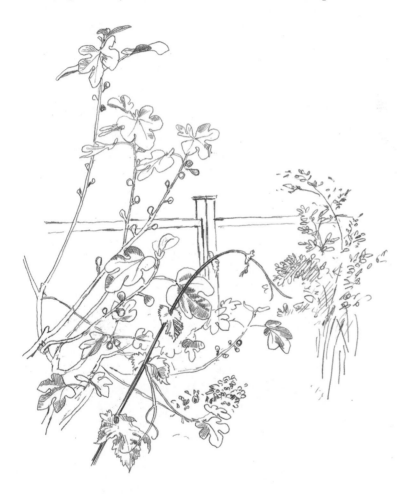

Our first example is of a fig tree with some vine leaves growing up from below a window and across the view of the fig. An exercise of this type gives you the chance to differentiate the closer plant from the further by altering your drawing style.

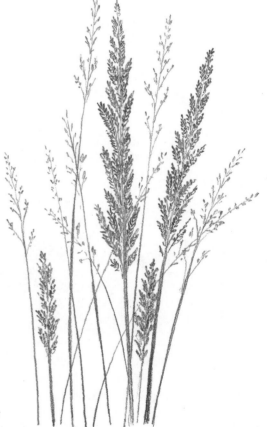

Tall grass, either ornamental or wild varieties, or cereal crops, can give a very open look in the forefront of a scene. The only problem is how much you draw – putting in too much can command all the attention and take away from the main point in a scene.

You will find these next two exercises useful when you have to draw large amounts of grass. Note the overlapping tufts and smaller plants like clover tucked in at their bases.

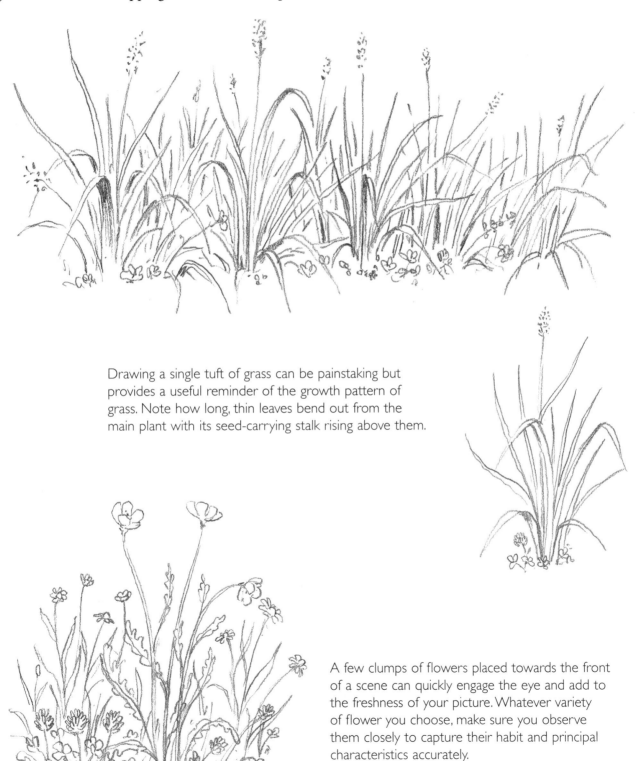

Drawing a single tuft of grass can be painstaking but provides a useful reminder of the growth pattern of grass. Note how long, thin leaves bend out from the main plant with its seed-carrying stalk rising above them.

A few clumps of flowers placed towards the front of a scene can quickly engage the eye and add to the freshness of your picture. Whatever variety of flower you choose, make sure you observe them closely to capture their habit and principal characteristics accurately.

FOREGROUND: FRAMING THE PICTURE

Here are two sketches I did while holidaying in Greece. Note how in each picture elements in the foreground combine to provide a perfect frame for the view. I was not aware of this natural frame until I started to consider the view and how best to draw it. Allowing us to see what is in front of our eyes is one of the aspects of drawing that never fails to delight me.

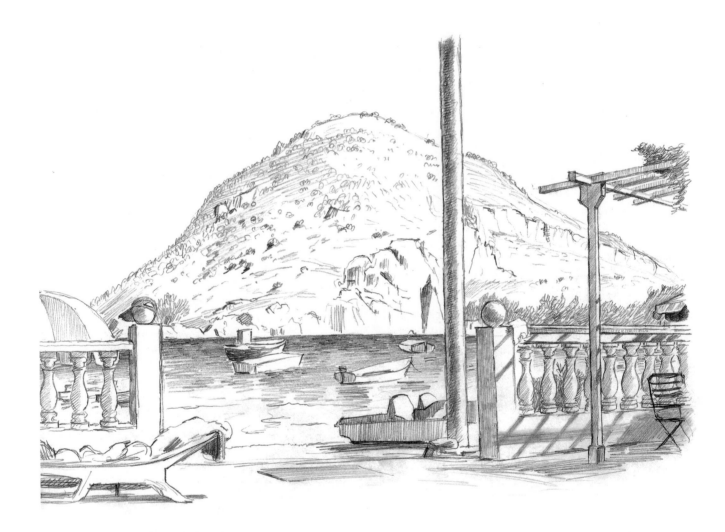

The man-made world of the holiday beach of Tolon is the main subject here. In the foreground there is a suggestion of a pergola, and sun loungers, pedaloes, a solid post for lighting and a sturdy verandah wall are in evidence. Framed between these details is a strip of sea with its moored pleasure boats and rafts. Across the stretch of water we can see an island, which is known locally as Aphrodite's Breasts on account of its twin hills. The carefully built foreground helps to create the feeling of serenity and well-being.

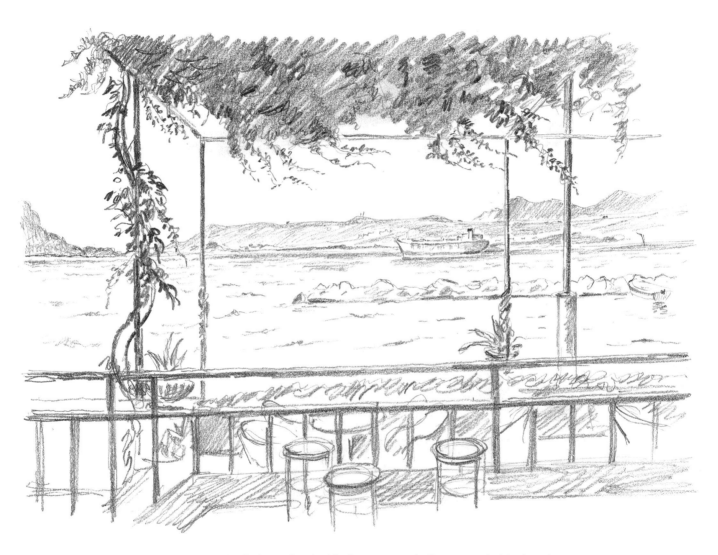

Once again the inclusion of a decidedly man-made foreground, this time in the shape of seats and railings, helps to temper the rugged naturalness of the sea and rocks. The view is of Navarino Bay as seen from Pylos.

INDICATING DISTANCE

In most landscapes you visit there will be man-made objects that can work in your picture as an instant pointer to the distance beyond or the distance between the viewer and the object. In this next series of drawings the subtler aspects have been purposely left out in order to show how foreground objects give definite clues as to size and distance.

A picket fence looks simple enough but to draw it is quite an exercise if you are to get the structure correct and capture its tones and texture. Placed in the foreground of a picture, it can be used as an indicator for the rest of the view, enabling us to relate to the size of the pickets and so judge the distances behind.

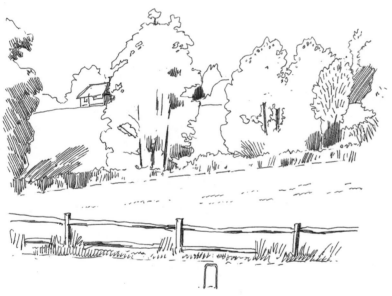

Now let's look at a fence alongside a country road with an open field and trees behind it. The fence must stand at waist-height at least, so giving the trees and spaces behind it a sense of distance, although these are drawn without any real effort to show distance variations. The croquet hoop in front of the fence provides another size indicator, but it is the fence that shapes our idea of depth in the picture.

A little way past the fence in this drawing you will notice three trees which act as a sort of frame for the landscape behind. We can tell by the line of the turf in which the trees are standing that they are a few yards from the fence and so we get some idea of their size. The field and simple depiction of tree lines behind the trees in the foreground give an indication of not only the space behind the fence and trees but also the slope of the landscape, dipping away from us and then rising up again towards the horizon.

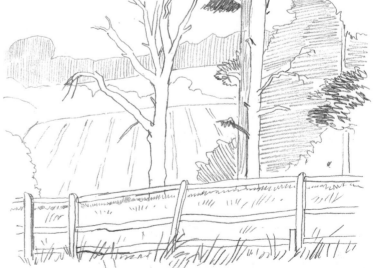

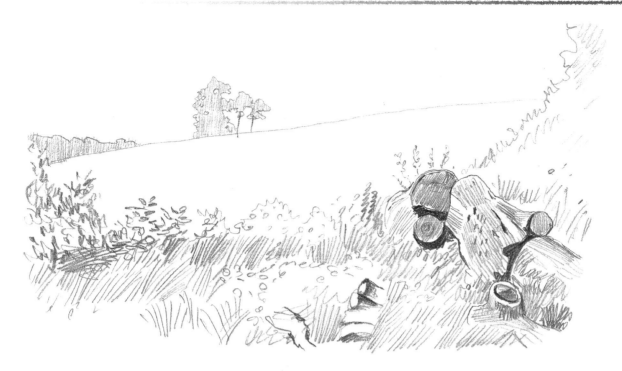

This example doesn't actually show a man-made object, but one affected by the activity of man. The large chunky logs, half hidden in the long grass next to a low hedge, give a very clear indication of how close we are to them, and also how far we are from the stretch of hillside with its isolated trees on the skyline. The logs offer a simple yet effective device to give an impression of open space.

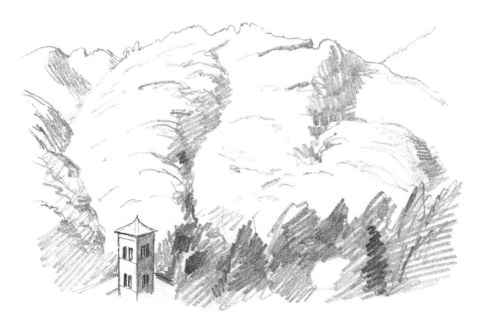

Our next scene is quite unusual and one I happened upon in an old village called Boveglio, near Lucca in Italy. The view is across a steep valley. On the opposite side thickly wooded hills sweep up to the skyline. The rather diminutive-looking tower below belongs to a church in Boveglio which is in fact large enough to house a couple of bells.

PRACTISING FOREGROUND FEATURES

Urban environments offer opportunities for drawing all sorts of objects you may want to include in your compositions as foreground details. A garden table and chairs or machinery such as a bicycle are found in most households and can be used creatively to make satisfying mini-landscapes. It is amazing how ordinary objects can add drama to a picture.

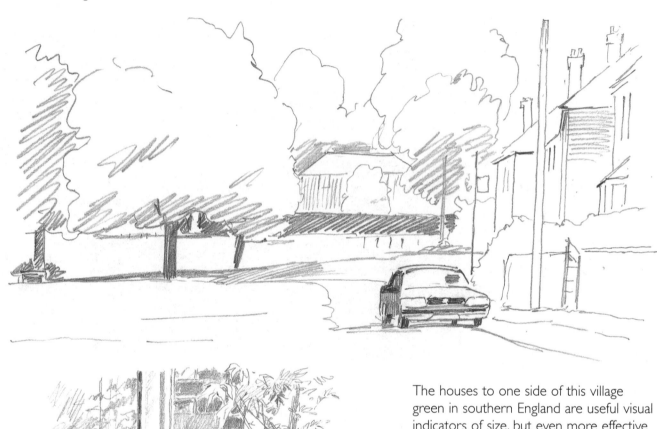

The houses to one side of this village green in southern England are useful visual indicators of size, but even more effective is the lone car parked on the pathway, because this tells us something about the distance between it and us. It also gives us a good idea of the space behind the trees in the middle distance and the hedges and house behind.

The bicycle lends an air of habitation to the blank corner on which it is balancing, with the vine curving around and up the brickwork. If part of the landscape could be seen past the corner it would give a very sharp contrast between our position as viewers and whatever was visible behind. Even a small garden would give an effect of space. If the landscape was a street the contrast would be even more dramatic.

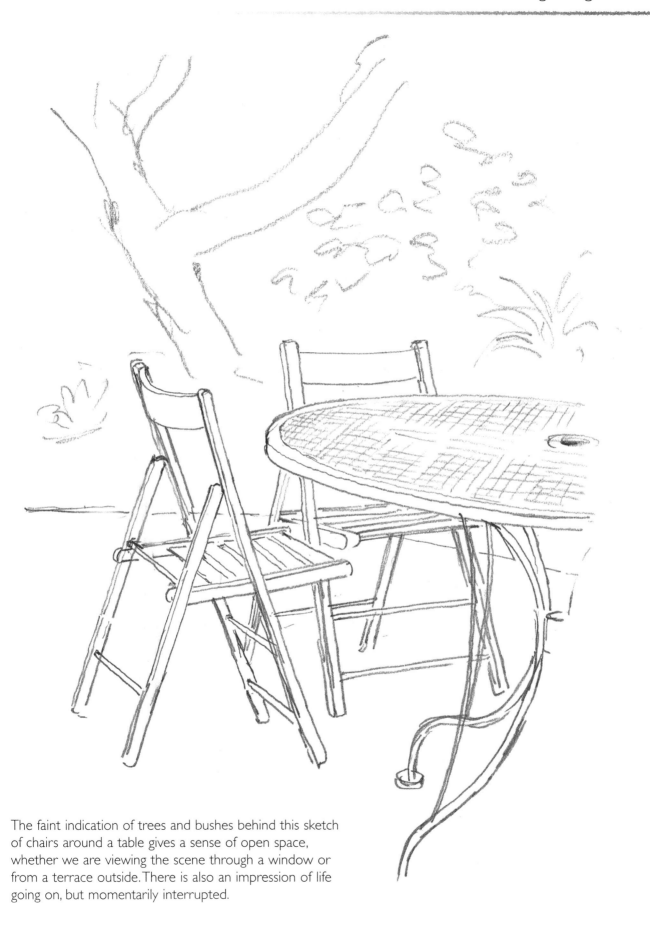

The faint indication of trees and bushes behind this sketch of chairs around a table gives a sense of open space, whether we are viewing the scene through a window or from a terrace outside. There is also an impression of life going on, but momentarily interrupted.

Architectural features abound
in town and country, in fact
anywhere there is human
habitation. Any details of
architecture that clearly give an
impression of age and sometimes
disrepair are always good points
of interest to include in a picture.

Steps or the front of an ordinary house
are the sorts of foreground details you
might well want to include in a larger
composition. They are very good examples
of the kinds of practice you will need if
you are to develop your skills.

This remarkable piece of Venetian Gothic architecture could easily act as a scene-setter for a larger view of the city. Such details add a historic – and often very attractive – dimension to a picture.

THE MIDDLEGROUND

If a foreground has done its job well, it will lead your eye into a picture, and then you will almost certainly find yourself scanning the middleground. This is, I suppose, the heart or main part of most landscape compositions and in many cases will take up the largest area or command the eye by virtue of its mass or central position. It is likely to include the features which encouraged the artist to draw that particular view. Sometimes it is full of interesting details that will keep your eyes busy discovering new parts of the composition. Often the colour in a painting is strongest in harmony and intensity in this area. The story of the picture is usually to be found here, too, but not always; some notable exceptions will be among the examples shown. The eye is irresistibly drawn to the centre and will invariably return there no matter how many times it travels to the foreground or on to the background. The only occasion when the middleground can lose some of its impact is if the artist decides to reduce it to very minor proportions in order to show off a sky. If the proportion of the sky is not emphasized the eye will quite naturally return to the middleground.

Let us now compare and contrast some treatments of the middleground, starting with two sharply contrasting examples. In order to emphasize the area of the middleground, I have shaded the foreground with vertical lines and the extent of the background is indicated by dotted lines.

A classical approach

The centre of this picture (after John Knox) contains all the points of interest. We see a beautiful valley of trees and parkland, with a few buildings that help to lead our eyes towards the river estuary. There, bang in the centre, is a tiny funnelled steamship, the first to ply back and forth along Scotland's River Clyde, its plume of smoke showing clearly against the bright water. Either side of it on the water, and making a nice contrast, are tall sailing ships. Although the middleground accounts for less than half the area taken up by the picture, its interesting layout and activity take our attention.

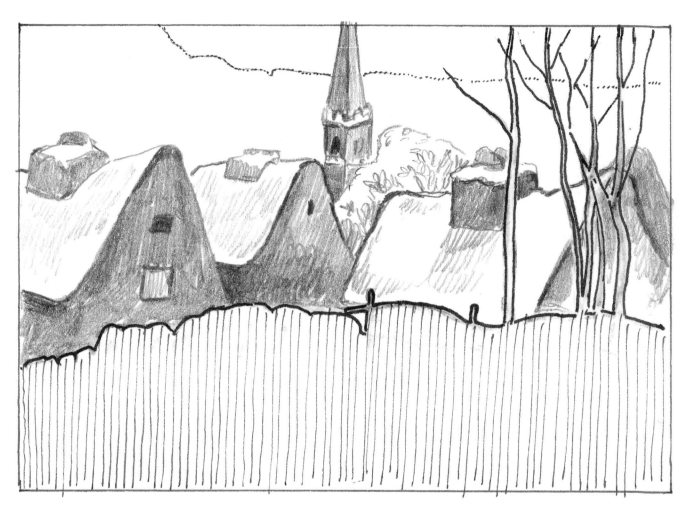

An unusual approach

In this snow scene (after Gauguin) the foreground, middleground and background take up about the same space. The primary importance of the middle area is suggested by keeping both foreground and background very simple and devoid of features. The only details we notice are the tree pattern stretching from the foreground across both middle- and background and the church steeple bisecting the background. The interest in the picture is framed between these two empty spaces which are made to seem emptier still by the snow. By contrast the central area is full of shape and colour.

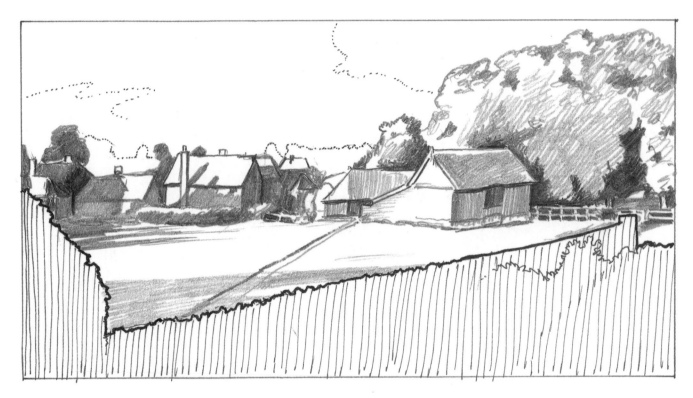

A ground-breaker

No attempt has been made here (after Constable's picture of his uncle's house at East Bergholt) to centralize or classicize the arrangement of buildings. Constable believed in sticking to the actuality of the view rather than recomposing it according to time-honoured methods. The result is a very direct way of using the middleground, a sort of new classicism. Our eye is led into the picture by the device of the diagonal length of new wall dividing the simple dark foreground from the middleground. The sky and a few treetops are all there is of the background; note how some of the sky is obscured by trees in the middleground. Everything ensures that the attention is firmly anchored on the middleground, where the main interest of the buildings is emphasized by the small space of the garden in the front. The composition is more accidental-looking – and therefore more daring – than was generally the case at that time.

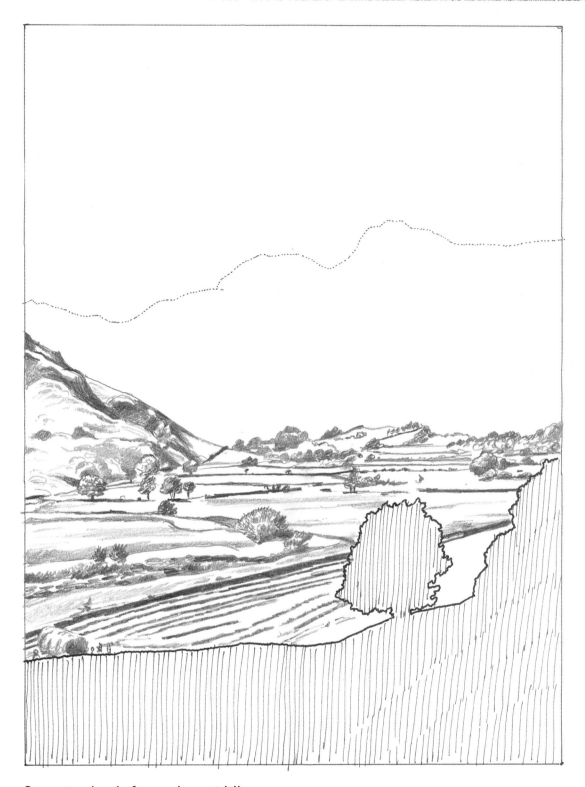

Stepping back from the middle

The point of this picture is actually in the background. The foreground is simple and effectively a lead-in frame. The middleground is full of interest as the floor of a flourishing valley. But the picture was framed purely for the reason of showing the mountains in the background. This time the middleground is merely a foil to make the mountains look better.

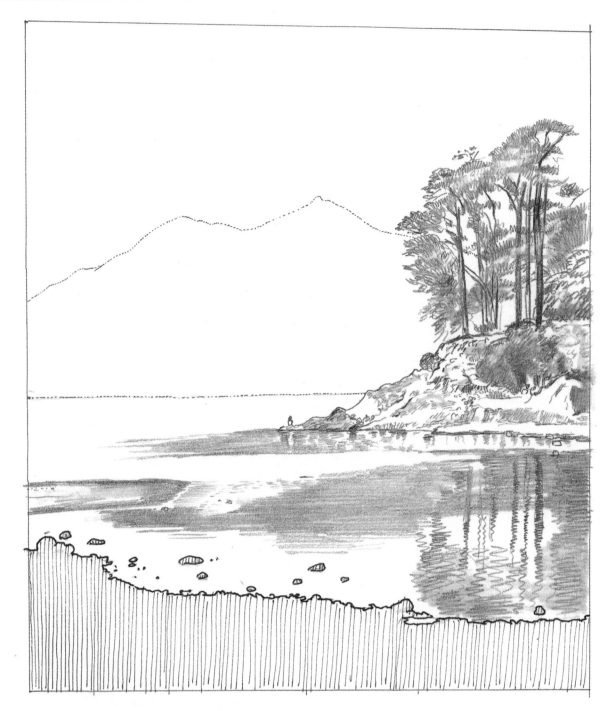

Pointing out the space

This view of Derwentwater in the Lake District offers a very simple yet effective way of highlighting the importance of the middleground. The majority of this area is taken up with one feature – water. However, as this might prove too bland to arrest the eye, a jutting spur of rock to the right acts as a focal point and keeps our attention well into the centre of the lake. The spur is almost like a finger pointing to the water to make sure we don't miss it.

The reflections in the water also give the expanse of lake a little more liveliness, although the smooth surface is uneventful.

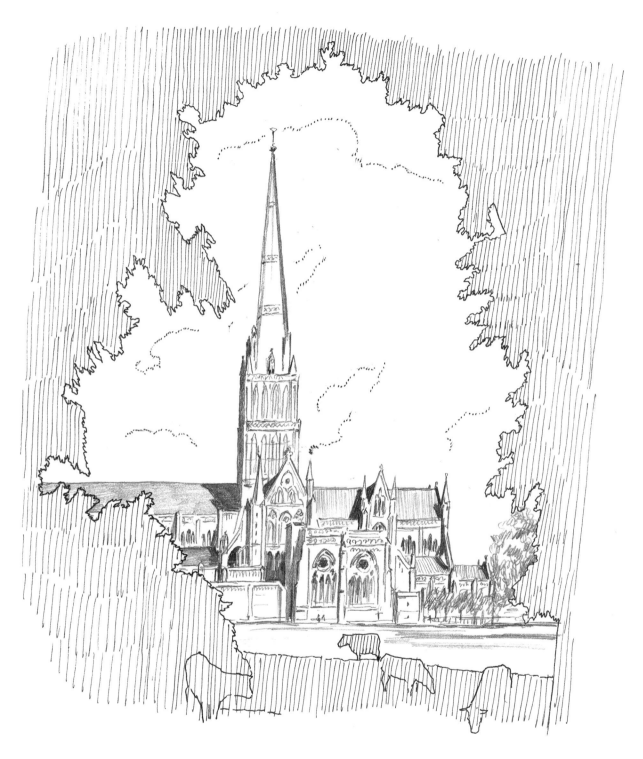

A triumph of economy

Another picture after that master of landscape, John Constable, this time
from his later years. The subject of the picture is Salisbury Cathedral, and
that is just what you get. The foreground is a frame of leaves and a few
cows grazing, brilliantly vignetting the building. The background is all sky, but
a lively one. The magnificent spire and long nave of the cathedral account
for the whole of the middleground.

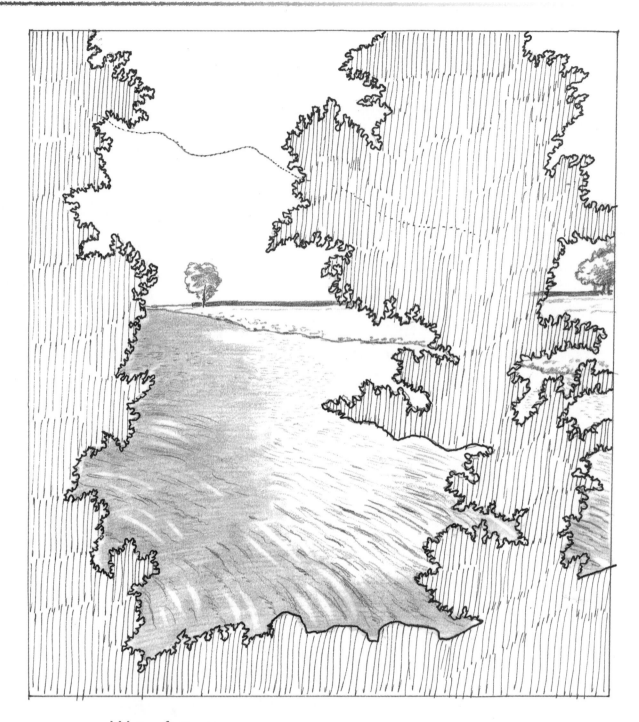

Water feature

This picture uses a similar device to that seen in the copy of the Constable (see preceding spread) but with a different result. The foreground of trees and rocks vignettes the middle and background, although less precisely, by having one tree obscuring almost half the scene. The tree is actually less solid than it appears here, and some of the scene is visible through its leaves. The background is just a mountain backdrop. The point of the picture, of Buttermere in the Lake District, is almost the whole of the middleground. There is just a small strip of land on the far side with a tree at each end to anchor it down, but the real focus for our attention is the water.

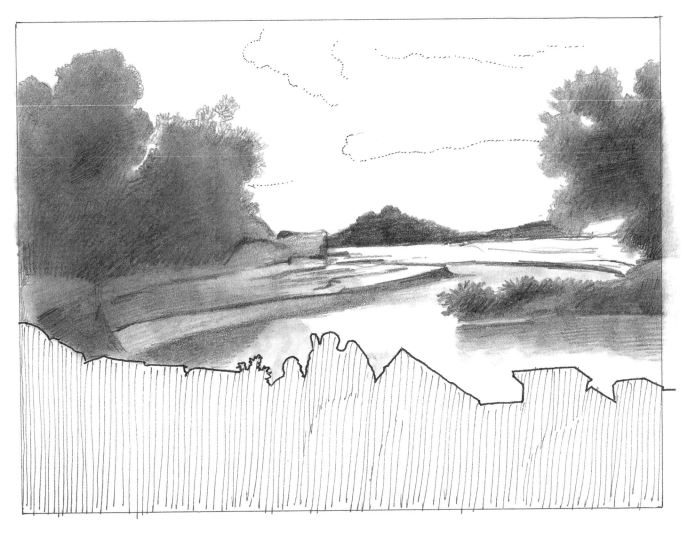

Middleground as backdrop

We come full circle, to an example of a classic approach to landscape, this time after the redoubtable Poussin, French artist of Italian scenes. In this picture the point of interest is transposed from middleground to foreground. The middleground is purely a landscape that takes our eye off into the distance, to a misty range of hills and some soft clouds. The real action is in the foreground, which has the figures of an angel and St Matthew at the centre point. Although the middleground is at least one third of the whole surface area, it and the background are just beautiful foils to the rocks and two figures in the foreground. It takes a great artist to turn convention upside down and succeed brilliantly. Now that you know how it is done, try it for yourself and see if you can make it work.

THE BACKGROUND

A little experience of the way artists use the background soon changes the misconception that it is a passive part of any scene. Obviously treatments differ. Some artists make the background so important that it begins to take over the whole picture, while others may reduce it to minimal proportions. However, whether its proportions are large or small, the background is important and the only means you have of stopping the main parts of the picture being isolated. Always remember that the background, however simple, is the stage on which the action of your picture takes place. Without it, your picture will look stilted and without depth.

In these pictures, only the background is drawn up; the foreground and middleground are shown as toned and blank outlines respectively.

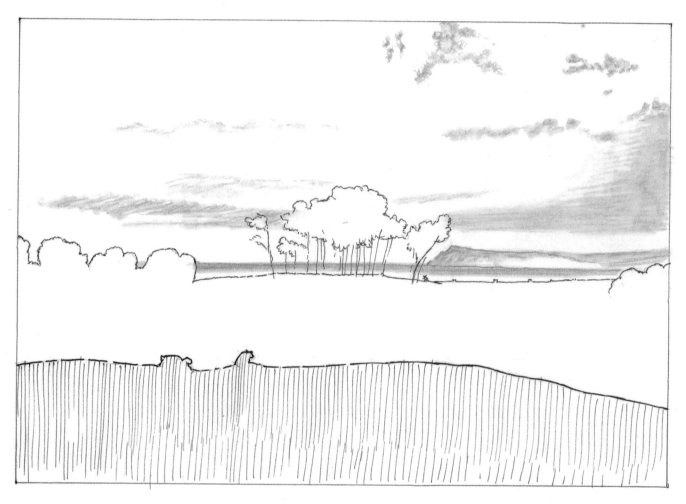

Supporting act

This background (after Turner's picture of Pevensey Bay) is most retiring and unassuming. All the interest in the picture is in the fore- and middlegrounds. Neither the very slim layer of sea and cliff on the horizon nor the peaceful-looking sky insists on being noticed. This background exists solely to provide a backdrop to the interest in the main parts of the picture.

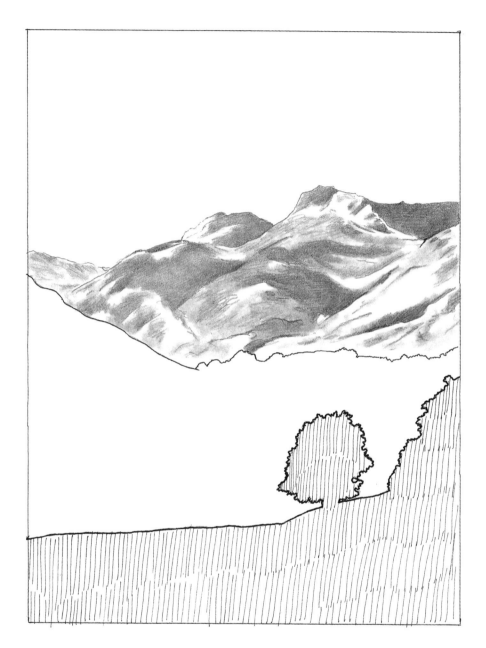

Attention-grabber

Here we see the background of the picture whose middleground we studied on p.231. Easily the most striking object in the scene, the mountain crag is the whole point of the picture. The viewpoint emphasizes its importance, the background rising majestically out of the foreground vegetation and the valley floor which make up the lower levels of the picture. The background dominates the picture, even though its tonal qualities are less intense than those of the fore- and middlegrounds. Our attention is caught by the mountain's sheer bulk.

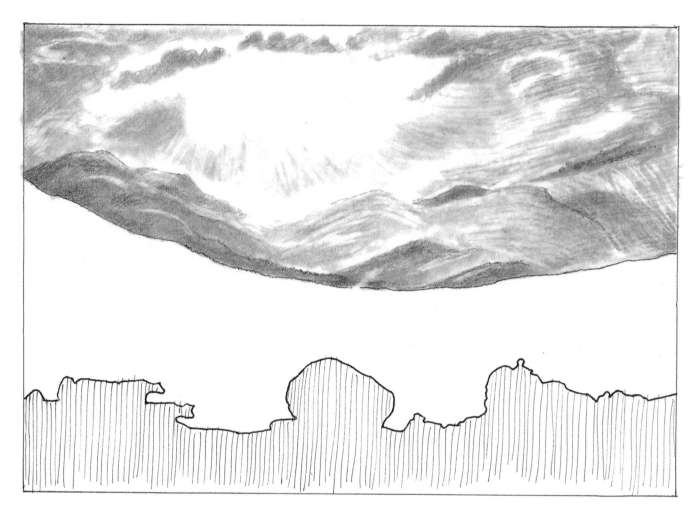

Incipient drama

Simmer Lake (after Turner) begins to show that great artist's interest
in the elemental parts of nature. The background of sky and mountains
does not have the restlessness we associate with much of his work but
is nevertheless fairly dramatic. The great burst of sunlight coming through
swirling clouds and partly obscuring the mountains gives a foretaste of
the scenes Turner would become renowned for, where the elements of
sunlight, clouds, rain and storms vie for mastery in the picture.

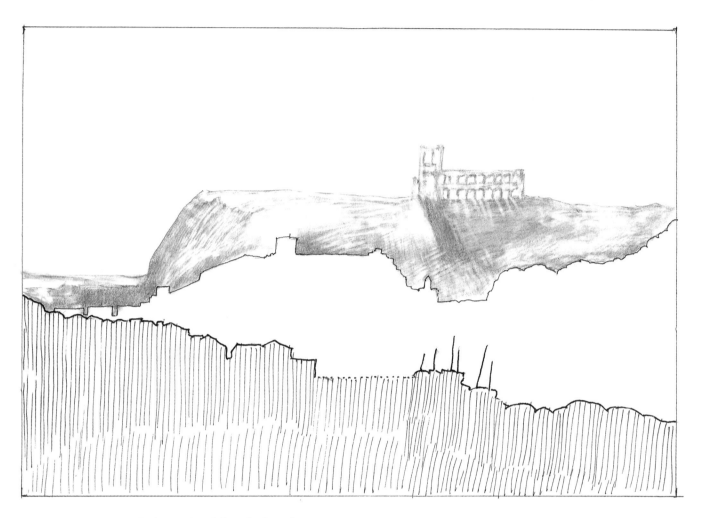

A knocked-back focal point

In this view of Whitby (after Turner) the background is dramatic and prominent in shape while reduced in intensity. The abbey on top of the cliff with the sun flooding through its arches creates a marvellous soft focal point above the buildings of the main part of the town. The clear bright sky helps to silhouette the background feature while also diminishing its strength in the picture by making it look almost insubstantial against the darker and more solid buildings in the town.

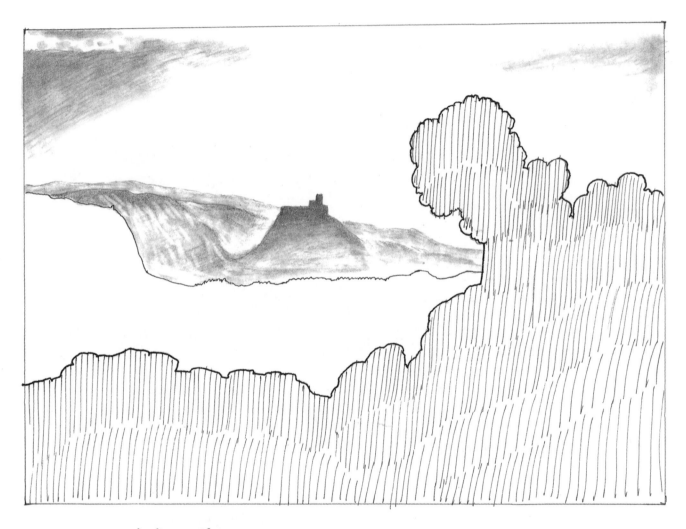

A distant feature

The title of this picture (again after Turner) is the name of the building silhouetted in the background, Prudhoe Castle. The picture is a brilliant piece of design by a master landscape artist. The interest is very clear because the castle is almost dead centre in the composition, and yet as a result of its lack of detail and its depth in the picture it seems to be both out of reach and also a beacon. Despite its distance from us, the castle's position and the way it is framed by both foreground and middleground ensure that our attention returns after scanning the rest of the picture.

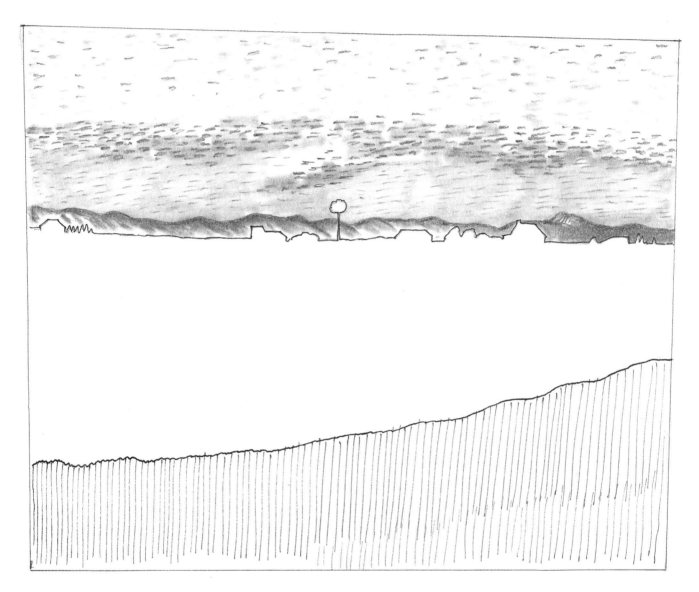

Minimal background

The main feature of this picture (after Van Gogh) lies in the middleground, where many peach trees are depicted in blossom. In the original, Van Gogh reduced the background to a very minimal range of hills only just appearing above the housetops. He painted the lively sky in small patches and strokes of paint which match the hills for intensity. By treating them in the same way he manages to create a backdrop where sky and hills, although clearly defined, produce a similar effect.

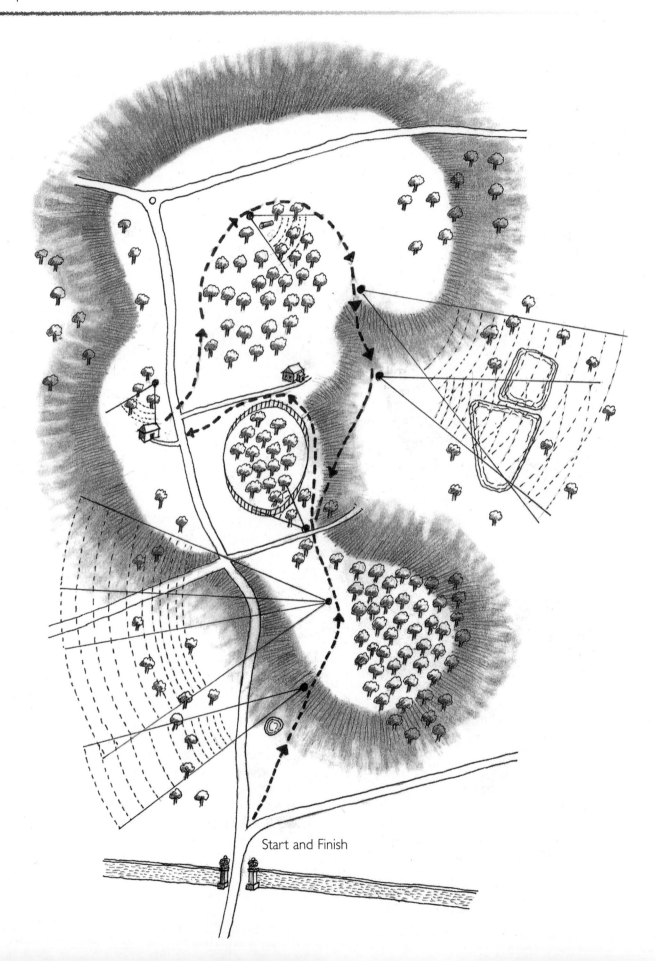

Start and Finish

LANDSCAPE PROJECT

LOOKING FOR THE VIEW

The first step in making a landscape composition is to choose an area that you would like to draw. Most people prefer to draw a country scene, but if that is not very convenient maybe there is a large park or country house with extensive grounds near where you live.

The countryside nearest my home is Richmond Park, which has within its boundaries magnificent woods, hills, a stream and ponds. I knew I would find good views across the landscape, this being the highest point of the land in the area. I decided at the outset to ignore the park's decorative lodges because they might complicate matters and would certainly take longer to draw.

As you can see from the plan of my route, I undertook quite a hike to assess the various viewpoints. It was a lovely summer day, just right for drawing in the open. Part of the fun of this type of exercise is searching for scenes and details that spark your interest.

All the views and details referred to in the following pages are included in the key below. You will need to draw up a similar map to ensure that you have a record of what you have done when you draw the scene later. Don't think you can rely on memory alone – you can't, and if you try you will only succeed in ruining what is an immensely enjoyable and rewarding experience.

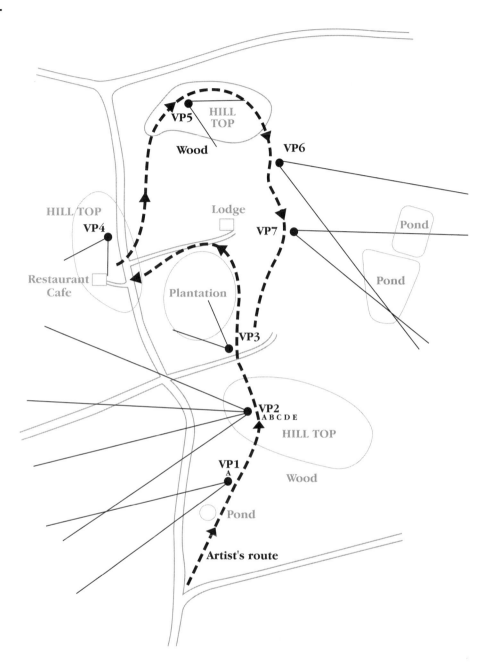

Key to Viewing Points and Features

VP1	View across parkland	VP3	Shattered oak tree
VP1A	Detail of ferns	VP4	Large chestnut tree near
VP2A	View to left across park from hilltop		café where I stopped for lunch
VP2B	View to half left across park	VP5	Large log
VP2C	View to centre across park	VP6	View of ponds in distance from hill
VP2D	View to centre right across park	VP7	View of ponds from lower down
VP2E	View to right across park		

SETTING OUT

As you can see from my map, I started from the gates of the park and walked slowly up the hill, looking back occasionally to see what the view was like. About halfway up the hill I thought the view looked quite interesting and so I sat down and sketched the main parts

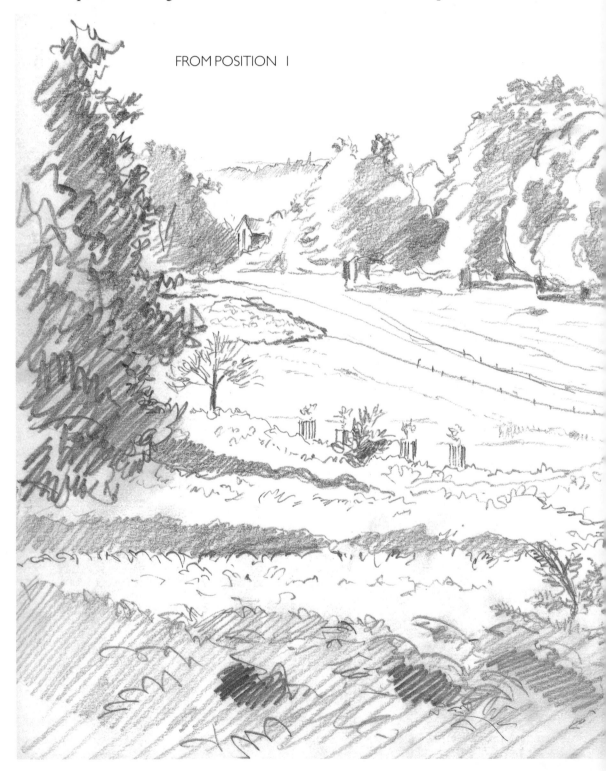

FROM POSITION 1

very simply (1). Much of the drawing is very minimal, like a sort of shorthand. This is because I was just looking for possibilities. The purpose was not to produce a finished picture. Some ferns caught my eye and I drew them as a possible detail to provide local colour (1a).

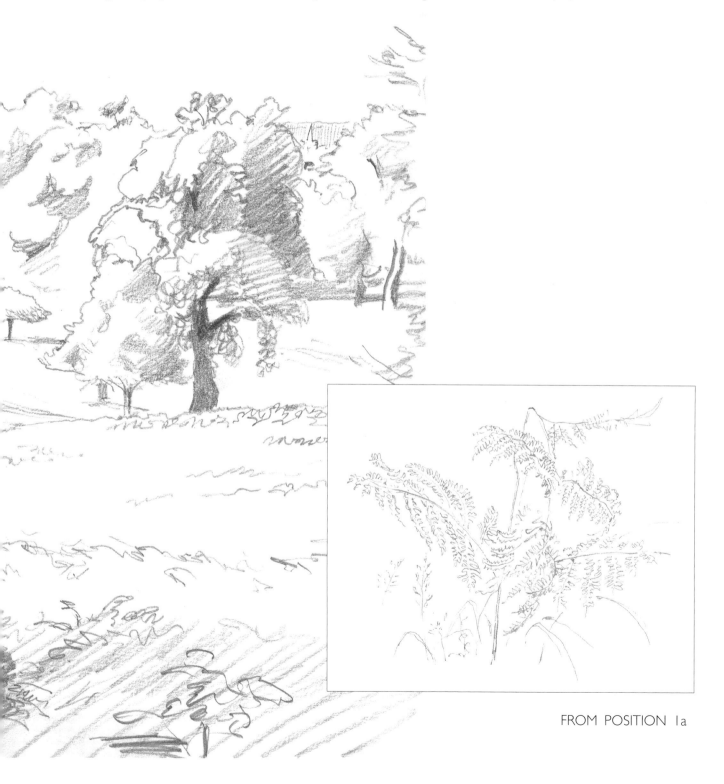

FROM POSITION 1a

VIEW FROM THE TOP

When I reached the top of the hill there was a natural viewing platform offering an enormous sweep of panoramic proportions, more than could possibly be put in one picture. However, I didn't want to miss anything and so I made a series of sketches (2a, b, c, d, e), showing the layout of the whole view in extremely simple outline forms. Arranged edge to edge with some overlaps, these drawings presented me with a whole range of views for later consideration.

 When you come to do this exercise, include written notes on your sketches to remind yourself of specific subtleties that you would need to include in a proper drawing. In these examples, the trees are put in as blobs of shape with only a rough indication of the darks and lights. Buildings in the distance are rendered as mere blocks to show their size and prominence. I would make detailed notes about the tonal values evident in all these features, including the various trees.

FROM POSITION 2a

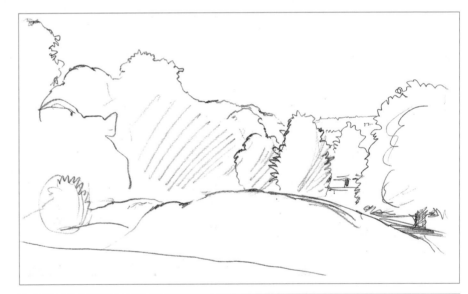

FROM POSITION 2b

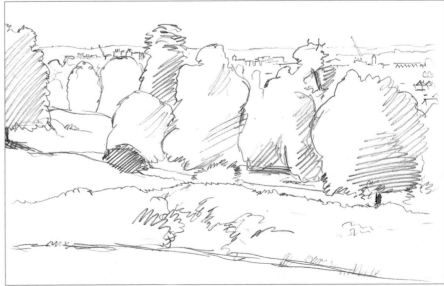

FROM POSITION 2c

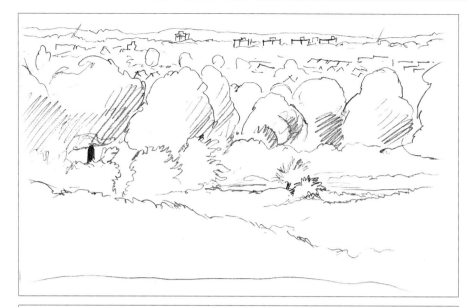

FROM POSITION 2d

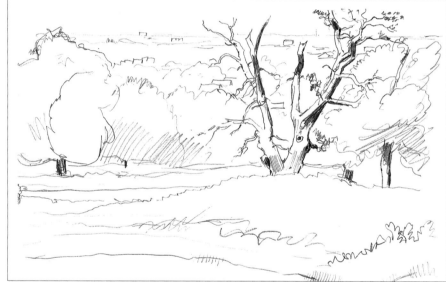

FROM POSITION 2e

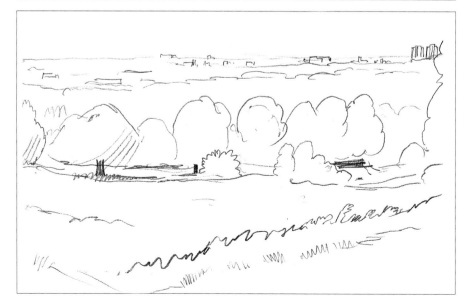

AN EYE FOR DETAIL

In any landscape you need to pay attention to details that might be included in the foreground. In the plantation area of the park I came across a superb blasted oak, mostly dead, its angular branches stabbing up into the sky. As you can see it makes a good focal point, but would you place it centrally in your picture or to the right or left side? Compositional and structural aspects will strike you even at this stage when your main aim is to decide where to draw from.

By this time I was hot and hungry. I went across to the café in the park, which has a

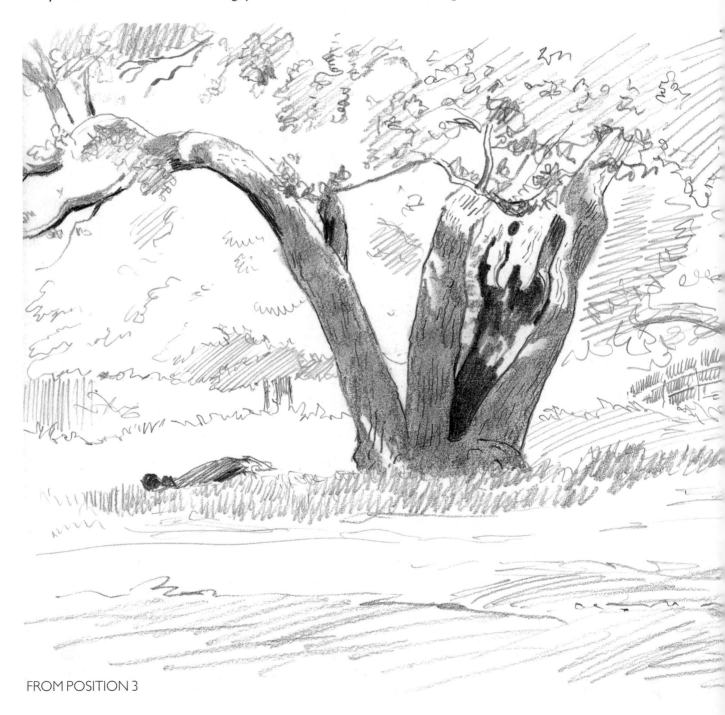

FROM POSITION 3

very good view from its windows. Fortified by a tasty lunch and cold drink, I returned to my task.

As I walked through the gardens surrounding the café, a superb group of chestnut trees set up on a mount presented themselves. I couldn't resist doing another tree portrait (4). This sort of close-up is useful in a composition that includes a long-distance view because it helps to give an appearance of space. This time I produced a more finished sketch. Drawings of groups of trees are always useful and the more information I have about them the greater is the likelihood of including them in one of my landscapes.

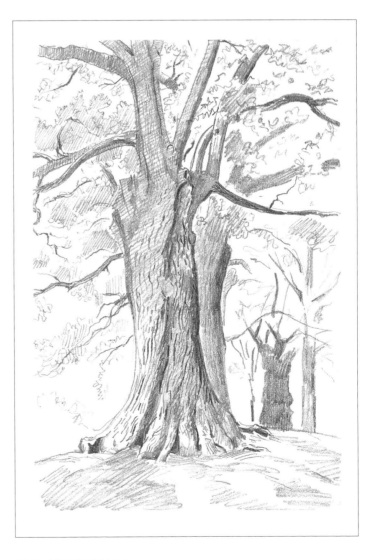

FROM POSITION 4

249

NEAR AND FAR

Not far from the café was a wood set atop another hill. Woods are often great providers of interesting foreground details, and so in I went. After a few minutes of wandering around, I noticed an enormous log that had obviously lain there for at least a year (5). Stripped of bark, it had weathered to a beautiful silvery grey. On the cut end I could see the rings of growth and saw marks. I made a fast but quite detailed drawing before continuing on my way.

As I rounded the wood I could see from the top of the hill a great sweep of countryside framed between two large plantations of trees. In the middle distance was the gleam of two large ponds, which added extra interest to the view. Paths led from my position down the hill towards the ponds, between which ran a sort of causeway. In a quick, simple sketch I put in the main shapes and gave some idea of the sweep (6).

Curious to see what the ponds looked like from closer up, I descended the hill to a point where the path to the causeway and the water of the right-hand pond were much more obvious. The view from here looked rather good, so I quickly made a sketch of it (7). Now that I had a long view and a nearer view, I had the information necessary to include more detail of the distant parts of the view, if I wanted to. The more viewpoints you have of a scene the greater are your options.

By this time I was fairly hot, my feet ached and my bag with my sketchbooks, pencils, pens, sharpener and rubbers was beginning to feel heavy. Keeping to the shady parts of the park, I slowly made my way home.

So that is the first stage of the exercise. Allow yourself a day, even if you draw only for half that time, because you never know what you are going to come across.

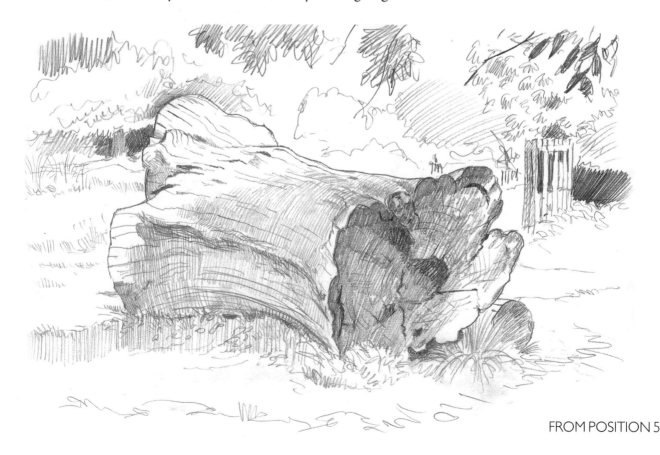

FROM POSITION 5

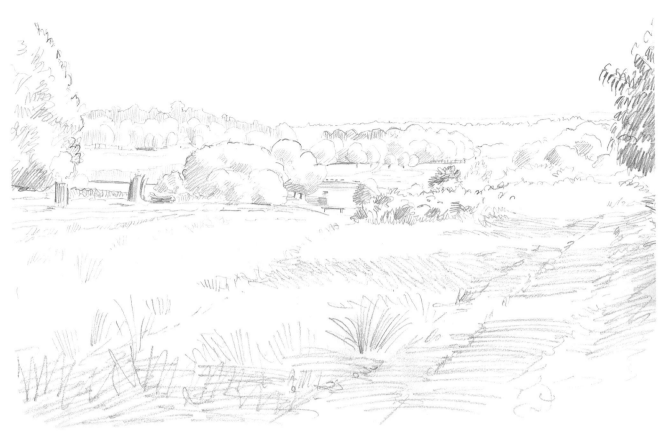

FROM POSITION 6

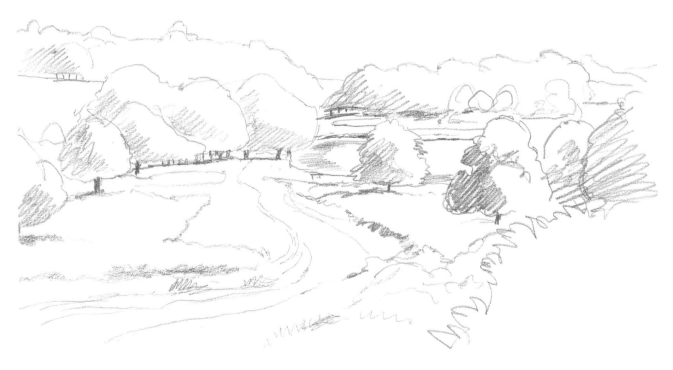

FROM POSITION 7

DECISION TIME

Now comes the decision-making, which will be based on your sketches and memory. If you are planning a complicated landscape, you might want to consider taking photographs as well as sketches.

Looking at all my sketches, I decided to opt for two particular views, including one of the large trees or the log somewhere in the foreground.

I quite liked the look of the two centre views (2b and 2c) from the panorama plus the river to the left. I considered shortening the view slightly, keeping the left-hand edge as a finial point and placing the central area with the blasted oak towards the right-hand edge of the picture. Then I thought it would be an effective touch to

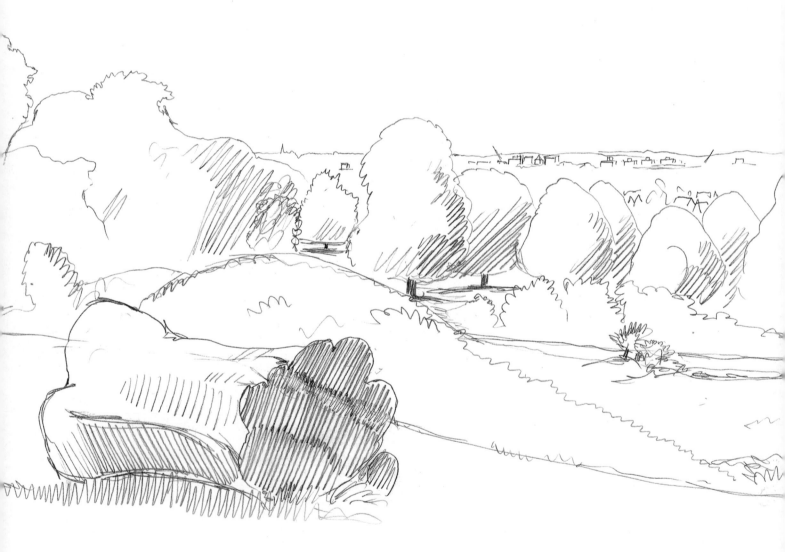

CREATED FROM 2a, 2c, 2d and 5

introduce something nearer to the foreground – here is where one of my large trees or the large log would come in handy (5).

For my second option, I considered the long view of the ponds first. The trees on either side gave it a good frame, but it needed something else to give it interest. I decided to extend the central area with details taken from the closer view. But what about the foreground, should I add anything there? I thought not, to avoid the picture looking crowded.

In the end I opted for the part-panoramic view. The next stage was to draw up a diagram of how this view might work (below).

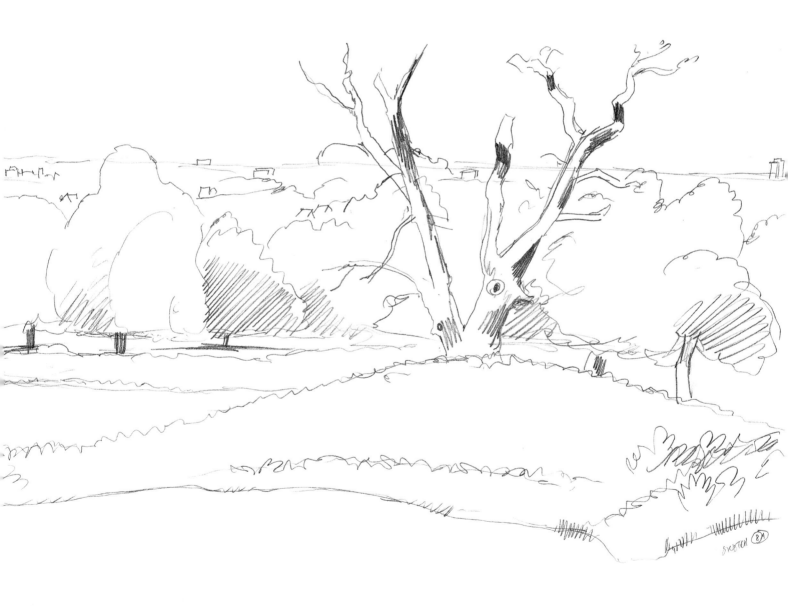

THE FINISHED DRAWING

After making an outline drawing of the scene, I embarked on the finished drawing. This must not be hurried, and if it takes longer than one day, so be it. Recently I completed a picture of the interior of a studio I work in, just for practice, and it took me two full days. I used pencils of various grades, a stick of charcoal for soft shadows, and a stump to smudge some of the mark-making to keep it subtle. The second day was taken up with doing a colour sketch in oils. Never allow time to be a problem.

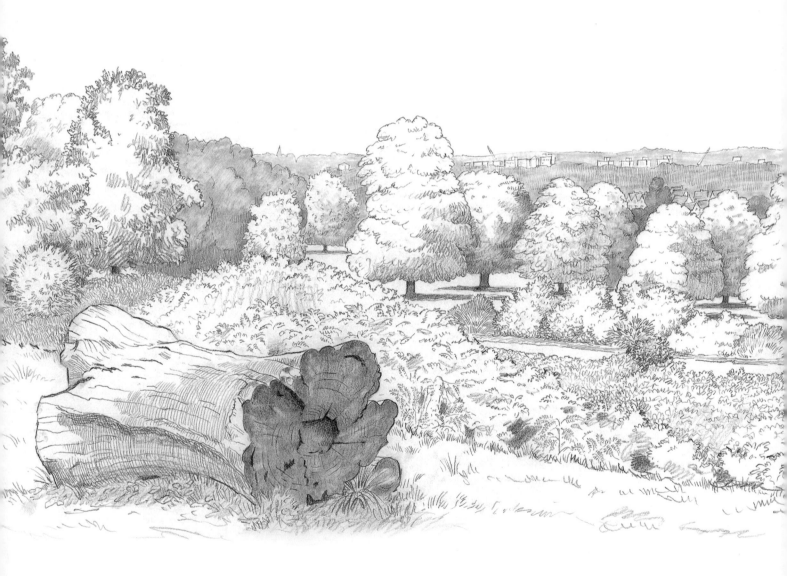

Everything at this stage depends on your artistic development and your attitude.
A large part of the resulting judgement of you as an artist will be based on how well
you can produce finished drawings. Although talent can bring that extra-special
touch to a work, a great deal can be accomplished with persistence and endeavour.
Indeed, talent without these other two qualities will not go far. It is only through hard
work and a willingness to learn from our mistakes and the example of others that any
of us improves.

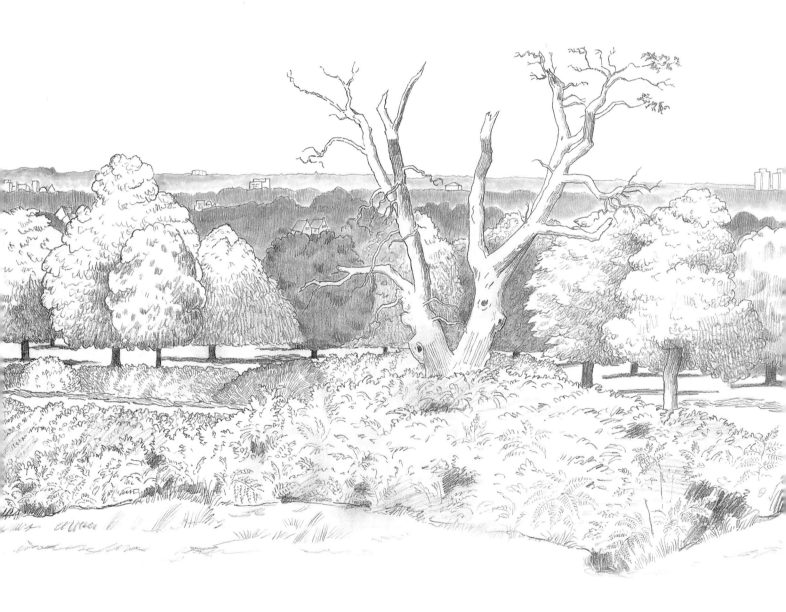

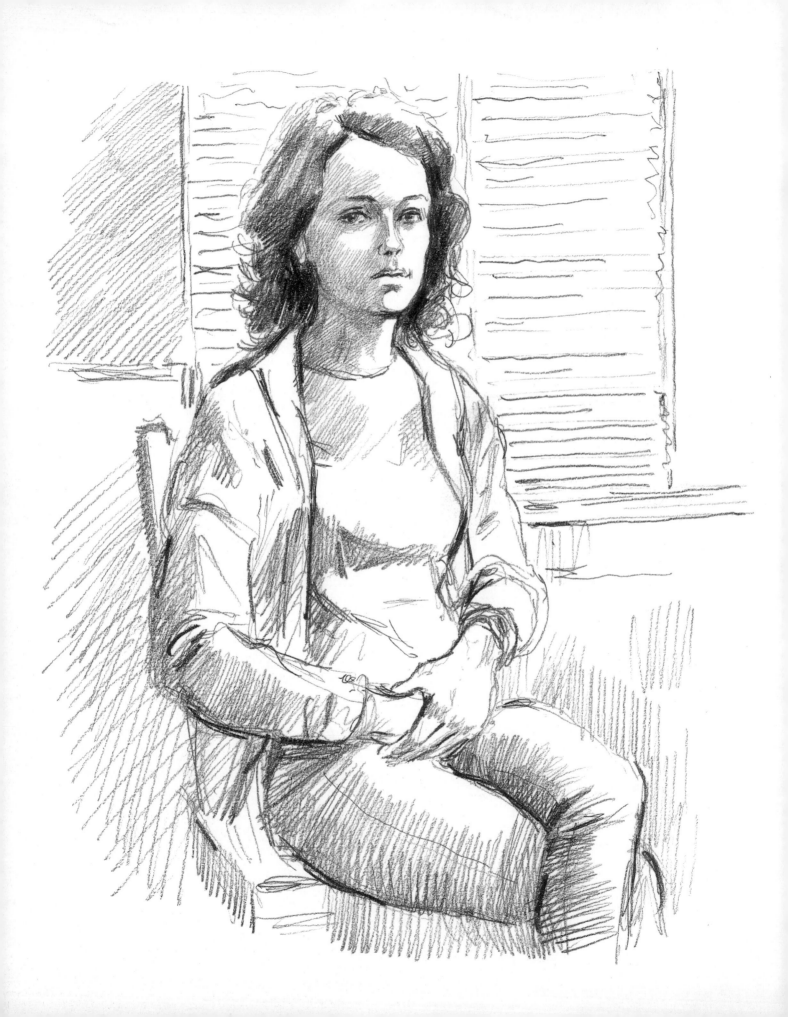

CHAPTER **6**

FIGURES AND PORTRAITS

In this chapter we come to one of the most interesting, most subtle and most taxing of our drawing challenges. The human figure is the one subject that we all think we know about, because we are humans ourselves. However, because of our close connection with the subject, it's easier not only to follow our preconceptions rather than relying on observation, but also then to realize we have got things wrong. It's consequently rather more difficult to satisfy our own demands of our skill, but that's not a bad thing because it pushes us to strive harder to achieve what we want.

There are many approaches to this field of drawing, and I have tried to include all the obvious ones. Eventually you will learn many more ways to draw the figure, but you have to start with a method that is easy to understand and achieve. You will see how to simplify your drawing and to get the main movement through the shape of the figure, and we shall also look at some details, including the figure in perspective and how to analyse the shape.

Finally, we shall come to one of the most satisfying subjects of all – portraiture. Achieving a good likeness of a friend or relative will confirm the high standard of your drawing skills and give both you and the sitter a great deal of pleasure.

THE PROPORTIONS OF THE HUMAN FIGURE

Obviously people vary in their exact proportions, but using the head as the basic unit, the average man or woman, fully grown, is about 7½ to 7¾ heads tall. However, most drawings and paintings of human figures can be drawn simply as if 8 units made up the height. This would probably be true of a tall person and so is not too out of proportion – in fact it was the measure generally used for beautiful or heroic figures in art history, so you will not find your models complaining!
It is certainly an easier proportion to draw than 7½ units.

Men and women hardly differ at all in their height proportions, but there is a difference in width; the male figure is wider at the shoulders, while the female is wider at the hips.

Male figure: front view

Female figure: side view

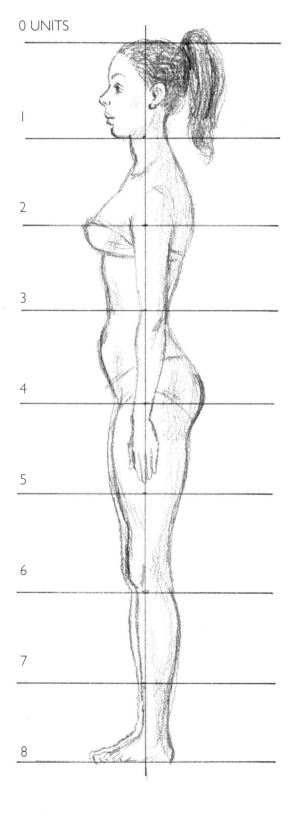

0 UNITS

1

2

3

4

5

6

7

8

Child (9–10 years old): front view

A child's head is much bigger in proportion to the body. At one year old it is about 3 to 1 and as they grow the proportions gradually approach those of an adult. At about 9 or 10 years old, a child will be about 6 units or heads to the full height.

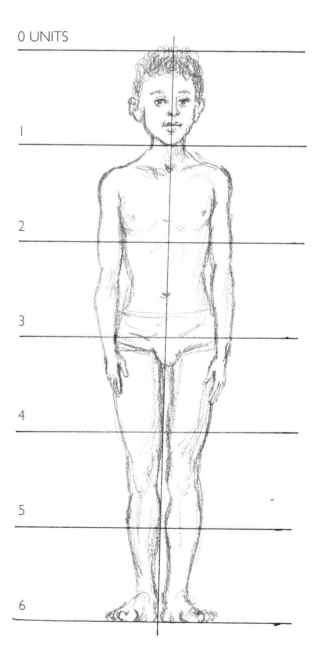

0 UNITS

1

2

3

4

5

6

THE SKELETON

The skeletons of men and women are basically the same, except for the difference in the width of the shoulders and hips. Also, the skeleton of the female will usually be finer and lighter.

One regular difference is that the bones of the male forearm are generally longer proportionally than those of the female and the feet tend to be larger as well. There are some slight differences in bone structure in terms of racial characteristics, but not enough to show in a drawing, unless it is very large in scale. So, this version of the human skeleton will do for general purposes, unless you choose to study the subject in greater depth.

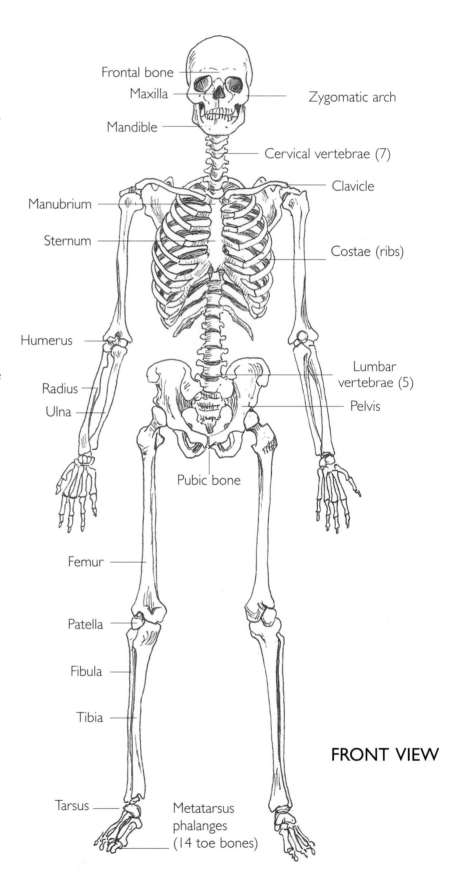

Frontal bone
Maxilla
Mandible
Zygomatic arch
Cervical vertebrae (7)
Clavicle
Manubrium
Sternum
Costae (ribs)
Humerus
Lumbar vertebrae (5)
Radius
Ulna
Pelvis
Pubic bone
Femur
Patella
Fibula
Tibia

FRONT VIEW

Tarsus
Metatarsus phalanges (14 toe bones)

The rear-view diagram is included to demonstrate how the shoulder blade forms part of the shoulder joint and slides over the upper portion of the rib cage; it also shows the rear view of the pelvis, which is quite different from the front. You may not remember all the correct names for the bones, but you are bound to familiarize yourself if you consult the skeleton plan often enough.

Parietal bone

Occipital bone

Scapula (shoulder blade)

Thoracic or dorsal vertebrae (12)

Iliac crest

Ilium

Sacrum (pelvis)

Ischium

Coccyx

REAR VIEW

MUSCLE STRUCTURE

The following diagrams illustrate the musculature that lies beneath the surface of the skin, moulding the contours that we recognize from our own bodies and those we observe on others; it is made up of both large and small muscles, together with various ligaments and tendons.

You will see only the muscles that constitute the top layer; however, this is sufficient because artists are chiefly concerned with the ones that show up just under the skin. Again, you probably won't remember all the names, but as you get used to referring to them, the principal ones will begin to stick in your memory. Most of the major muscles are connected with the way that we move about, pushing or pulling on the bone structure and coordinating with other muscles.

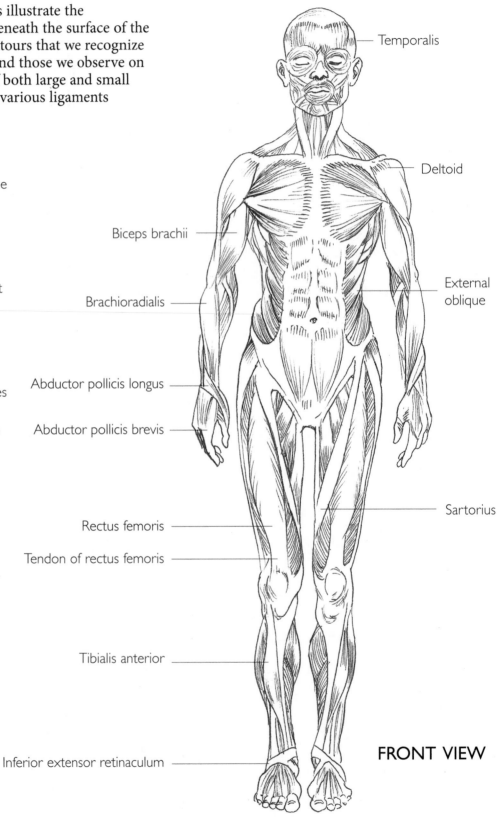

Temporalis

Deltoid

Biceps brachii

External oblique

Brachioradialis

Abductor pollicis longus

Abductor pollicis brevis

Sartorius

Rectus femoris

Tendon of rectus femoris

Tibialis anterior

Inferior extensor retinaculum

FRONT VIEW

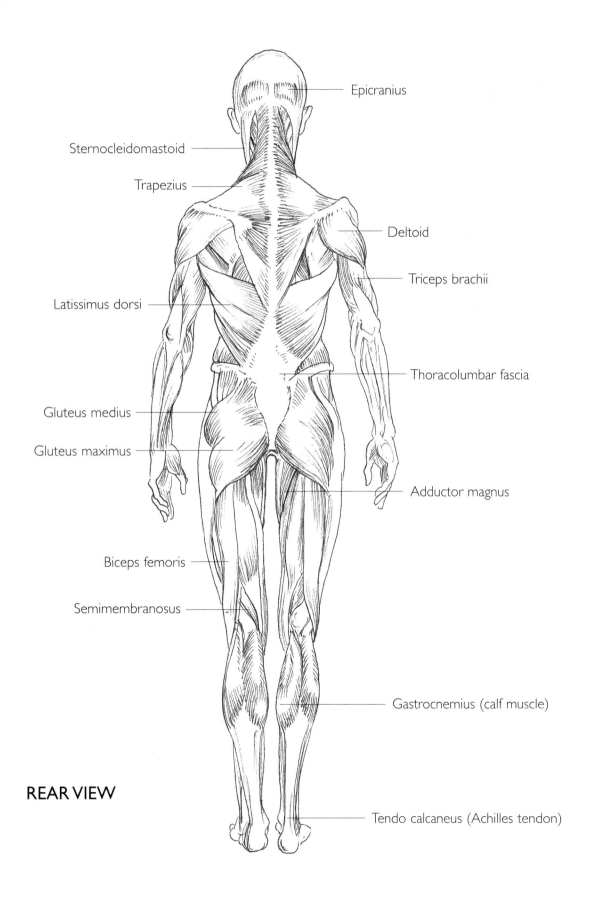

Epicranius

Sternocleidomastoid

Trapezius

Deltoid

Triceps brachii

Latissimus dorsi

Thoracolumbar fascia

Gluteus medius

Gluteus maximus

Adductor magnus

Biceps femoris

Semimembranosus

Gastrocnemius (calf muscle)

REAR VIEW

Tendo calcaneus (Achilles tendon)

THE HEAD IN PROPORTION

Treating the head separately is worthwhile, because this is the part of the body that everyone relates to most strongly. Begin by making a note of its basic proportions, which are simple and easy to remember – although if this is the first time that you have measured a head you may find them a little surprising.

The first diagram shows that the general proportion of the head, viewed straight on, is in the ratio of 2:3; that is, the width is about two-thirds of the height. Something that most people find difficult to believe at first is that the distance between the top of the head and the eyes is the same as the distance between the eyes and the tip of the chin. The reason for the common misapprehension that the eyes are higher than halfway is that most people look at the face alone, and don't take into account the portion of the head that is covered by hair.

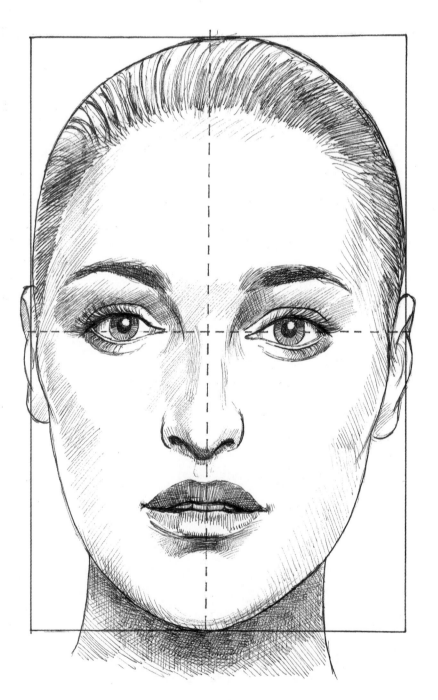

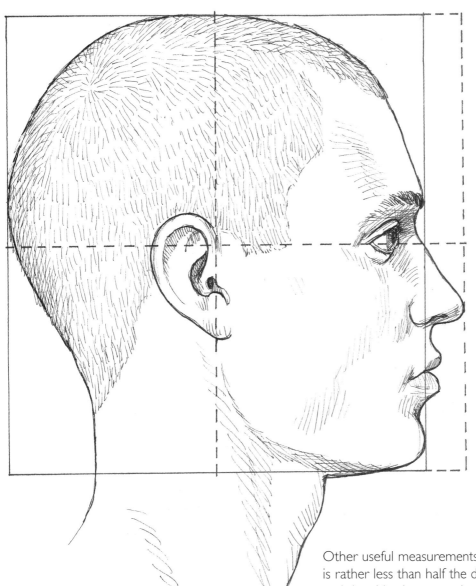

The second diagram shows the side view, or profile, of the head. It measures as much from front to back as it does from top to bottom. The nose, which is obviously variable in size and shape, projects beyond the square.

Other useful measurements are: the length of the nose is rather less than half the distance between the eyes and the chin; the spaces between and either side of the eyes, when seen from directly in front, are equal to the horizontal length of the eye. The mouth is somewhat nearer the nose than the chin, so don't leave too big a distance between the base of the nose and the mouth. The ear, seen in profile, lies behind the halfway vertical that bisects the head. Generally speaking, in the case of most younger people, the lips project in front of the square. For the elderly, especially those who have lost their teeth, this may not always be so.

THE SKULL AND ITS MUSCLES

We should now look at the anatomy of the head in greater detail, so here are two diagrams that explain the structure and name the various parts.

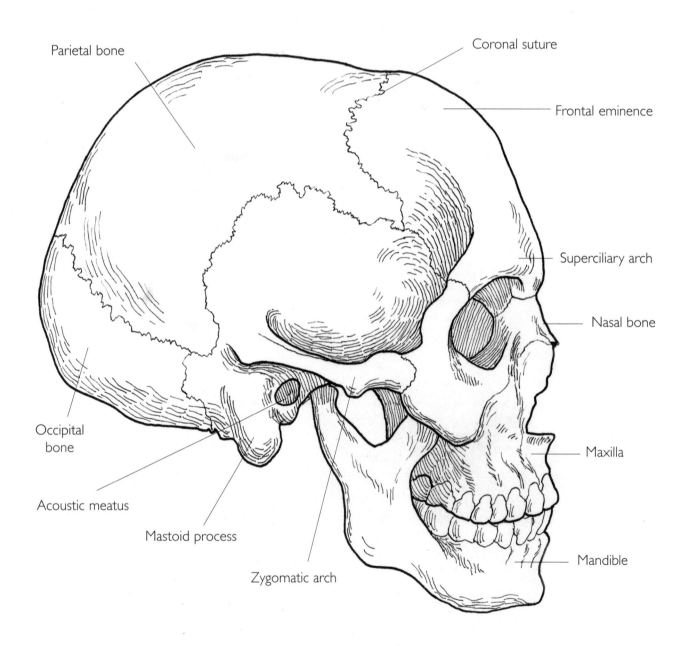

Parietal bone

Coronal suture

Frontal eminence

Superciliary arch

Nasal bone

Maxilla

Mandible

Occipital bone

Acoustic meatus

Mastoid process

Zygomatic arch

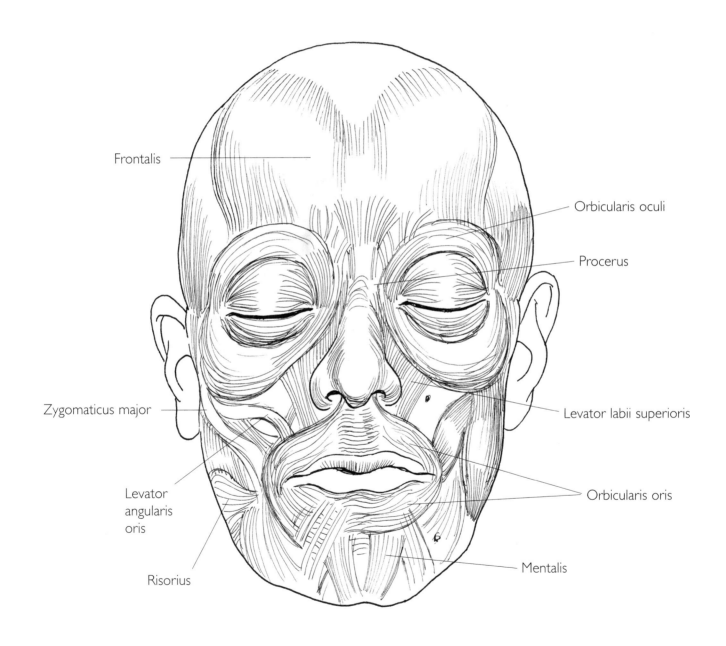

Frontalis

Orbicularis oculi

Procerus

Zygomaticus major

Levator labii superioris

Levator
angularis
oris

Orbicularis oris

Risorius

Mentalis

THE HEAD FROM DIFFERENT ANGLES

Here I have drawn the head seen from a variety of different angles. In the main there are no particular details of the face – just the basic structure of the head when seen from above, below and the side. Notice how the line of eyes and mouth curve around the shape of the head, because if you omit to show this the features will not fit in with the curve of the head when viewed from an angle. When seen from a low angle, the curve of the eyebrows becomes important, as does that of the cheekbones, so study these carefully.

Sometimes the nose appears to be just a small point sticking out from the shape of the head, especially when seen from below. The underside of the chin also has a very characteristic shape, which is worth noting if you want your drawing to be convincing. Conversely, when seen from above, the chin and mouth almost disappear but the nose becomes very dominant. From above, the hair becomes very much the main part of the head, whereas when seen from below the hair may be visible only at the sides.

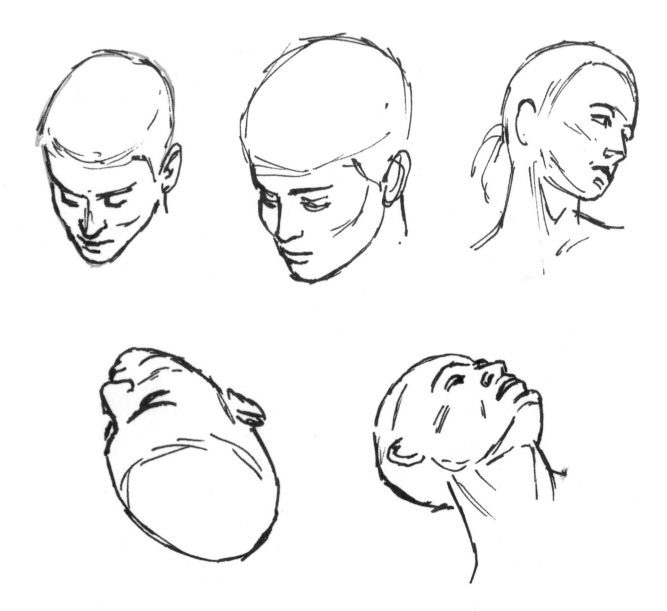

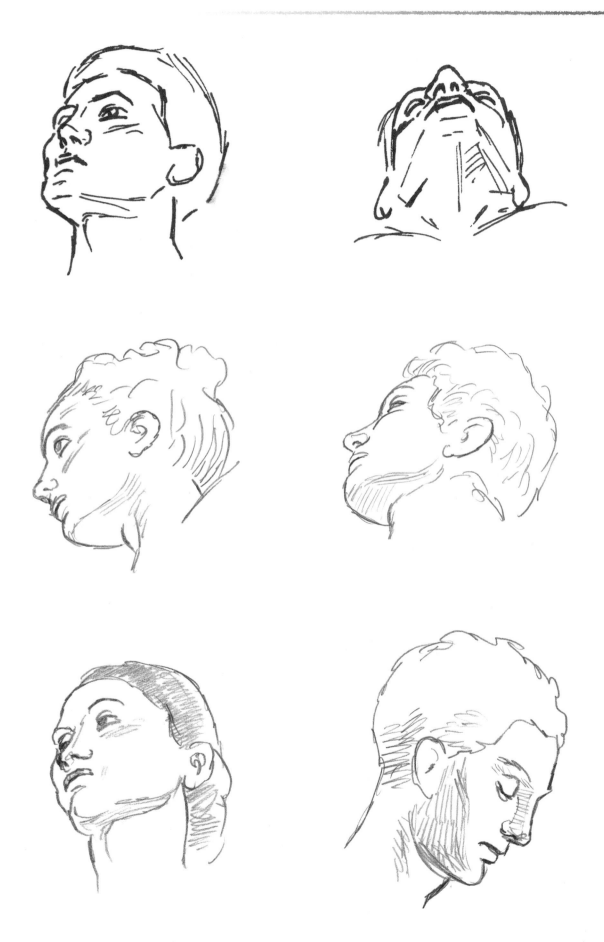

THE TORSO: BENDING AND STRETCHING

In these drawings you can see how the spinal cord is such a good indicator of what is happening to the body when it bends and stretches. The curves of the spine help to define the pose very clearly and it is best to start drawing a figure by taking a note of them. All the other parts of the body's structure can then be built around that. Even if you can't see the spine, some idea of its curves will always help to keep your drawing convincing.

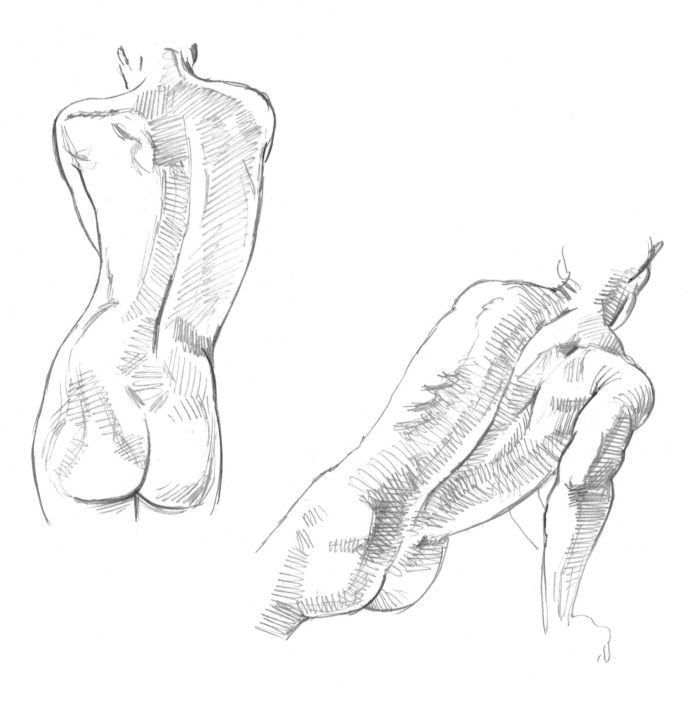

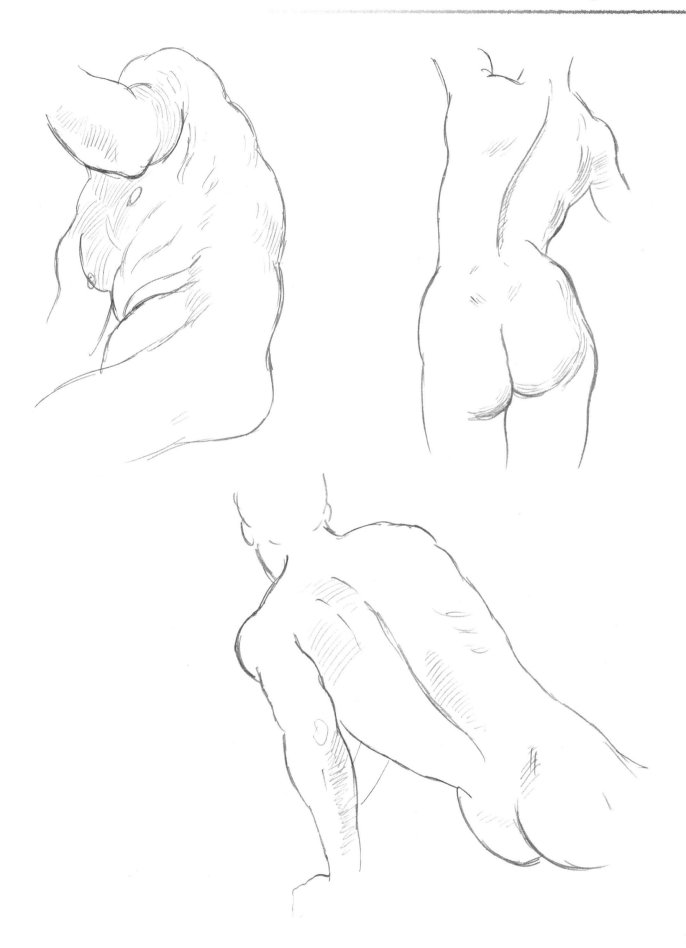

THE ARMS AND HANDS

The narrowness of the limb makes the musculature show much more easily than in the torso, and at the shoulder, elbow and wrist it is even possible to see the end of the skeletal structure. This tendency of bone and muscle structure to diminish in size as it moves away from the centre of the body is something that should inform your drawings. Fingers and thumbs are narrower than wrists; wrists are narrower than elbows; elbows narrower than shoulders: a surprisingly large number of students draw them the opposite way round. As always, it is a matter of observing carefully and drawing what you actually see before you.

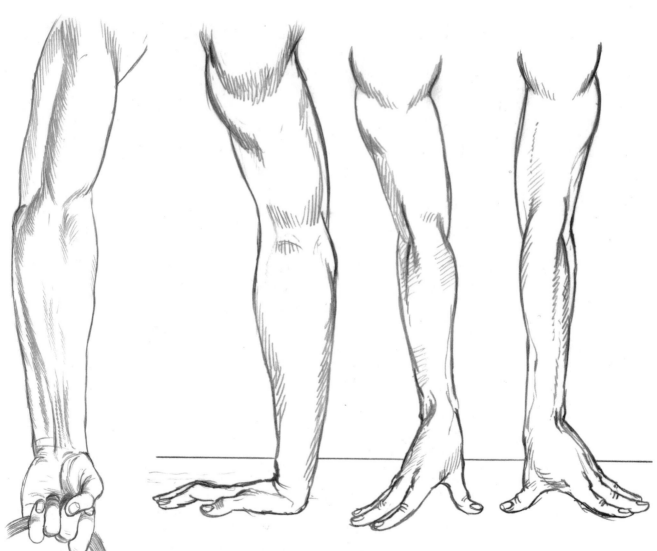

In these examples, notice how when the arm is under tension in the act of grasping an object or bearing weight, the muscles stand out and their tendons show clearly at the inner wrist. As can be seen on the page opposite, when the arm is bent the larger muscles in the upper arm show themselves more clearly and the shoulder muscles are more defined.

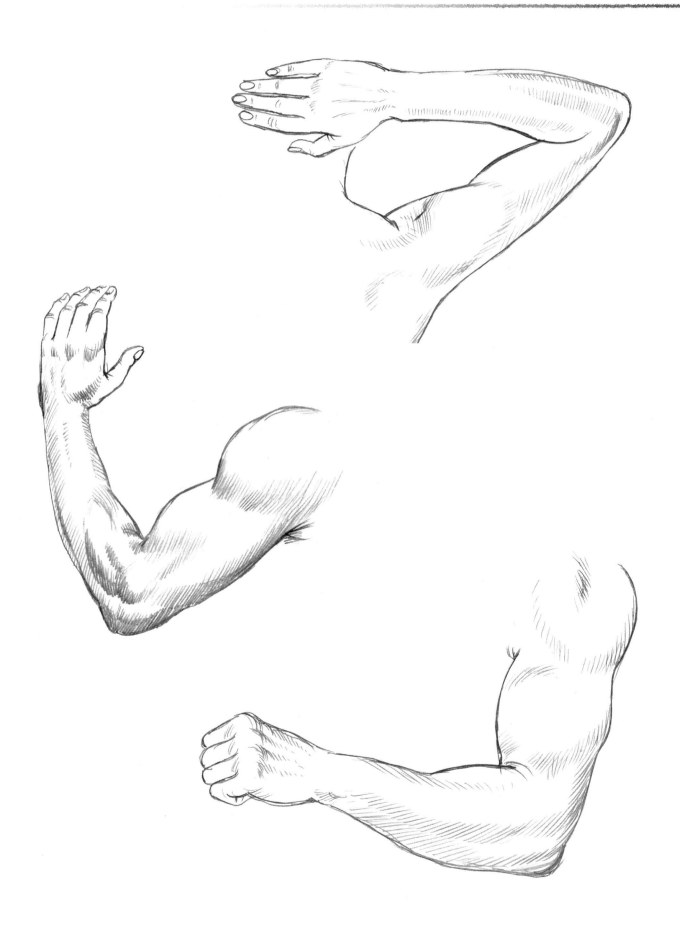

THE HANDS

Many people find hands difficult to draw. You will never lack a model here as you can simply draw your own free hand, so keep practising and study it from as many different angles as possible. The arrangement of the fingers and thumb into a fist or a hand with the fingers relaxed and open create very different shapes and it is useful to draw these constantly to get the feel of how they look. There is inevitably a lot of foreshortening in the palm and fingers when the hand is angled towards you or away from your sight.

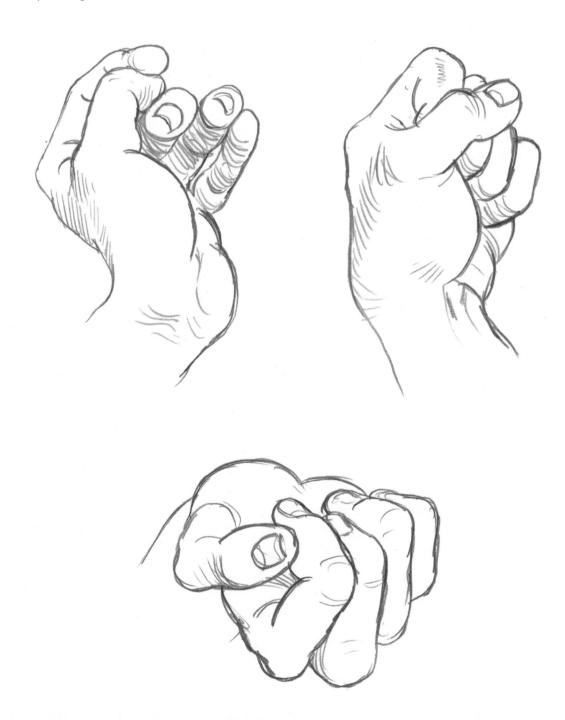

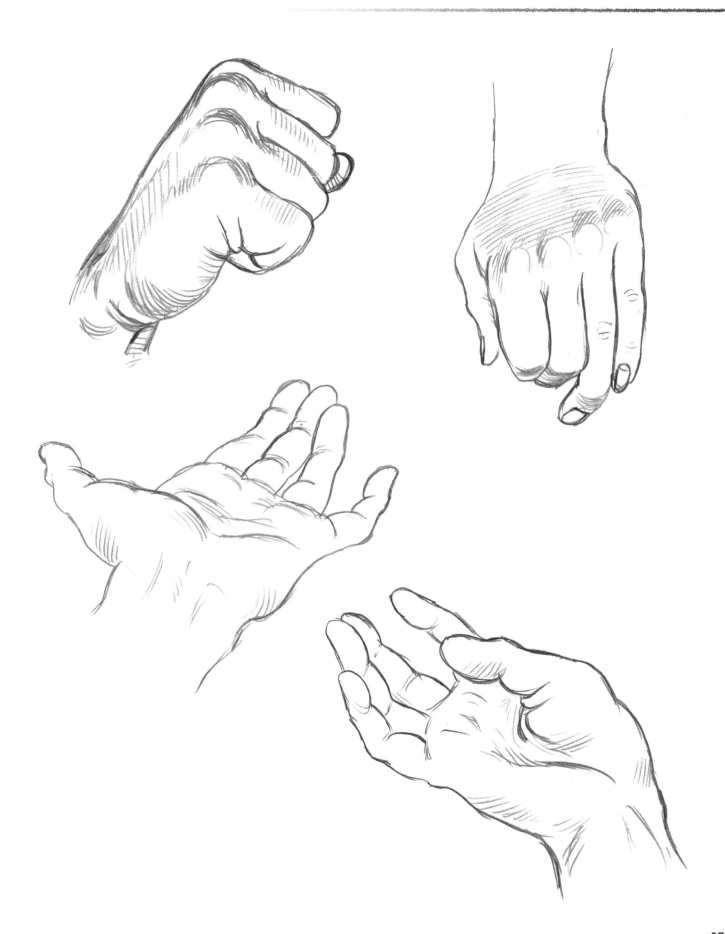

THE LEGS AND FEET

From the side, you will see that the muscles in the thigh and the calf of the leg show up most clearly, the thigh mostly towards the front of the leg and the calf toward the back. The large tendons show mostly at the back of the knees and around the ankle. Notice the way the patella changes shape as the knee is bent or straightened. As with the arms, the bones and muscles in the leg are bigger towards the body and smaller towards the extremities.

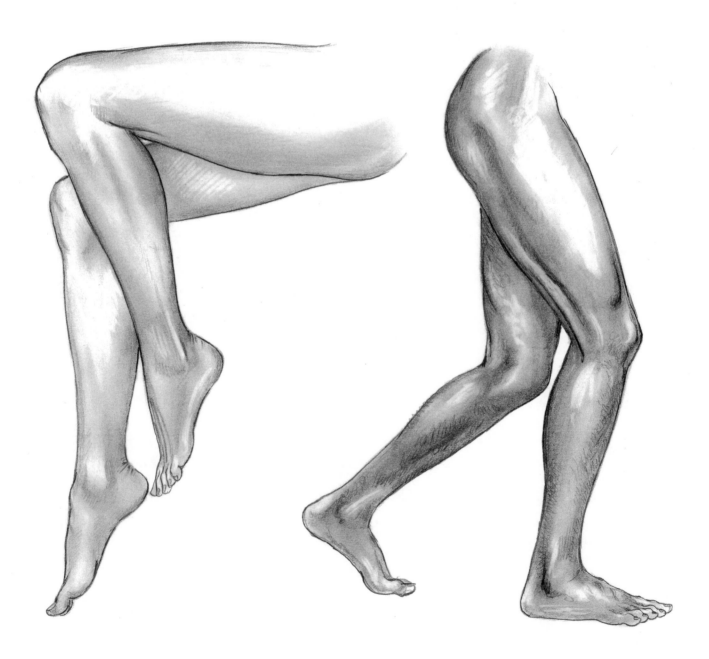

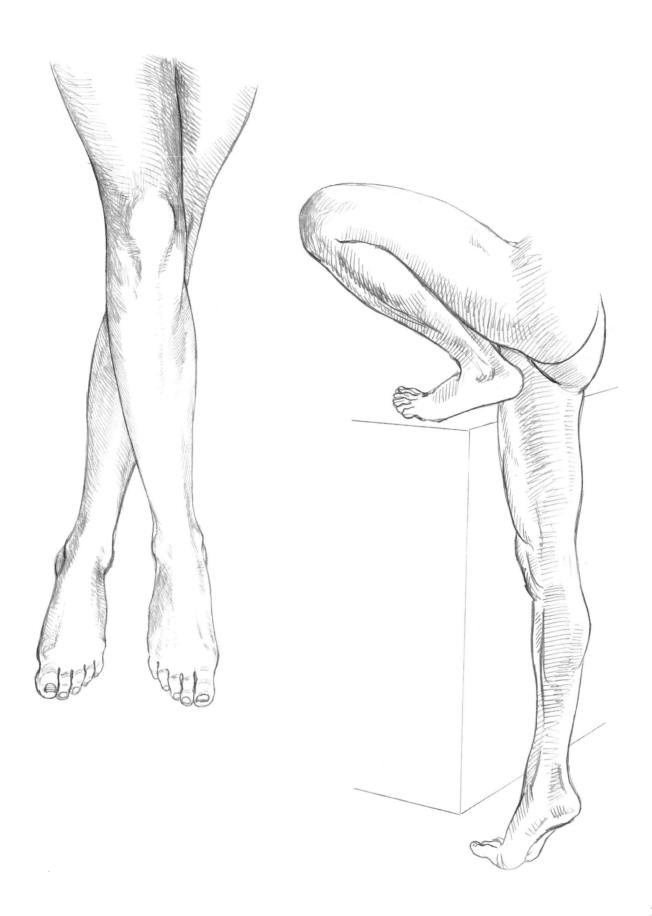

The back view of the legs shows the interesting reverse of the knee joint and looks very round and smooth, especially in the female form.

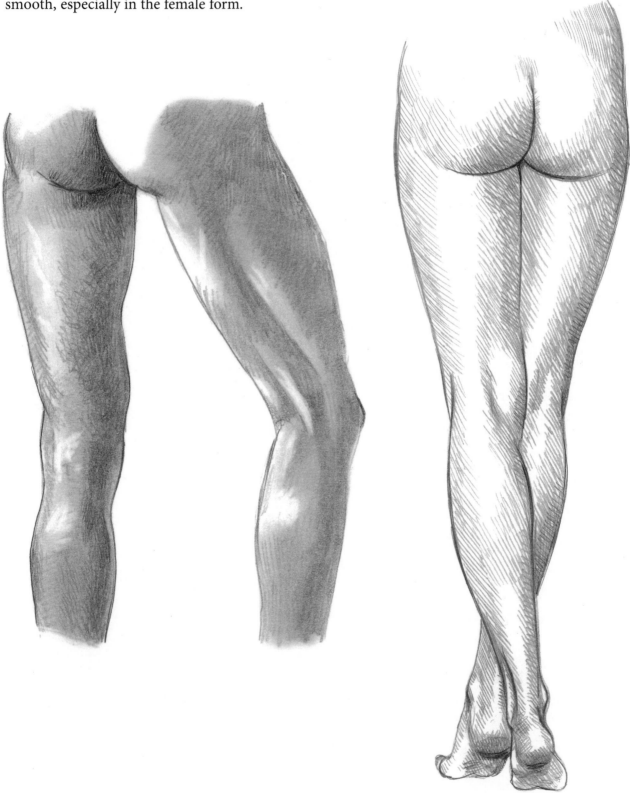

The legs bent show the distinctive effect that this has on the knee joint, producing a largish area of flat padded bone structure. Foreshortening the view of the legs produces all sorts of interesting views of the larger muscles, which are less well defined.

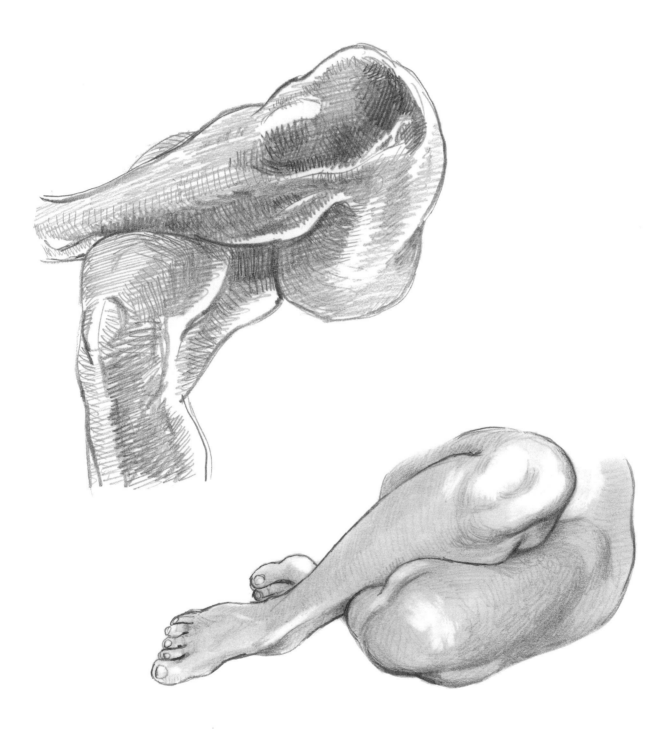

THE FEET

Feet are simpler than hands and don't have the same flexibility but are still quite difficult to draw well, especially when seen from the front or back.

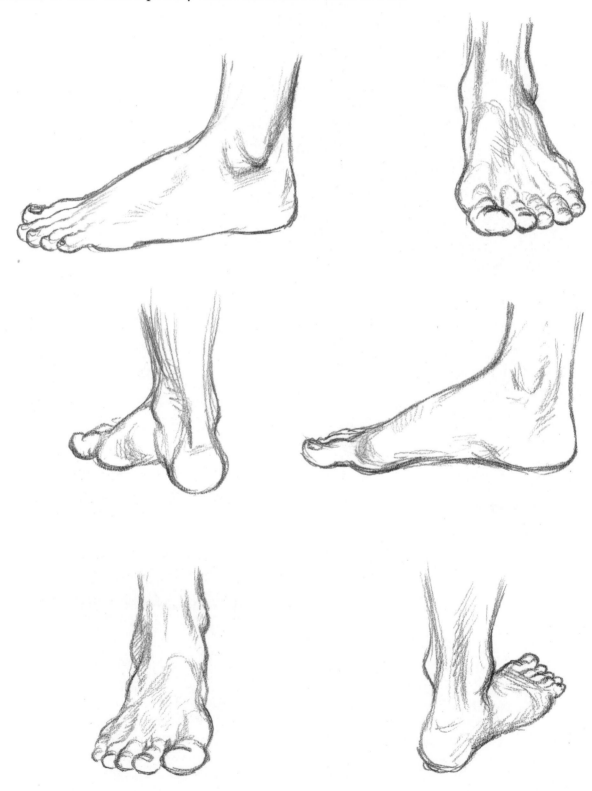

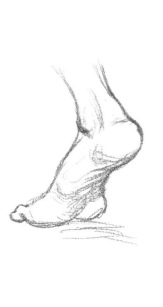
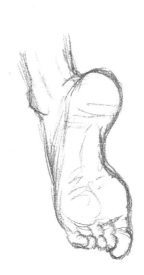
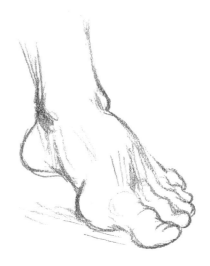

Notice the difference of the inner side of the foot to the outer side view. Which ankle bone is higher – is it the inner ankle or the outer? The awkwardness of feet seen from the front has to be addressed because you cannot always draw people in profile, so have a good try at showing how the toes project from the solid part of the foot. Don't forget to look at the feet from below as well. When a model is not available, you can practise drawing your own reflected in a mirror.

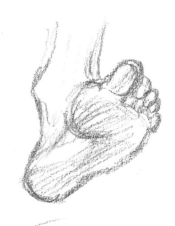

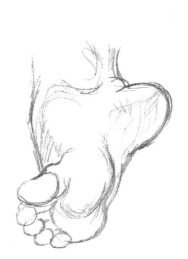

ANALYSING BALANCE AND POSE

The next group of figures demonstrates how to observe the human form and simultaneously to analyse what is happening to the placing of the body as you draw it.

Start off by visualizing a line from the top of the head to the point between the feet where the weight of the body is resting – this is its centre of gravity. Our system labels this line (from head to ground) as line A.

Next, take the lines across the body that denote the shoulders, hips, knees and feet. The way that these lines lend balance to the form tells you a lot about how to compose the figure. The system labels these as follows: the shoulders, line B; hips, line C; knees, line D; feet, line E.

Then, note the relationship between the elbows and the hands, although these are not always so easy to see. The system here is: the elbows, line F; hands, line G.

So now, as you glance down the length of the figure, your eye automatically notes the distribution of these points of balance. Concentrating your observations in this way, you will find it much easier to render the figure realistically.

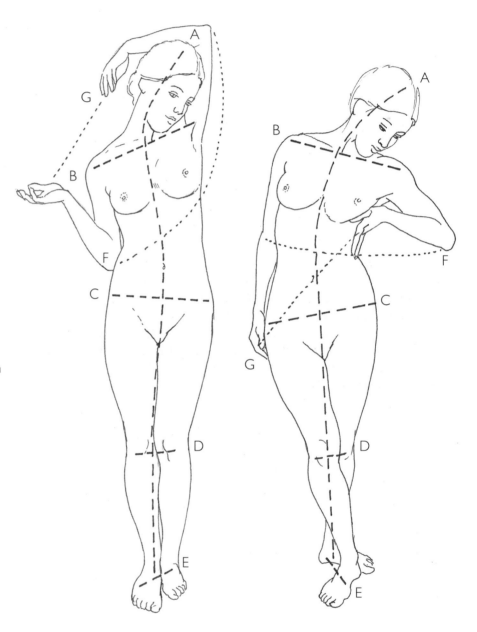

The first figure is standing and the distribution of the various levels of balance can be seen quite clearly. The only one that is a bit difficult to relate to is line F, linking the elbows.

The second figure is also standing, although the shoulders and hips are different. Nevertheless, it is still fairly easy to see how the points relate to one another.

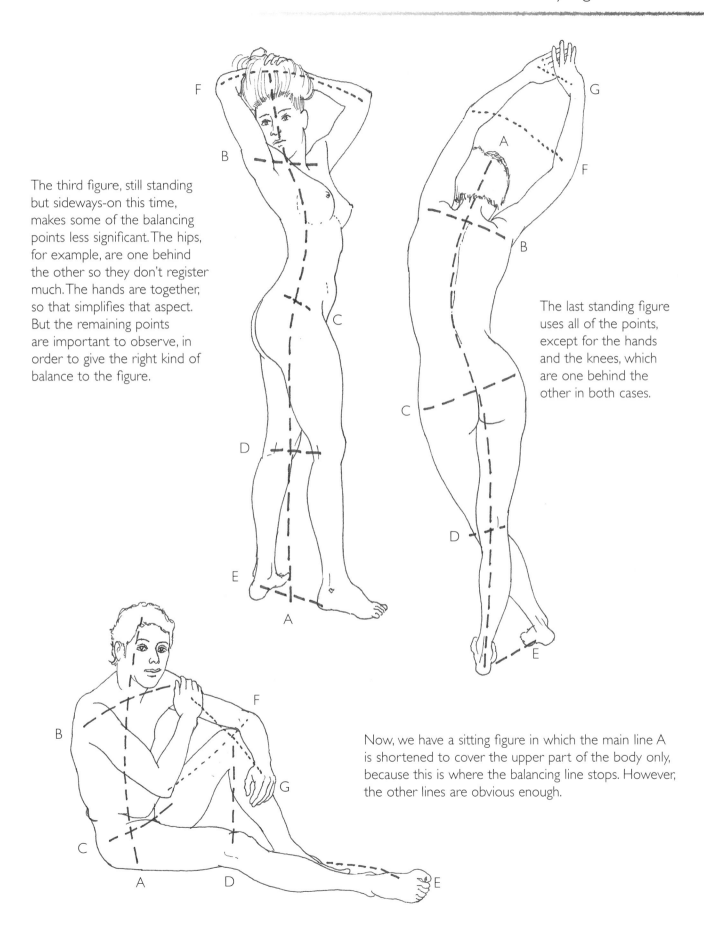

The third figure, still standing but sideways-on this time, makes some of the balancing points less significant. The hips, for example, are one behind the other so they don't register much. The hands are together, so that simplifies that aspect. But the remaining points are important to observe, in order to give the right kind of balance to the figure.

The last standing figure uses all of the points, except for the hands and the knees, which are one behind the other in both cases.

Now, we have a sitting figure in which the main line A is shortened to cover the upper part of the body only, because this is where the balancing line stops. However, the other lines are obvious enough.

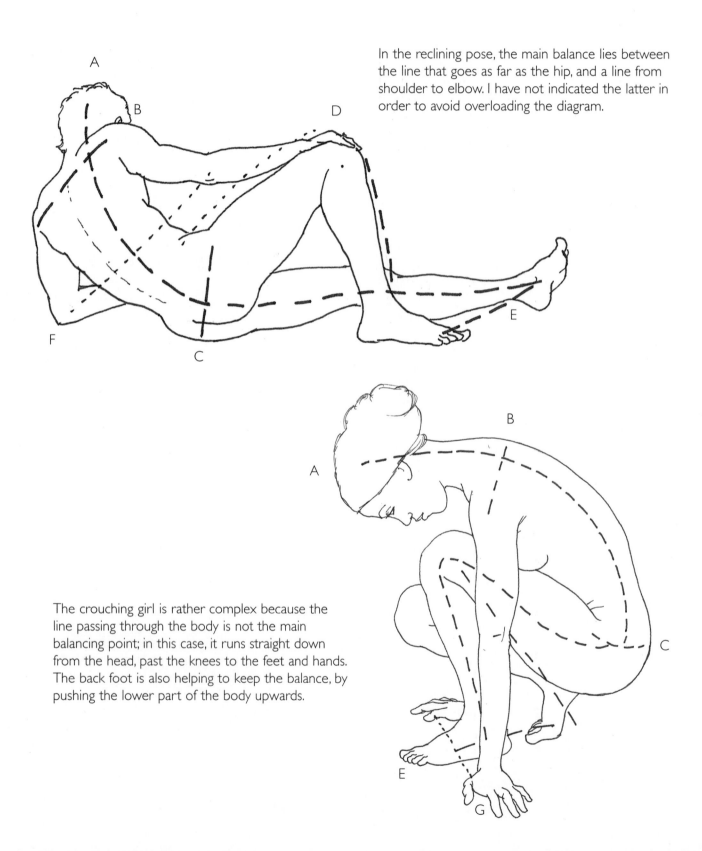

In the reclining pose, the main balance lies between the line that goes as far as the hip, and a line from shoulder to elbow. I have not indicated the latter in order to avoid overloading the diagram.

The crouching girl is rather complex because the line passing through the body is not the main balancing point; in this case, it runs straight down from the head, past the knees to the feet and hands. The back foot is also helping to keep the balance, by pushing the lower part of the body upwards.

This bending figure illustrates the principle of the cantilever, where the feet planted apart and the position of the arm on the knee, supporting the back, combine to keep the figure upright despite the horizontal angle of the upper body. But to draw the pose convincingly, it is still important to register the balancing points and the positioning of the other pairs of limbs.

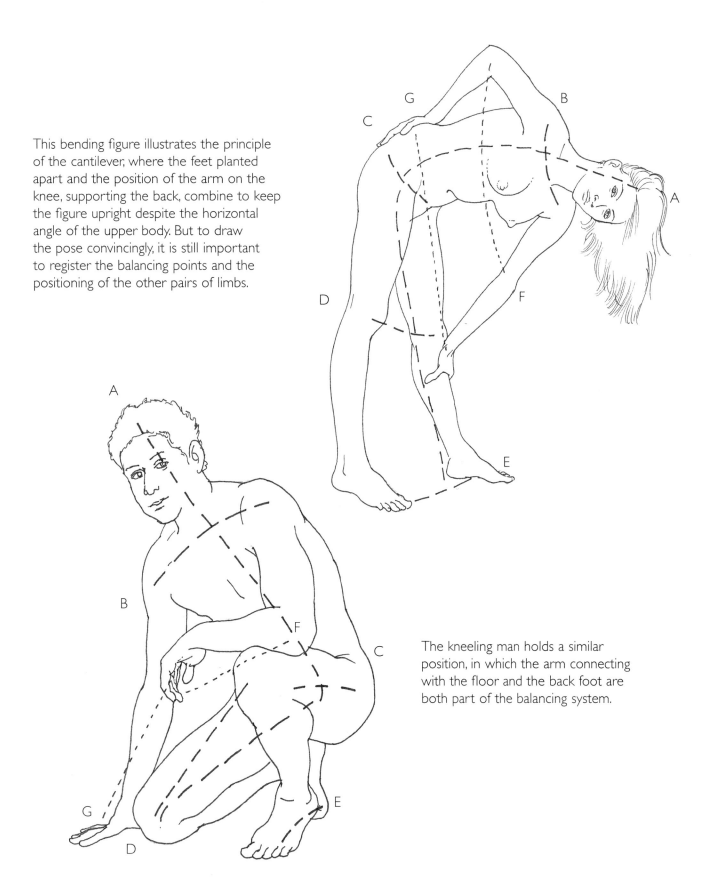

The kneeling man holds a similar position, in which the arm connecting with the floor and the back foot are both part of the balancing system.

BLOCKING IN FIGURES

The next four drawings are approached in a slightly different way from those on the previous pages, because I have blocked in the main shape rather than taking a line through the movement. This makes me look at them in a slightly different way, because now I am concentrating on the solidity of the shapes. It helps that these people are in more settled positions, so there is more time to draw them.

Once again there is no detail at all in these drawings – even the features are mere dashes of pencil to indicate their position rather than their shape. Make your own drawings of figures in more reposeful positions than you have tried so far.

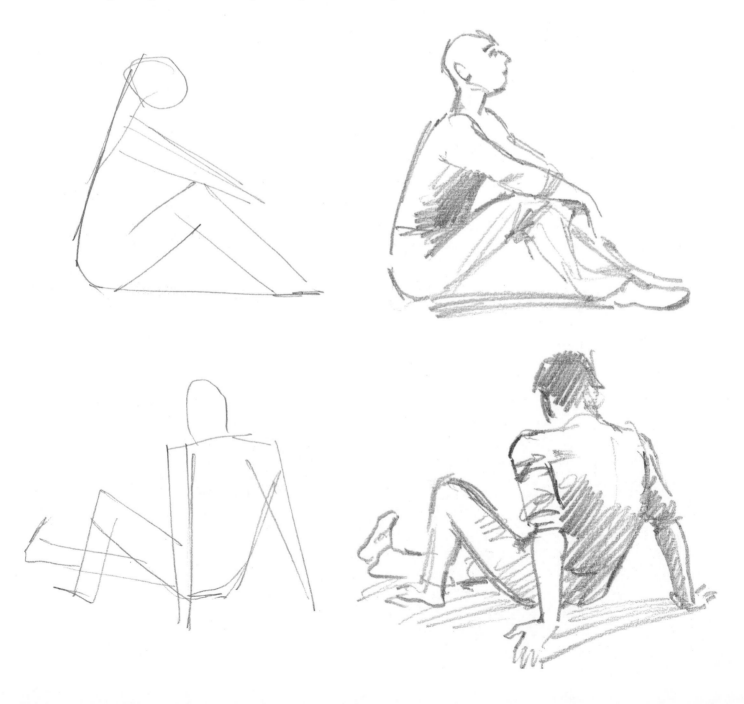

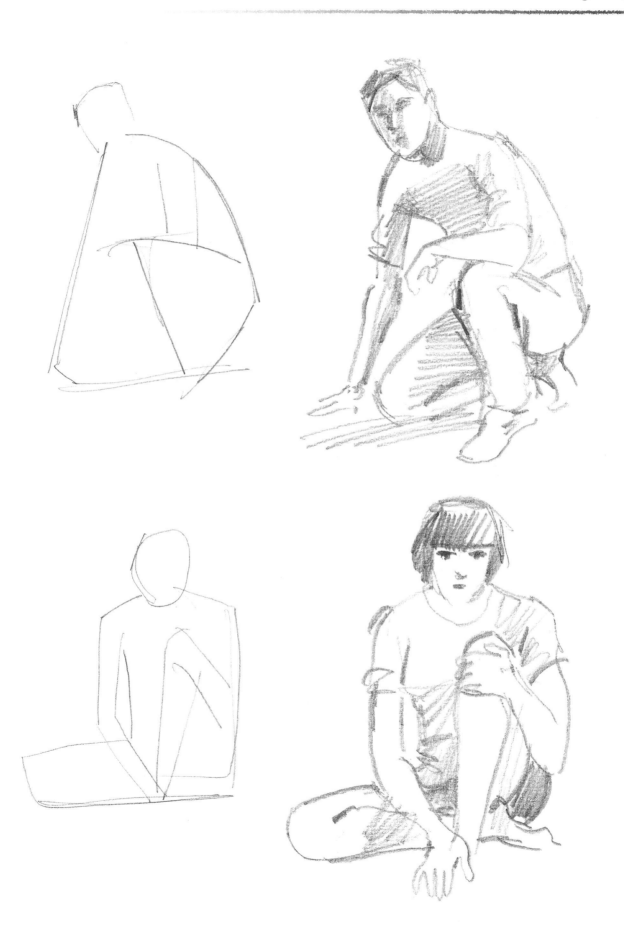

EXPRESSIVE FIGURES

Here we are still looking at the human form, but in poses that are less formal and more expressive. The four figures on this spread are not even shown in full, because my interest is in the gesticulating hands. Once again these might be easier for you to draw from photographs that have frozen the moment.

Block these in to start with as you did before, but pay particular attention to the position of the hands. One girl looks as if she is ticking off points on her fingers, one man is gesturing to draw attention to something, the other girl is in the process of combing her hair and the last man is sitting down to draw something . . . perhaps you!

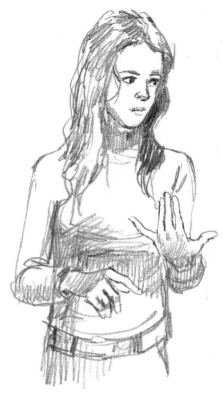

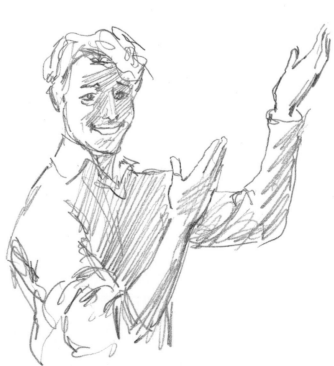

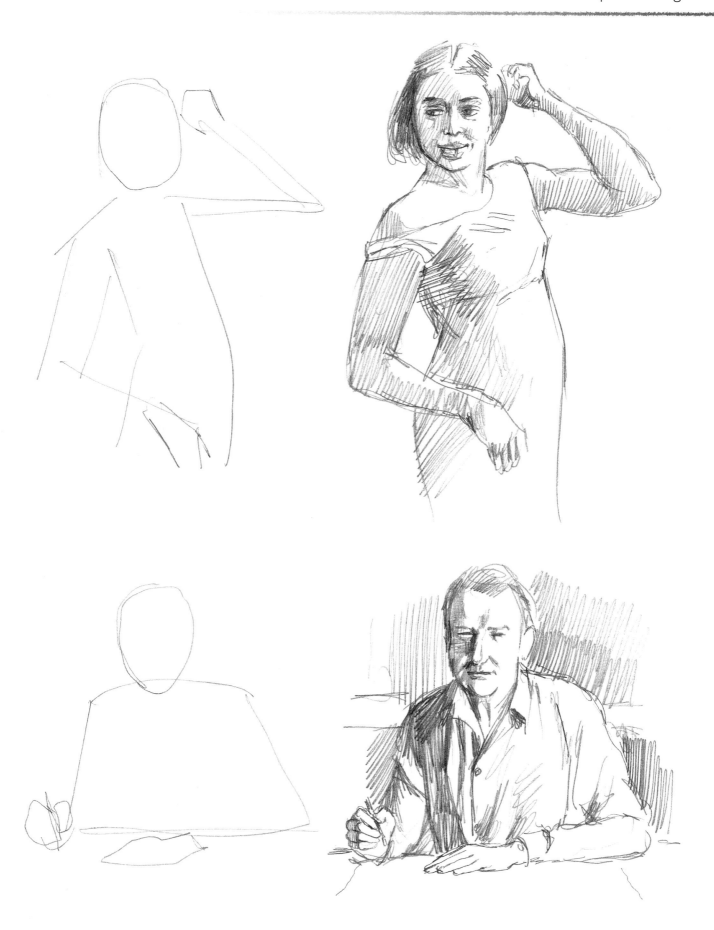

FORESHORTENED FIGURES

The next drawings look at figures which are lying and sitting in such a way that some of their limbs are foreshortened, making your task more difficult. You will have to look carefully at how the proportions of the limbs differ from how they would appear if the same figures were standing up.

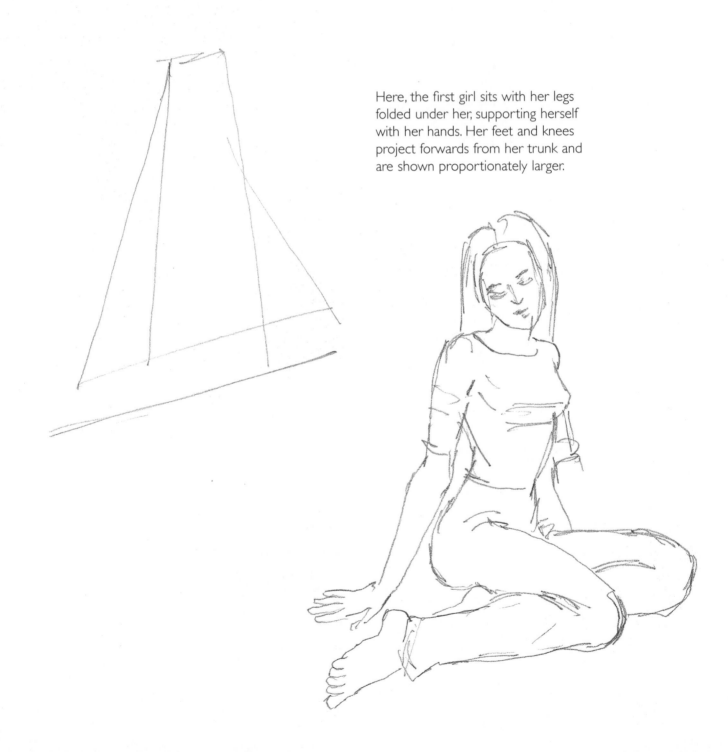

Here, the first girl sits with her legs folded under her, supporting herself with her hands. Her feet and knees project forwards from her trunk and are shown proportionately larger.

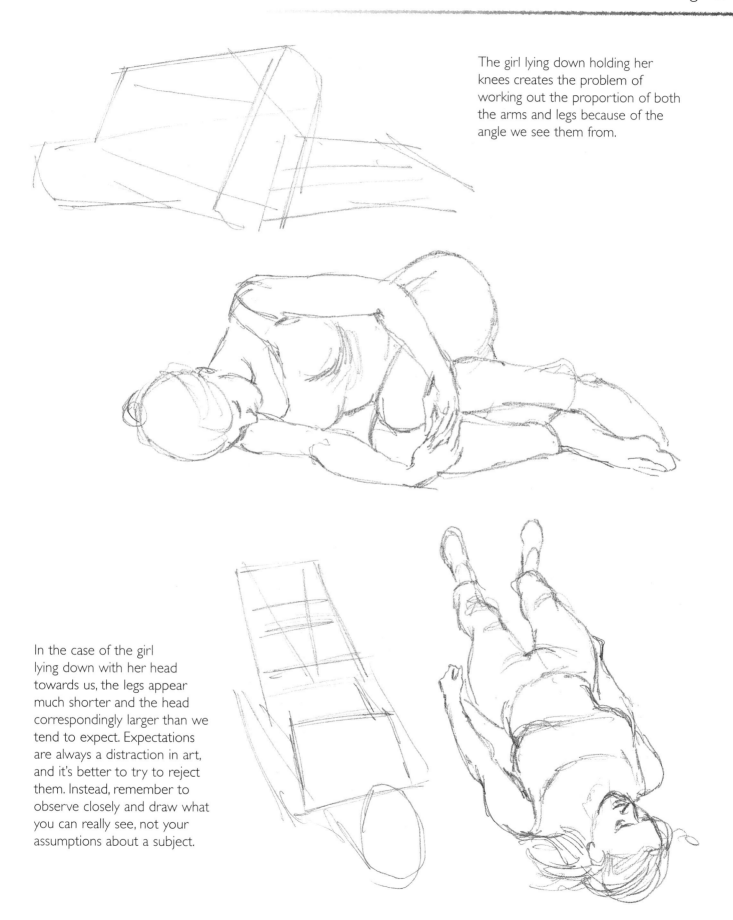

The girl lying down holding her knees creates the problem of working out the proportion of both the arms and legs because of the angle we see them from.

In the case of the girl lying down with her head towards us, the legs appear much shorter and the head correspondingly larger than we tend to expect. Expectations are always a distraction in art, and it's better to try to reject them. Instead, remember to observe closely and draw what you can really see, not your assumptions about a subject.

Finally we have three male figures in poses where the foreshortening of the limbs needs to be noticed as you draw them. When you ask your friends or family to pose for you, make sure that sometimes they sit with their limbs advancing or receding to create this opportunity for you to draw in perspective.

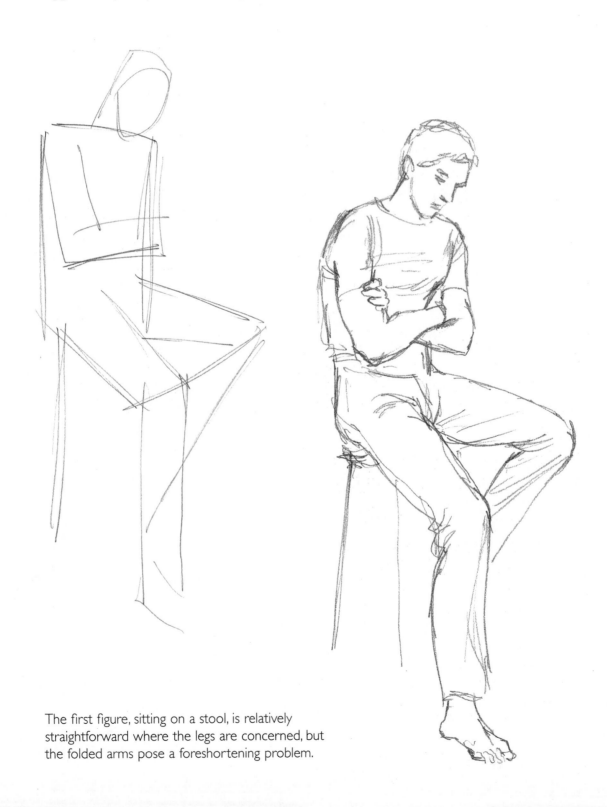

The first figure, sitting on a stool, is relatively straightforward where the legs are concerned, but the folded arms pose a foreshortening problem.

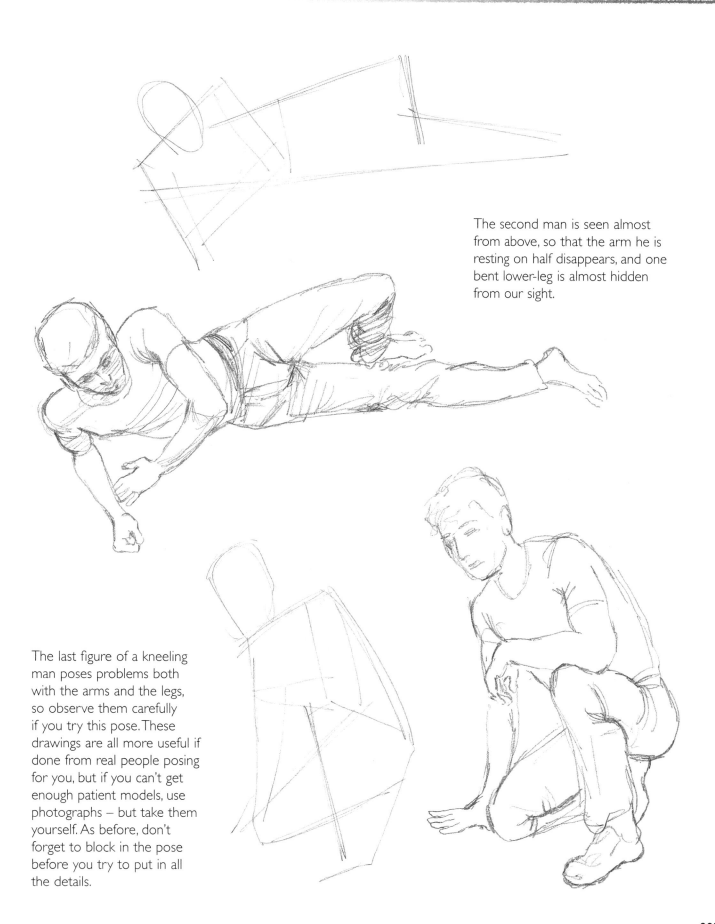

The second man is seen almost from above, so that the arm he is resting on half disappears, and one bent lower-leg is almost hidden from our sight.

The last figure of a kneeling man poses problems both with the arms and the legs, so observe them carefully if you try this pose. These drawings are all more useful if done from real people posing for you, but if you can't get enough patient models, use photographs – but take them yourself. As before, don't forget to block in the pose before you try to put in all the details.

DRAWING THE WHOLE FIGURE

Drawing the complete human body is really the subject of a life class. Generally speaking, the best you will be able to coax from friends and family is a pose in a bathing costume, since other than the young and beautiful most people are too self-conscious to subject themselves to such close scrutiny. This is sufficient for a general view of the body, but if you need to study it more closely in order to understand the bones and muscles showing on the surface a tutored course in life drawing is the obvious answer. While these vary, most of the tuition in such classes is good, because they are usually run by expert art teachers. The complete body is definitely the hardest thing that you will ever draw, and you will find that after a time spent studying it your drawing of other things will also improve. So start with the details of bodies, and then graduate to the complete figure.

A standing position with no foreshortening is easiest, but you will also need to draw models sitting, reclining and also in various more complex poses where the limbs and torso are turned, folded and twisted to show how the different parts of the structure function together. Try to draw from models of different shapes, sizes and ages where possible. One very good way to gain an understanding of the structure of the body is to have the model sitting on a revolvable chair and gradually turn it around so that you are drawing the figure in the same pose from a variety of positions.

You will need to study the front and back of the torso carefully, as the musculature is vastly different from these two views. Also draw from both the head and foot ends of the reclining figure to see how foreshortening changes the way we see the shape of the human body – the conventional image in our minds is a standing figure, but of course the body looks very different when it is in other poses. Any study of the human figure will do wonders for your powers of concentration and your ability to draw any other subject.

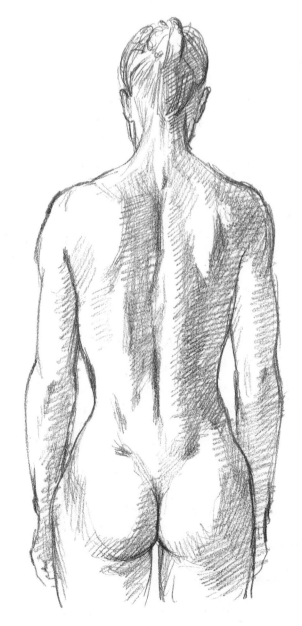

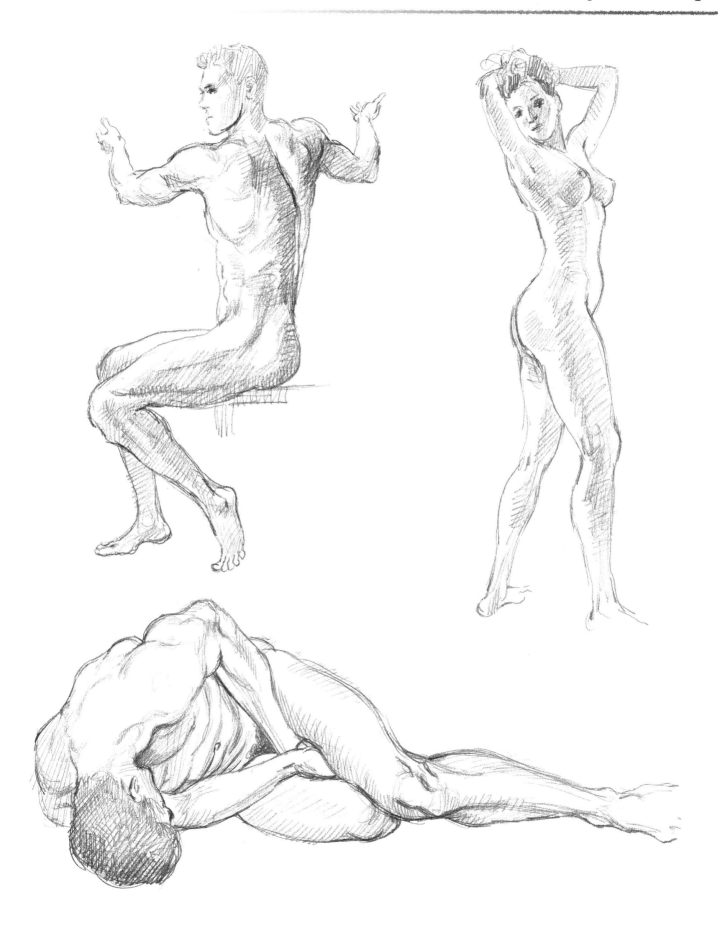

SEATED AND RECLINING FIGURES

Sitting or reclining are hardly considered to be movements, and yet the dynamics of the figures do suggest a quality for potential activity as their poses suggest imminent movement.

Here a girl is sitting with legs crossed, arms across the knee and head turned to one side as though she is talking to somebody. This is not a pose she is going to keep for long so there is a definite feeling of movement in the position. You can almost see how she is going to uncross her legs and possibly recross them in the other direction.

The second figure is of a ballet dancer sitting down for a rest. She has pushed her feet out to the extreme position and is massaging her calf muscle. We can tell this is not a pose she is going to hold for very long and so there is implicit movement even though she is not at present very active.

There are, of course, as many poses or actions as there are movements in the human body. These are all posed models who are reclining or sitting in a pose that can be held for a while. The drawing needs to show that the body is at rest, which is fairly obvious by the positions shown.

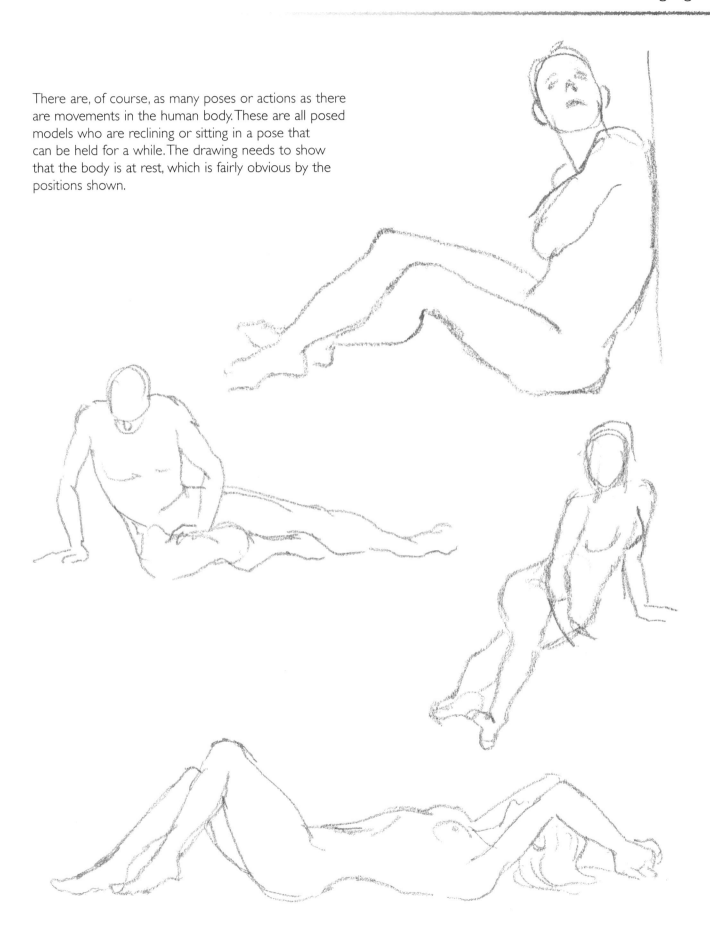

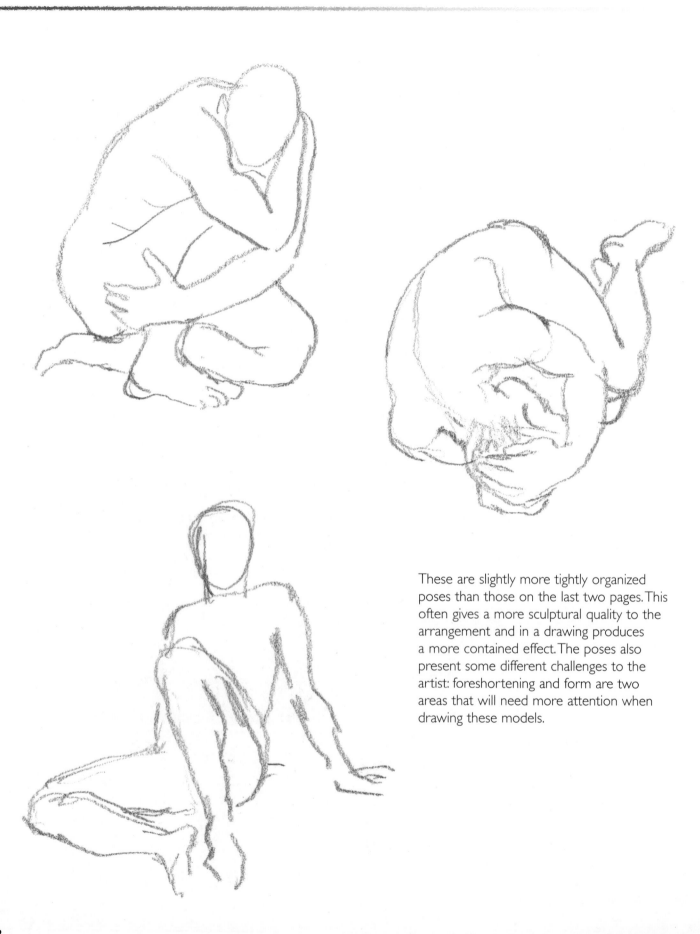

These are slightly more tightly organized poses than those on the last two pages. This often gives a more sculptural quality to the arrangement and in a drawing produces a more contained effect. The poses also present some different challenges to the artist: foreshortening and form are two areas that will need more attention when drawing these models.

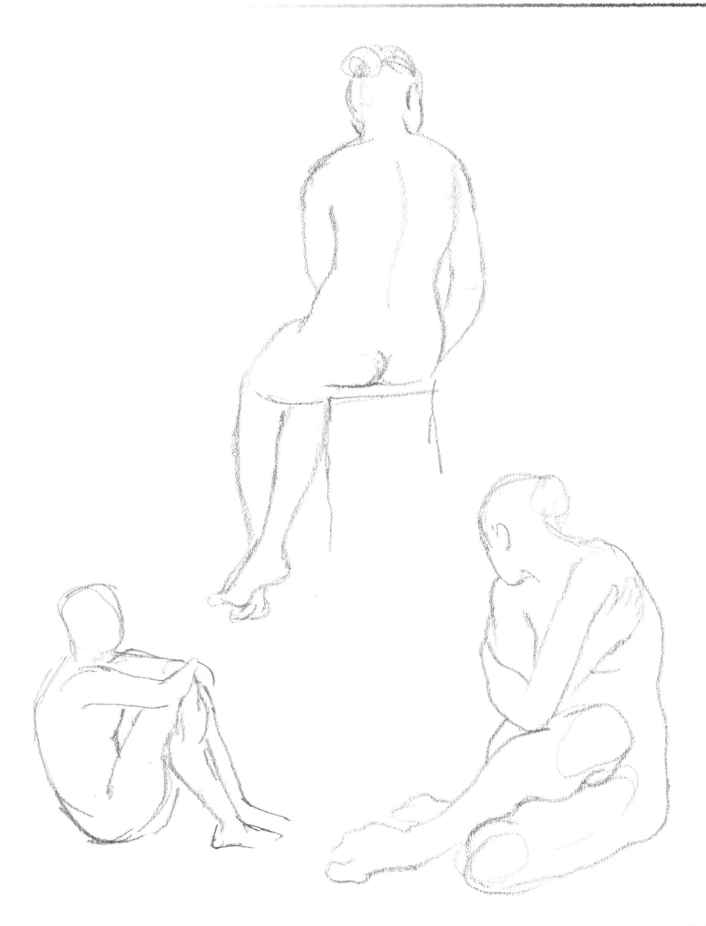

WALKING AND RUNNING FIGURES

Photographs are a great boon to the artist wanting to discover just how the parts of the body relate to each other as the model moves, but they should be used with caution as copying from a photograph can produce sterile results. An artist should be looking not just to make an accurate drawing of lines and shapes but also to express the feeling of the occasion in a way that can be understood by the viewer: look particularly at the styles of depiction chosen here. Study photographs, but stamp your own mark as an artist on your drawings.

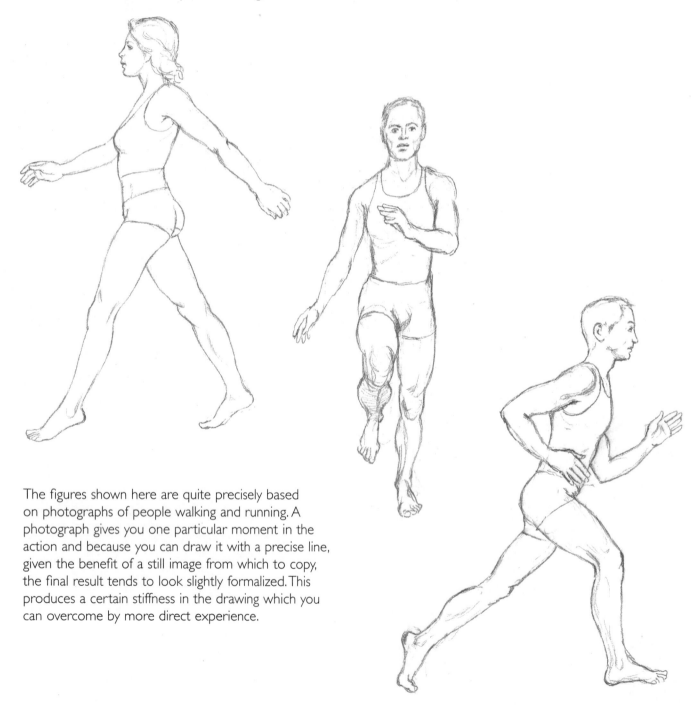

The figures shown here are quite precisely based on photographs of people walking and running. A photograph gives you one particular moment in the action and because you can draw it with a precise line, given the benefit of a still image from which to copy, the final result tends to look slightly formalized. This produces a certain stiffness in the drawing which you can overcome by more direct experience.

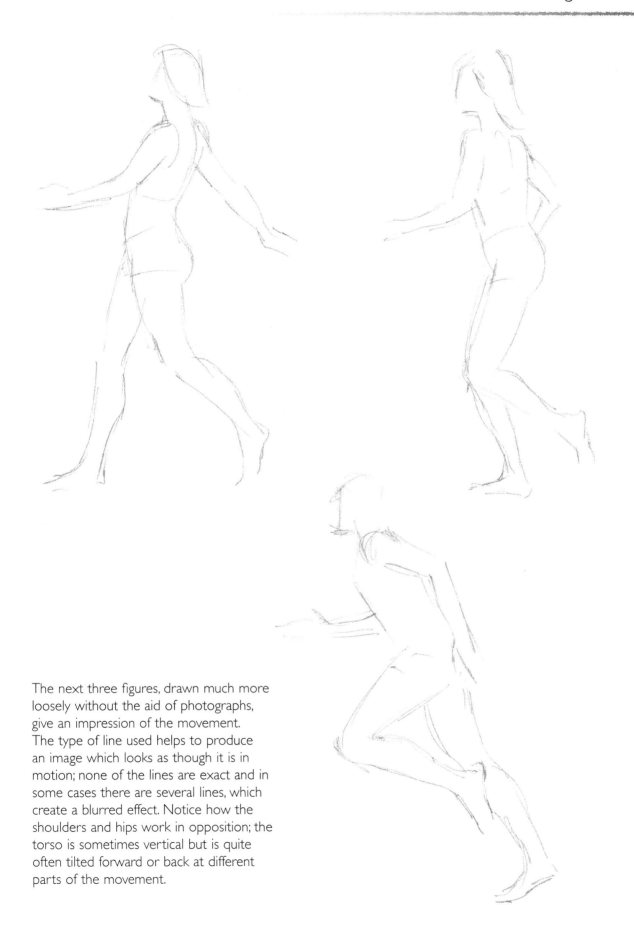

The next three figures, drawn much more loosely without the aid of photographs, give an impression of the movement. The type of line used helps to produce an image which looks as though it is in motion; none of the lines are exact and in some cases there are several lines, which create a blurred effect. Notice how the shoulders and hips work in opposition; the torso is sometimes vertical but is quite often tilted forward or back at different parts of the movement.

DANCING FIGURES

The figures here show what happens when the body is projected off the ground with necessary vigour, in some cases informally and in others in more stylized poses.

This drawing of a leaping man shows how the left leg is bent as much as possible while the right leg is extended. The torso is leaning forward, as is the head, and the arms are lifted above the shoulders to help increase his elevation.

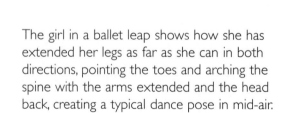

The girl in a ballet leap shows how she has extended her legs as far as she can in both directions, pointing the toes and arching the spine with the arms extended and the head back, creating a typical dance pose in mid-air.

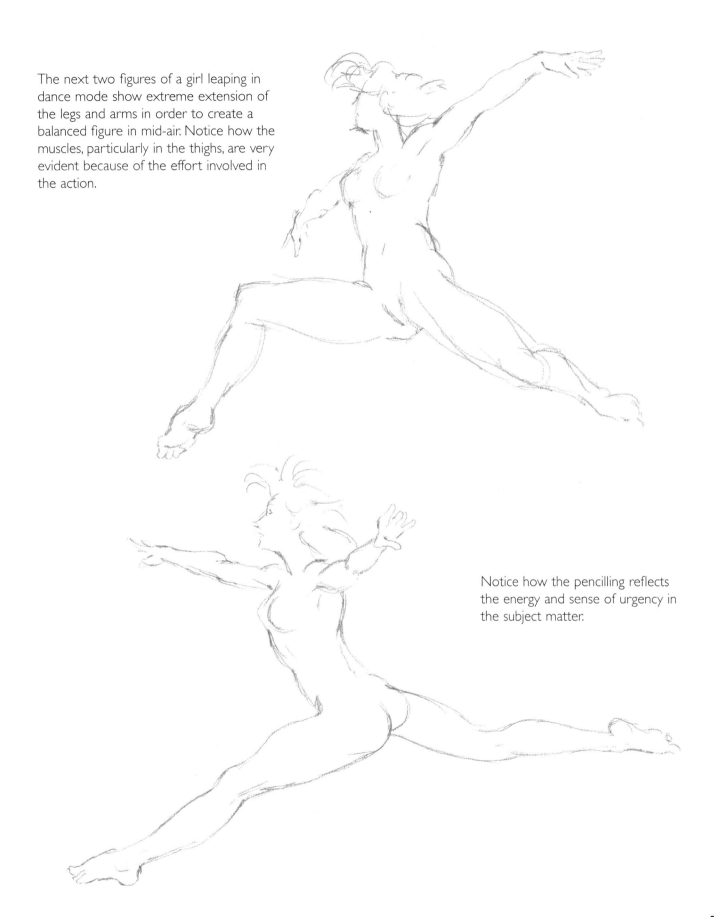

The next two figures of a girl leaping in dance mode show extreme extension of the legs and arms in order to create a balanced figure in mid-air. Notice how the muscles, particularly in the thighs, are very evident because of the effort involved in the action.

Notice how the pencilling reflects the energy and sense of urgency in the subject matter.

BALANCE AND IMBALANCE

It is an interesting exercise to try to draw someone at the point where they have lost their balance and begun to fall over. It is not easy to do, because even if the occasion presents itself your reaction will probably be to try to help rather than take advantage of the situation. However, an accident such as this is often clearly imprinted on your memory for a short time, so you can sometimes remember enough to make a sketch shortly afterwards. Asking someone to adopt a falling pose is never quite the same, but it is worth trying.

Conversely, people engaged in an activity such as throwing a ball or climbing rocks and trees are usually in a state of perfect balance. Here the body is under tight control, with deliberate movements – note how careful pencilling reflects this control.

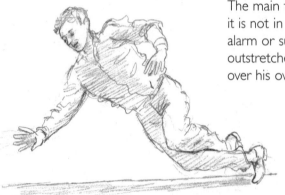

The main thing about drawing the figure falling is to show that it is not in balance. There are obvious things to note, such as the alarm or surprise on the face, the attempt to save oneself with outstretched arms and other details. Here a man who has tripped over his own leg has thrust out a hand to save himself.

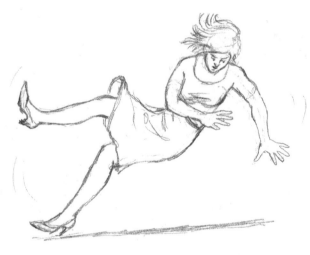

A girl who has slipped over is trying to turn to protect herself from a bruising. Again, there is an instinctive attempt to cushion the fall with the arms, and her untidy hair and alarmed face reinforce the message that she has temporarily lost control of her body.

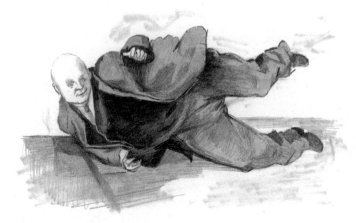

This example is from a painting by Michael Andrews. The expression on the rather rotund businessman's face as he crashes to the ground, probably about to roll over; the ineffectual movement of the arms and hands which will obviously not save him from the bump; and the movement of the coat and trousers indicating the passage through the air of his descent all go to make this a remarkable piece of work. In the original there is in the background a woman with her hands to her face, shocked by the accident, which helps to increase the effect of the falling body.

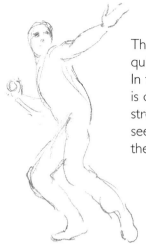

The action of throwing something is quite a dynamic subject for a drawing. In this figure throwing a ball the body is drawn back, with the free arm stretched to help with the aim. You can see that when the body is unleashed the ball will go far.

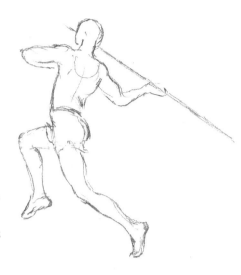

Here an athlete is in the run-up for the casting of his javelin. His arm is back, his body is turned and his legs are poised for the final twist as the object is sent flying.

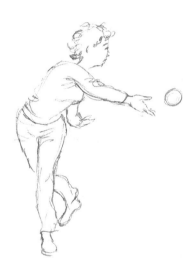

This young woman is throwing a ball underarm with a sudden twist of the body. The effort is more gentle than in the previous two drawings and suggests that she hopes the recipient, perhaps a child, will catch the ball.

In an activity such as climbing, balance and grip are two very necessary parts of the success of the enterprise. Here a young person is scaling an almost vertical rock face or climbing wall in which his hands and feet are firmly placed. His body is hugging the rock and his head is up to see where the next handhold is. All the climber's attention is on not making any false moves.

With the two figures climbing a tree the emphasis is on effort and a certain sense of risk, where the youngsters seem to be taking chances. The lower boy is in a rather tricky position from which he might have to drop down or wait for the upper boy to help him. The upper boy is climbing up quite fast and looks agile and strong. The balance is there but less deliberate than with the rock climber.

SPORTING FIGURES

In figures playing sports, the feeling is of controlled power and often fast action. The figures are acting with concentrated purpose and they are carrying out movements that have been rehearsed over and over again, so their balance and coordination are carefully tuned.

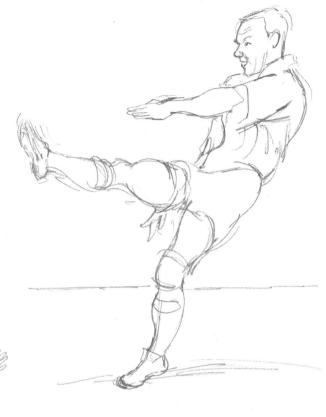

This drawing shows the powerful kick of a rugby player, his body swung back to balance the forceful thrust of his leg, his eye on the direction of travel of the ball. There seems no doubt that the ball will go where he wants it to.

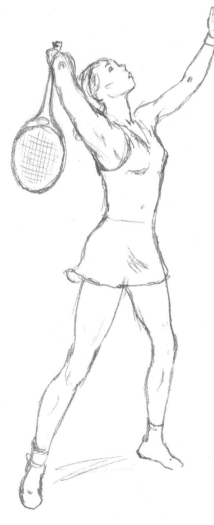

A young tennis player is about to serve, balanced on her toes with her racquet swung back behind her and her eyes on the ball that she has just thrown up into the air. The whole poise of the action is contained in the upward-reaching stance of the girl, in contrast to the ball (if it were shown) as it begins to descend.

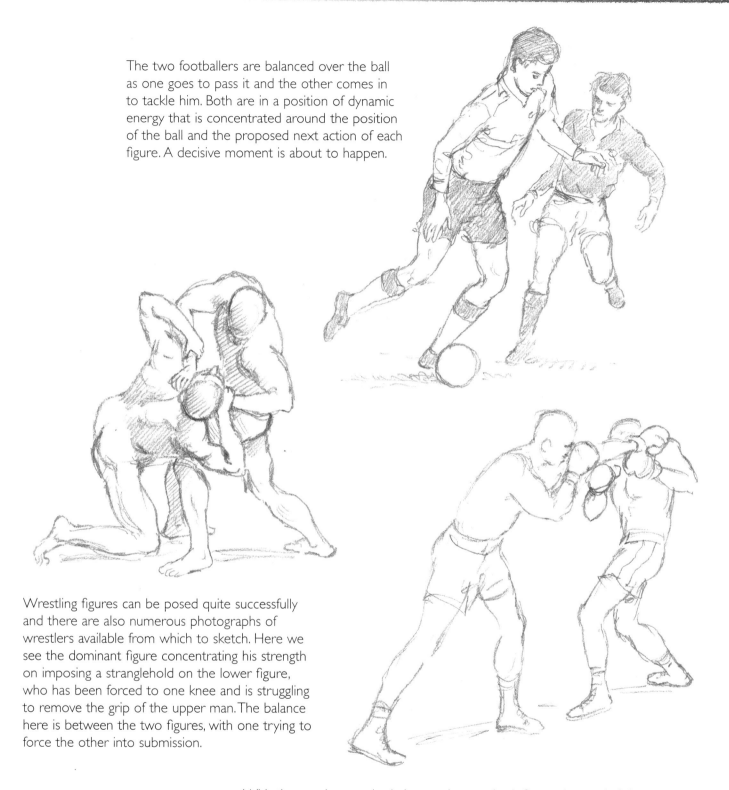

The two footballers are balanced over the ball as one goes to pass it and the other comes in to tackle him. Both are in a position of dynamic energy that is concentrated around the position of the ball and the proposed next action of each figure. A decisive moment is about to happen.

Wrestling figures can be posed quite successfully and there are also numerous photographs of wrestlers available from which to sketch. Here we see the dominant figure concentrating his strength on imposing a stranglehold on the lower figure, who has been forced to one knee and is struggling to remove the grip of the upper man. The balance here is between the two figures, with one trying to force the other into submission.

With the two boxers the balance relates to both figures but each fighter is also in balance himself. The one striking the blow is extended but both feet are on the floor and his guard is up. The other has moved to the side with both hands up to defend himself from the incoming fist and be ready to strike back. His feet are also firmly on the floor and his body weaves in order to retain both balance and hitting power.

FRAMING THE PICTURE

A very useful tool to help you to achieve interesting and satisfying figure compositions is a framing device such as is shown here. It can be made cheaply by cutting it out of card to any size and format that you wish to work on. Holding it in front of you to look through it and moving it slightly up and down and from left to right will allow you to examine the relationship between the figure and the boundaries of the paper and visualize your composition before you actually begin to draw. It will also help you to see the perspective of a figure at an angle to you, as the foreshortening becomes more evident. Dividing the space into a grid will assist you in placing the figure accurately within the format when you draw it.

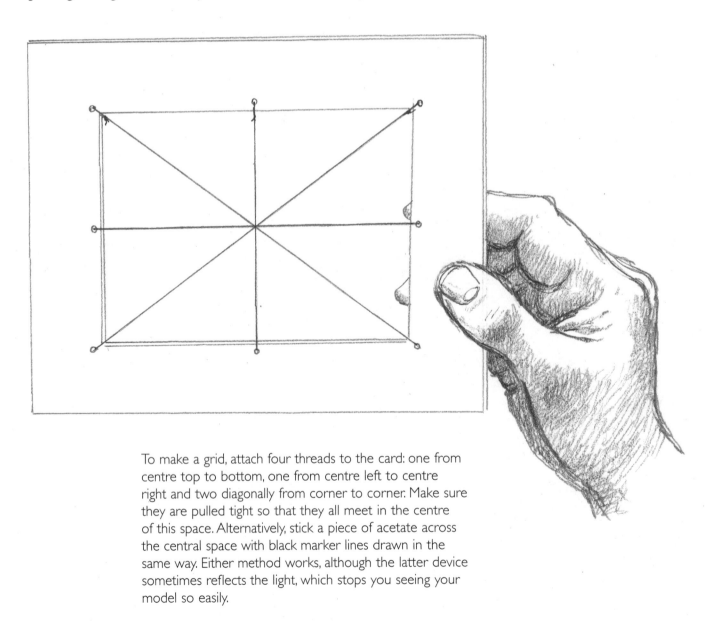

To make a grid, attach four threads to the card: one from centre top to bottom, one from centre left to centre right and two diagonally from corner to corner. Make sure they are pulled tight so that they all meet in the centre of this space. Alternatively, stick a piece of acetate across the central space with black marker lines drawn in the same way. Either method works, although the latter device sometimes reflects the light, which stops you seeing your model so easily.

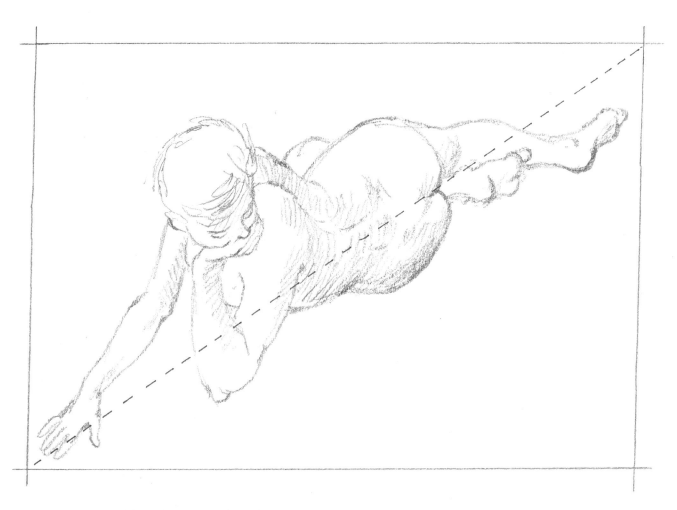

Here the edges of the frame are placed so that the figure appears to stretch from the upper right-hand corner to the lower left-hand corner. The centre of the picture is taken up by the torso and hips and the figure is just about balanced between the upper and lower parts of the diagonal line. This would give you a picture that covered the whole area of your surface but left interesting spaces at either side. You will find that it is quite often the spaces left by the figures that help to define the dynamics of your picture and create drama and interest.

USING SPACE

Think about the areas of paper around your figures; they should fulfil a purpose rather than appearing by default. Space in your composition can suggest as much about the mood of the piece as the pose of the figure itself. Planning ahead is what transforms a drawing of a figure into a complete composition that affects the emotion of the viewer.

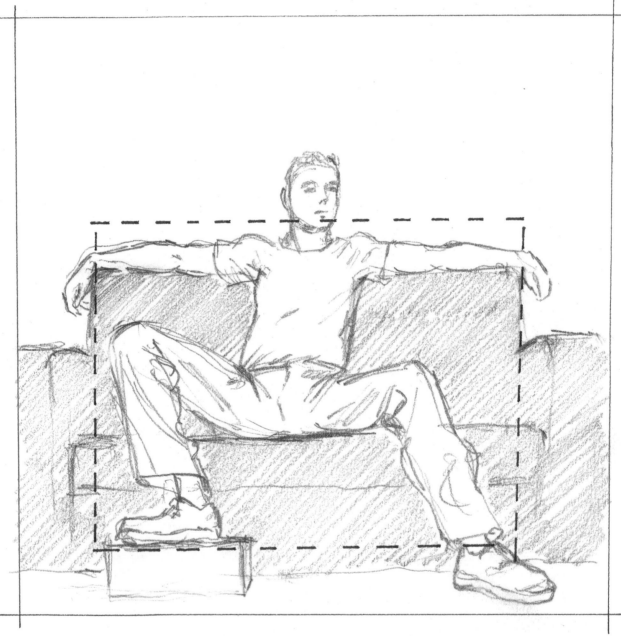

In this rather static pose, a young man is stretched out on a sofa. The pose is very foursquare, so that he looks extended to the rectangular shape of the seat. The only elements that slightly disrupt this solid pattern are his slightly raised leg and his head, which juts up above the main shape. He is set across the bottom half of the space with a significant area of space above him, creating a very steady, immobile composition. He not only inhabits the space, he takes it over.

The standing figure of the girl turning away from the viewer is a gentle dynamic pose with a strong, straight, upright shape. You might choose to fit the edge of the picture closely around her, as shown by the unbroken line. This is the simplest possible composition, making the figure fit in as in a box. Alternatively, you could use a space as shown by the rectangle with the lighter broken line, which encloses a large amount of space over to her right. Here she is on one side of the composition and the space suggests airiness and the light that is falling on her from the right.

A third choice of composition, shown with the heavier broken line, places her in a space which gives her room on both sides, making a dynamic out of the larger space to the right and the smaller space to the left. It also seems to set her back into the square more effectively, lending distance to the view that didn't occur with the first two compositions.

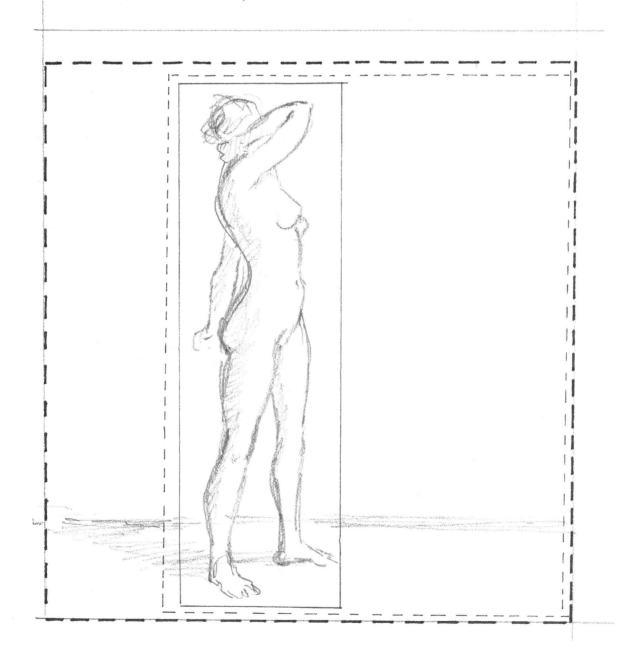

DYNAMIC ENERGY

When you are deciding on your composition you will have some theme in mind that will influence the way you pose and draw the model. Generally, the pose falls into one of two types: the dynamic, energetic pose or the relaxed, passive pose. Shown here are four examples of ways to produce the former, showing power, energy or movement. We understand the message they carry partly because of the associations we have with particular movements of the body and partly because of the activities the figures are engaged in; the drawings of a footballer kicking a ball and of the runner starting from the starting blocks immediately inform the eye of the dynamics involved.

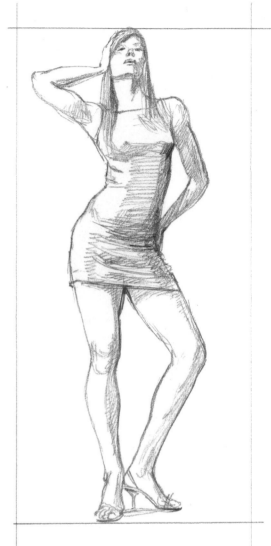

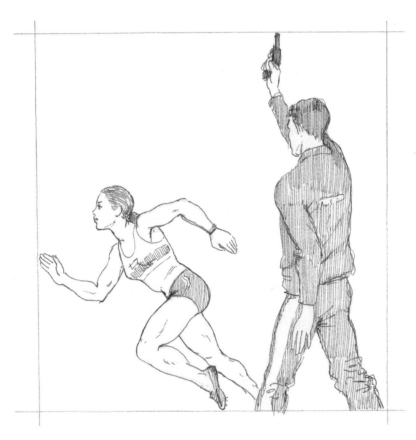

The runner exploding off the starting blocks is a sharp diagonal towards the edge of the picture, also helped by the hand and feet being right on the frame. The man with the starting gun gives a strong, stretched form from top to bottom of the picture from which the runner is angled off in a very dynamic shape.

In a classic fashion pose, the model is thrusting out one hip and both her elbows and bent knee are also pushed out to create strong angles all along the length of the body. Although we are aware that this is a static pose, it has the movement implicit in the angled, arched torso, the uneven bending of the arms, one to the head, one to the hip, and the attitude of head, feet and shoulders. It has the look of a dance movement, which helps to maintain the dynamic. Again the framing of the figure helps by being as close in as seems effective.

These two figures are apparently startled, turning to see something that may be alarming or surprising. They are looking above the head of the artist, bending towards each other, their arms seeming to indicate disturbance. There is some feeling of movement about to take place, but there isn't a real source of activity; it is just a pose. However, the movements of the bodies, their juxtaposition to each other and the apparent focus of their attention outside the picture frame helps to produce a dynamic, energetic set of forms, which we read as movement. The way the figures are framed also helps this feeling, with the outstretched arm of the man almost touching the top edge and their legs being out of sight below the knees. The diagonal forms of the two torsos, leaning in towards each other away from the lower corners of the frame, also help this appearance of action.

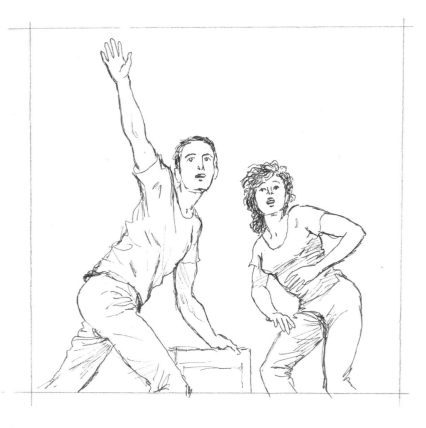

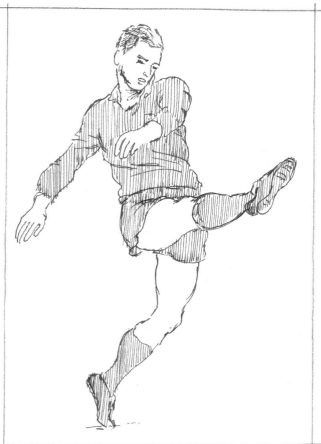

This straightforward drawing of a footballer kicking a ball with his body twisted, head down, shows that an individual figure can also produce dynamics. Again, the frame of the picture cuts in very close to the extended arms, legs and top of the head. This close framing helps to produce the movement, which seems to continue outside of the frame.

RELAXED POSES

Here the basis of the pose is more relaxed. This is of course a much easier way to pose a model, because most people can keep still in a comfortable reclining or sitting position. When you want to do longer, more detailed drawings you will always have to rely on more static poses.

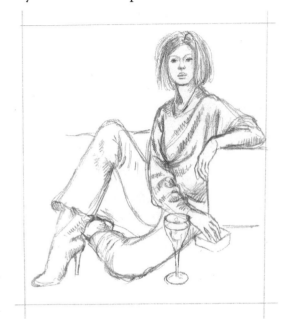

Sitting upright on the floor, the model has her legs bent, one tucked underneath the other. Her fashionable appearance and the wine glass on the floor in front of her helps to give a static easy-going composition which looks as if she is engaged in a conversation at a party. The arrangement of the legs crossing each other and the arms bent around the torso help to give a fairly compact appearance to the arrangement.

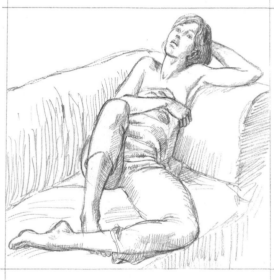

The second figure is even more relaxed and literally laid back, with the head supported on one bent arm resting on the side of the couch and the other arm bent across the torso, holding a garment across the body. The legs are tucked around each other in a way similar to the previous pose but even more loosely arranged. The viewpoint from the foot end of the body does give a certain dynamic, but the energy is reduced to give an effect of rest. The head bent back onto the hand and the arm of the couch helps this passivity.

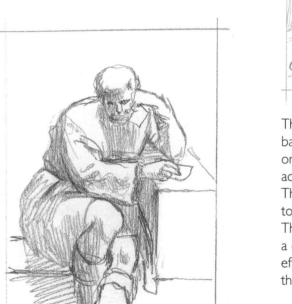

This sitting figure, taken from a Raphael design in the Vatican, is in a pose that looks both thoughtful and relaxed. The figure is of a philosopher about to write his thoughts, a pose that is obviously going to be static for some while.

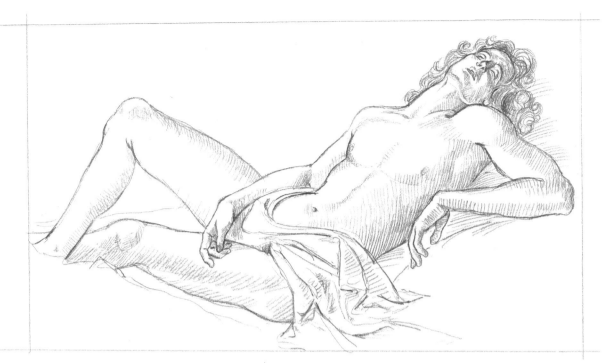

I based this drawing on Botticelli's picture 'Venus and Mars', which can be seen in London's National Gallery, in which the reclining figure of Mars is totally surrendered to sleep. As a reclining figure it is one of the most relaxed-looking examples of a human figure.

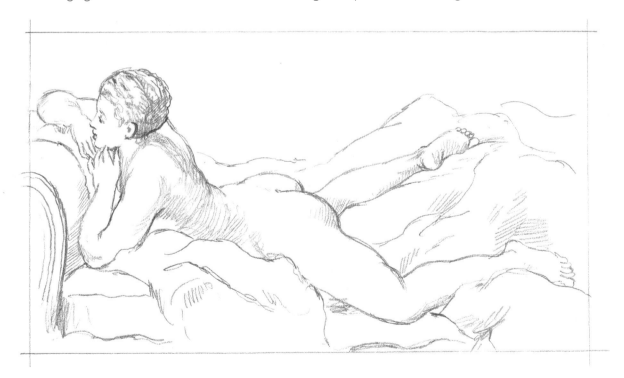

In this drawing, based on a work by the 18th-century French painter François Boucher, a nude girl is reclining on a couch, posing for the artist. Although her head is erect, supported by her hands, and her back is hollowed, she is in a pose that doesn't suggest action on her part at all. The side view of a reclining pose is always the most calm and peaceful in effect.

SOCIAL SETTINGS

Figures in social settings are much simpler to draw than those engaged in energetic sports. Their movements are slower and calmer as they will stay in one spot for longer. Their gestures and body language will tend to be repeated again and again, giving you plenty of time to observe them and draw them accurately. Notice how they may change as people begin to relax in the company of someone they have only just met.

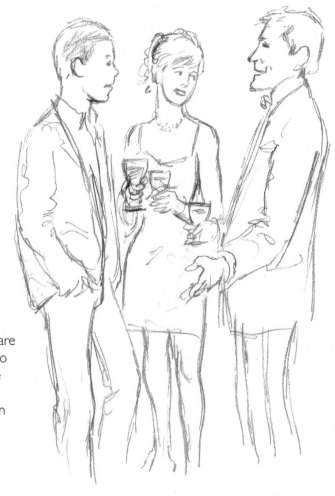

These three figures engaged in conversation look relaxed and are fairly still. The animation tends to be in the hands and faces while the bodies take on poses of comfortable balance rather than energetic shapes.

A group around a table at a meal is even more static and here you will probably see only the upper half of the bodies with any clarity. Again all the animation will be in the faces and it is the glances and direction of the turning heads that help to create the dynamic. Lighting helps here and drama can be enhanced by candlelight, which tends to obscure details.

Social settings outside tend to be more dynamic in terms of body movements and poses. Here, at a garden party, a group of young people are seen eating and talking. One leans aside to replenish his plate, while the girl with her back towards us gestures to the table. The man opposite her is partially obscured but one can get the effect of some rather direct expression from him. The other woman points to herself with hand on hip. All this is against the background of foliage and roofs.

Street scenes are less easy to draw because people don't tend to linger much and it is difficult to find places where you can obtain a good view. However, the dynamics of this group of shoppers as they pass each other, commenting on their purchases, makes an interesting balance of figures across the pavement with other figures lightly indicated in the background.

317

STEP BY STEP TO A FINAL COMPOSITION

Now we have come to the final hurdle – putting all the things that you have learnt into a complete figure composition. By starting from the very beginning and proceeding through to a carefully finished piece of drawing you should be able to produce a convincing scene with human figures in it, if not a great work of art. Remember that you have to walk before you can run, so even if the final result is not inspired it should be effective enough to show how to construct the final presentation of figures in a scene that is within your capabilities and interesting enough to carry some conviction.

Step 1 The Format
What shape and size will this composition be? The format will be landscape, square, portrait or panoramic. Within these categories the size will make a lot of difference. Your choice is up to you and what you think you are capable of drawing. For the sake of this exercise I decided that a landscape format would be the right one.

Step 2 The Number of Figures
There should be at least two figures to make a composition, but it could be three, four, five or even more. For the sake of simplicity and precision I elected to have three figures in the composition. Added to this the choice had to be made as to whether they would be male, female or both. My initial decision was to have one female and two males, though in this I was open to change along the way.

or more

A.

B.

C.

D.

Step 3 What Space Will the Figures Occupy?

Will the composition have a large upper space and the figures in the lower area sweeping up to the right side towards the top (see A)? Or will there be a more central shape like a hill with small spaces either side in the upper half (see B)? A sort of valley shape with a large central space and figures at the lower edge and up either side might work well (see C). Or why not have a complete sweep of figures across the whole scene covering most of the space (see D)? Because there are only three figures I opted for something that is weighted to one lower side sweeping up to the other higher side.

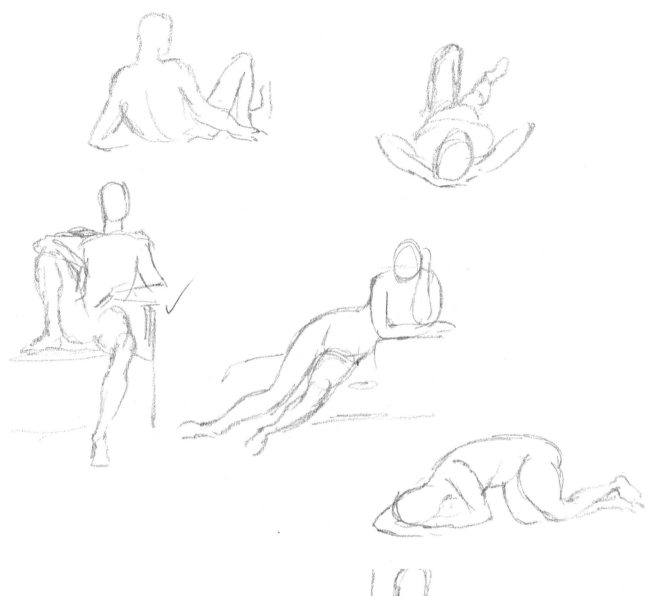

Step 4 Choosing a Pose

In order to reach a decision on what sort of poses to look for, it is a good thing to have some sort of theme. For an easy one that would enable the figures to be in a variety of positions and have an open-air background, I chose the theme of figures in a park in summer, sitting down or lounging around while others walk by. The next step was to start to sketch people sitting, lying down, standing or walking as though they were in a park on a summer's day. It is relatively easy to get people to adopt such poses, and you can probably persuade your family or friends to be your models.

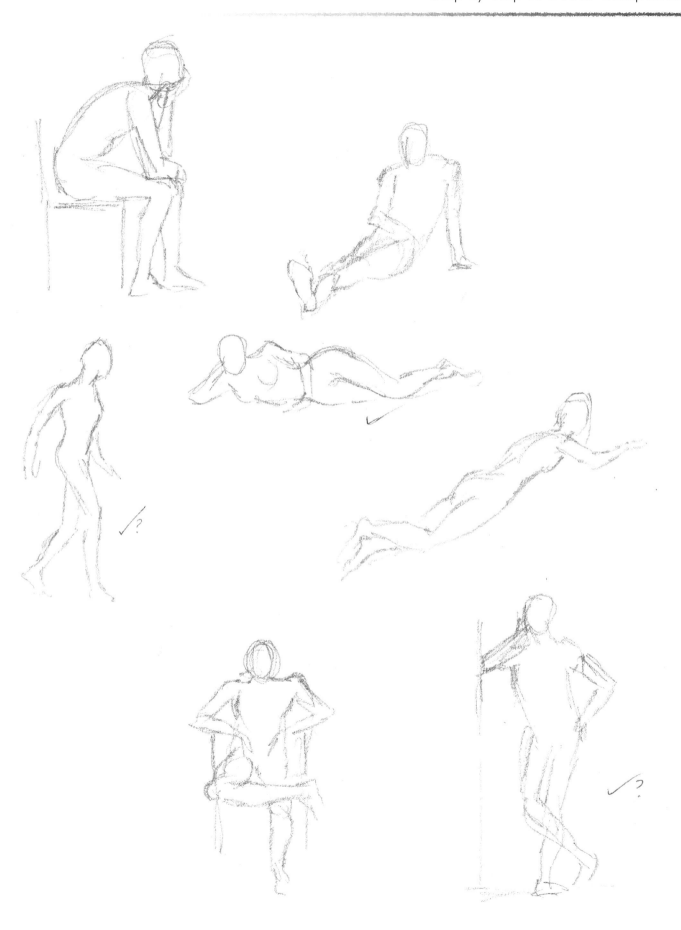

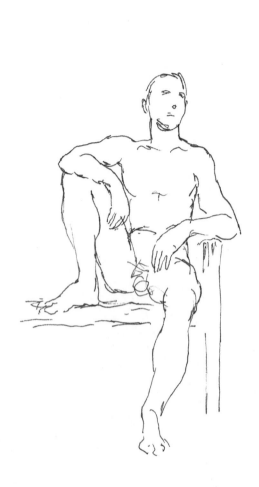

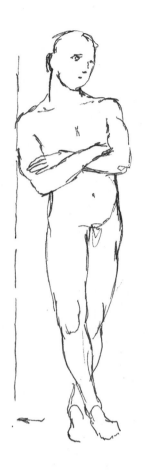

Step 5 Choosing the Main Poses

Having investigated a range of poses, the next thing to do is to draw up rather more considered sketches of the poses that you think will work together and then try them out in a series of frames of the same size and format. You will then begin to get an idea of how the composition might be most successful.

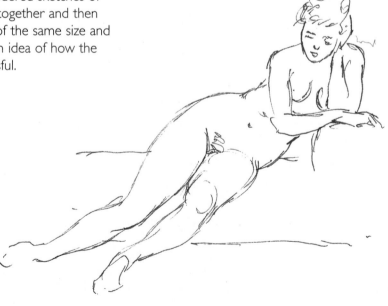

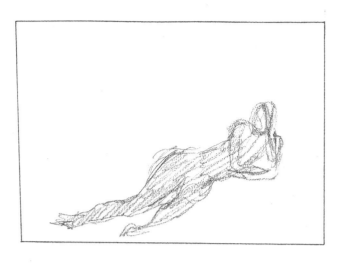

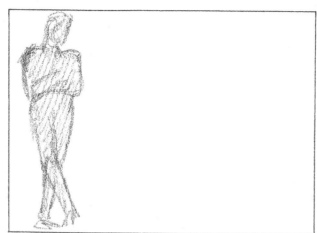

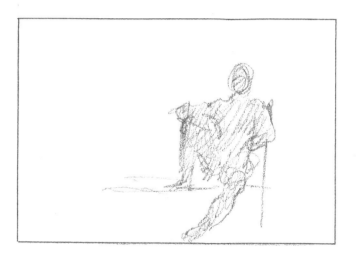

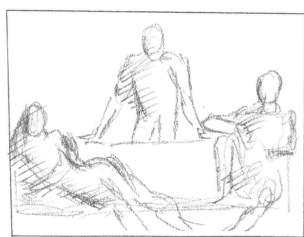

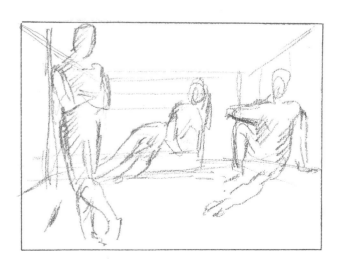

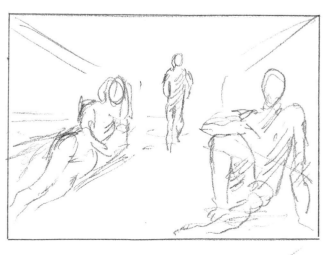

Arrangement

This page gives an idea about arranging your models. The page opposite shows how the arrangement would look from the different angles A, B/C and D.

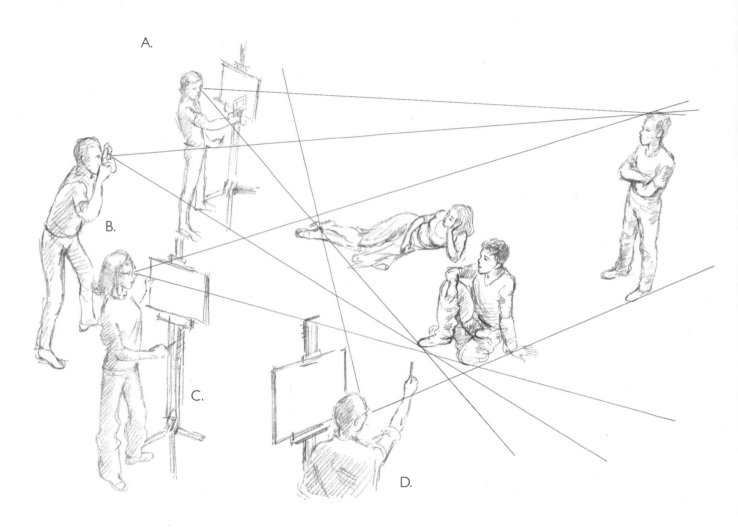

Step 6 Viewing Different Angles

Now is the time to try to get your three models together to sketch them in some sort of relationship with each other, with space and depth around them. It doesn't matter about the scenery yet but you need to know how the figures will look together in reality. Either get them to pose while you do a quick sketch, or take a photograph (B) to give you an idea of how the composition might work. Even now it doesn't have to be set in stone and if necessary you can still change them around, but a good drawing of how the figures relate is now essential. You might use a card framing device (A), or do it by eye (C) or measure it by judging with your pencil (D).

A.

B/C.

D.

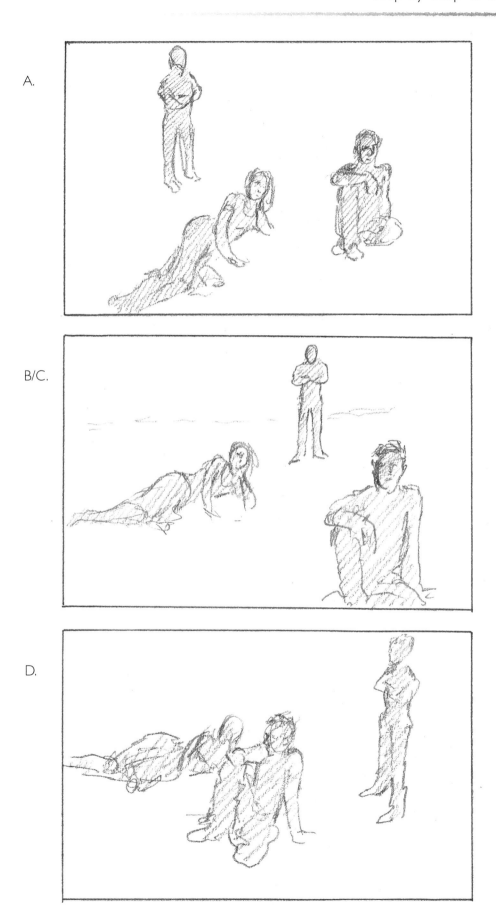

Step 7 Exploring the Setting

Relaxing in the park in summer is the theme, so you will need to make some drawings of background scenes in your nearest parkland or gardens. With your drawings of the three characters to work on, place them in the scene in as many ways as you think fit to get the best effect you require. When you have considered some options, make a choice. All these stages are about making decisions that gradually limit your picture to a pattern that you find aesthetically satisfying.

In all these scenes the dynamics are different, although the scene is similar. Each could work and my choice is just that I liked the contrast between the girl lit up in the foreground and the man sitting in the shade behind (above).

Step 8 Detailed Figure Drawings

Having chosen your composition you will now have to do detailed drawings of your three figures. This time you can take them one at a time and make a more careful drawing that will have all the information you want in it. This means that now you have to notch up the level of your drawing to something more developed and finished. Take your time at this stage; it is worth getting these drawings absolutely right. It doesn't matter if it takes several days or even weeks to complete them, it will be worth it in the long run and the end result will be all the better for it.

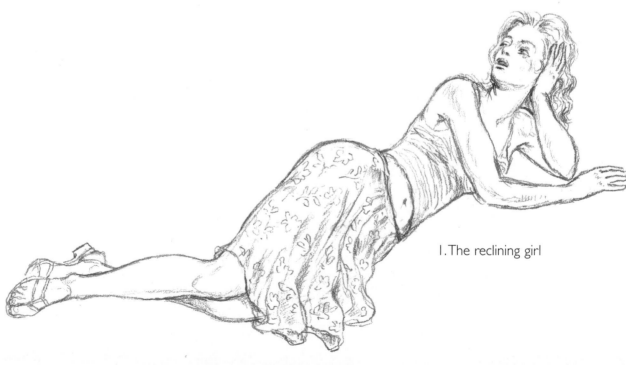

1. The reclining girl

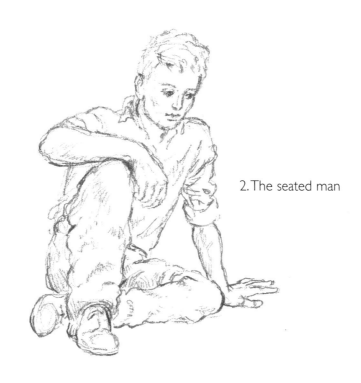

2. The seated man

3. The strolling man

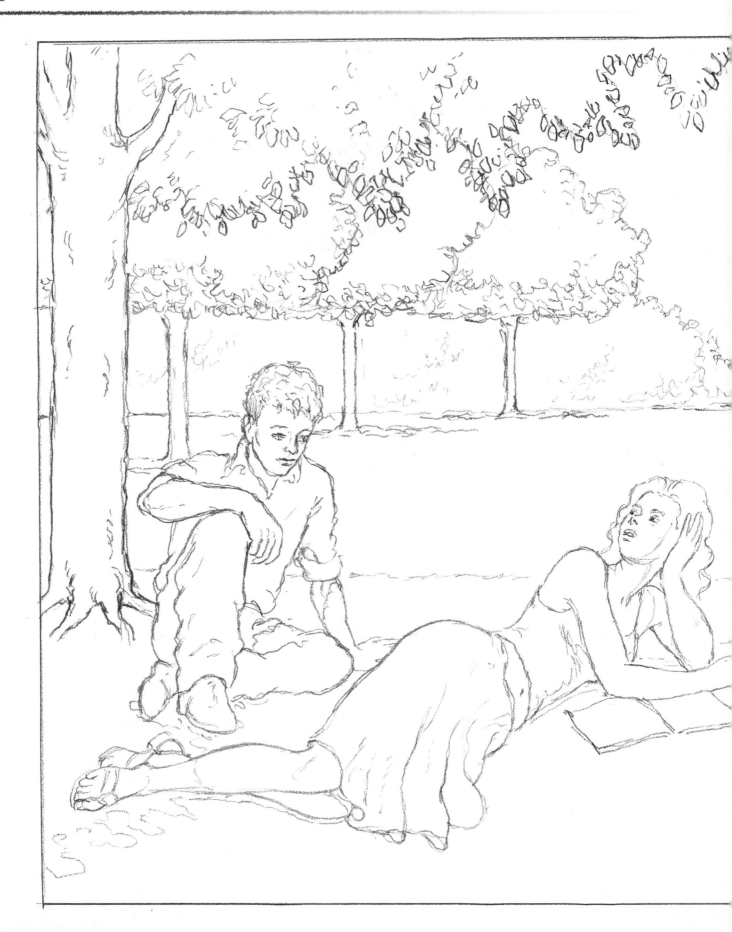

Step 9 Putting it All Together

Now you have three excellent drawings of your characters, you have to fit them convincingly into your scene. You may have to reduce or increase their size as you set the relationship of the three figures for the final piece. Draw them up very carefully, tracing them off in line, and placing them in an outlined drawing of the setting. This is your 'cartoon' in which everything is going to be drawn as the final picture requires. It has to be the same size as the finished drawing and everything should be in it except for tone and texture. At this stage what is required is a full-size complete line drawing in pencil of your composition.

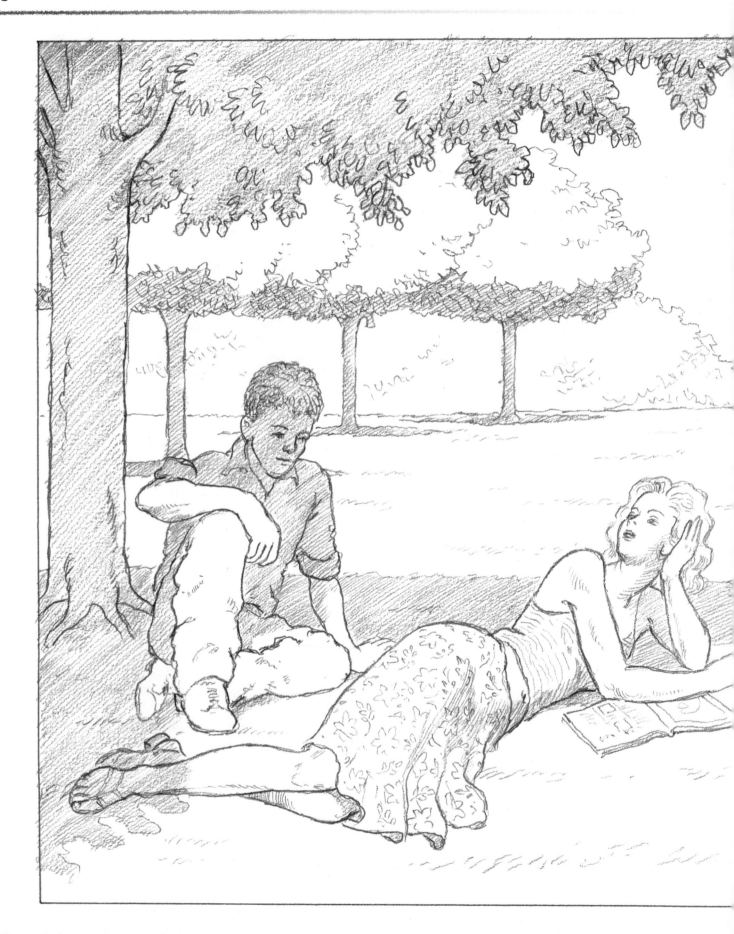

Step 10 Blocking in the Tone

The next stage is to put in every bit of tone, but in one tone only – the lightest you are going to use. At this stage you can also begin drawing in your final technique (for example pen and ink, or line and wash). All heavier tones can be worked in later and even the texture of each area can be left until after this stage. So you should at the end of this stage have a complete drawing in line and tone, but only one bland tone.

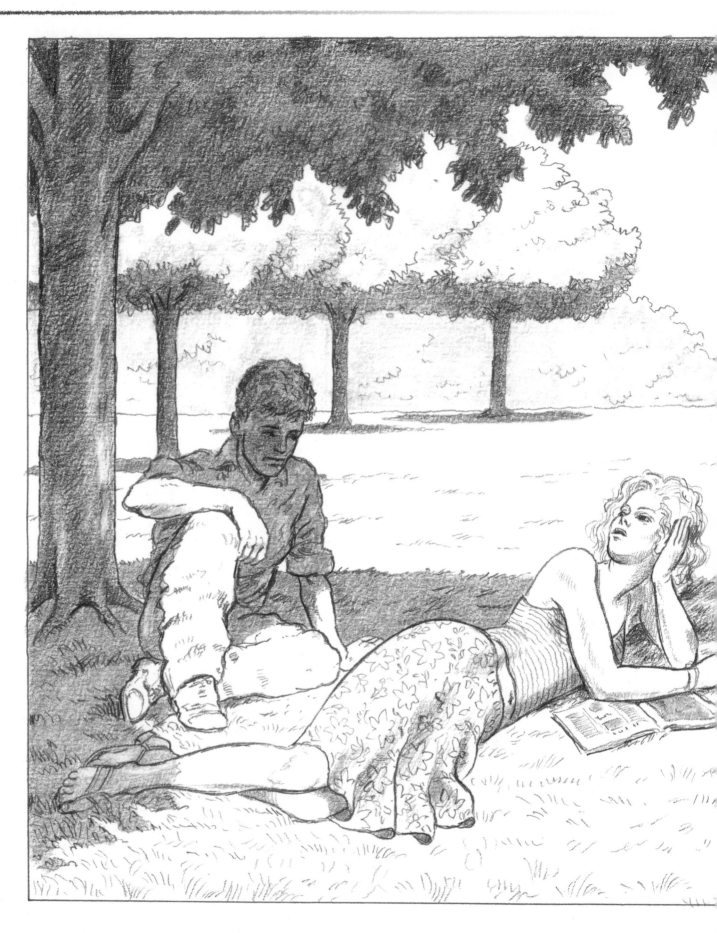

THE COMPLETE PICTURE

Tone and Texture in Depth

Having made all the necessary decisions which have produced a convincing picture, you can now let rip with light and shade, the textural qualities of the scene and the subtleties of outline. Work into your shaded areas so that darker, bigger areas of shade have more variety of tone from very dark to light. The objects and people further away should have lighter and less varied tones to give a feeling of recession. Show the textural qualities such as grass and leaves, again making those in the foreground more textured and more obvious. The figures themselves are dealt with in a similar fashion, the further figures being less strongly toned and textured while the nearer ones are more varied and stronger in detail. Even the outlines of the foreground figures should be stronger in the front of the picture and fainter as they recede.

Now you have accomplished a complete figure composition on the theme of summer in the park with three figures. Well done! You will no doubt have realized how necessary it is to have a system of working your way through a picture, and while you may wish to adapt it, this system has stood the test of time.

PORTRAIT: PUTTING THE SUBJECT IN THE FRAME

When you are going to draw a portrait, your first consideration is the format of the picture. This is usually the normal portrait shape, taller than its width, but of course this might not always be the case, and you should follow your own ideas. In the examples I have chosen, I've stuck to the upright format in order to simplify the explanation. The idea of these pictures is to give some thought to the way that you use the format to determine the composition. You might choose to draw the head alone or include the entire figure.

The first example shows the most conventional treatment of the sitter, occupying a central position in the picture, showing the top half of the figure with a simple background suggesting the room in which she is sitting. There are probably more portraits showing this proportion of the sitter than any other.

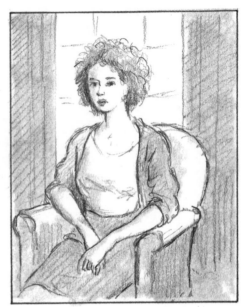

In the second picture, I have gone in close to the face of the sitter and the background is just a dark tone, against which the head is seen. The features are as big as I could get them without losing the whole head, and all the attention is on the face.

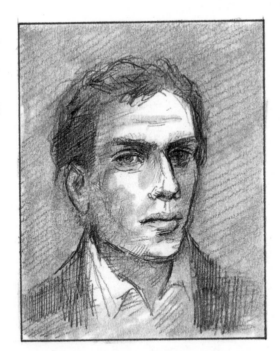

The next picture shows the other extreme, the full-figure portrait. In this, the figure is standing, with the surrounding room shown in some detail, although this does not always have to be the case; it could be an empty space or perhaps an outdoor scene. The full-length portrait is often a tour de force for the artist involved.

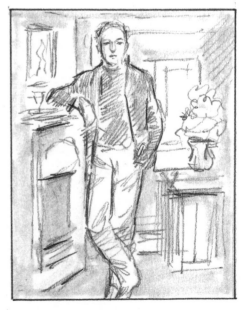

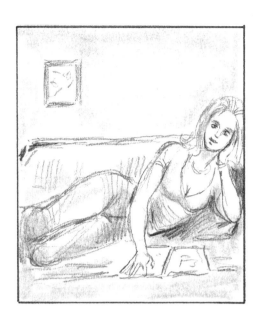

Here we see a figure, not quite complete, but taking on a more horizontal position. This could be done just as well in a landscape (horizontal) format, but can be most effective in the vertical. In this example, the space above the sitter becomes significant and often features some detail to balance the composition, like the picture shown.

A double portrait – such as a parent and child – creates its own dynamic. All you have to decide is how much of each figure you choose to show, and what will be in the centre of the composition.

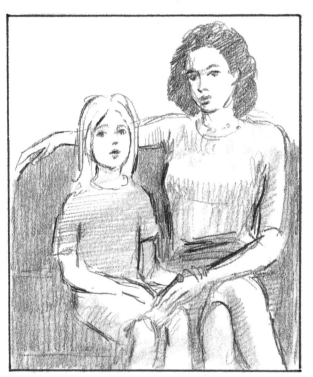

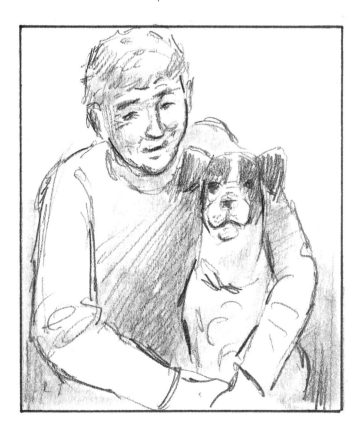

The final example is a portrait of the sitter and his dog. Putting pets into the portrait is always tricky, but the answer is to draw the animal first and then the owner. Will you make the animal a mere adjunct or the centrepiece?

There are many ways to approach the drawing of a portrait and this stage of consideration is crucial to the final result.

MAPPING OUT THE PORTRAIT

Starting on a portrait is always a bit tricky, but there are time-honoured methods of approach that should help you.

First, treat the head like any other object and make a rough sketch of the overall shape. This is not as easy as it sounds because the hair often hides the outline, so you may have to do a little bit of guesswork to get as close to the basic shape as you can.

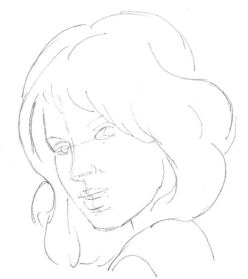

When you have done that, block in the hair area quite simply – not trying to make it look like hair – and note how much of the overall shape it occupies.

Now comes the most critical part of the drawing, the features. These must be placed at the correct levels on the face, in a very simple form. Check by measuring if you are in any doubt, but remember that normally the eyes are halfway between the top of the head and the point of the chin, and make sure the eyes are far enough apart. Also, check the size of the nose and its relationship with the mouth. In this example, the face is seen three-quarters on, and this means that the space occupied by the far side of the face measures much less than the near side.

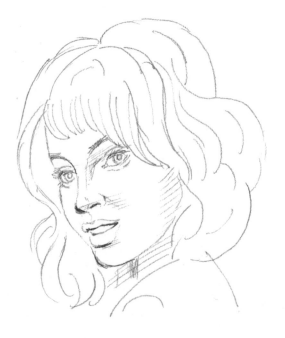

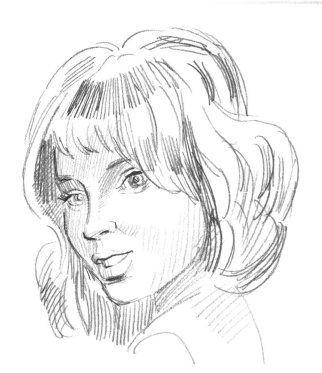

Having sketched the features in the right place – and got them basically the right shape – now draw them in greater detail.

Mark the main areas of shadow; keep shading light to start with and add more intensity when you are satisfied that all is correct. Finish off by refining both the shapes and the tonal areas.

AN ALTERNATIVE METHOD

Using this method, you start with a line down the centre of the face, drawn from the top of the head to the chin and neck.

Mark a line at eye level (halfway down the whole length), then a line for the mouth, the tip of the nose, and the hairline. Check these thoroughly before moving on. Now carefully draw in the eyes, the nose, the mouth, the chin and the front of the hair.

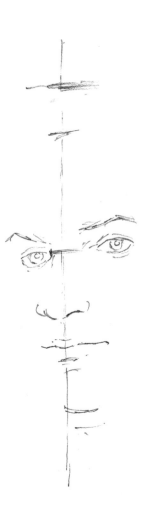

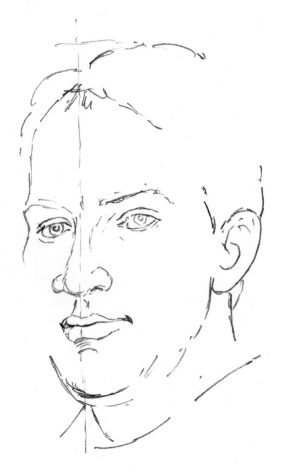

Ascertain the position of the nearer ear in relation to the eyes and nose. Next, draw these in clearly so that you can see if the face looks right. If not, alter anything that doesn't appear like your sitter's face.

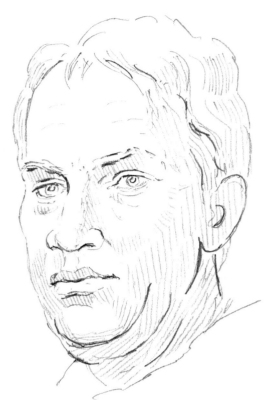

Now you can put in all the rest of the head outline and then the main areas of shading. At this stage, shade lightly, in case it needs to be changed.

After rubbing out the initial guideline, work in the more subtle tones and details of the face. You may need to increase the intensity of the tonal areas in some places.

These are two methods of achieving a good result.

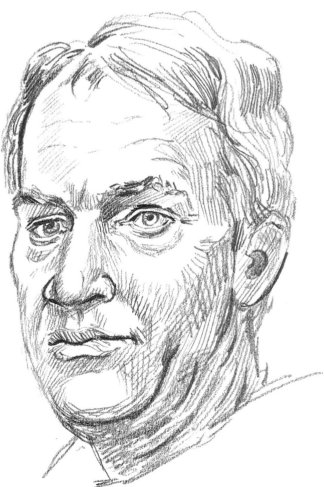

EYES AND MOUTHS

One practice that you will have to make regular is to look at all the features of the face in some detail. Before you start drawing, you need to check how they all work together.

Eyes

Looking at the eyes of your model, viewed from the front, the corners may be aligned exactly horizontally; or the inner corners may be lower than the outer ones, which will make them look tilted up; or the outer corners may be lower than the inner ones, which will make them look tilted down.

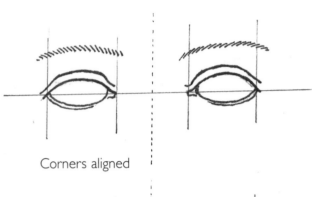

Corners aligned

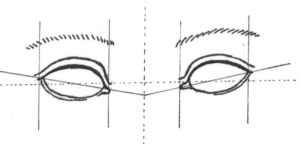

Inner corners lower than outer ones

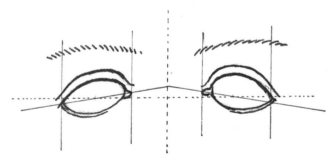

Outer corners lower than inner ones

Eyes can have either thin or heavy eyelids.

Eyebrows can be arched or straight, as shown. They can also be thick or thin.

Straight mouth

Mouths

Mouths may be straight along the central horizontal; or curved upwards at the outer corners; or curved downwards at the outer corners.

Curved up at the corners

Mouths can also be thin- or full-lipped, as shown.

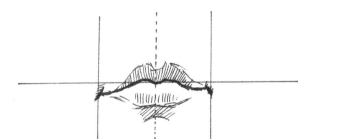

Curved down at the corners

NOSES, EARS AND HAIR

The nose is the most prominent of the features on the head, and although not all that complex, it needs some study to be able to draw it convincingly from any angle.

The ears are a more complex shape and because we rarely look at them in detail, quite a bit of care is needed to get them right.

Hair has infinite possibilities, but it is worth considering the basic styles or forms of it and then drawing it from direct observation.

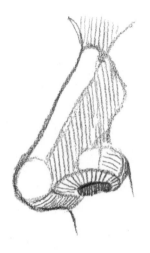

Noses are much easier to draw in profile than from the front. As the head moves closer towards a facing position you will need to note the facets of the surface which show the solidity of the shape. These images give you an idea of how the average nose has a long, narrow frontal surface inclined upwards, a rounded end surface, side areas of varying shape and then the more complex surfaces around the nostrils. When the nose is facing towards you the nostrils, being holes, are the most dominant feature. Noses vary enormously from the most hawk-like and aquiline beaks to the softest retroussé snub noses. The tilt of the nostrils is often a defining shape.

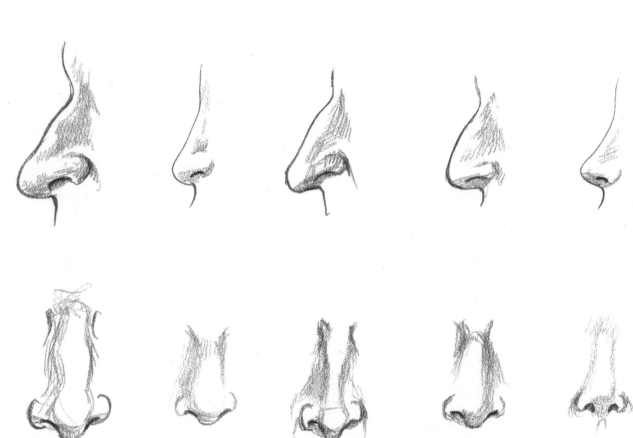

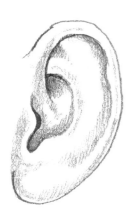

Ears are only difficult because we rarely look at them. The diagram here shows an ear of average shape and although there are many variations the basic structure remains the same. Some ears are much flatter against the side of the head and are not noticeable from the front; others stick out like jug handles and can be quite a strong feature on a head with short hair. Apart from their size and the amount they protrude, they are not an instantly recognizable feature in the human face.

When it comes to hair, the most obvious differences are in length and whether the hair is curly or straight. There tends to be less range in style among men, though the advent of thinning hair with age does tend to change the look of someone's face. Shown here are just four examples of how to tackle short, straight, curly and long hair.

SETTING THE POSE

Your first concern when you set out to draw a portrait is how to pose your subject. There are many possibilities and you must decide how much you wish to draw of the subject, apart from the face. You might choose the whole figure, or go for half or three-quarters; your subject may well have ideas on how he or she wants to be drawn too.

In this session, I decided to draw my daughter and so I sketched out various positions that she might sit in.

In a chair . . .

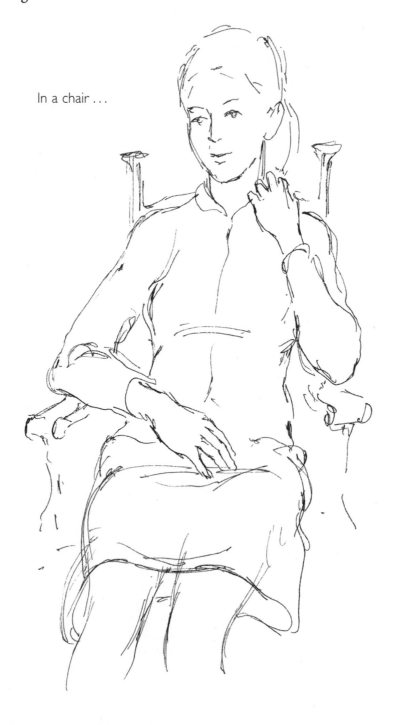

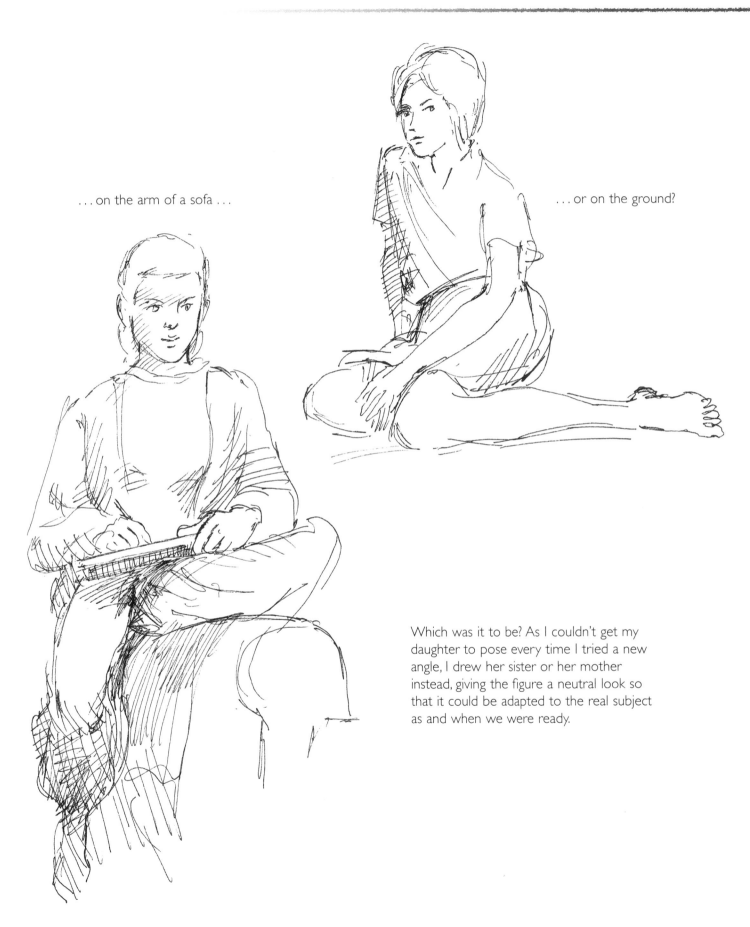

...on the arm of a sofa ...

... or on the ground?

Which was it to be? As I couldn't get my daughter to pose every time I tried a new angle, I drew her sister or her mother instead, giving the figure a neutral look so that it could be adapted to the real subject as and when we were ready.

CHOOSING THE ANGLE

To make sure that you are familiar enough with the facial features of your subject, you need to produce several sketches of the face from slightly different angles, so that things are easier when you come to do the finished drawing.

 Of course, I had been familiar with my own daughter's face over the years, and was able to call on several drawings that I had done before, which I studied carefully for the salient features.

There was this profile, which is quite easy to draw as long as you get the proportions right. The hair tends to dominate a side view.

This three-quarter view is the kind of angle that people like in a portrait, because the face is more recognizable.

This drawing, glimpsed from a distance when she was smiling, is useful but it doesn't give much detail to the face. This is often the sort of result that you get from a quick snapshot.

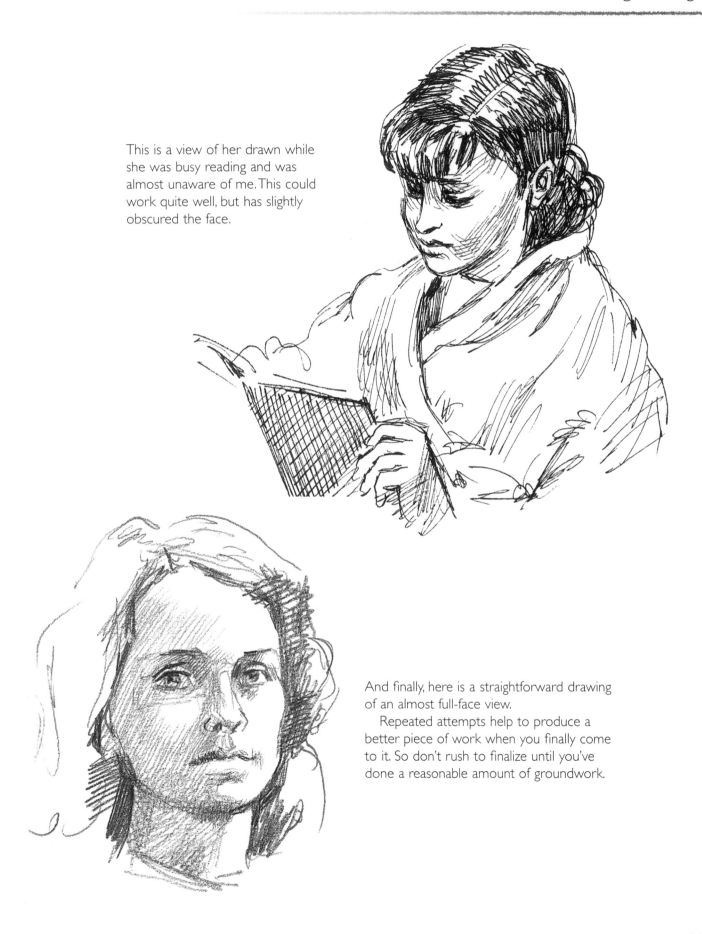

This is a view of her drawn while she was busy reading and was almost unaware of me. This could work quite well, but has slightly obscured the face.

And finally, here is a straightforward drawing of an almost full-face view.

Repeated attempts help to produce a better piece of work when you finally come to it. So don't rush to finalize until you've done a reasonable amount of groundwork.

A FINISHED PORTRAIT

When I decided to do the final portrait, my daughter just sat down in a chair and told me I had only a short time to draw her as she had other things that she needed to do.

I let her arrange herself until she felt comfortable although, as you can see, she is perched on the edge of the chair, ready to go at a moment's notice. This is a mark of character that will probably help to give the drawing more verisimilitude.

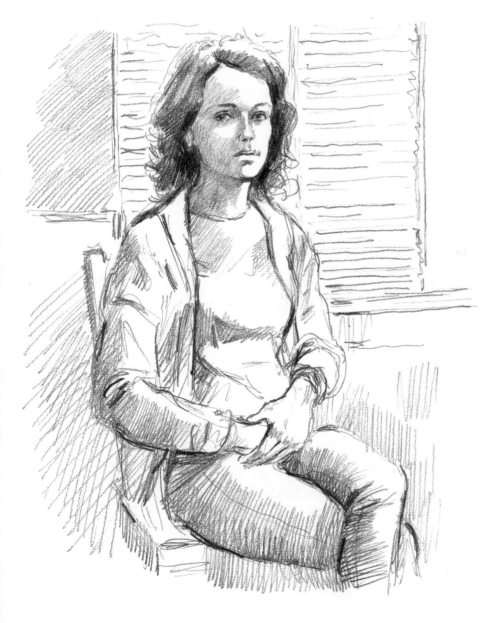

The background was just the texture of a Venetian blind, so it was not too difficult to draw. I first sketched in the whole head and then the rest of the figure, to make sure that I had got all the proportions right. The facial proportions took three attempts before I was satisfied with the result.

I kept the shading simple and only allowed two grades of tone, a mid-tone and a dark one. I used the 2B pencil in a light, feathery way to put on large areas of tone evenly, and I emphasized certain areas where I thought the darkest shadows should be. This seemed to work all right and I finished off the portrait with a few areas of tone on the background, to help set the figure in the space.

Follow these steps when you come to try portraiture for yourself, and you should end up with a good drawing.

INDEX